VINCENT VAN GOGH

DRAWINGS

VOLUME I

———

THE EARLY YEARS

1880-1883

VAN GOGH MUSEUM

———

VINCENT VAN GOGH

DRAWINGS

VOLUME I

———

THE EARLY YEARS

1880-1883

VAN GOGH MUSEUM

———

SJRAAR VAN HEUGTEN

VAN GOGH MUSEUM, AMSTERDAM

LUND HUMPHRIES PUBLISHERS,

LONDON

First published in Great Britain in 1996 by
Lund Humphries Publishers
Park House
1 Russell Gardens
London NW11 9NN

Vincent van Gogh: Drawings
Volume 1: The Early Years 1880-1883
© 1996 Van Gogh Museum, Amsterdam, The Netherlands,
V+K Publishing, Bussum, The Netherlands and
Lund Humphries Publishers Ltd, London, Great Britain

British Library Cataloguing in Publication Data
A catalogue record for this book is available from the British
Library

ISBN 0 85331 721 6

Printed and bound in The Netherlands by
bv Kunstdrukkerij Mercurius Wormerveer

Distributed in the USA by
Antique Collectors' Club
Market Street Industrial Park
Wappingers Falls
NY 12590
USA

Contents

Foreword

The Dutch art critic W. Jos de Gruyter said in his *Tekeningen van Vincent van Gogh* of 1961: 'An immense amount has been published about Van Gogh, but more about the person than the painter, and more about the painter than the draughtsman.' Although the literature on the artist has expanded almost exponentially since then, De Gruyter's assessment of the relative amount of attention devoted to Van Gogh's drawings seems no less valid today.

The new series of catalogues of the collection of drawings in the Van Gogh Museum, of which this is the first, therefore fills a certain gap. With some 460 drawings, more than 200 letter sketches and most of Van Gogh's surviving sketchbooks, almost all of which belong to the Vincent van Gogh Foundation, the Van Gogh Museum has the largest and richest collection of drawings by the artist. It contains sheets typical of all the periods in his career, and the wide variety of subjects makes it in a sense even more well-rounded and representative than the museum's collection of paintings, in which landscapes and still lifes predominate over the relatively few figure pieces.

Even before the Van Gogh Museum opened in 1973, the Vincent van Gogh Foundation had been energetically filling gaps in the core collection. Time and again Dr V.W. van Gogh acted swiftly to secure a prize, even if it meant advancing the money himself. It was above all the early work from The Hague and Drenthe that was under-represented. For instance, the views of The Hague commissioned from the artist by his uncle, the art dealer C.M. van Gogh, were naturally not part of the family collection. The Vincent van Gogh Foundation nevertheless succeeded in acquiring three representative sheets from the series *(cats. 24-26)*. The Hague group of drawings was augmented with the *Old woman with a shawl and a walking-stick (cat. 23)*, an unknown portrait of Sien Hoornik *(cat. 28)*, *Old man drinking coffee (cat. 32)*, *Soup distribution in a public soup kitchen (cat. 60)*, and the monumental study of a worn-out horse *(cat. 66)*.

The museum itself was equally active on the acquisitions front. In addition to the *Man with a sack of wood* from the Etten period *(cat. 19)*, mention should be made of the two superb landscapes which can justly be regarded as the high points of Van Gogh's work in Drenthe *(cats. 67, 68)*. The museum also received a number of donations, among them the fine pen drawing of Austin Friars Church from the period before Van Gogh decided to become an artist *(cat. 5)*, and the technically fascinating study of a baby *(cat. 54)*.

Although the printroom on the second floor of the museum was originally designed for exhibiting drawings and prints, Van Gogh's works on paper can, alas,

rarely be allowed to go on display. They are so fragile that they can only be exhibited sporadically. One such occasion was the Van Gogh commemorative exhibition in 1990, when no fewer than 124 sheets from the Amsterdam collection went on display in the Kröller-Müller Museum in Otterlo. In that same year the Van Gogh Museum also exhibited most of the sketches with which Van Gogh used to enliven his letters.

It has been decided to mark the appearance of each volume in the series of catalogues with an exhibition of the drawings discussed in it. By way of an overture, the publication of Van Gogh's complete print oeuvre in 1995 was accompanied by an exhibition of the prints. Not only will this enable art-lovers to become acquainted with our entire holdings of works on paper in the space of a few years, but it has the added attraction of matching research and presentation with the museum's responsibilities towards the public.

The Van Gogh Museum hopes that this, the first in the new series of catalogues of the collection, will make an important contribution to the scholarly presentation of the rich heritage to be found in Dutch museums. For some time now the Van Gogh Museum has been participating in the Dutch Post-Graduate School for Art History, which aims not only to narrow the gap between the study of art history in universities and museums, but also regards the publication of catalogues of Dutch collections as one of its priorities.

All the drawings in this catalogue are reproduced in colour. That is no wild extravagance, not even in the case of those drawings seemingly conceived 'merely' in black and white. Monochrome reproductions invariably change the surface of the white or coloured paper into a grey tone, and more violence is done to the subtle interplay of values within a drawing than one would suspect at first sight.

However fine the quality of the reproductions, there is no concealing the extent to which some sheets have faded in the past 100 years, particularly those in ink or watercolour. Often, too, there have been considerable changes in the nature of the paper. It takes a great deal of effort and knowledge on the viewer's part to imagine how some of these drawings looked when they were still fresh. It is partly for that reason that Sjraar van Heugten, the museum's Curator of Prints and Drawings, goes into great detail on the genesis of each sheet, the technique used and, where necessary, its present condition.

To date there has been insufficient research on the manner of drawing used by Van Gogh's Dutch contemporaries, the painters of the Hague School, for any firm pronouncement to be made on the extent to which Van Gogh's use of the medium differed from the standard practice of his day. One suspects, though, that it was considerable, as is only to be expected of a self-taught artist. Van Gogh was always quite isolated from his immediate colleagues, and this would have forced him to turn to books for the information he needed. He could also draw on the experience he had undoubtedly gained in the years when he worked in the art trade. A very close reading of that

vital source of information, the letters to Theo, led Sjraar van Heugten to the manuals used by Van Gogh, and this, combined with his intimate acquaintance with the drawings themselves, enabled him to explain many puzzling technical features of the works or the use of unorthodox drawing materials.

When confronted with an artist of such an emotional appeal as Van Gogh, authors usually tended to discuss the content of a sheet rather than investigate Van Gogh's actual draughtsmanship, or the experimental approach that is such a hallmark of this autodidact. Not only were the drawings studied rather cursorily, but interest usually focused on the same sheets every time, with museums constantly requesting the same limited number of drawings for exhibitions, ignoring the others. As a result, for decades the information about drawings that had been pushed into the shade was often uncritically copied from out-of-date publications. Individual descriptions of these works were also scarce. Even in the retrospective exhibition in 1990 only a few drawings were subjected to detailed, individual analysis. Fortunately the tide has now turned a little, and it seems that the spotlight turned on the drawings in 1990, and at the earlier exhibitions curated by Ronald Pickvance at the Metropolitan Museum in New York, has aroused the interest of a new generation of scholars.

The present catalogue does not include several sheets that have been attributed to Van Gogh over the years. This is because it was impossible to establish their credentials beyond all shadow of doubt. The museum simply cannot lend itself to creating yet more legends around the oeuvre of an artist which is already surrounded by such a forest of myths. One clear problem was posed by the group of so-called 'juvenilia', a few of which were acquired by the Vincent van Gogh Foundation itself (see Appendix 2, nrs. 2.1-2.6). When they surfaced in the 1940s and 1950s, several prominent scholars accepted them as authentic works from the hand of a very youthful Van Gogh, and they were later tolerated as such by many people without further comment. Their pedigree, however, is so vague and unsubstantiated that the author of this book was unable to forge a solid argument for attributing them to Van Gogh. Datings, too, have been treated with caution, and occasionally a wider margin of error has been adopted than previous authors considered necessary. The same applies to the identification of some of the figures and places depicted.

Many people in and outside the museum assisted the author in his preparatory research and the presentation of his findings, and Sjraar van Heugten thanks them elsewhere in this volume. Van Gogh's dictum that 'drawing is a hard and laborious struggle' can be applied without any exaggeration to the production of a book such as this. A great debt of gratitude is owed to the publishers, V+K, who in the person of Cees de Jong were closely involved in the conception of the entire series of catalogues from the very outset, and no less so in the design of this first volume. In the museum itself, Deputy Director Ton Boxma established a close-knit financial basis for this ambitious project in consultation with the publisher, as a result of which Marije Vellekoop

could be taken on as curatorial assistant. Thijs Quispel took new photographs of all
the works under the supervision of Melchert Zwetsman. Several dozen drawings
were treated by conservators Nico Lingbeek, Francien van Daalen and Marieke Kraan.
Finally, Chief Curator Louis van Tilborgh created the conditions within the Collections
Department that made it possible for minds to be concentrated on this publication,
and I would like to thank him and, through him, all the other members of his depart-
ment who were involved in the making of this book.

Ronald de Leeuw
Director

Author's preface

A certain amount of sifting and weeding out is inevitable when cataloguing the many works on paper in the Van Gogh Museum. In addition to ambitious drawings and finished studies there are sketchbooks and loose sketchbook sheets. The sketches that Van Gogh made in his letters or enclosed with them are yet another category.

Sheets which can be traced back to a surviving sketchbook have not been included in this catalogue, and nor have most of the letter sketches. Whether the latter were drawn on a page in a letter or on a separate piece of paper, most of them are just rough sketches whose sole purpose was to clarify a passage in a letter or give an idea of what Van Gogh was working on at the time. Only a few sheets enclosed with letters had more serious pretensions, and they have been included in the catalogue, with an explanation as to why. There are a number of sketches that fall between these two stools, but I felt that they had a value that warranted their inclusion.

An exception has also been made for the loose sheets that Van Gogh enclosed with his letters in the years prior to becoming an artist. Since it is not really possible to classify them as 'more' or 'less' serious work, they have all been included (cats. 8, 10, 11, and possibly 9) among the other juvenilia. The remaining letter sketches, sketchbooks and loose sketchbook sheets will be discussed in a separate volume.

This volume is the first of the four-part catalogue of the drawings held in the Van Gogh Museum. It covers the years 1880-83, the period in which Van Gogh developed from a rank novice into an assured draughtsman. The catalogue opens with a group of drawings made between c. 1872 and 1879, before Van Gogh took his momentous decision to become an artist *(cats. 1-12)*.

The Introduction is devoted mainly to a discussion of the technical aspects of Van Gogh's early artistic development. The aim in the catalogue entries has been to give equal weight to questions of both technique and content.

Appendix 1 examines a few unpretentious sketches which Van Gogh would normally have thrown away but which have somehow survived. It also contains one or two sketches which are otherwise impossible to catalogue.

Appendix 2 covers drawings in the collection which I believe are not by Van Gogh, although others do count them among the œuvre.

While writing this book I enjoyed the vital support of many colleagues. I owe a great debt to Monique Hageman, Fieke Pabst and Marije Vellekoop, who both individually and as a lively team made a great contribution to the documentary sections in particular – the provenances of the works and the relevant exhibitions and literature. Marije also carried

out archival research on some of the drawings. She and, as ever, Louis van Tilborgh edited my text with a remarkable lack of clemency, which resulted in numerous improvements to the first draft. Elly Cassee, Leo Jansen and Hans Luijten, who are preparing the scholarly edition of Van Gogh's letters, not only checked all the quotations from the letters against the originals but also helped me to decipher seemingly impenetrable inscriptions on the drawings. Anita Vriend succeeded in tracking down publications in the most obscure places. Alex Nikken and Frans Stive ensured that the drawings were always available for study. Han Veenenbos of the Vincent van Gogh Foundation unearthed several important pieces of information from the archives that helped clarify the provenance of various works.

I was also able to count on the support of many people outside the museum. I had long conversations with Nico Lingbeek and Francien van Daalen on Van Gogh's drawing technique. I carefully examined the drawings in the museum with them, and in the course of several sessions in their studio we and Marieke Kraan reconstructed techniques mentioned or discussed by Van Gogh in his letters. My understanding of his irrepressible desire to experiment in his early work would have had a far shakier basis had it not been for their help and enthusiasm.

Michael Hoyle's excellent translation was occasionally such a model of concision that I reformulated some passages in the Dutch text on the basis of his English version. In his usual, cheerful way, Gerard Rooijakkers of the Meertens Institute in Amsterdam was more than generous in supplying me with information on the way of life and work in Van Gogh's 19th-century Brabant. When encountering words like 'sligtmes', the reader may rightly assume that they are not part of the author's standard vocabulary.

The help I received from various other individuals is acknowledged in the appropriate entries. I am also grateful to Roland Dorn, Mannheim; Martha Op de Coul, Netherlands Institute for Art History (RKD), The Hague; and to P. Wander, W. de Koning Gans and C.C. Berg of the Hague City Archives.

And finally, but effortlessly in first place, there is my partner May Rijs. She was a constant source of encouragement while I was writing this catalogue, and was thus completely indispensable for the making of this book.

Sjraar van Heugten

Van Gogh's early years as a draughtsman

In 1880, the 27-year-old Vincent van Gogh could look back on a disastrous start to his adult life. In the space of ten years he had proved a failure as a trainee art dealer and as a teacher, and had given up a job serving in a bookshop in order to study theology in Amsterdam. That proved to be beyond his grasp, and then in 1878 he was turned down by the Flemish training school for preachers in Brussels. He did manage to get a temporary appointment as an evangelist in the Borinage mining region of Belgium, but in July 1879 it was not renewed. Well-meaning members of the family were immediately ready with suggestions for new occupations. His brother Theo advised him to become a lithographer at a commercial printer's, or a bookkeeper, or even a carpenter's apprentice. His sister Anna greatly offended her eldest brother by proposing that he try his hand at the bakery business.[1]

A year of soul-searching led to a deep depression, which he aired in a long and moving letter to Theo in the summer of 1880. He confessed, among other things, that he desperately wanted to return to 'the land of pictures' [154/133], but he still had no firm plans for the future. Suddenly, though, that changed, for in a slightly later letter he

See the Note to the reader on p. 38 for the abbreviations and short-form references to the literature used in the notes.

1 *Letter 153/132.*

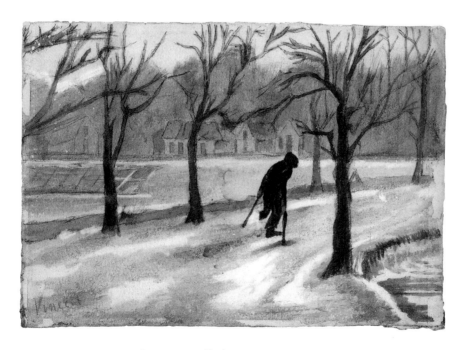

1 *Man in a snow-covered landscape,* 1877. Epe, Bockweg Gallery

asked his brother to send him some prints after Millet that he wanted to copy. Without saying so in so many words, he had decided to become an artist.[2]

2 Letter 155/134.

Although this change of course has always been presented as Van Gogh's own idea, it was in fact Theo's. Possibly prompted by Vincent's wish to revisit 'the land of pictures,' he had suggested that he become a painter. This emerges from a passage in a later letter that has escaped notice until now. Vincent had at first considered it a rather silly idea. 'I remember very well, now that you write about it, that when you spoke of my becoming a painter I thought it very impractical and would not hear of it' [213/184]. Further on in the letter it turns out that the main obstacle was his own lack of faith in his technical ability. 'What removed my doubts was reading a comprehensible book on perspective, Cassagne's Guide de l'Abc du dessin; and a week later I drew the interior of a kitchen with stove, chair, table and window in their proper places and on their legs, whereas before it had seemed to me that getting depth and the right perspective into a drawing was witchcraft or pure chance.' That it was Theo who persuaded his brother to become an artist throws a new light on their relationship in the years that followed, for now it was little less than Theo's moral obligation to support Vincent in his chosen profession. The above quotation also shows how important Armand Cassagne was for Van Gogh, so his work will be dealt with at some length in this Introduction.

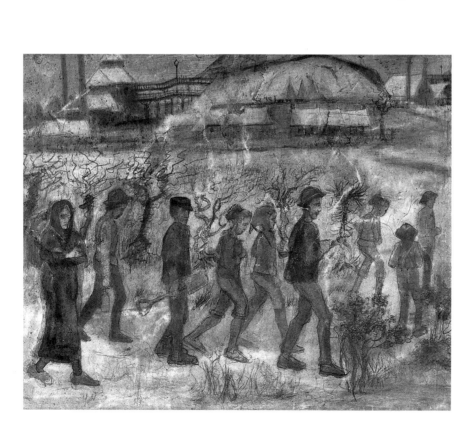

2 *Miners in the snow* (F 831), 1880.
Otterlo, Kröller-Müller Museum.

Van Gogh's doubts about the wisdom of this choice of career were not unfounded, for he had never shown any marked artistic talent. There is a group of drawings which some believe he made between the ages of eight and ten, but it is a very dubious attribution. Works from that group in the Van Gogh Museum are not accepted as authentic in this catalogue (see Appendix 2). There is more certainty about a number of drawings dating from circa 1872-80, 12 of which are in the museum *(cats. 1-12)*. In quality they range from rather clumsy sketches to quite successful scenes, but not one of them displays signs of any real talent. At that time Van Gogh drew for his own pleasure, and had no need to explore the potential of different media. Most are simple drawings in pencil and pen, and two sheets show that he occasionally used colour as well. Recently there was a fairly secure attribution of a small watercolour that would date from 1877 *(fig. 1)*.³ A watercolour from the Borinage in the Van Gogh Museum *(cat. 12)* must have been made in the summer of 1879, when Van Gogh was given a box of watercolours.

In spite of his own doubts and inexperience, Van Gogh seems to have decided to take Theo's suggestion seriously, and he imposed a strict regime on himself. He evidently knew of the traditional, academic method of teaching, for his first exercises followed that basic curriculum: copying prints and examples in manuals of drawing. From Theo he received the prints he had asked for after the work of the French painter Jean-François Millet, who was his role model. He asked H.G. Tersteeg (1845-1917), who had been his superior from July 1869 to May 1873 at the Hague branch of the Paris art gallery Goupil & Cie, to lend him Charles Bargue's Exercices au fusain. These drawing models for sketching the human figure with charcoal (fusain) were well-known to Van Gogh, for they had been published by Goupil's in 1871, when Van Gogh was still working for the firm. In addition to the Exercices, Tersteeg sent him Bargue's Cours de dessin, which contained drawing examples after the work of great masters.⁴

Not one of the dozens of copies that Van Gogh made after Bargue in this period has survived. There are a few drawings after prints of Millet's work, but it is not always certain where they were made – in the Borinage, Brussels or Etten. In 1888, at least, Van Gogh told his friend Eugène Boch (1855-1941) that he had destroyed his Borinage work [696/553b]. A few scattered facts garnered from Van Gogh's letters shed a little more light on his study sketches. It is known that he made full-size copies of the examples in the *Exercices* and the *Cours de dessin*, and several of those after Millet were also quite large.⁵ He became so accustomed to working on this scale that he continued using it in Etten and The Hague for compositions of his own (see *cat. 19*). Many of the nude studies after the *Exercices de fusain* would have been done with charcoal, as Bargue intended – at any rate it is known from a letter of 24 September 1880 that he used that material [157/136].

Although he deliberately chose masters whom he admired as his guides, Van Gogh occasionally produced more independent work during these early months of his new career. The only sheet that can definitely be placed in that period is a scene of miners in the snow, which Van Gogh sketched in a letter *(fig. 2)*.

3 Van Gogh probably made this watercolour, which is signed 'Vincent' in pencil at bottom left, when he was in Amsterdam in 1877 preparing to study theology. He was living with his Uncle Jan, and had decorated his room with prints of works by his favourite artists, including a small lithograph after Jozef Israëls's Winter, in life as well (which Van Gogh described as a poor man on a snowy winter road; letter 114/95). The print, which was published twice in Kunstkronijk, in 1863 on p. 66 and in 1866 on p. 69, is preserved in a scrapbook of prints that belonged to Van Gogh that is now in the Van Gogh Museum (inv. no. t 1487). He copied the lithograph in virtually the same size (his watercolour measures 15.7 × 22.5 cm) in pencil, transparent watercolour and pen in brown ink.
4 Charles Bargue, Cours de dessin, Paris 1868-70; idem, Exercices au fusain pour préparer à l'étude de l'académie d'après nature, Paris 1871.
5 See letters 155/134 and 156/135.

6 See Tralbaut 1969, pp. 69, 74. For Dutchmen studying or working in Brussels see De Bodt 1995; for the Brussels academy pp. 49-56; and for Dutch students the list on pp. 246-79. Van Gogh (p. 279) was enrolled as no. 8488.

BRUSSELS AND THE ACADEMY

In the first half of October 1880 Van Gogh moved to Brussels. He continued making copies, but was now wondering what he should do next to further his development. Theo put him in touch with the Dutch painter Willem Roelofs (1822-1897), who was living in the Belgian capital. Roelofs advised him to work from life from now on, by which he meant that Van Gogh should no longer concentrate on print models but should start studying three-dimensional subjects like plaster casts and the live model, and do so under the supervision of an accomplished teacher. He recommended that he take lessons at the Brussels academy, which were free of charge. Van Gogh did not like the idea very much, but enrolled nonetheless. He followed Roelofs's advice quite closely by choosing the class in 'dessin d'après l'antique,' which involved drawing from plaster casts of antique torsos and fragments.[6] This was one step up the ladder from the primary class, where the students learned only how to make drawings after prints, which Van Gogh had already taught himself to do.

It is not known whether he attended even a single class at the academy. Perhaps the most important aspect of his stay in Brussels is that he was surrounded by kindred spirits and really developed a taste for the artistic profession. He had little or no further contact with Roelofs, but he did meet other novice draughtsmen whose names are

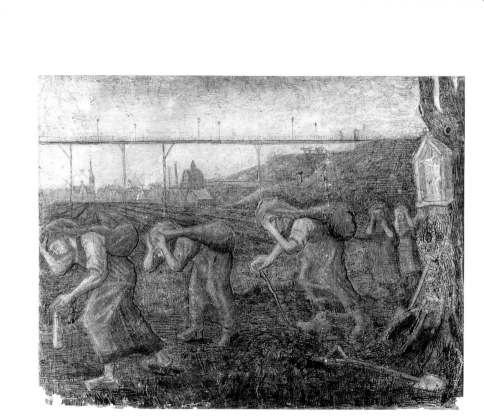

3 *The bearers of the burden* (F 832),
1881. Otterlo, Kröller-Müller Museum.

unknown to us.[7] He also got to know a fellow-student from the northern Dutch city of Groningen, Adriaan Jan Madiol (c. 1845-c.1892), who is nowadays all but forgotten.

His most important contact, though, was with another student, Anthon van Rappard (1858-1892), who had been training as an artist for four years and could pass on some of his experience. Their relationship, reserved at first, soon evolved into a friendship that was to last for four and a half years. Van Gogh occasionally worked in Van Rappard's Brussels studio because the conditions in his own room were far from ideal.

If Van Gogh did anything more than make copies and anatomical studies during his first few months in Brussels, nothing has survived. It was only in January 1881 that he began producing more independent work. He had found drawing difficult for a while, as he had told Theo, but it was now going more smoothly (see *cat. 13*). He worked from the live model and sent his brother two small examples of his work – very anecdotal drawings done in pencil and pen *(cats. 13, 14)*. One sheet that was almost certainly begun in Brussels but was probably completed in Etten is *The bearers of the burden (fig. 3)*. It is a carefully worked figure piece in which Van Gogh lavished great care on the landscape details. It represents a major step forward in his development, and surpasses what he said was his main aim in Brussels: 'to make strict anatomical studies, not my own compositions' [163/143].

MANUALS

Van Gogh had received considerable support from Tersteeg while he was in the Borinage, although their relationship cooled when Van Gogh later went to live in The Hague. In 1879 his former employer had given him a box of paints, and in August-September the following year he had sent him Bargue's books of drawing examples, and added another two manuals, evidently on his own initiative. One was about perspective, the other about anatomy. The latter may have been John Marshall's *Esquisses anatomiques à l'usage des artistes*, which Van Gogh mentions in a letter from Brussels of 1 November 1880.[8] The book on perspective may have been the work by Cassagne which, as Van Gogh himself said, had put an end to his doubts about pursuing a career as an artist. There he called it the 'Guide de l'Abc du dessin' [213/184], but it was actually called *Guide de l'alphabet du dessin* and was published in 1880.[9]

Whatever books Tersteeg sent, Van Gogh found them difficult and sometimes extremely tedious, but he realised that this kind of study was unavoidable. Marshall's anatomy manual, a very solid piece of work indeed, was written for artists but would not have been out of place in the bookcase of an advanced student of medicine. Van Gogh read it carefully in Brussels, and subsequently made studies of a skeleton.[10] He also hoped to be able to extend his knowledge by studying the anatomy of various animals at the veterinary school (see *cat. 20*).

7 *Letter 158/137.*

8 *Letter 159/138.*

9 *Armand Cassagne,* Guide de l'alphabet du dessin, ou l'art d'apprendre et d'enseigner les principes rationnels du dessin d'après nature. *The edition I have used is Paris 1880. The principles described in the Guide had already been explained by the author in 1862 in an identical way in the introduction to a detailed drawing method he had developed,* Le dessin pour tous, *which was published in the form of loose instalments. The introduction was entitled* L'alphabet du dessin, *and was sold in two parts.*

10 *Letter 159/138. I do not know the French edition of the book. Use has been made here of the second English edition,* John Marshall, Anatomy for artists, *London 1883.*

While in the Belgian capital Van Gogh also displayed an interest in two other 'sciences' which were very popular in the nineteenth century: phrenology and physiognomy. The latter was based on the premise that there was a link between a person's facial appearance and character, while the related phrenology saw human nature reflected in the structure of the skull. Van Gogh found a handy summary of these theories in a book by A. Ysabeau, *Lavater et Gall. Physiognomonie et phrénologie*, his reading of which had a marked influence on the many studies of the human face he drew later (see *cat. 46*).

CASSAGNE

Translating space and proportions onto the flat surface of a piece of paper or canvas gave Van Gogh problems throughout his career. He had hoped to learn something about it in Brussels from an artist who had helped him with anatomy, very probably the Madiol mentioned above. If the book on perspective that Tersteeg had sent him was indeed the work by Cassagne, then it was probably Madiol who had told him about it.

Armand-Théophile Cassagne (1823-1907), a landscape painter, draughtsman and lithographer who has been completely forgotten in those capacities, wrote books about various artistic principles. Several, of varying degrees of difficulty, were designed to enable artists (and amateurs and technical draughtsman as well) to reproduce the effect of recession into depth and proportions convincingly. The simplest method for

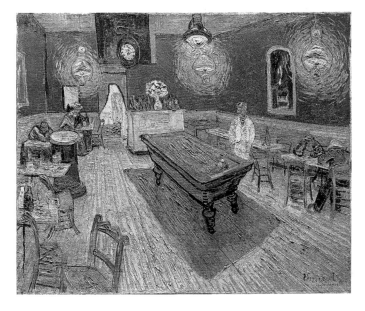

4 *The night café* (F 463 JH 1575), 1888.
New Haven, Yale University Art
Gallery.

getting to grips with reality was explained in the *Guide de l'alphabet du dessin* of 1880, which was actually intended, in the author's words, 'to teach the child how to draw just as it learns how to read and write.'[11]

Two other books by Cassagne that deal with the subject at greater length were also available to Van Gogh in this period: the *Eléments de perspective* and the extremely thorough *Traité pratique de perspective*. Although Van Gogh only mentions the *Guide* in his correspondence, he almost certainly knew these publications, or at any rate one of them, for when his friend Van Rappard was having difficulty with perspective in the summer of 1881, Van Gogh announced that he knew of no better remedy than Cassagne's 'books' [167/146].[12] However, one seriously wonders whether the highly technical explanations, particularly in the *Traité*, were not beyond Van Gogh's technical grasp. In 1888, when he was making his colouristic masterpieces in Arles, he asked his brother to send him Cassagne's simplest work, the *Guide de l'alphabet du dessin*, because it would come in useful both for him and for a few other artists there.[13] Some quirky perspectives in his later work were undoubtedly intended to improve the composition or heighten the expressiveness, but it would be going too far to use this as a blanket excuse. One need only look at the distorted billiard table in *The night café* of 1888 to realise that mastery of perspective never became second nature to Van Gogh *(fig. 4)*. He had no real talent for intricate technical structures.[14]

11 *Cassagne 1880, p. 1. The French text, cited at slightly greater length, reads: 'Le but de cette Méthode est: 1° D'enseigner le dessin à l'enfant comme il apprend à lire et à écrire, par des principes très élémentaires et parfaitement gradués [...]. 2° De guider l'institeur et le père de famille dans cet enseignement.'*

12 *Cassagne's* Eléments de perspective *was published before 1880, for it is listed in the* Guide de l'alphabet du dessin *of that year as one of the other works by the author that were available. I do not know when it was first published, but the edition I have used is Paris 1881. The* Traité pratique de perspective appliquée au dessin artistique et industriel *was published in Paris in 1866; I have used the revised and enlarged edition, Paris 1879. A third work by Cassagne on perspective is* La perspective du paysagiste, *Paris 1858. By around 1880 it had probably been out of print for some time, for it does not appear in the lists of books by the author given in Cassagne's later publications.*

13 *See letters 634/502, 641/505, 644/510, 661/519, 664/522. It emerges from letter 644/510 that Van Gogh was familiar with Cassagne's* Le dessin pour tous *(see note 9), but it is not known when he got to know the series.*

14 *Wylie 1970 examined the influence that the publications by Cassagne and Bargue had on the suggestion of space in Van Gogh's works. She constructed a complex system which Van Gogh supposedly used, in which he packed his subjects, as it were, in imaginary boxes. Van Gogh's œuvre displays not the slightest evidence that he ever worked like this. In F 1415 JH 1416, the drawing with the view of Arles with irises in the foreground, Wylie found pencilled lines with which she reconstructed one such imaginary box*

5 Illustration from Armand Cassagne, *Guide de l'alphabet du dessin*, Paris 1880, p. 14.

6 Illustration from Armand Cassagne, *Guide de l'alphabet du dessin*, Paris 1880, p. 10.

Cassagne did his best to skirt around the complex geometry underlying perspective in his *Guide*. His method, as he himself explained, was based on ideas developed by Dürer (of which more below). In order to gauge the proportions and perspectival distortion of an object one had to project a rectangular frame onto it with lines that formed grids, or a frame with a horizontal, a vertical and two diagonal lines that met in the centre *(figs. 5, 6)*. The latter was the version mainly used by Cassagne. The frame itself was usually imaginary; one was meant to construct it around an object or part of an object in one's mind's eye and then transfer the object to the paper in the correct proportions. Sometimes, though, one could use a physical 'frame,' such as a window or a door surrounding the subject *(fig. 5)*. If the draughtsman saw his subject from an awkward angle, because it was tilted, say, then the imaginary frame and its associated lines should also be tilted, making the distortion comprehensible *(fig. 7)*.

In the *Traité pratique de perspective* the author mentioned a handy instrument almost in passing. It was called a 'cadre rectificateur' or 'cadre isolateur' – a 'correcting frame' or 'isolating frame.' This consisted of a small cardboard or wooden frame, which an artist could carry in his pocket when working out of doors, in which a hori-

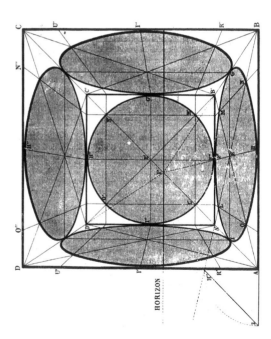

7 Illustration from Armand Cassagne, *Guide de l'alphabet du dessin*, Paris 1880, p. 142.

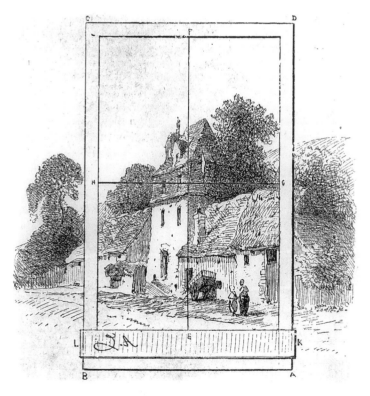

8 'Cadre rectificateur', illustration from Armand Cassagne, *Traité d'aquarelle*, Paris 1875, p. 137.

zontal and a vertical wire divided the field of view into four equal rectangles *(fig. 8)*. The artist could then look at his subject through it. A movable strip (the hatched section LK in the illustration) could be slid upwards to isolate a particular part of the subject even further. Cassagne explained the use of the 'cadre rectificateur' a second time, and in greater detail, in his *Traité d'aquarelle*, which Van Gogh read at Etten in the spring of 1881.[15]

ETTEN

In Brussels Van Gogh had developed the habit of working on white laid paper, which he consistently and wrongly called 'Ingres' paper.[16] This continued to be his main support in Etten, where he went to live with his parents in April 1881. The shade he preferred was a yellowish off-white, not too cool, which Van Gogh described as the 'colour of unbleached linen' [191/164]. The quality was quite reasonable, and it had the added advantage of being fairly cheap, so Van Gogh could use full sheets of it. They measured approximately 62 × 47 cm, which was roughly the size that he had become used to when copying Bargue's drawing examples. He now used it in the rural surroundings of Etten to record motifs from life on the land.

At first he worked in pencil, or in pen over an initial design in pencil. In June he discovered another book by Cassagne. 'I have got hold of Cassagne's Traité d'aquarelle and am studying it. Even if I do not make any watercolours I shall probably find many things in it, about sepia and ink for instance. For until now I have drawn solely in pencil accented or worked up with the pen, if needs be with a reed pen, which has a broader stroke' [167/146]. In his *Traité d'aquarelle* Cassagne dealt at length with various watercolour methods, and at the back of the book there are even some samples of paper with an explanation of their properties. In the ensuing months Van Gogh began using

15 The Traité d'aquarelle *was published in Paris in 1874; the edition used here is Paris 1875. For the 'cadre rectificateur' see pp. 136-38.*
16 *See also the catalogue entries for the types of paper used. Liesbeth Heenk has carried out extensive research on the paper of Van Gogh's drawings, and published some of her findings in Heenk 1994. In January 1996 she received her doctorate for this research from the Courtauld Institute in London. Her dissertation could not be consulted prior to the completion of this catalogue.*

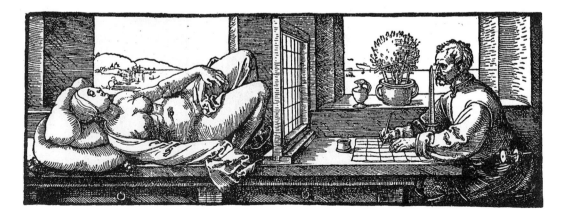

9 Albrecht Dürer, *Artist behind a perspective frame*, 1525.

watercolour, although always in combination with other materials. It was only in his Hague period that he really began exploring the potential of the medium.

After a visit to the Hague painter Anton Mauve (1838-1888), probably in August 1881, he experimented a little more adventurously with different materials. Mauve, who was a cousin of Van Gogh's by marriage, had looked at his pen drawings and said: 'Now you must try it with charcoal and chalk and brush and stump' [170/149]. Van Gogh took his advice. He tried out a combination of charcoal and chalk of various colours, used a stump occasionally, and combined opaque and transparent watercolour in one and the same drawing (see *cat. 21*).

He devoted himself even more to watercolour when his Uncle Cent, the art dealer Vincent van Gogh (1820-1888), gave him a box of Paillard colours.[17] However, he only became really proficient in the use of transparent watercolour in November-December 1881 during a three-week visit to Mauve in The Hague (see *cat. 22*). Mauve also taught him other drawing techniques, and gave him his first lessons in painting in oils. Around Christmas, after a difference of opinion with his parents that flared up into a full-scale row, Van Gogh moved to The Hague, where he remained until September 1883.

FURTHER STUDY OF PERSPECTIVE

In Etten, Van Gogh had continued practising the principles of perspective that he had learned from Cassagne, but in The Hague, where he arrived in the last week of 1881, he decided to adopt a more systematic approach. He had already read in Cassagne's *Guide de l'alphabet du dessin* that the author's method of projecting a grid on a scene was based on a discovery by Albrecht Dürer. The German master had discussed perspective in detail in his *Das Lehrbuch der Malerei*, and had devised a new instrument (*fig. 9*).[18] It was a frame in which a number of horizontal and vertical wires were strung at equal intervals from each other to form a grid. The artist should draw a grid with the same ratios on his paper or canvas. The frame was then placed in front of the subject, the proportions of which could now easily be gauged and transferred to the support. It was a very useful device, particularly for rendering extreme foreshortenings of the human figure, which have a very awkward perspective and are almost impossible to construct. In the succeeding centuries it was described in a number of manuals.

It is unlikely that Van Gogh knew of Dürer's invention from the woodcut reproduced here, or from an illustration of it. When, in early June 1882, he first wrote to Theo about the perspective frame that he probably used until the very end of his career, his reference to Dürer is so vague that it seems his information was second-hand. It was undoubtedly Cassagne, who made no secret of his debt to the German artist, who gave Van Gogh the idea of constructing this instrument that was to be so important to him. 'It is true that I spent less last winter on *paint* than other artists, but I spent *more* on making an instrument for studying perspective and proportion,

17 Letter 173/151.
18 Das Lehrbuch der Malerei *is published in Hans Rupprich (ed.)*, Dürer. Schriftlicher Nachlass, Berlin 1966, vol. 2. See pp. 390-92 for drawing with the aid of a perspective frame ('Fadengitter').

10 Reconstruction of Van Gogh's first perspective frame.

the description of which can be found in a book by Albrecht Dürer, and it is one that the old Dutch masters also used. It makes it possible to compare the proportions of objects nearby with those on a more distant plane in cases where construction according to the rules of perspective is not possible. And when one tries to do it *with the eye alone* – unless one is an expert and very far advanced – it is always hopelessly wrong. I did not manage to make the instrument at once, but after many efforts I eventually succeeded with the help of the carpenter and the smith. And after more efforts I see a chance of getting even better results' [235/205].

19 F 1078 JH 134.

That frame was probably his second attempt at constructing the instrument. Horizontal and vertical pencil lines which point to the use of this visual aid can already be found in Van Gogh's townscapes of March 1882 *(cats. 24-26)*. That perspective frame was quite a small one, as can be seen from a study that is now in the Kröller-Müller Museum.[19] In order to define the scene of the two men by their cart, Van Gogh first drew the pattern of the wires in his frame. This he did by laying the frame on the paper and running his pencil along the wires, and in this particular case he also included the inside and outside edges of the frame itself. This is particularly visible at the bottom, where the lines are hardly erased at all. Simple measurement shows that the sides of the frame were 2.5 cm wide. The entire instrument was a little more than 29 cm long and 17 or 20 cm wide, although the latter is an estimate based on a certain number of squares in the grid. The inside length was thus approximately 24 cm, and the width probably 12 or 15 cm.

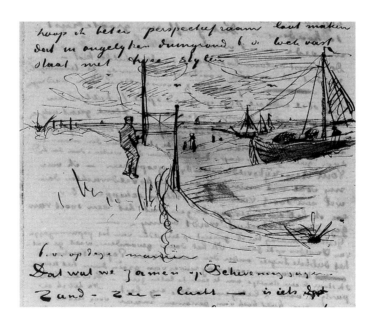

11 Sketch in a letter to Theo of
5 August 1882 (254/222). Amsterdam,
Van Gogh Museum.

This aid was a variant of the 'cadre rectificateur' recommended by Cassagne. It had more wires and seems to have been a variant that resembled the imaginary frame Cassagne had described in his *Guide de l'alphabet du dessin (fig. 5)*. The distance between the pencilled lines in the townscapes from this period in the Van Gogh Museum (*cats. 24-26*) is approximately 3 cm, and that would have been roughly the interval between the wires (it was not necessary to get the interval exactly right, as long as the ratios were correct). Taking the inside measurements given above, there must have been seven wires breadthwise and three or four lengthwise (*fig. 10*). It was a handy instrument which must have been particularly useful in the city for observing subjects on the spot, the more so in that it could be used quite unobtrusively.

The frame was not suitable for larger formats or for more complex subjects that required careful and longer study. One precondition for using the instrument is that the object, the frame and the artist's eye remain in the same relative positions while the drawing is being made. That would have been one of the reasons why Van Gogh wanted a larger and more stable perspective frame – the instrument he was talking about in the letter quoted above.

We can only guess as to the appearance of that particular version.[20] The interval between the wires in this and the third, slightly later frame would have been approximately 5-6 cm, going by the pencilled lines in numerous drawings from 1882-83. The second frame was probably not very large, or at least still not large enough,

20 *The interval between the wires is 5 cm in the* View of Scheveningen *(cat. 29). Van Gogh also sketched parts of the wooden frame itself, the wood of which was 4 cm wide. Unfortunately, that drawing cannot be dated very precisely (in the catalogue it is placed in the summer or autumn of 1882), so it is not possible to say whether this was Van Gogh's second or third perspective frame.*

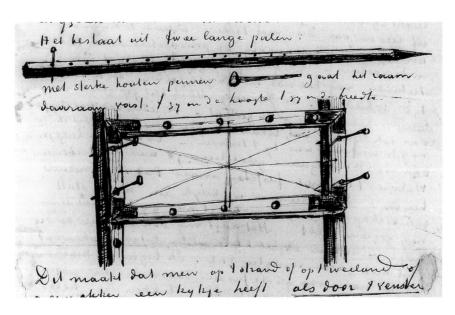

12 Sketch in a letter to Theo of c. 6 August 1882 (255/223). Amsterdam, Van Gogh Museum.

for in August Van Gogh had a new frame made that would enable him to make large sketches which he could later use as models for paintings. Two drawings in letters to Theo of August 1882 illustrate that instrument, which was certainly large, although the relationship to the man in the sketch should perhaps not be taken too literally (fig. 11). The frame was adjustable vertically with pegs that fitted into holes in the legs (fig. 12). The legs ended in iron spikes, enabling the frame to be stuck into the ground. The many holes in the legs made it possible to keep the frame horizontal, even on rough ground. Once in position, 'on the shore or in the meadows or the fields, one can look through it *like a window*. The vertical and horizontal lines of the frame and the diagonal lines and the intersection, either that or the division into squares, certainly give a few fundamental pointers which help one make a solid drawing and which indicate the main lines and proportions. At least for those who have some feeling for perspective and some understanding of why and how the perspective causes an apparent change of direction in the lines and change of size in the planes and in the whole mass. Without this, the instrument is of little or no use, and looking through it makes one *dizzy*.

'I think you can imagine how delightful it is to turn this sighting frame on the sea, on the green meadows, or on the snowy fields in winter, or on the fantastic network of thin and thick branches and tree-trunks in autumn or on a stormy sky. *Long* and *continuous* practice with it enables one to draw as quick as lightning – and, once the drawing is done firmly, to *paint* as quick as lightning, too' [255/223].

Van Gogh drew this particular perspective frame with one of the two patterns of lines recommended by Cassagne: a horizontal and a vertical bisecting two diagonals. The same pattern is found in later sketches of perspective frames, right up until 1890.[21] Going by the Hague drawings mentioned above, however, all that can be said is that Van Gogh usually had a grid of rectangles between himself and his subjects from at least March 1881, that being an alternative derived from Cassagne that he mentions in the above passage but does not illustrate with a sketch. The pattern of several horizontal and vertical lines can be seen in many drawings, be they townscapes, studies of heads, single figures or composed figure pieces. A network of diagonals can be seen in various later paintings and in drawings from the Arles period, but it has not so far been detected in Van Gogh's Hague work.[22]

TECHNICAL EXPERIMENTS

Van Gogh investigated the properties of a large number of drawing materials while he was living in The Hague,[23] and he did so without any concern for convention. Not every experiment will be discussed here, only those that shaped the look of this particular part of his œuvre. Most of his trials were typical of this period in his career, when he was hard at work refining his draughtsmanship. Techniques which he employed for months on end later disappeared for good, and he increasingly came to prefer simple drawing materials as he grew more skilled.

21 *Van der Wolk 1986, pp. 265-67, refers to sketches of perspective frames in Van Gogh's sketchbooks and on loose sketchbook pages. The latter include F 1637v JH 2082, which Van Gogh made in 1890 at Auvers-sur-Oise. There are various sketches of these frames in a sketchbook which Van Gogh used in 1884-85 in Nuenen (Van Gogh Museum, d 411 V/1962); see ibidem, pp. 50, 53, 75, 76 and 79.*
22 *See Hulshoff / Van Heugten 1994 on the use of infrared reflectography, mainly to examine works from Van Gogh's Paris period. The artist used the perspective frame with a horizontal, vertical and two diagonal lines for various paintings in this group.*
23 *For drawing materials in general, use has been made here of Meder 1922 and Koschatzky 1977. For the specific materials used by Van Gogh see Pey 1990.*

24 There is another reason why the term gouache has been avoided in this catalogue. Strictly speaking, gouache is an opaque watercolour with gum arabic as the binding medium, which as a rule remains soluble in water after drying, even after more than 100 years. Investigation of the opaque water-colours in Van Gogh's drawings showed that the bodycolours were often completely insensitive to water, while others did dissolve. It is true that chemical processes can take place in gouache that render it insoluble in water, but it happens too often in Van Gogh's drawings for that to be an acceptable explanation. Experiments seemed to indicate that the medium in the opaque water-colours used by Van Gogh was not always gum arabic, but as yet there is no conclusive proof of this. On the grounds of these observations it was decided not to use the term gouache but to speak instead of 'opaque watercolour.'

25 Cassagne 1875, pp. 128-31, 263-66, 273-75.

26 Ibidem, p. 26.

27 In the summer of 1886 Van Gogh wrote from Paris to Theo, who was on a brief visit to the Netherlands, telling him that he would approve of 'the exchange' for two water-colours by Isabey [571/460]. It also emerges from the letter that Theo had taken one of his brother's flower still lifes with him, so that was evidently the work to be exchanged. The identity of the other person involved is not known. The collection formed by the two brothers, which is now in the Van Gogh Museum, contains no work by Isabey, so it seems that the transaction fell through.

28 Cassagne 1875, p. 131: 'ce que fait la supériorité de l'aquarelle Isabey, c'est l'emploi de la gouache, qui donne à la fois du corps, de la force et de la finesse, et l'usage des glacis, qui suppriment le lavage.'

29 For seascapes and interiors in this technique Cassagne recommended blue-grey paper with a smooth surface; ibidem, p. 129.

WATERCOLOUR

In the early months of 1882 in The Hague Van Gogh confined himself mainly to drawing in pencil or pen and ink, mostly on laid paper, because he wanted to practise the correct rendering of proportions and perspective. Whether they are landscapes, city views or figure studies, it is in that light that his drawings must be seen.

In the meantime, Theo was insisting that his brother start making watercolours, because there was a better market for colourful drawings (of appealing subjects, of course) than there was for the rather severe, black-and-white works that Vincent was producing at the time. Although not indifferent to the prospect of selling drawings, Van Gogh did not yet want to concentrate on the technical problems associated with working in watercolour and mastering the use of colour. Pencil and ink, moreover, lasted a good while, whereas working with watercolour would have involved higher expenses for paint and brushes. He urged Theo to be patient, explaining that he expected to be able to send him commercially attractive watercolours around Christmas 1882. As early as September, though, he sent him a few small watercolour drawings which he thought would appeal to the public (see *cat. 30*).

He did experiment with the medium in the summer. Although he consistently describes these drawings as watercolours, technically they rarely were. A watercolour is made with transparent watercolour, and the use of opaque paint is avoided as much as possible. Van Gogh had a marked preference for opaque watercolour, not just in The Hague but throughout his Dutch period. Even thin passages in his 'watercolours' generally prove not to be in transparent but in heavily diluted opaque watercolour. The term 'gouache' usually applied to a drawing in opaque watercolour is not, however, found in Van Gogh's letters.[24]

This odd way of working was due to the *Traité d'aquarelle*, in which Cassagne gives a detailed account of a technique known as 'aquarelle gouachée.'[25] This method, which Cassagne said could not at first sight be distinguished from pure watercolour,[26] involved the use of thinned opaque paint. Corrections could be made by applying further thin layers – the glaze. The procedure described by Cassagne with examples from the work of Eugène Isabey (1803-1886), one of the great masters of the technique, is quite complex, and it is not known whether Van Gogh followed all the rules scrupulously.[27] He certainly worked in a similar manner, undoubtedly fired by Cassagne's enthusiasm: 'The superiority of the Isabey watercolour lies in the use of gouache, which gives firmness, vigour and finesse, and the use of glaze, which conceals weaknesses.'[28] In several cases Van Gogh also took Cassagne's advice to follow Isabey's example and work on white paper with only a slightly granular surface *(cats. 39, 67).*[29]

PENCIL DRAWINGS

In the summer of 1882 Van Gogh began making pencil drawings on a fairly rough kind of watercolour paper that he referred to with the French word 'torchon.' From the

beginning of that year he had been using pencils of the kind used by carpenters to mark planks – a broad, rectangular piece of graphite in an oval, wooden holder. The point of the pencil made it possible to draw both delicate lines, for it is very narrow when seen vertically through the oval, and very powerful, broad strokes, for horizontally through the oval the point looks almost like a miniature chisel. Van Gogh was fond of robust materials like this, and found the combination with a strong, coarse type of paper ideal. The fact that the latter was designed to be used with liquid was another good reason for using it, for around now Van Gogh started fixing his pencil drawings with a liberal application of milk. In addition to fixing the pencilled lines, this treatment had an effect that greatly appealed to him. The milk took the sheen off the graphite and gave it a matt black tone, 'far more forceful than one usually sees in a pencil drawing,' as he wrote to Theo [216/187]. Speaking of one of his drawings, he advised his brother in the same letter simply to throw 'a glass of milk, or water and milk' over it if he found the pencil too shiny. A trial we carried out showed that the effect of milk on a piece of paper with pencil marks is indeed startling. The graphite becomes matt, darker, and at first sight strongly resembles black chalk. The drawings that Van Gogh treated with milk, however, do not have the same appearance, or not today at any rate, for in most cases the material has the sheen typical of graphite. Because it is not known how Van Gogh's pencil drawings looked immediately after they were finished, it is virtually impossible to make any firm pronouncements. There are very noticeable fixative stains on the drawings treated with milk, and some even have white residues where he was particularly heavy-handed.

Once again, it was very probably a manual by Cassagne that gave Van Gogh this idea. He certainly knew of the author's *Guide pratique pour les différents genres du dessin* of 1873,[30] and there is every reason to believe that he had read it. There he found explanations about drawing with different kinds of dry drawing materials and with ink, as well as suggestions for various fixatives. For fixing pencil drawings Cassagne recommended a mixture of equal parts of milk and water.[31] This must have led to Van Gogh's experiments, which resulted in his discovery of the remarkable results of this treatment. Needless to say, Cassagne did not advise his readers to pour the fixative over their drawings by the glassful, but said that it should be sprayed on.

On more than one occasion Van Gogh continued working on the wet drawing, which was again made possible by the strength of the paper, although it did sometimes blister and crease *(fig. 13)*.

'PAINTING' WITH BLACK
The sturdiness of the watercolour paper made it ideal for a technique that Van Gogh developed in December, namely working with lithographic crayon. He was a great admirer of the black-and-white wood engravings mainly by English artists that were published in illustrated magazines like the London *Graphic* and *Illustrated London*

30 *The author's other publications are warmly recommended in a number of Cassagne's books, including the* Guide de l'alphabet du dessin *read by Van Gogh.*
31 *Cassagne 1873, p. 16-17.*

13 Cat. 42 under raking light (detail).

News*, and valued them both for their realistic treatment of social themes and their expressiveness. His large collection of these prints is now in the Van Gogh Museum and runs to around 1,400 sheets, most of which he pasted neatly onto stiff paper.

The English illustrators aptly called their work 'black and whites,' and from 1872 they even organised 'black and white exhibitions' that were reviewed in *The Graphic*, which Van Gogh collected (see also *cat. 47*). Following the example of these artists, Van Gogh embarked on lengthy experiments with lithography in November 1882 with the ultimate aim of producing a large series, although he never actually did so.[32] The drawings he made with black materials were attempts to achieve the expressiveness of the 'black-and-white' graphics, and he adopted that term for this type of drawing. He also spoke of '*painting with black*' [298/256]. In the course of his lithographic trials he had worked with lithographic crayon, and he was so struck by the deep black it produced that he wanted to use it in his drawings as well. That, though, was easier said than done, and in a letter to Theo written around the turn of the year he explained the special requirements and advantages of working with the crayon. 'However, there is one drawback which you will understand – it is greasy so cannot be erased in the usual way; working with it on paper even rules out the only thing with which one can erase on the stone itself, namely the scraper – it cannot be used on the paper with any force because it cuts through it. But it occurred to me to make a drawing first with carpenter's pencil and then to work in and over it with lithographic crayon, which (because of the greasiness) adheres to the pencil, a thing ordinary crayon does *not* do, or at least does very badly. After doing a sketch in this way one can, with a firm hand, use the lithographic crayon where required, without much hesitation or erasure.

'So I finished my drawings pretty well in pencil, indeed as much as possible. Then I fixed them and dulled them with milk. And then I worked them up again with lithographic crayon where the deepest tones were, retouched them here and there with a brush or pen, with lamp-black, and worked in the lighter parts with white bodycolour' [298/256]. Shortly afterwards he made a discovery that brought his goal of 'painting with black' even closer, and once again it was due to the fact that watercolour paper was designed for use with liquids. He had made a model study following the method outlined above, 'then I threw a pail of water on the drawing, completely soaking it, and then began to model with the brush. If it succeeds, one gets very delicate tones; but it is a dangerous method which may turn out badly. But if it succeeds the result is quite "non ébarbé" – delicate tones of black which most resemble an eau-forte' [301/259]. Van Gogh's description of the resulting effect is a little confusing, for the term 'non ébarbé' (with burr intact) refers to the velvety effect that a line in a drypoint print (or an etching plate touched up with a drypoint) has if the burrs along its edges are not removed. An etching (eau-forte), on the other hand, has no burr. Theo once used the term in connection with some of his brother's drawings (it is not known which), whereupon it seems to have taken on a life of its own. Judging by the appearance of

14 Cat. 47 under raking light (detail).

32 *For Van Gogh's experiments with lithography see Van Heugten / Pabst 1995.*

28

the sheets produced in this way *(cats. 47-53, 55-58)*, it seems to apply mainly to the effect found with aquatint in an etching, which is often equally velvety. Van Gogh exploited the fact that lithographic crayon could be worked so well with water – an unexpected property of this greasy material, for one would have expected it to reject liquid.[33] This can be seen in numerous drawings from December 1882 and the first few months of 1883. To the naked eye the crayon dispersed with water looks more like ink or opaque watercolour than greasy crayon, and the paper is often very cockled due to the lavish use of water *(fig. 14)*. Examination under the microscope shows how the crayon spread out thinly in the 'valleys' of the paper surface and is relatively thick on the 'peaks'.[34]

After this treatment, when the paper had dried out sufficiently, Van Gogh often finished off the drawing with pen and brush in black ink (which in many cases has now turned brown) and then heightened it with opaque watercolour.

In the period March-July 1883 he combined printing ink with other black drawing materials, with a similar end in view (see *cat. 54*), one example being the large sheet of peat-cutters in the dunes *(fig. 15)*. This heavy, greasy type of ink was diluted with turpentine to make it flow better. The Van Gogh Museum has no specimens of this kind of drawing.

In March and April 1883 Van Gogh also experimented with a combination of printing ink and oil paint. As yet it is unclear which drawings are the result of this technique, assuming any have survived. There are several known works in which he worked with oils on paper, but they are not drawings in black and white. They include the study of a baby in the Van Gogh Museum *(cat. 54)*, for which Van Gogh also seems to have used charcoal soaked in linseed oil.[35]

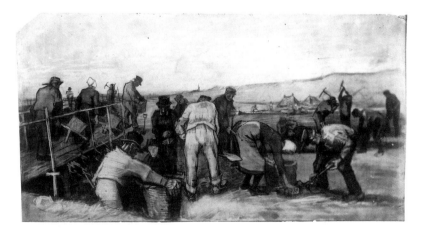

15 *Peat-cutters in the dunes (F 1031 JH 363),*
1883. Whereabouts unknown.

33 *Simulations of the technique described by Van Gogh (lithographic crayon over pencil, worked with the brush in water) showed that the crayon dissolved immediately, particularly the softer types. On the one hand it could be used to apply quite a thin wash, but it could also be spread out in a dark, opaque form. The effect was identical to that of the passages executed in this way in Van Gogh's drawings.*
It should be noted that the modern lithographic crayon used in these experiments would not have had a make-up identical to that of the material used by Van Gogh, but broadly speaking the composition is the same as it was in the last century.
The fact that it dissolves in water is probably due to the fact that one of the ingredients is soap.
34 *Pey 1990, p. 32, states that, under the microscope, the appearance of the black material more than a century old in Van Gogh's drawings that we take to be lithographic crayon differs so much from a specimen of fresh crayon that optical identification is not really possible. Our experiments, however, led to different conclusions. It is true that the material in the drawings is more desiccated than fresh crayon, which is still soft, but it nevertheless has the same protruding scales here and there, albeit rather dried out. Features that are very similar under the microscope are the smooth edges of the fresh and the old crayon on the peaks in the surface of the paper. Taken in conjunction with the method of working over pencil described by Van Gogh, the identification of lithographic crayon can be made with a high degree of certainty in such cases.*
35 *As far as can be made out this is the first time that this drawing material has been identified in Van Gogh's work. He does mention it in letters of April and May 1882, and praises its 'non ébarbé' look, but*

had no wish to use it at that time [216/187, 221/195]. Plain charcoal was not one of his favourite materials. He did use it, but mainly in combination with other materials. In 1881 and 1882 he made regular attempts to produce charcoal drawings, or 'fusains', to use the French word, partly stimulated by a book he had borrowed from Van Rappard, Karl Robert's Le fusain sans maître, Paris 1879. In October 1881 he asked his friend if he could keep it a little longer [172/R 1]. He sent it back a year later, announcing that he could not master the material and that he preferred his carpenter's pencil.

36 Van Gogh consistently uses the Dutch word 'bergkrijt,' literally 'mountain chalk' – a term that does not exist in English. Moreover, 'bergkrijt' is not a very specific kind of natural chalk but is in essence a synonym for black chalk of natural origin, which is why the material is referred to in this catalogue as natural chalk.

37 See letters 324/270 and 326/272.

38 This is rather a surprising statement, for normally one would expect natural chalk to leave more scratches than fabricated chalk. In the drawings in the Van Gogh Museum scratches made by hard particles can be seen in many of the chalk lines. See also Pey 1990, p. 35.

NATURAL CHALK

In the summer of 1882, Theo gave Vincent a small amount of natural chalk, which at this date had largely been displaced by fabricated chalk.[36] Van Gogh tried it out but was disappointed with the results. In March 1883 he experimented with it again, and this time was delighted with the effect. He sent Theo a letter asking for more of the chalk and enclosing a drawing he had made with it *(cat. 59).*[37] His sudden enthusiasm (he told Van Rappard that he was planning to get hold of no less than $1^1/_2$ bushels of the chalk [327/R 30]) was undoubtedly due to the many trials he had conducted in the previous nine months with black drawing materials of various kinds. He assessed the merits of the natural chalk by that yardstick, and was particularly excited by its colour. The natural chalk in the drawings from that period *(cats. 59-63)* has a warm black tone tending towards brown, which Van Gogh described to Van Rappard as the colour 'of a ploughed field on a summer's evening' *(fig. 16)*. To Theo he enthused over the 'gypsy soul' that he felt in it, saying that other black chalks and conté crayon had 'something dead' about them [326/272]. Because it came in large lumps it was easy to handle and did not need to be inserted in a holder. Van Gogh also found it softer and less scratchy than conté crayon.[38]

One limitation of natural chalk was that it was not very easy to get different tones of grey from it (see *cat. 61*). To some extent that could be remedied by rubbing breadcrumbs over the chalk, which removed part of it and gave it a lighter tone. However, Van Gogh always combined his natural chalk drawings with other black or grey materials in order to obtain the variety of tones he wanted.

Lithographic crayon and natural chalk were not used in any drawings that Van Gogh made after leaving The Hague. He gives no reason for this in his letters, but in the case of natural chalk it was probably because it was too difficult to get hold of, certainly in the quantities that he had envisaged in The Hague.

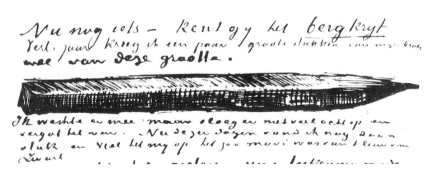

16 Sketch of a piece of natural chalk in a letter to Van Rappard of c. 5 March 1883 (327/R 30). Amsterdam, Van Gogh Museum.

DRENTHE

In Drenthe, which he visited from 11 September to 5 December 1883, Van Gogh was restricted in his work by a lack of materials. He was hard-up at the time, and it was not easy to get hold of drawing and painting materials in that rather remote province. He had hoped to stock up on supplies in the village of Hoogeveen, which he had imagined to be a town with all the usual amenities, but he could not even get 'any drawing materials' [394/329]. As a result, his output was small, and there was no opportunity at all for experiments. Apart from the sketches in his letters, there are only 16 or 17 drawings known from this period.[39]

Two sheets are in black chalk, and one is in pencil.[40] There are seven surviving watercolours, mainly done with opaque paints, of which the *Landscape with a stack of peat and farmhouses* in the Van Gogh Museum is fairly representative in terms of technique *(cat. 68)*. It and at least one other drawing are on paper with the fine grain found in *The poor and money* from the Hague period *(cat. 39)*.[41]

Van Gogh had rather neglected the true pen drawing in The Hague, but he made several in Drenthe. Six are known today, including the evocative twilight landscape in the Van Gogh Museum *(cat. 67)*.[42] In a sense they were intended as counterparts to his studies in oils, 'because with the pen one can enter into such details as are impossible in painted studies, and it is advisable to make two studies, one solely drawn for the composition and one painted for the colour. That is to say, if it is possible and circumstances permit, that is the way to put vigour into the painted studies later on' [391/326].

MODELS, COSTUMES AND VAN GOGH'S STUDIO

In the little village of Cuesmes in the Borinage Van Gogh had hoped to find 'a model with some character,' so that he could sketch a miner, for example.[43] Since he was already quite at home there and was not too diffident about approaching people, we can take it that he was successful. That, though, is no more than an assumption, for there are no surviving figure studies from that period and nor do the letters give any further clues.

He evidently had little difficulty in working from the live model in Brussels, for in a letter to Theo he said that he found someone to pose for him almost every day, among them 'an old errand-man,' 'a workman or boy' and 'perhaps a soldier or two' [161/140]. The only surviving results of these endeavours are two small and highly anecdotal drawings *(cats. 13, 14)*.

Symptomatic of Van Gogh's determination in pursuing his new career was his plan to build up a collection of distinctive clothing in the Belgian capital, 'in order to dress the models for my drawings. For instance, a Brabant blue smock, the grey linen suit that the miners wear and their leather hat, then a straw hat and clogs, a fisherman's outfit of brown fustian and a sou'wester. And certainly also that suit of black

39 *In Otterlo 1990, nr. 72, a newly discovered drawing by Van Gogh was published and allocated to his Drenthe period. It cannot be ruled out, however, that it was executed in The Hague; see cat. 65.*
40 *They are F 1248 JH 707, F 1347 JH 408 and F 1096 JH 411.*
41 *The other sheet is F 1094 JH 398.*
42 *Heenk 1994, pp 33-34, convincingly argued that F 902a JH 10 must not be placed in Van Gogh's Etten period but was drawn in Drenthe, probably in the village of Zweeloo.*
43 *Letter 156/135.*

44 Letter 184/159.

45 See letters 167/146, 169/148, 171/150, 172/R 1, 173/151, 183/158, 185/160.

46 The small illustration, a scene of a woman in the snow, is of the canvas Priscilla (the print is incorrectly titled 'Pricilla') by George Henry Boughton, a painter whom Van Gogh admired greatly. Boughton had submitted the painting to the 111th exhibition of the Royal Academy of Arts in 1879, and the illustration must have been published that same year, although it is not known in which periodical. Van Gogh may have been thinking of this print when he wrote to his brother about a work by Edwin Abbey: 'I have a little figure of a woman in the snow by him which reminds me of both Boughton and Heilbuth' [335/277].

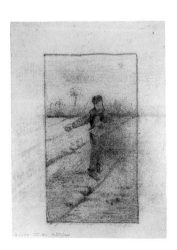

17 *Sower* (JH 44), 1881. Amsterdam, Van Gogh Museum.

or brown corduroy which is very picturesque and distinctive – and then a red flannel shirt or undervest. And also a few women's costumes, for instance that of the Kempen and from the neighbourhood of Antwerp with the Brabant bonnet and, for instance, those of Blankenberg, Scheveningen or Katwijk.

'I certainly do not intend to buy all this at once, but to collect it gradually, bit by bit, when I have the opportunity. And as those clothes can be bought secondhand they are not at all difficult to get hold of.

'I shall only be able to get them together properly when I have some kind of studio of my own' [162/141].

The lack of a studio forced him to draw in his room, but the light was so poor that he sometimes worked in Van Rappard's studio. His models' wardrobe probably only became a reality when he moved to The Hague.

Van Gogh's parents, who lived in a large house in Etten, gave him a workroom there in April 1881. Thanks to the survival of a letter from his sister Lies (1859-1936) it is known that it was the small out-building to the right of the vicarage in a drawing that Van Gogh had made some years earlier *(cat. 7)*. Before he moved in it had been used as a Sunday school. Here he surrounded himself with his model studies, 'men, women and children from the Heike' [179/155]. Towards the end of the year he moved to another room in the vicarage because the out-building was too damp.44

Van Gogh had few problems in drawing from the model in the Brabant village, particularly because he was prepared to pay his sitters a little money, '20, 25, 30 cents a day' [185/160].45 One constant source of irritation, though, was that they wanted to wear their Sunday best whereas Van Gogh wanted them in their ordinary working clothes doing their daily work.

He drew indoors when the weather was bad, either in his models' homes or work-places, or in his studio, where the scenes were staged. He preferred drawing out of doors, though, and there is a rather grubby composition sketch which gives some idea of how he worked *(fig. 17; see also Appendix 1)*. He probably studied his subjects first with sketches like this, which may have come from a sketchbook. The drawing shows how he refined the composition on the same sheet. The scene originally covered the entire width of the paper, but Van Gogh then drew a border around part of it and erased everything outside it, although remnants can still be seen. It is not absolutely certain what he did next, but it can be assumed that sketches like this were used as guides for larger model studies with the composition he had finally decided upon.

These small drawings were usually thrown away once they had served their purpose, particularly if they were damaged like this one. It survived because Van Gogh used it as backing for an illustration after a painting by George Henry Boughton (1833-1905).46 The names of some of the Etten villagers who posed for Van Gogh are known. His youngest sister, Willemien (1862-1941) was 'very good' at it [167/146], but no model study of her is known. The 17-year-old Piet Kauffman, a labourer who was also the Van Goghs'

gardener, was also prepared to pose, and he may be the young man seen in four sheets from the period *(fig. 18)*.[47] A peasant by the name of Schuitemaker was immortalised in the drawing *Worn out*, and the clothes he is wearing there – a waistcoat and a rather high cap – make it possible to identify him in a number of other drawings. He may have posed for the composition sketch of the sower as well *(fig. 17)*.[48] As part of his ambition to depict every facet of rural life, Van Gogh also felt the need to study animals, which resulted in drawings of a horse and a donkey (see *cat. 20*).

The novice artist naturally chose fairly straightforward poses for his Etten drawings, without any awkward foreshortening, which is why quite a few of the models are seen from the side *(cat. 19)*. Many of the men and women look utterly immobile, even though they are supposed to be working, and thus in motion. Van Gogh laboured hard to overcome shortcomings like this, but was forced to agree with his friend Van Rappard when the latter remarked of a drawing of a peasant that it was not a man sowing 'but one posing as a sower' [175/R 2]. His attention was drawn to another problem by Anton Mauve in December 1881, who told him that he was too close to his subjects, which made it almost impossible for him to gauge their proportions properly.[49] Van Gogh realised that he would have to work hard to correct these weaknesses, and that meant spending a lot of his money on models.

THE HAGUE

When Van Gogh moved to The Hague in the closing days of 1881 his first concern was to find a decent studio. Because of the attractive subjects to be found there, he first

47 Drawings F 851 JH 61, F 855 JH 43,
F 859 JH 29 and F 879 JH 62. See also
Hulsker 1990, p. 101.
48 In addition to Worn out (F 863 JH 63)
he appears to have posed in these clothes
for F 856 JH 17, as a sower; for F 897
JH 63, reading by the fire; and as a man
digging up potatoes which is only known
as a sketch in letter 174/152, JH 60. The
same man, in a waistcoat but wearing a
slightly different cap, can be seen as a
winnower in F 891 JH 24, and as a digger
in F 860 JH 38 en F 860a JH 42.
49 Letter 191/164.

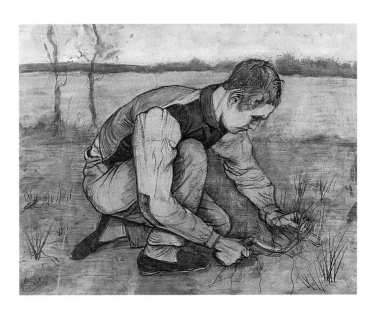

18 *Boy cutting grass* (F 851 JH 61),
1881. Otterlo, Kröller-Müller Museum.

50 See letters 198/169 and 201/172.
51 Letter 201/172.
52 Letter 207/178.

looked for one in the picturesque fishing village of Scheveningen, where he considered settling when he left Brussels in April 1881. During a brief stay in The Hague in December his thoughts turned to it again when he drew a Scheveningen woman *(cat. 22)*. He discovered that these models were horrifyingly expensive '1.50 or 2 guilders a day, some even more' [190/163], and then learned that rented accommodation in the village, which was an artists' colony and was also becoming a popular holiday resort, was completely beyond his means. He eventually found rooms in Schenkstraat (Van Gogh calls it Schenkweg, but the house stood on a street leading off it), on what was then the edge of town. His studio there was small but adequate and had enough light for him to work. The only snag was that he had to make it more diffuse, for the windows faced south and let in too much direct light.

For a time it looked as if working with models would be impossible because of his shortage of money, but the situation soon improved. From around mid-January 1882 he had models from time to time, and an old woman posed for him more frequently. On the recommendation of Mauve, who was treasurer of Pulchri Studio, Van Gogh was also made an associate member of that artists' society.[50] This entitled him to come and draw from the live model free of charge on two evenings a week. Although no drawings can be traced to those sessions, and Van Gogh says nothing about them in his letters, it can be assumed that he regularly took advantage of this arrangement. In that way, as he wrote to Theo, he only needed paid models for four days.[51]

His stable of models was enlarged in January or February with the addition of Sien Hoornik, followed by her younger sister and mother. They were very willing to pose, initially for little money on Van Gogh's promise that he would pay them a guilder a day as soon as he could.[52] Sien, however, soon moved in with him, and from then on he always had a model to hand, and a free one at that.

His relationship with Sien also enabled him to put into effect a long-cherished plan to draw from the nude. He explained the purpose of this to Theo in March 1882. 'When summer comes and the cold no longer prevents it, I must somehow make some studies of the nude, not in exactly academic poses. But, for instance, I should like so very, very much to have a nude model for a digger or a seamstress, seen from the front, back and side. To learn to see and feel the body through the clothing and to understand the action. I reckon that about a dozen studies, six of men and six of women, would help me a great deal. Every study costs a day's work. The difficulty, though, is to find the models for this purpose; and if I can I shall avoid having a nude model in the studio so as not to frighten away the others' [211/182]. It is not known whether any other models were prepared to disrobe for the artist, but it seems unlikely. Sien very probably posed for all the nude studies that he made soon afterwards. They included a sheet with the title *The great lady*, which is known only from a sketch, and *Sorrow*, of which he made several versions *(figs. 19, 20)*. He wanted some 30 studies of the nude, and a little later drew 'a woman's figure, kneeling and [...] one of a girl knitting, but also nude' [215/186, 216/187].

Van Gogh often went out of doors in search of suitable subjects, and made sketches of figures he saw. He was not usually able to study them at any length, so these location sketches were used back in the studio to put a model into the same pose. He had several items of clothing in his collection – it is not known what they were in this period – in order to lend the scene an air of authenticity. The resulting studies, if they were considered successful, were hung up or stored away in portfolios for later use in populating more complex compositions with human figures (see *cats. 23, 24, 33, 39, 43, 44, 59)*.

In May Van Gogh moved to a better house in Schenkweg, where he fitted out a large room as a studio which he found very satisfactory. It was well-equipped, and the daylight was diffused by muslin he stretched over the windows. 'The studio looks so real, I think – plain, greyish brown wallpaper, a scrubbed wooden floor, white muslin over the windows, everything clean. And, of course, studies on the wall, an easel on both sides, and a large white deal working table. A kind of alcove adjoins the studio

19 *The great lady* (JH 128), 1881.
Amsterdam, Van Gogh Museum.

20 *Sorrow* (F 929a JH 130), 1882.
Walsall, Walsall Museum & Art Gallery.

53 *For the smock see letter 325/271; for the Scheveningen cape and hat letters 352/289, 353/291 and 356/R 37; and for the fisherman's jacket letter 365/300.*
54 *See letters 381/316 and 384/319.*

where I keep all the drawing boards, portfolios, boxes, sticks, etc., and also the prints. And in the corner a closet with all the bottles and pots, and then all my books' [245/213]. He gradually became more fussy about the lighting, but for the time being it was a very suitable room to work in, and he could even have several models posing at once. None of the contents of the room listed above have survived, of course, but the drawing boards he mentions did leave their traces in his work, for many of the Hague drawings bear the impressions of the grain of the wood (see *cat. 28*).

Van Gogh was also having little difficulty finding the working-class types he was so eager to draw. They were neighbours or people he persuaded to pose for him while out on his sketching forays in city districts like De Geest, a small street that gave its name to the area around it. He generally paid his models 50 cents for a morning or afternoon session. In September 1882 he came into contact with residents from the Dutch Reformed Old People's Home, who were known as pensioners, and from then on ensured himself of a steady supply of people with interesting, weathered faces *(fig. 21; see cat. 31)*. One of them became the most frequent model in his entire œuvre, and even his name is known. He was called Adrianus Zuyderland, and can be seen in all sorts of poses and costumes in Van Gogh's work from this period.

Van Gogh now had quite a large collection of costumes, but he continued looking for authentic items of dress which should preferably show signs of long use. He was delighted with the acquisition of a sou'wester in January 1883, and it led to a series of studies of fishermen *(cats. 55-58)*. When he was remodelling his studio the following month, mainly because he was not satisfied with the lighting, he also improved the storage of this paraphernalia. He got hold of several boards and made a large closet 'in the alcove to put away drawings, prints, books' and a 'coatrack for various smocks and jackets, old coats, shawls, hats, and last but not least, the sou'wester – all the things that I need for the models' [320/268]. Over the next few months he also acquired a coarse linen smock, a 'superb' woman's cape in the traditional Scheveningen style with a rather less impressive hat, and a fisherman's jacket.[53]

The studio lighting was improved by attaching four shutters to each of the three windows *(fig. 22)* in order to control the infall of light. He could close off entire windows or allow just a little light to enter, and he also experimented with light entering from above or below by opening the top or bottom shutters. He explained all this to Theo in a letter about his trials with the subject of a public soup kitchen (see *cat. 60*).

MODELS IN DRENTHE

Van Gogh had heard from artist friends who had been to Drenthe that life was much cheaper there and that models could be had for very little money.[54] He had hoped to benefit from this, but was disappointed when he finally arrived. There was widespread unwillingness to pose for him, even though he was prepared to pay quite well, and it was only gradually that he found any models.

21 *Old man with a stick*, cat. 31.

Nor did he have a studio. He did work in a barn, but the lighting was very poor. Attempts to make a model study in the inn in Hoogeveen where he was lodging failed for the same reason.[55]

Van Gogh found many attractive subjects in Drenthe, but on balance the artistic prospects were hopeless due to his lack of materials and models. After only a month he began to think of going to live with his parents and sisters in Nuenen. He hoped to find willing models there, provided his family was prepared to cooperate. 'As to their being my models, they really must do as I ask and trust in me having my reasons. If I say to mother or Wil or Lies: You must pose, they ought to do so. Of course I would not make any unreasonable demands' [397/332]. And so it was, at the beginning of December 1883, that he left Drenthe to seek refuge in Brabant.

55 *See letters 393/328 and 394/329*

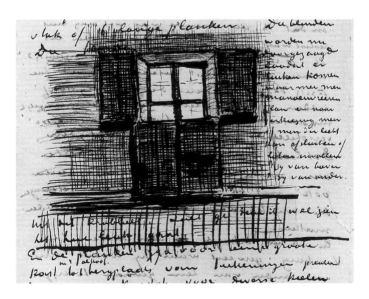

22 Sketch in a letter to Theo of c. 20 February 1883 (320/268). Amsterdam, Van Gogh Museum.

Note to the reader

Each catalogue entry consists of three sections: technical description, discussion and documentation. The last is broken down into provenance, relevant letters by Van Gogh, literature and exhibitions. Reference is made only to those letters in which Van Gogh specifically mentions that particular drawing. The literature is restricted to publications that make a substantive contribution to our knowledge of the drawing. The other parts of the documentary section are as exhaustive as possible.

References to publication and exhibitions are given in abbreviated form. The full titles and exhibition details will be found at the back of the book.

Data on the provenance and exhibitions are based on the 1970 oeuvre catalogue by J.-B. de la Faille. The museum archives, in the form of exhibition catalogues, archive cards, newspaper cuttings, annotations by Jo van Gogh-Bonger and V.W. van Gogh, and other documents, are the source for any supplementary information or corrections to De la Faille.

If it is known when Van Gogh sent a particular drawing to his brother, Theo is listed in the provenance as the owner from that year. Where such information is not available he is regarded as the owner from 1890, the year of Vincent's death.

Although, formally speaking, V.W. van Gogh was joint owner of the Van Gogh Collection from 1891, he is only listed in the provenance from 1925, the year in which his mother died.

Displays of works in the Stedelijk Museum in Amsterdam in the period when the collection was housed there (circa 1931-73) are not included in the list of exhibitions.

Wherever possible, Van Gogh's works bear the titles that he himself gave them. In all other cases they have been given concise, straightforward titles.

A distinction is made throughout the catalogue between transparent and opaque watercolour. The term 'gouache' has been avoided for technical reasons. For further information on this point see note 24 in the Introduction.

The material used for the signature is only specified if it differs from that in which the drawing was executed.

Inscriptions on the backs of the drawings are only recorded when they are considered relevant.

The present owner of the work is listed in the provenance section. By far the majority of the drawings are in the collection of the Vincent van Gogh Foundation, but a small number belong to the Van Gogh Museum itself. All the works reproduced in the comparative illustrations are from the collection of the Vincent van Gogh Foundation, as are the documents in the Van Gogh Museum. The works belonging to the Vincent van Gogh Foundation are on permanent loan to the Van Gogh Museum.

The quotations from the letters have been checked against the originals and corrected where necessary. They are followed by two numbers within square brackets. Where information from the letters is used in the text without quotation marks, the letter numbers will be found in a note. The first of the two numbers refers to Han van Crimpen and Monique Berends (eds.), De brieven van Vincent van Gogh, 4 vols., The Hague 1990, and the second to The complete letters of Vincent van Gogh, 3 vols., Greenwich (Conn.) 1958. All the quotations from the English edition have been checked by the present translator and revised where necessary.

The F numbers in the texts refer to the relevant catalogue numbers in J.-B. de la Faille, The works of Vincent van Gogh. His paintings and drawings, Amsterdam 1970; the JH numbers to Jan Hulsker, The complete Van Gogh: paintings, drawings, sketches, New York 1980.

Catalogue

The documentation in the catalogue entries
was compiled by Monique Hageman, Fieke
Pabst and Marije Vellekoop.

1 Lange Vijverberg, The Hague

THE HAGUE,
AUTUMN 1872-SPRING 1873

Pencil, pen in brown ink, on
watercolour paper
22.2 × 16.9 cm
Unsigned

Inv. d 287 V/1962
Juv. XIV JH –

PROVENANCE
1890-91 T. van Gogh; 1891-1925
J.G. van Gogh-Bonger; 1925-62
V.W. van Gogh; 1931-62 on loan
to the Stedelijk Museum,
Amsterdam; 1962 Vincent van
Gogh Foundation; 1962-73 on loan
to the Stedelijk Museum,
Amsterdam; 1973 on permanent
loan to the Van Gogh Museum,
Amsterdam.

LITERATURE
De la Faille 1928, vol. 3, p. 4, no.
837, vol. 4, pl. IV; Vanbeselaere
1937, pp. 38, 407, no. 837; Van
Gelder 1955, pp. 24-25; Van Gelder
1959, pp. XVII, XX-XXI; De Gruyter
1961, pp. 7, 92, fig. 1; Szymańska
1968, p. 19; Wadley 1969, p. 21;
De la Faille 1970, p. 603; Amster-
dam 1987, p. 384, no. 2.108; Van
der Mast / Dumas 1990, pp. 11-12,
47; De la Faille 1992, vol. 1, p. 4,
no. 837, pp. 205-06, vol. 2, pl. IV.

This and the following three drawings are Van Gogh's earliest essays in draughtsmanship that are securely attributable to him, partly because of their provenance from the Van Gogh family.[1] All were probably executed in the period autumn 1872-spring 1873 in The Hague, where he worked at the Goupil gallery on the Plaats from July 1869 to May 1873. The view is of Lange Vijverberg, in the heart of the city, which gives onto the Plaats, so it would have been a very familiar sight to Van Gogh. The three other sheets in the Van Gogh Museum *(cats. 2-4)*, which are of landscape subjects, are stylistically identical. They were first sketched in pencil and then the contours and details were drawn with the pen, after which open passages and textures were filled in with the pencil. They are all roughly the same size and are in a format that is rarely encountered elsewhere in Van Gogh's œuvre. This makes them a close-knit group of drawings, and it can be assumed that they were all made around the same time.[2]

There are various reasons for dating them autumn 1872-spring 1873. In a letter of July 1874 from London (where he lived from June 1873 to May 1875), Van Gogh wrote: 'my love of drawing has ceased' [27/20], so he had clearly been drawing previously, in Holland.[3] His drawing style in that early period is known chiefly from the three small sketchbooks he made for Betsy Tersteeg (b. 1869), the daughter of his superior at Goupil's. The draughtsmanship of the second and third sketchbooks is particularly close to that of the four Hague sheets *(fig. 1a)*. Only the date of the third book is known: it was made in London in June 1874. So although it is only implicitly documented in words that Van Gogh made drawings while in The Hague, the present sheet proves beyond a doubt that he did.

For want of more reliable data, this and the following three drawings are dated late in Van Gogh's first Hague period, close to the above-mentioned sketchbooks. They are assigned to the period autumn-spring on the basis of the bare trees in all of them. However, stubborn self-assurance about the date would be out of place here, for there is no firm evidence that would preclude them being dated as much as three years earlier, at the start of Van Gogh's stay in The Hague.

The townscape shows the Hofvijver from a vantage-point on Lange Vijverberg, with the Senate building behind it. In a photograph of circa

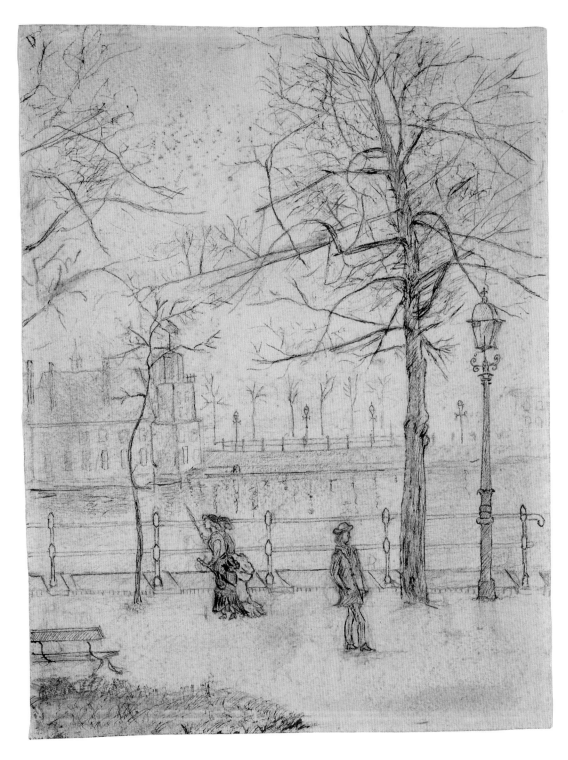

1 Lange Vijverberg, The Hague

1 On the Juvenilia, the drawings that Van
Gogh made before becoming an artist, see
Appendix 2.

2 For want of anything to compare them
with, De la Faille 1928 dated these works,
which at the time had the numbers F 836
(cat. 4), F 837 (Lange Vijverberg), F 838
(cat. 3) and F 839 (cat. 2), to the
Cuesmes-Brussels period, 1879-80. Van
Gelder 1959, p. XVII, placed all four in The
Hague and dated them to the winter of
1870 or 1871. Szymańska 1968, pp. 19-21,
grouped the present drawing with cat. 4,
which she also regarded as a townscape,
and allocated them to The Hague, spring
1873. She dated the other two sheets, which
she described as village scenes, in May of
that year, and believed that they were
drawn in Helvoirt when Van Gogh was
visiting his parents. That is not impossible,
although there are no hard facts to support
this theory. In De la Faille 1970, under
'Juvenilia,' Van Gelder accepted the date
of spring 1873, but remained firm on The
Hague as the location.

3 He later recalled that he had in fact
done a great deal of drawing in London;
see letter 397/332.

4 See the types in W.H.N. Eggenkamp,
'Negentiende-eeuwse gietijzeren lantaarn-
palen,' Heemschut 60 (1983), no. 6,
pp. 92-97, especially the 'Haagse paal'
(Hague post) on p. 93. Although this type
was produced from 1867 on, it is not known
when it was first installed in The Hague.

1879 the lake and the parliament building are seen from an oblique angle
(fig. 1b; the photographer stood a little closer to the Plaats than Van Gogh
did). Another photograph, of 1890, is an extensive view of Lange Vijver-
berg looking towards Korte Voorhout, with the photographer's back to the
Plaats (fig. 1c).

Comparison of these two photographs with the drawing sheds some
light on Van Gogh's method, which was to make a rapid pencil sketch on
the spot and then work it up with the pen. Since he did not record any
details he had to rely on his memory or, if that failed him, his imagination.
As a result, the parliament building lost one of its three floors and the rail-
ings around the lake were given a different shape. The decorative cast-iron
lamppost on the right also seems to be the artist's own creation, for it has
not been possible to identify one with this design. The top of the lamp
housing, which Van Gogh shows with four rounded sides surmounted by
a cross, in reality probably had four flat sides and a flue at the top to allow
the combustion gases to escape, along the lines of the lamppost in figure 1b.[4]

What remains of the initial pencil draft is indeed no more than a rather
sketchy indication of parts of the composition. The outlines and details
were then added with the pen, rather unevenly here and there. Van Gogh
was working on watercolour paper with a cockled surface and a fairly
rough texture which is in fact not suited to this technique, with the result

1ª Page from a sketchbook for Betsy
Tersteeg, c. 1874. Amsterdam,
Van Gogh Museum.

that his pen kept catching in the fibres. Nevertheless, the as yet unskilled draughtsman did succeed in giving the scene a lively look with the reflections in the water and the unexpected truncations on the left. The sheet owes its charm above all to the small figures in the foreground: the young man with a hat sauntering by, and two women hurrying along with their parasols.

1b Photograph of the Hofvijver with parliament buildings, The Hague, c. 1879. The Hague City Archives.

1c Photograph of the Lange Vijverberg, The Hague, c. 1890. The Hague City Archives.

2 Canal

THE HAGUE,
AUTUMN 1872-SPRING 1873

Pencil, pen in brown ink, on
wove paper
25.4 × 25.8 cm
Unsigned
Verso: a drawing in another hand

Inv. d 290 V/1962
Juv. XVI JH –

PROVENANCE
1890-91 T. van Gogh; 1891-1925
J.G. van Gogh-Bonger; 1925-62
V.W. van Gogh; 1962 Vincent
van Gogh Foundation; 1962-73
on loan to the Stedelijk Museum,
Amsterdam; 1973 on permanent
loan to the Van Gogh Museum,
Amsterdam.

LITERATURE
De la Faille 1928, vol. 3, p. 4,
no. 839, vol. 4, pl. IV; Meier-Graefe
1928, pl. 3; Vanbeselaere 1937,
pp. 38, 46-47, 52, 59-60, 124,
126-27, 407, no. 839; Van Gelder
1959, pp. XVII, XX-XXI; Szymańska
1968, p. 19; De la Faille 1970,
p. 604; Amsterdam 1987, p. 384,
no. 2.110; De la Faille 1992,
vol. 1, p. 4, no. 839, p. 206, vol. 2,
pl. IV.

EXHIBITIONS
1927-28 Berlin, Vienna &
Hannover, no. 2; 1928 Paris,
no. 2; 1947 Rotterdam, no. 4;
1953 Zürich, no. 2; 1954-55 Bern,
no. 75; 1955 Antwerp, no. 20; 1956
Haarlem, no. 2; 1957 Nijmegen,
no. 2; 1957 Stockholm, no. 5; 1962
London, no. 11; 1964 Zundert,
no. 2; 1992 London, no. 2.

Three of the four sheets which together make up an early 'Hague' group
(cats. 1-4) were probably executed by Van Gogh while out walking in the
rural surroundings of The Hague *(cats. 2-4)*. This, the first of them, shows
a canal flanked by tree-lined paths. On the far side is a gate with a jetty,
and here the path leads to what looks like a small summer-house. In the
distance there is a bridge over the water and even further away a windmill,
this time on the left bank of the canal. Despite these topographical details
it has not been possible to identify the location.

The three drawings are closely related in their rendering of the land-
scape. Striking details include the prominent trees, in which close atten-
tion has been paid to the tangle of branches and spindly twigs.

Van Gogh used a simple perspective with a single vanishing point at
the horizon on the left. The initial drawing is in pencil, which was then
worked up with pen and ink in the contours and details. The pencil was
also used to fill in open passages or, in the path on the left bank, to add
texture.

On the verso there is a cursory sketch of a windmill, together with a
few isolated lines, all of which appear to have been done by a child and not
by Van Gogh himself *(fig. 2a)*.

See the preceding entry for the dating.

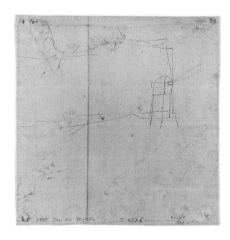

2a Verso of cat. 2.

2 Canal

3 Ditch

THE HAGUE,
AUTUMN 1872-SPRING 1873

Pencil, pen in brown ink, on
watercolour paper
24.8 × 18.3 cm
Watermark: [WH]ATMAN [18]68
(cropped by the lower edge)
Unsigned

Inv. d 291 V/1962
Juv. XV JH –

PROVENANCE
1890-91 T. van Gogh; 1891-1925
J.G. van Gogh-Bonger; 1925-62
V.W. van Gogh; 1931-62 on loan
to the Stedelijk Museum,
Amsterdam; 1962 Vincent van
Gogh Foundation; 1962-73 on
loan to the Stedelijk Museum,
Amsterdam; 1973 on permanent
loan to the Van Gogh Museum,
Amsterdam.

LITERATURE
De la Faille 1928, vol. 3, p. 4, no.
838, vol. 4, pl. IV; Vanbeselaere
1937, pp. 46-47, 52, 59, 124, 126,
407, no. 838; Szymańska 1968,
p. 19; De la Faille 1970, p. 603;
Amsterdam 1987, p. 384, no.
2.109; De la Faille 1992, vol. 1,
p. 4, no. 838, p. 206, vol. 2, pl. IV.

EXHIBITIONS
1931 Amsterdam, no. 96; 1958-59
San Francisco, Los Angeles,
Portland & Seattle, no. 87; 1960
Enschede, no. 2; 1992 London,
no. 3.

This landscape drawing is closely related to the previous sheet in its composition, although it is reversed left for right and is less detailed. Here too the diagonal of the stretch of water – either a narrow canal or a ditch – establishes the scene, together with the trees on its banks.

See catalogue number 1 for the dating.

3 Ditch

4 Driveway

The Hague,
autumn 1872-spring 1873

Pencil, pen in brown ink, on wove
paper
18.3 × 22.4 cm
Unsigned
Verso: drawings and annotations
in another hand

Inv. d 288 V/1962
Juv. XIII JH –

Provenance
1890-91 T. van Gogh; 1891-1925
J.G. van Gogh-Bonger; 1925-62
V.W. van Gogh; 1931-62 on loan to
the Stedelijk Museum,
Amsterdam; 1962 Vincent van
Gogh Foundation; 1962-73 on loan
to the Stedelijk Museum,
Amsterdam; 1973 on permanent
loan to the Van Gogh Museum,
Amsterdam.

1 The verso was also rejected as being by
Van Gogh in De la Faille 1970. It was
included with the drawings in
Amsterdam 1987, p. 383, but was not
regarded as authentic. All that can be
made out is: '2 rij op 2 weg / hooge [?]
Stee[..] / hooge kant weg maken / hier en
daar / een struik'.
2 That support also has an erased but
still reasonably legible inscription in an
unknown hand: 'Deschamp Worms'.

The preceding drawings *(cats. 2, 3)* were diagonal compositions, but this, the third and last of these landscapes, is a composition with a central vanishing point where the converging lines of the drive and its flanking ditches meet. It is a view of a driveway with a closed gate at the end, beyond which an object resembling a carriage is on the point of disappearing out of sight.

On the verso there are some slapdash drawings of houses done in an inexperienced hand that has nothing in common with Van Gogh's *(fig. 4a)*, and nor did he write the cryptic annotations.[1] At one time the sheet was attached to a sturdy piece of paper on which some unknown person wrote the name 'Van Gogh' preceded by an illegible initial.[2]

See catalogue number 1 for the dating.

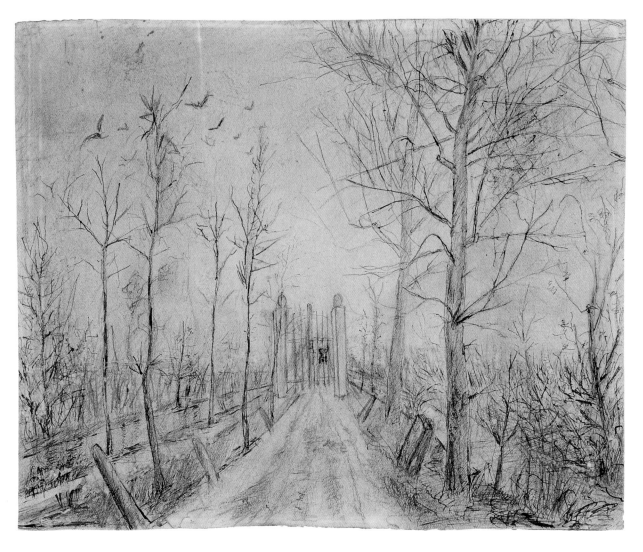

4 Driveway

LITERATURE
De la Faille 1928, vol. 3, p. 4,
no. 836, vol. 4, pl. IV; Vanbeselaere
1937, pp. 38, 46-47, 52, 59, 124,
126-27, 407, no. 836; Szymańska
1968, pp. 19, 21; De la Faille
1970, pp. 602-03; Amsterdam
1987, p. 383, no. 2.106, 2.107;
De la Faille 1992, vol. 1, p. 4,
no. 836, p. 205, vol. 2, pl. IV.

EXHIBITIONS
1914-15 Amsterdam, no. 4; 1926
London, no. 29; 1929 Amsterdam,
no. 2; 1931 Amsterdam, no. 97;
1945 Amsterdam, unnumbered;
1946 Maastricht & Heerlen, no.
22; 1946 Stockholm, Gothenburg
& Malmö, no. 1; 1946 Copenhagen,
no. 1; 1947 Rotterdam, no. 2;
1954-55 Bern, no. 74; 1955
Antwerp, no. 19; 1957-58 Leiden
& Schiedam, no. 51; 1958 Bergen,
no. 52; 1964 Zundert, no. 1;
1968-69 London, no. 1; 1992
London, no. 1.

4ª Verso of cat. 4.

5 Old woman asleep (after Rops)

This pencil copy after a lithograph by Félicien Rops (1833-1898) was regarded by De la Faille in 1928 as one of the copies that Van Gogh made in 1880-81 in the Borinage or Brussels. In the 1970 edition of De la Faille it is dated before 1873-74 on the evidence of a letter that Van Gogh wrote to his brother in 1882 from The Hague, in which he told him that he had once given away a number of magazine illustrations that he had treasured. 'Do you remember the figures by De Groux from the "Uilenspiegel" that I once had but have no longer, alas. Well, those two prints by Daumier I just mentioned are like them, and if you know of more like them, those are what I mean (I care far less for the caricatures). I very much regret that I don't have those De Grouxs and Ropses any more. I gave them away in England with some other things to Richardson, the traveller for G[oupil] & Cie' [276/239]. This is an allusion to Van Gogh's time in the London art trade between June 1873 and May 1875. Like the De Groux, the Rops lithograph *(fig. 5a)* had been cut out of the magazine *Uylenspieghel* (as it was actually called). It can be assumed – cautiously, for there is no hard evidence – that Van Gogh gave the print away in those years and that he had already made the copy, either in The Hague or London.

Rops gave his scene the title *Souvenirs* (Recollections), with the subtitle, probably added by the editor of the magazine: *En attendant la confession* (Waiting for confession), and it is the sort of genre work that greatly appealed to Van Gogh. The old woman has nodded off while waiting for the priest to call her into the confessional. Rops's lithograph shows part of that box on the right; the light comes diagonally from the left and just falls on the step under the door. The Protestant Van Gogh did not fully understand that part of the scene. He seems not to have recognised the confessional for what it was, thinking that it was a doorway in the wall. He was also a little undecided about the fall of light in his copy, which is exactly the same size as the original. At first he probably avoided the problem altogether, for the light was added later by scraping away the pencil with an erasing knife or hard rubber, damaging the surface of the paper in the process.

THE HAGUE-LONDON, CIRCA 1873

Pencil, scraped, on wove paper
26.3 × 19.4 cm
Unsigned
Annotated at lower right: d'après F. Rops

Inv. d 289 V/1962
Juv. XVII JH –

PROVENANCE
1890-91 T. van Gogh; 1891-1925 J.G. van Gogh-Bonger; 1925-62 V.W. van Gogh; 1962 Vincent van Gogh Foundation; 1962-73 on loan to the Stedelijk Museum, Amsterdam; 1973 on permanent loan to the Van Gogh Museum, Amsterdam.

LITERATURE
De la Faille 1928, vol. 3, p. 4, no. 835, vol. 4, pl. II; Vanbeselaere 1937, pp. 37, 45, 407, no. 835; De la Faille 1970, p. 604; Chetham 1976, p. 15; Amsterdam 1987, p. 384, no. 2.III; De la Faille 1992, vol. 1, p. 4, no. 835, p. 206, vol. 2, pl. II.

EXHIBITIONS
1955 Antwerp, no. 18; 1992 London, no. 5.

The drawing is entirely in pencil, and in that it differs from the preceding four pen and pencil drawings from the Hague period. The use of a dry, black drawing material was undoubtedly prompted by Rops's print, which was made with lithographic crayon. Van Gogh added the annotation at lower right with pen and brown ink.

5ª Félicien Rops, *Recollections (Waiting for confession)*, from: *Uylenspieghel. Journal des ébats artistiques et littéraires,* 29 March 1857, p. 4.

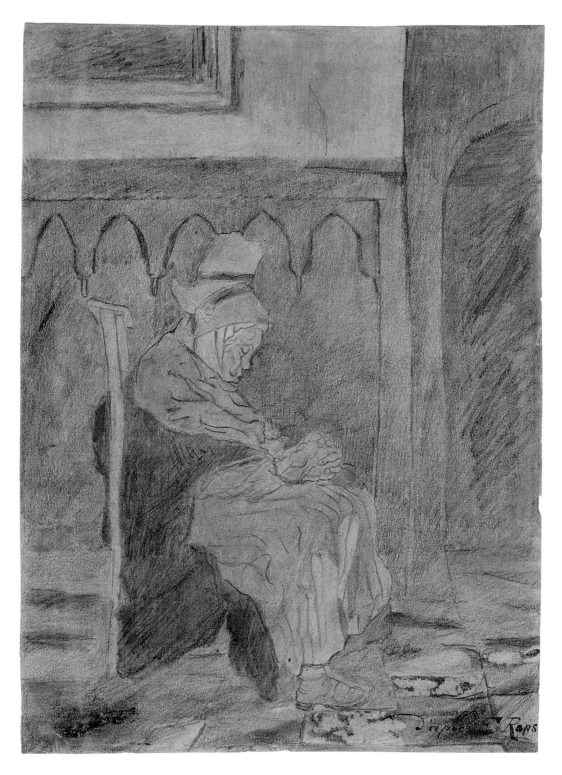

5 Old woman asleep (after Rops)

6 Austin Friars Church, London

LONDON,
JULY 1873-MAY 1875

Pen in brown ink, on wove paper
10.4 × 17.2 cm
Watermark: C & I H (?) (cropped
at the top left corner)
Unsigned
Annotated on the recto: Dit kerkje
is een merkwaardig overblijfsel
van eene oude Augustijner stich-
ing (Austin Friars) minstens
reeds / dateerende van het jaar
1354 zoo niet reeds een 100 jaren
vroeger. Reeds sedert 1550
ingevolge van eene vrijwillige /
schenking van Eduard vi houdt
de Nederduitse gemeente hier
hare godsdienstige zamenkom-
sten (This little church is a
remarkable remnant of an old
Augustinian foundation [Austin
Friars] dating from at least 1354,
if not from 100 years earlier.
Since 1550, by virtue of a volun-
tary gift by Edward vi, the Dutch
congregation has held its reli-
gious services here)
Annotated on the verso by
J. Nieweg: Vincent van Gogh /
gekregen van zijn zuster Mevr
van Houten 1914 / J. Nieweg
(Vincent van Gogh / received from
his sister, Mrs Van Houten, in
1914 / J. Nieweg)

Inv. d 405 M/1973
Juv. XXV JH –

Van Gelder placed this drawing of Austin Friars, a Gothic church in London *(fig. 6a)*,[1] in the period when Van Gogh also made two small drawings in Ramsgate *(cats. 8, 9)*. Since then the sheet has always been dated April-December 1876, when Van Gogh was working as a teacher in Ramsgate and then in Isleworth, and regularly visited London from the latter village. Although this is not impossible, it still makes more sense to date the sheet earlier. The reason is that Van Gogh worked in London for more than two years for the Goupil gallery at No. 17, Southampton Street, from June 1873 to May 1875 (with a brief interruption from October to December 1874, when he was in Paris), and it is known from his letters that he occasionally made drawings at that time.[2] He would also have had every opportunity to sketch the church. The Goupil gallery was close to the Strand only a few miles from Austin Friars, which stands in the City of London. There is even a good chance that he visited the church. As he correctly states in the annotation, Edward VI assigned Austin Friars

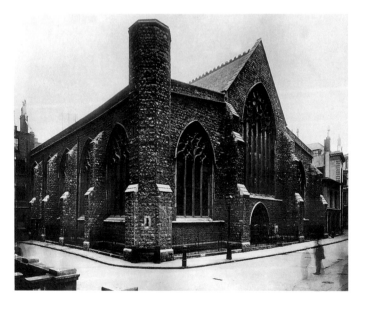

6a Photograph of Austin Friars Church,
London, 1892. London, Royal
Commission on the Historical
Monuments of England.

6 Austin Friars Church, London

PROVENANCE
1874-1914 A.C. van Houten-van Gogh, Dieren; 1914-55 J. Nieweg and N.G. Nieweg-van der Meulen, Spankeren-Bloemendaal; 1955-73 R. Nieweg and M. Nieweg, Amersfoort, H. Nieweg, Doetinchem; 1973 donated to the Van Gogh Museum, Amsterdam.

LITERATURE
De la Faille 1928, vol. 3, p. 1, no. 826, vol. 4, pl. 1; Van Gelder 1959, p. XIX, note 1; De la Faille 1970, p. 606; Verkade-Bruining 1974, p. 16; Amsterdam 1987, p. 385, no. 2.117; De la Faille 1992, vol. 1, p. 1, no. 826, p. 208, vol. 2, pl. 1.

EXHIBITIONS
1945 Amsterdam, unnumbered; 1992 London, no. 14.

1 *The church, whose history goes back to 1253, was hit by a bomb in 1940 and then rebuilt to a modern design.*
2 *See letters 23/17, 32/25 and 397/332.*
3 *London 1992, no. 14.*
4 *See the letter from M. Nieweg to E.R. Meijer of 21 November 1972 (Van Gogh Museum archives) on Nieweg as a pupil of Bremmer. See also Balk 1993, p. 8.*
5 *The latter is F 1193 JH 566.*

(known popularly as the Dutch Church) to Dutch Protestants in 1550, and as a pious clergyman's son Van Gogh may well have attended services there. No letter can be identified to which the sketch may have belonged, and it is perfectly possible that it was never sent with a letter but that Van Gogh gave it to his sister Anna, who was also living in England, having moved there at the end of July 1874. She stayed in London until the end of August, and then moved to Welwyn. As far as is known she was the first owner of the sketch, which she may have been given on one of her brother's visits. Even if this theory is correct, there are no clues for dating the drawing precisely. All that can be said is that it was probably made between July 1873 and May 1875.

Technically, it is certainly an accomplished piece of work, which led Martin Bailey to suggest that it had been copied from a photograph or a print.[3] That is not implausible, for the perspective, in particular, is handled very well compared to that in other of Van Gogh's juvenilia *(cats. 7, 11)*. The technique is also different, for in works from that period he generally used a combination of pencil and pen and ink, whereas this is a pure pen drawing. If there was a model it was probably a line etching or engraving, judging by the decidedly linear style.

As stated in the inscription on the verso, Anna gave the drawing to Jaap Nieweg (1877-1955) in 1914. He was pastor of the Dutch Reformed Congregation in Dieren, where she lived, but at the time he was trying to become a painter under the tutelage of the art educationist H.P. Bremmer (1871-1956).[4] Like Bremmer and his 'followers,' Nieweg greatly admired Van Gogh's work, and as a mark of her appreciation Anna gave him this London sheet and a drawing of a Brabant peasant woman.[5]

In the period 1901-07, The Nieweg family donated the drawing of Austin Friars Church to the museum to mark its opening in 1973.

7 Vicarage and church at Etten

This charming little drawing of the vicarage where Van Gogh's parents and sisters lived was probably made in April 1876. Vincent had been dismissed from Goupil's Paris gallery at the beginning of the month and had found a job as a teacher in Ramsgate. Before leaving for England he spent almost a fortnight in Etten. In 1958, Van Gelder arrived at this dating on the evidence of the stylistic similarities to two small townscapes of Ramsgate which are known to have been made in April-May of that year (*cats. 8, 9*).[1] The comparison is convincing, for they too are small drawings in which the initial design is in pencil, which was also used to fill in the open passages. All the contours and the details were then drawn with a fine pen.

The annotation in Vincent's handwriting on the verso states that this sheet was a present for his sister Wil (1862-1941). The Van Gogh Museum also has a copy of this drawing that was made by Wil herself (*fig. 7a*).

Van Gogh produced a variant of his drawing, now in a private collection, in which the vicarage is seen directly from the front and the church is omitted (*fig. 7b*). Both miniatures once belonged to S.M. de Jong-van Houten (1880-1977). This was Saar van Houten, a daughter of Vincent's eldest sister, Anna (1855-1930). De la Faille's œuvre catalogue states that the work now in private hands passed to Saar from her mother, who in turn received it from Wil. The earliest provenance given in De la Faille for the sheet in the Van Gogh Museum is Saar van Houten, but given the inscription on the back there cannot be any doubt that Vincent gave it to Wil, his youngest sister, so she must have been the first owner. Confirmation of this, if any were needed, is provided by her own meticulous copy. It is not clear whether the data on the provenance of the two drawings were transposed in De la Faille, or whether both first belonged to Wil before coming into Anna's possession. From 1902, Anna and her husband administered Wil's estate after she had been admitted to a mental asylum with psychiatric problems. It was probably via that route (possibly after Anna's death in 1930) that this sheet passed to Saar van Houten, who eventually owned both the variant and Wil's copy as well.

ETTEN, APRIL 1876

Pencil, pen in brown ink, on wove paper
9.5 × 17.8 cm
Unsigned
Annotated on the verso: Van Vincent voor Wil[lemien; erased]

Inv. d 307 V/1972
Juv. XXI JH –

PROVENANCE
1881-1941 W.J. van Gogh; from 1902 in the keeping of A.C. van Houten-van Gogh and J.M. van Houten; S.M. de Jong-van Houten, Bloemendaal; 1972 (probably) bought by the Vincent van Gogh Foundation; 1973 on permanent loan to the Van Gogh Museum, Amsterdam.

LITERATURE
Van Gelder 1955, p. 24; Van Gelder 1959, pp. xv, xxi; Szymańska 1968, pp. 23-24, 52; Tralbaut 1969, p. 71; De la Faille 1970, p. 605; Amsterdam 1987, p. 384, no. 2.113; De la Faille 1992, vol. 1, p. 207, vol. 2, pl. CCLX.

EXHIBITIONS
1962 London, no. III; 1992 London, no. 9.

1 Van Gelder 1959, pp. XV, XXI;
Szymańska 1968, p. 23, states that the
sheet was made in the spring of 1878, but
provides no supporting evidence. In the
1953 edition of Van Gogh's correspondence
it was reproduced at the beginning of the
section with the letters from Etten, without
any suggestion of it being associated with a
specific letter.
2 Elisabeth du Quesne van Bruchem-van
Gogh to Anny van Houten, 11 June 1933;
inv. b 4538 V/1990. The original Dutch of
the quotation reads: 'Oorspronkelijk is het
door Vincent geteekend, en heel fijn uit-
gevoerd. Toen heeft Tante Wil het hier
even verdienstelijk nageteekend. [...] Een
bijzonderheid is dat dit huis, heel ruim en
pleizierig, niet meer bestaat, werd afgebro-
ken en modern herbouwd op dezelfde plaats.
Dat bijgebouwtje rechts was eerst een cate-
chiseerkamertje en later toen V. uit Antw.
was teruggekomen, zijn atelier.' Lies repro-
duced Wil's copy in her reminiscences of
Vincent: Du Quesne-van Gogh 1923,
between pp. 40 and 41.

She probably received the copy from her sister Anny (1883-1969), who had been given it as a present from her Aunt Lies (1859-1936), Vincent's sister. Lies wrote her a letter with more information on both the drawing and the vicarage, which was demolished in 1904. 'The original was drawn by Vincent, and was very finely done. *Aunt Wil* then *copied* it here equally creditably. [...] One interesting point is that this house, which was very spacious and pleasant, no longer exists, was pulled down and rebuilt in the modern style on the same spot. The little out-building on the right was first used as a Sunday school and later, when V. [Vincent] returned from Antw. [Antwerp, a mistake for Brussels], it became his studio.'[2] These three scenes, in other words, also show what was to become Van Gogh's first studio as an artist in April 1881.

The drawing that is the subject of this entry was bought from Saar de Jong-van Houten by the Vincent van Gogh Foundation, probably in 1972.

7a Willemien van Gogh, *Vicarage and church at Etten*. Amsterdam, Van Gogh Museum.

7b *Vicarage at Etten* (Juv. XXII), 1876. Private collection.

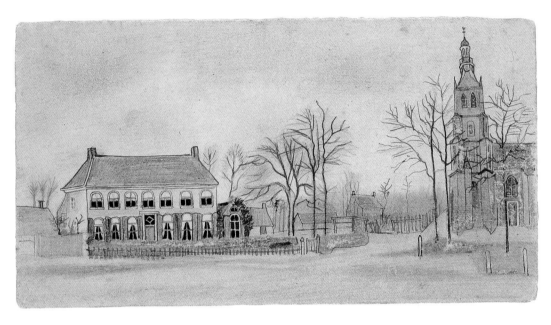

7 Vicarage and church at Etten

8 View of Royal Road, Ramsgate

RAMSGATE, MAY 1876

Pencil, pen in brown ink, on laid
paper
5.6 × 5.7 cm
Unsigned

Inv. d 301 V/1972
Juv. XXVII JH –

PROVENANCE
1876-91 T. van Gogh; 1891-1925
J.G. van Gogh-Bonger; 1925-62
V.W. van Gogh; 1931-62 on loan
to the Stedelijk Museum, Amster-
dam; 1962 Vincent van Gogh
Foundation; 1962-73 on loan to
the Stedelijk Museum, Amster-
dam; 1973 on permanent loan
to the Van Gogh Museum,
Amsterdam.

LETTER
81/67

LITERATURE
Tralbaut 1969, pp. 48-49;
De la Faille 1970, p. 606;
Verkade-Bruining 1974, pp. 14-15;
Nottingham 1974-75, pp. 8-13;
Amsterdam 1987, p. 385, no. 2.115;
De la Faille 1992, vol. 1, p. 208,
vol. 2, pl. CCLXI; London 1992,
pp. 121-22.

EXHIBITIONS
1962 London, no. v; 1992
London, no. 12.

The two tiny drawings discussed in this and the following entry were
made in the two months when Van Gogh was living and working in
Ramsgate.

His relationship with his employers at the Goupil gallery in Paris
had cooled considerably in the course of 1875, and on 1 April 1876 he was
dismissed. He had already been replying to advertisements for some time,
and he now found a job as a teacher at a boys' boarding school at No. 6,
Royal Road in Ramsgate that was run by William Port Stokes (c. 1832-
1890).[1] He was delighted with the view of the sea from the school win-
dow.[2] He wrote about it in a letter to Theo of May 1876, in which he
enclosed this small, square sketch. It is readily identifiable from the acci-
dental, circular smudge at lower right that was made by Van Gogh's
pupils, as he mentioned in the letter. 'Enclosed is a little drawing of the
view from the school window through which the boys wave goodbye to
their parents when they are going back to the station after a visit. Many
will never forget the view from that window' [81/67]. A little further on he
added: 'The boys made an oil stain on your drawing, please excuse them.'

Apart from the format (the second sketch is slightly higher and
almost twice as wide) there is little difference between the two scenes.
They are views of the garden bordering on Royal Road that extended to
West Cliff, beyond which lay the sea. Only a small part of the garden is
shown. On the right, a lamppost serves as a repoussoir. Van Gogh seems
to have fudged reality here, for on the evidence of the other drawing it
was beyond his field of view. The scene as a whole is quite airy. The skies
are cloudless, and there are four sailing ships in the distance. Van Gogh
drew the basic composition with the pencil and reinforced the contours
with a fine pen.

1 For Van Gogh's stay there see
Nottingham 1974-75, pp. 8-13.
2 Letter 75/61. He also speaks of a view
from the window in letter 76/62, but it is
not the same as the one drawn here. See
cat. 9, note 1.

9 View of Royal Road, Ramsgate

This is a slightly wider view of the square featured in the preceding drawing. In the 1953 edition of Van Gogh's letters it is placed with the second letter that he wrote to Theo from Ramsgate. He speaks of the view from the school window in both the first and second letters, but there is no mention of an enclosed sketch in either of them.[1] In the slightly later letter accompanying the oil-stained drawing *(cat. 8)* he says nothing about having already sent another drawing. It is also unlikely that he would have sent his brother two virtually identical townscapes. Van Gogh may have sent it to his parents or to one of his sisters in a letter that has not survived.[2] The dating is therefore not as precise as that of the preceding sheet; it was made in April-May 1876, the two months when Van Gogh was living in Ramsgate.

 This drawing shows a larger expanse of the garden, and this time the sky is overcast. There is a boat close to the shore on the left, and in the right background a sailing ship. From the technical point of view this work is identical to the previous sheet: drawn in pencil, with the contours reinforced with the pen.

RAMSGATE, APRIL-MAY 1876

Pencil, pen in brown ink, on
laid paper
6.9 × 10.9 cm
Watermark: segment of a circle
with a tower (?) (cropped by the
lower edge)
Unsigned

Inv. d 292 V/1972
Juv. XXVI JH –

PROVENANCE
1890-91 T. van Gogh; 1891-1925
J.G. van Gogh-Bonger; 1925-62
V.W. van Gogh; 1931-62 on loan to
the Stedelijk Museum, Amsterdam;
1962 Vincent van Gogh Foundation;
1962-73 on loan to the Stedelijk
Museum, Amsterdam; 1973 on
permanent loan to the Van Gogh
Museum, Amsterdam.

LITERATURE
Van Gelder 1955, pp. 23-24; De la
Faille 1970, p. 606; Nottingham
1974-75, pp. 8-13; Amsterdam 1987,
p. 385, no. 2.114; De la Faille 1992,
vol. 1, p. 208, vol. 2, pl. CCLXI;
London 1992, p. 121.

EXHIBITIONS
1962 London, no. IV; 1992
London, no. 11.

1 *Letters 75/61 and 76/62. Moreover, as pointed out by Martin Bailey (London 1992, no. 11), Van Gogh describes a view from the window in letter 76/62 that was not the same as the one in the sketch. 'The house,' he wrote, 'stands in a square (all the houses around it are the same, which is often the case here). In the middle of the square is a large lawn enclosed by iron railings and surrounded by lilac bushes; the boys play there during the recreation hour. The house where I am staying is in the same square.' That was Spencer Square, directly off Royal Road, and thus visible from the window (Bailey reproduces a photograph of circa 1900 on p. 12). The garden in Van Gogh's two drawings is indeed not surrounded by iron railings.*

2 *Bailey, loc. cit., note 1.*

8 View of Royal Road, Ramsgate

9 View of Royal Road, Ramsgate

10 The cave of Machpelah

AMSTERDAM, MAY 1877

Pen in brown ink, on laid paper
7.2 × 15.4 cm
Unsigned
Annotations on the verso: Latin
exercises, and a note in Van
Gogh's hand: Mendes vragen over
examen / Wanneer heeft dat
plaats zou het / mogelijk zijn dat
bij te wonen (Ask Mendes about
the examination. When will it be
[and] would it be possible to sit in)

Inv. d 300 V/1970
Juv. XXX JH –

PROVENANCE
1877-91 T. van Gogh; 1891-1925
J.G. van Gogh-Bonger; 1925-70
V.W. van Gogh; 1931-70 on loan
to the Stedelijk Museum, Amster-
dam; 1970 Vincent van Gogh
Foundation; 1970-73 on loan to
the Stedelijk Museum, Amster-
dam; 1973 on permanent loan to
the Van Gogh Museum, Amster-
dam.

LETTER
116/97.

LITERATURE
Van Gelder 1955, pp. 27-28;
De la Faille 1970, pp. 606, 609;
Amsterdam 1987, p. 385, no. 2.119;
De la Faille 1992, vol. 1, p. 209,
vol. 2, pl. CCLXI.

EXHIBITIONS
None

It was in the 1953 edition of Van Gogh's correspondence that this small pen drawing was first reproduced as a so-called letter sketch, being reproduced with letter 142/121 of 3 April 1878. That, though, was a fairly arbitrary choice, for there is no mention of a drawing in that letter, nor a passage that relates to this scene.[1] The connection was undoubtedly made on the basis of the annotations on the verso, from which it is possible to establish the period within which the drawing was made. They are exercises in Latin together with a note by Van Gogh reminding him to ask 'Mendes' a question. This shows that the drawing must have been made between May 1877 and July 1878, when Van Gogh was in Amsterdam preparing to study theology, and was being tutored in Latin and Greek by Maurits Benjamin Mendes da Costa (1851-1939), whom Van Gogh calls Mendes for short.

Van Gelder described the subject as a bridge, and in De la Faille 1970 and the catalogue of the collection of the Van Gogh Museum of 1987 the drawing was accordingly given the title *Landscape with bridge*.[2] A closer examination suggests that this is not a bridge at all but a sort of grotto with a stone with an illegible inscription on top of it. One of Van Gogh's first letters from Amsterdam contains a passage which applies to this scene. He had recently been reading Genesis 23, about the burial of Sarah, Abraham's wife, who was laid to rest 'in the field that Abraham had bought in order to bury her there, in the cave of Machpelah; and I spontaneously made a little drawing of how I imagined the place looked. It is nothing very special, but I enclose it all the same' [116/97]. Van Gogh added the tombstone to make it clear that the cave was a burial place. The letter is dated 28 May 1877, so the sketch was made shortly before.

Judging by the ragged top edge, the sheet was torn from a notebook or exercise book. Only part of it was used, for the lower edge shows that it was once larger. The scene was drawn with a fine pen, which was also used for making some strokes on the reverse. The ink is now quite a light brown, but was probably darker originally.

1 The sketch is not included in the 1990
edition of the letters.
2 See Van Gelder 1955, pp. 27-28, and
Amsterdam 1987, no. 2.119.

10 The cave of Machpelah

11 The 'Au charbonnage' café

Laken (Brussels),
November 1878

Pencil, pen in brown ink, on
laid paper
14.0 × 14.2 cm
Unsigned
Verso: Greek exercises

Inv. d 293 V/1970
Juv. XXXI JH –

Provenance
1890-91 T. van Gogh; 1891-1925
J.G. van Gogh-Bonger; 1925-62
V.W. van Gogh; 1931-62 on loan
to the Stedelijk Museum,
Amsterdam; 1962 Vincent van
Gogh Foundation; 1962-73 on
loan to the Stedelijk Museum,
Amsterdam; 1973 on permanent
loan to the Van Gogh Museum,
Amsterdam.

Letter
147/126

Literature
Tralbaut 1969, p. 71; De la Faille
1970, pp. 606, 609; Verkade-
Bruining 1975, p. 8; Amsterdam
1987, p. 386, no. 2.120; De la
Faille 1992, vol. 1, p. 209, vol.
2, pl. cclxi.

Exhibition
1962 London, no. viii.

1 See Lutjeharms 1978, p. 104.

This drawing of a Belgian café was made in November 1878 at Laken,
near Brussels. Van Gogh arrived there after a disappointing year
preparing to study theology in Amsterdam (see *cat. 12*). He left for
Brussels (taking lodgings in Laken) to follow a less exacting course to
train as an evangelist. Before being enrolled he was placed on a three-
month probationary period under the supervision of pastors N. de Jong
and A.J. vander Waeyen Pieterszen. Once again he did not start on
the actual training course, but in December was nevertheless sent to
the Borinage mining region of Belgium as an evangelist.

He mailed this small sheet to Theo. The latter had visited him on
15 November and that same evening Vincent wrote him a letter, enclos-
ing 'that scratch, "Au Charbonnage",' which makes it clear that they
had already spoken about it [147/126]. In order to fit it into the envelope
he had to fold it twice, and those vertical and horizontal creases can
still be seen. Van Gogh readily admitted that it was nothing very
special, but he had drawn the scene 'because one sees so many people
here who work in the coal mines, and they are odd types. This little
house stands not far from the road; it is actually a small inn adjoining
the big workshop, and the workmen come here to eat their bread and
drink their glass of beer during the lunch-hour.' Further on in the let-
ter Van Gogh says that he was longing to go to the Borinage to work
as an evangelist among the miners, and he was evidently exploring
the same kind of environment to prepare himself. Beside the 'Au
Charbonnage' café, on the site of the mine, is a shed where, accord-
ing to the signboard: 'Charbons Cokes &c', coal and similar fuels
were sold. On the far left and in the centre are a few roofs rising over
the café. The cobbles in front are depicted with delightful ineptitude.

The scene was first drawn in pencil and then the contours were
reinforced with the pen in black or very dark brown ink. The acid dam-
age to the sheet shows that it was iron-gall ink, which turns brown in
the course of time and can eventually fade away altogether. The letter-
ing on the boards above the doors to the café and the shed were writ-
ten with the pen and are in Van Gogh's own handwriting rather than
the more stylised lettering one would expect. On the back of the sheet

11 The 'Au charbonnage' café

are exercises in Greek pronouns which Van Gogh probably did back in Amsterdam, for he was not allowed to follow the Greek classes while on the course in Brussels *(fig. 11a)*.[1]

11a Verso of cat. 11.

12 Coalmine in the Borinage

De la Faille included this watercolour in his œuvre catalogue of 1928 as a sheet from Van Gogh's Hague period, and gave it the title *Usine de gaz* (Gasworks). Visser, in his 1973 study of the subjects Van Gogh had depicted in The Hague, was certain that the complex in the background was a laundry.[1] In 1990, Michiel van der Mast resolved the issue once and for all; this is not a laundry but the buildings attached to a coal mine, with a slagheap on the right.[2] The drawing could therefore not have been made in The Hague, but must date from Van Gogh's time in the Borinage mining region of Belgium. Pencilled inscriptions in French (the language that Van Gogh spoke in the Borinage) tend to support this. Written in the sky above the square building are the words 'four à coke' (coke oven). At bottom left is a sentence that can only be read with difficulty: 'tirer du charbon avec des chevaux 25 ans' (Coal mining with the aid of horses 25 years). Horses were indeed used in the Borinage mines, but the point of the annotation remains unclear. Equally puzzling is the addition '25 ans'. It seems unlikely that the draughtsman would note down his age in passing, and if the dating proposed below is correct the figure could not even refer to Van Gogh, who had his 26th birthday on 30 March 1879. Above this odd annotation is another cryptic jotting: '2 m 3 fr le metre' (2 m[etres] 3 fr[ancs] per metre). On the back of the sheet, in the same hand, are the notes '7', '4' and '4 metres'.

There are also various colour notations which indicate that the artist made this preliminary drawing on the spot and noted down the colours that he saw in order to add them in the appropriate passages when he got back home. In the roof of the third building from the left is the word 'rou[ge...]' (red...); to the left of the small figure of a man 'vert jaune' (green-yellow). In the slagheap on the far right 'rose' (pink), and in the heap to the left of it possibly the word 'clair' (bright).

Leaving aside the colour notations, inscriptions of this kind are most unusual in Van Gogh's œuvre, and in fact it is not entirely certain that the handwriting is his. Nor, finally, is there any other work that closely corresponds to this sheet. Although it is difficult to explain these oddities, there is no real reason to doubt the drawing's authenticity. It comes directly from the Van Gogh family, and Vincent's handwriting in pencil

CUESMES-WASMES,
JULY-AUGUST 1879

Pencil, transparent watercolour,
on wove paper
26.4 × 37.5 cm
Unsigned
Annotations on the recto and
verso: inscriptions in French and
colour notations

Inv. d 370 V/1962
F 1040 JH 100

PROVENANCE
1890-91 T. van Gogh; 1891-1925
J.G. van Gogh-Bonger; 1925-62
V.W. van Gogh; 1962 Vincent van
Gogh Foundation; 1962-73 on
loan to the Stedelijk Museum,
Amsterdam; 1973 on permanent
loan to the Van Gogh Museum,
Amsterdam.

LITERATURE
De la Faille 1928, vol. 3, p. 50,
vol. 4, pl. LIV; Vanbeselaere 1937,
pp. 80, 128, 409; De la Faille
1970, p. 384; Visser 1973, pp. 107-
10; Hulsker 1980, pp. 32-33, 38,
no. 100; Amsterdam 1987, p. 389,
no. 2.139; Van der Mast / Dumas
1990, pp. 74-75; De la Faille 1992,
vol. 1, pp. 50, 268, vol. 2, pl. LIV.

EXHIBITIONS
1905 Amsterdam, no. 449?; 1914-15 Amsterdam, no. 27; 1948-49 The Hague, no. 175; 1953 Zürich, no. 17; 1953 Zundert, no. 40; 1953 Assen, no. 33; 1953-54 Bergen op Zoom, no. 18; 1953 Hoensbroek, no. 66; 1954-55 Bern, no. 85; 1955 Antwerp, no. 24; 1955 Amsterdam, no. 4; 1957 Nijmegen, no. 12; 1975 Malmö, no. 5; 1976 Stockholm, no. 5; 1976 Oslo, no catalogue; 1980-81 Amsterdam, no. 56; 1982 Amsterdam, no catalogue.

1 Visser 1973, pp. 108-10.
2 Van der Mast / Dumas 1990, pp. 74-75.
3 Letter 696/553b.

often differs quite considerably from that done with the pen. The fact that there is no comparable work is probably because the artist simply did not consider it worth keeping exercises of this kind. In 1888 he was to tell his friend Eugène Boch (1855-1941) that he had destroyed his work from this period, but a few drawings must have escaped that fate.3 It is known that when he was in the Borinage he received a box of paints from his former superior at the Goupil gallery in The Hague, H.G. Tersteeg (1845-1917), and used it to make watercolours. In August 1879 he had a 'sketchbook which is already half full' [152/131]. As far as is known, the present watercolour is the only one of those colour sketches to have survived.

12 Coalmine in the Borinage

13 En route

JANUARY 1881

Pencil, pen and brush in brown
and black ink, on wove paper
9.8 × 5.8 cm
Unsigned
Annotated at lower right:
En route
Verso: pencil scribbles

Inv. d 294 V/1972
F – JH –

PROVENANCE
1880-91 T. van Gogh; 1891-1925
J.G. van Gogh-Bonger; 1925-62
V.W. van Gogh; 1962 Vincent
van Gogh Foundation; 1962-72
with V.W. van Gogh, Laren;
1972-73 on loan to the Stedelijk
Museum, Amsterdam; 1973 on
permanent loan to the Van
Gogh Museum, Amsterdam.

LETTER
161/140.

LITERATURE
Amsterdam 1987, p. 386,
no. 2.124.

EXHIBITION
1962 London, no. IX.

1 *For more on this point see the*
Introduction.

In the Borinage, Van Gogh began making drawn copies of prints in preparation for his planned career as an artist. He moved to Brussels in the early autumn of 1880, where he doggedly continued with similar exercises. At the same time, though, he produced more independent work from the live model, including this and the following drawing *(cat. 14)*.[1] Together with *The bearers of the burden*, these are the only works of this kind from that period. They were probably made in January 1881. It was in that month, anyway, that he sent both of them to Theo, along with a letter describing his most recent work. 'They vaguely resemble certain drawings by Lançon, or certain English wood engravings, but as yet they are more clumsy and awkward. They are of an errand-man, a miner, a snow shoveller, a walk in the snow, old women, an old man ("Ferragus" from Balzac's *L'histoire des treize*), and the like. I am sending you two small ones, "En route" and "Before the hearth." I am well aware that they are not good yet, but they are beginning to look like something' [161/140]. Despite their small size, then, these should not be regarded as letter sketches but as drawings in their own right, although they were reproduced with this letter in the 1914 edition of Van Gogh's correspondence. Such scenes of 'working-class types' were studies in the tradition of the social-realist illustrations that Van Gogh liked so much, and which he himself wanted to make for magazines.

The small man in *En route* may be the 'errand-man' mentioned in the quotation, a domestic servant or office worker who carried messages to and fro and did odd jobs. Further on in that letter Van Gogh wrote that he indeed had an 'errand-man' as a model. Here he is still out late at night, with a lantern to light his way. The drab pollard willow to the right of him and the house with lighted windows in the background underscore his loneliness. Although the man's features are so clumsily drawn as to be barely distinguishable, he does seem to be identical to the figure in the following sheet. Both appear to be wearing the same clothes, which include an eye-catching, oddly shaped hat, possibly a sort of tricorn.

Van Gogh drew the scene in pencil and then worked it up with the pen and brush in brown and black ink. The title inscribed with the pen at bottom right is in French, as were Van Gogh's letters of this period. It is impossible to make out what the pencilled scribbles on the back of the sheet are meant to represent.

14 Before the hearth

This small drawing was made in the same period as the previous sheet, and is probably of the same model. Van Gogh sent them both to Theo (see *cat. 13*). The old messenger who posed for Van Gogh is warming himself by an open hearth ('devant les tisons' in French, the title Vincent inscribed with the pen at lower right). The two drawings may be companion pieces, for in one the man is carrying out his duties at dead of night, while here he is enjoying his well-earned rest.

The motif of a man or woman by a hearth is also found in Van Gogh's work from Etten and The Hague. Sometimes the message is not so happy (see *cat. 42*), but a drawing from Etten of a peasant reading a book by the fire breathes the same atmosphere of repose after the day's labours *(fig. 14a)*.

This scene, too, was drawn in pencil and then worked on with the pen and brush in brown and black ink. Van Gogh very successfully captured the reflection of the light from the fire on the floor and the side wall of the hearth. In the latter case he did so with nothing more than a stumped pencil smudge at the top which contrasts strongly with the bare white surface of the paper that suggests the glow of the fire. Leaning against the wall within the hearth is a pair of fire tongs.

JANUARY 1881

Pencil, pen and brush in brown and black ink, on wove paper
9.8 × 5.8 cm
Unsigned
Annotated at lower right:
Devant les tisons
Verso: pencil strokes

Inv. d 295 V/1972
F – JH –

PROVENANCE
1880-91 T. van Gogh; 1891-1925 J.G. van Gogh-Bonger; 1925-62 V.W. van Gogh; 1962 Vincent van Gogh Foundation; 1962-72 with V.W. van Gogh, Laren; 1972-73 on loan to the Stedelijk Museum, Amsterdam; 1973 on permanent loan to the Van Gogh Museum, Amsterdam.

LETTER
161/140

LITERATURE
Amsterdam 1987, p. 386, no. 2.125.

EXHIBITIONS
None

14a *Peasant reading by the fire* (F 897 JH 63), 1881. Otterlo, Kröller-Müller Museum.

73

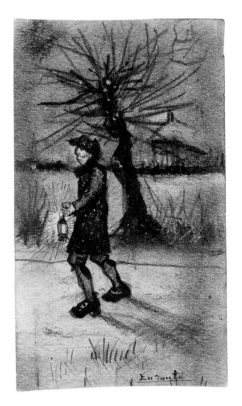

13 En route

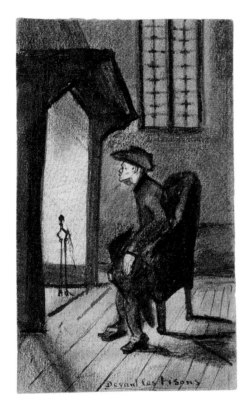

14 Before the hearth

15 French peasant woman suckling her baby (after Dalou)

WINTER-SPRING 1880-81

Pencil, wash, on wove paper
48.3 × 26.4 cm
Unsigned
Annotated at lower left: PAYSANNE
FRANÇAISE / D'APRES LA TERRE-
CUITE DE DALOU

Inv. d 61 V/1962
SD 1673 JH –

PROVENANCE
1890-91 T. van Gogh; 1891-1925
J.G. van Gogh-Bonger; 1925-62
V.W. van Gogh; 1962 Vincent van
Gogh Foundation; 1962-73 on
loan to the Stedelijk Museum,
Amsterdam; 1973 on permanent
loan to the Van Gogh Museum,
Amsterdam.

LITERATURE
De la Faille 1970, p. 574;
Chetham 1976, p. 15; Amsterdam
1987, p. 386, no. 2.123; De la
Faille 1992, vol. 1, p. 447, vol. 2,
pl. CCXLII.

EXHIBITIONS
None

Among the models copied by Van Gogh in order to practise his draughts-manship is this scene of a woman suckling her child, which he drew from an engraving entitled *Paysanne française* after the terracotta figure by Jules Dalou (1838-1902). Van Gogh came across the engraving in an article about the London art world in 1876 volume of the journal *L'Art*, together with other work by the sculptor *(fig. 15a)*.[1]

Van Gogh only mentions Dalou once in his letters, in 1885, when he praised him for being one of the sculptors who could depict a nude that was both simple and modern in the 'most thorough' way [522/418]. The figure of the peasant woman with her child was well-known to him. A lifesize version had been displayed at the Royal Academy Summer Exhibition in

15a Achille-Isodore Gilbert after Jules
Dalou, *Paysanne française*, illustration
from: *l'Art* 2 (1876), p. 38.

15 French peasant woman suckling her baby
(after Dalou)

1 John Dubouloz, 'London Season', l'Art 2 (1876), pp. 37-40, the illustration on p. 38.
2 Ronald Pickvance noted that Van Gogh had visited this exhibition; see Nottingham 1974-75, p. 14. This can be deduced from Van Gogh's mention of several of the works in the show in letter 13/11 of 3 September 1873. Dalou was living and working in London at the time. The fact that a large version of the Paysanne française was included in the Royal Academy Summer Exhibition of 1873 is reported by John M. Hunisak, The sculptor Jules Dalou: studies in his style and imagery, New York 1977, p. 280.

London in 1873, and Van Gogh, who was working in London at the time, visited the show.[2]

Although Van Gogh clearly respected Dalou's qualities, there is no need to regard this drawing as a mark of homage to him, as was certainly the case with his choice of Millet as a model *(cat. 16)*. He must simply have been struck by this intimate scene of motherhood – a theme for which he already had a weakness (see *cat. 63)*. The fact that this was a peasant woman with her child would only have increased its attraction to Van Gogh, who wanted to study every aspect of peasant life.

He copied the scene faithfully in pencil, and undoubtedly ruled a grid on both the illustration and his own sheet of paper to facilitate the transfer (cf. *cat. 16)*. There are no longer any traces of it in the drawing (the illustration that Van Gogh owned, and used for making his copy, has been lost). Van Gogh failed to capture the woman's gentle smile; indeed the downturned left corner of her mouth gives her a slightly disgruntled look. Nor is the baby's skull very successful. In the print the engraver copied some fine cracks that had evidently developed in the terracotta. It is not clear whether Van Gogh failed to understand this, but he certainly exaggerated these details to the unfortunate extent that we appear to be seeing the baby's fontanelle. The delicate hatching is effective in suggesting the shadowing that defines the volumes of the woman and child. Shaded passages with stumped pencil were added in the background (which is blank in the engraving) in order to give the figure contrast. Van Gogh must then have applied a wash with watercolour or ink, for along the woman's contour are slightly irregular lines of liquid (which are always incorrectly described as pen-strokes). It is not clear what the colour of this wash was, for it has now faded.

16 The sower (after Millet)

This is the only surviving example of Van Gogh's drawn copies after a print of the masterpiece by Jean-François Millet (1814-1875), *The sower* of 1850. While in the Borinage in the summer of 1880 he had begun making drawings of the scenes of peasant life by this French painter, whom he idolised. He produced at least five versions of this particular painting, two small and three large ones.[1] In Etten in April 1881 he copied the scene yet again.[2] The sheet in the Van Gogh Museum was regarded by De la Faille in 1928 as a work from the Borinage or Brussels, but since then it has always been identified as the Etten copy. Although no arguments have ever been put forward in support of this it is indeed the most likely theory, particularly in view of the very extensive use of pen and ink. Little comparative material has survived from the Borinage-Brussels period (see *cat. 12*), but the little there is, such as the two copies after Millet's *Diggers*,[3] is largely done with dry media like pencil and chalk.

The immediate model for Van Gogh's copies was Paul-Edmé LeRat's etching after Millet's painting, which was included in the *Recueil d'estampes gravées à l'eau-fort* published by the Paris art dealer Durand-Ruel. An impression of that etching that was once owned by Van Gogh is preserved in the Van Gogh Museum *(fig. 16a)*. A grid has been drawn on it to make it easier to copy, but it is impossible to say whether this is the illustration that Van Gogh used in Etten. In 1889-90, in Saint-Rémy, he made a few painted copies of this scene, and because he no longer had the etching Theo sent him an impression.[4]

Certain peculiarities in Van Gogh's drawing are due to an incorrect interpretation of details in the print by LeRat, who in his turn had not understood everything in Millet's painting. One has to turn to the original picture, which Van Gogh had never seen, in order to explain these 'translation errors' *(fig. 16b)*. Millet's sower, for instance, has tied straw around his legs to keep them warm. That cannot be seen in the print, which is why Van Gogh has given him knee-length stockings or boots. The sower in Millet's picture is grasping the full, rather heavy sack firmly with his left hand, but neither LeRat nor Van Gogh saw the need for this, and their peasant has merely a flap of the sack hanging over his left forearm. The most striking error, however, is the misinterpretation of the

APRIL 1881

Pencil, pen and brush in brown ink, grey and green opaque watercolour, brown wash, on grey wove paper
48.1 × 36.7 cm
Unsigned

Inv. d 443 V/1962
F 830 JH 1

PROVENANCE
1890-91 T. van Gogh; 1891-1925 J.G. van Gogh-Bonger; 1925-62 V.W. van Gogh; 1962 Vincent van Gogh Foundation; 1962-73 on loan to the Stedelijk Museum, Amsterdam; 1973 on permanent loan to the Van Gogh Museum, Amsterdam.

LETTER
165/144

LITERATURE
De la Faille 1928, vol. 3, p. 2, vol. 4, pl. 11; Meier-Graefe 1928, pl. 2; Vanbeselaere 1937, pp. 36, 192, 407; Cooper 1955, pp. 11-13; De Gruyter 1961, pp. 6, 92, fig. 2; De la Faille 1970, pp. 332-33; Chetham 1976, pp. 11-12; Hulsker 1980, p. 13, no. 1; Amsterdam 1980-81, pp. 28-29, 148, no. 43; Osaka 1986, p. 97, no. 8; Amsterdam 1987, p. 387, no. 2.126; Van der Wolk 1987, p. 284; Den Bosch 1987-88, pp. 132-33, no. 1; Amsterdam 1988-89, pp. 164-65, no. 65; De la Faille 1992, vol. 1, pp. 2, 213, vol. 2, pl. 11.

EXHIBITIONS
1914-15 Amsterdam, no. 148; 1927-28 Berlin, Vienna & Hannover, no. 1; 1928 Paris, no.

sower's action. In the painting he lets the seed slip through his fingers as he swings his arm in an arc. Above his hand, on the horizon, is a swarm of birds. The seed cannot be seen in the print, and the birds are barely recognisable as such. Van Gogh must therefore have taken the black spots above the horizon in the print for seed, with the result that his sower is energetically scattering the seed behind his back.

Van Gogh made more than 30 drawings and paintings of sowers, which testifies to the impact the motif had on him.[5] Despite this, he rarely spoke of his feelings about it. He is at his most explicit in a letter of June 1888 to Emile Bernard (1868-1941), in which he mentions in passing that the sower and the wheatsheaf were symbols of infinity.[6] The subject has a religious dimension, and various authors have accordingly pointed to the association with the biblical parable of the sower.[7] The gist of that story – scattering seed as a metaphor for spreading the faith,

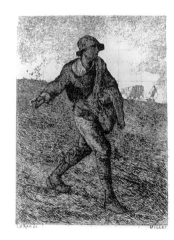

16ª Paul-Edmé Le Rat after Jean-François Millet, *The sower*. Amsterdam, Van Gogh Museum.

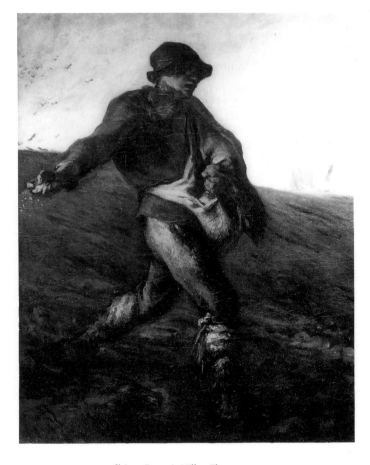

16ᵇ Jean-François Millet, *The sower*, 1850. Boston, Museum of Fine Arts.

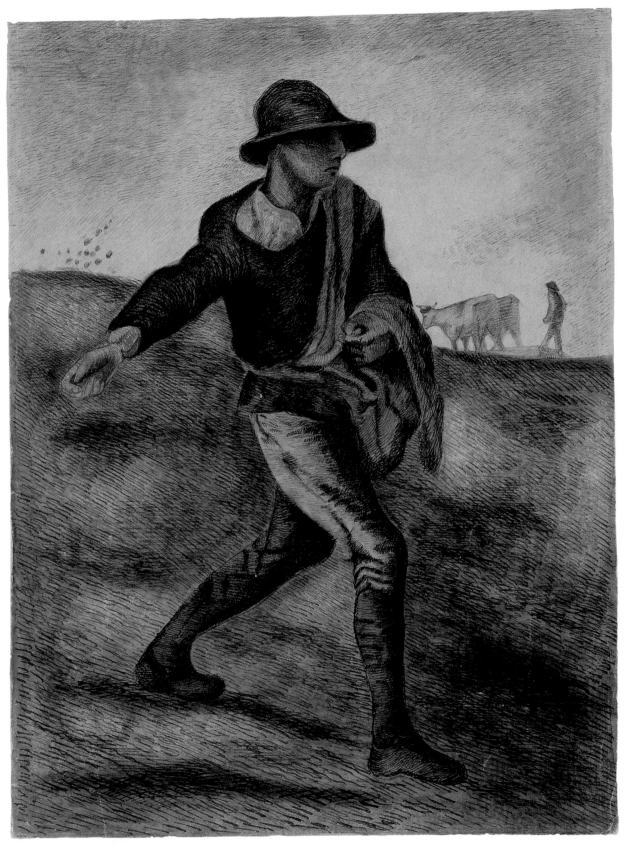

16 The sower (after Millet)

1 See letter 156/135. See Chetham 1976, passim, on these early copies by Van Gogh, and p. 19 for The sower.

2 See letter 165/144.

3 F 828 and F 829 / Hulsker 1980, pp. 10-11, fig. D. The pencil drawing F 831 was also made in the Borinage.

4 F 689 JH 1836 and F 690 JH 1837.

5 For the motif of the sower in Van Gogh's œuvre see Werness 1972, pp. 135-47; and Louis van Tilborgh, 'De zaaier,' Amsterdam 1988-89, pp. 156-59, and nos. 65-80 by the present author in the same catalogue.

6 See letter 630/B 7.

7 See, for example, Werness 1972, pp. 138-40; Osaka 1986, no. 8; and Van Uitert 1983, p. 87.

8 This letter is translated from the French.

9 Werness 1972, pp. 137-44, and Amsterdam 1988-89, nos. 18 and 68.

which only flourishes in fertile soil – does not really apply to Van Gogh's work. A pronouncement of September 1889, when he was working on the subject of the reaper in Saint-Rémy, provides an indirect clue to the sower's significance. 'For I saw in this reaper – a vague figure slaving like one possessed in the midst of the heat to get to the end of his task – I saw in him the image of death, in the sense that humanity stands for the wheat he is reaping. If you like he is the opposite of that sower that I tried earlier' [801/604].[8] The sower, who gives birth to wheat, as it were, and the reaper, who cuts it down, are thus elevated to symbols of a loftier sentiment. The sower's meaning was no different nine years earlier: his labour ushers in each new cycle of the crop's growth, fruition and harvesting, and consequently stands for life itself. Because sowing is done in the autumn months of September and October, the sower is also a traditional representative of that season, and later Van Gogh also gave him that connotation.[9]

The artist very probably ruled a grid on his model and his blank sheet of paper – which is a greyish shade with a hint of blue – in order to make the copy, although there is no longer any trace of it on the drawing. He then laid down the main lines of the composition in pencil and worked it up in detail with the pen, using numerous short lines to imitate the appearance of the etching. He gave the man's collar and left sleeve a few grey highlights and added a strip of green on the right with thinned opaque watercolour.

17 Boy with a cap and clogs

This pencil drawing of a boy, who clearly felt awkward posing for the artist (having nothing to occupy him, he does not know what to do with his hands), led a hidden existence for many decades. It was probably around 1900 that Jo van Gogh-Bonger (1862-1925), Theo's widow, gave it to Mr and Mrs Hamburger of Groningen, who were relatives of her second husband, Johan Cohen-Gosschalk (1873-1912). Although a handful of people knew of its existence it was not included in De la Faille's œuvre catalogue of 1928 and remained in obscurity. It stayed in the family until 1967, when V.W. van Gogh (1890-1978) purchased it for the Vincent van Gogh Foundation. The editorial committee of the 1970 edition of De la Faille included it as a 'supplementary drawing,' giving its possible place and date as The Hague, October 1882. Hulsker followed suit but dated it a month earlier, although without giving his reasons. In both cases the materials used were probably an important consideration in associating the sheet with the group of pencil drawings from that period.

Stylistically, though, that dating is untenable. The figure studies that quite definitely originated in September-October 1882 display a far greater control of the spatial representation of the human figure, as do sheets from several months earlier, for that matter. By comparison, this model is very flat indeed, with little feel for the modelling of dress and anatomy. There is none of the hatching that Van Gogh so often used in his Hague drawings to give volume to his figures. The boy's face and right hand are totally expressionless, and the background appears to consist of a landscape of fields done in an unconvincing perspective. In the course of 1882 Van Gogh had managed to get quite a firm grip on artistic problems of this kind, so this sketch should be dated much earlier. A small piece of further evidence for this is the tall kind of cap the boy is wearing, which was mainly found in the south of the Netherlands. The sheet probably belongs to the earliest figure studies from the Etten period, and was most likely drawn in April or June 1881.

Despite its clumsiness, the sheet does illustrate one aspect that Van Gogh felt important in his studies from the model, namely to depict people wearing their everyday clothes. In a letter of August that year he

APRIL-JUNE 1881

Pencil on wove paper
31.2 × 15.9 cm
Signed at lower right: Vincent

Inv. d 279 V/1967
SD 1681 JH 202

PROVENANCE
1890-91 T. van Gogh; 1891-c. 1900
J.G. van Gogh-Bonger; c. 1900-24
H.J. Hamburger and F.R. Ham-
burger-Cohen Gosschalk, Gronin-
gen; 1924-67 S.C. Hamburger
(later Leopold-Hamburger); 1967
bought by the Vincent van Gogh
Foundation; 1967-73 on loan to
the Stedelijk Museum, Amster-
dam; 1973 on permanent loan to
the Van Gogh Museum, Amster-
dam.

LITERATURE
De la Faille 1970, p. 575; Hulsker
1980, pp. 54, 60, no. 202; Amster-
dam 1987, p. 390, no. 2.148; De
la Faille 1992, vol. 1, p. 449, vol. 2,
pl. CCXLIV.

EXHIBITION
1968-69 London, no. 26.

complained to Theo: 'Oh what a job it is to make people understand how to pose. Peasants and townsfolk are desperately obstinate about one point from which they will not budge. They only want to pose in their Sunday best, with impossible folds in which neither knees, elbows, shoulder-blades nor any other part of the body have left their characteristic dents or bulges. Truly, that is one of the *petites misères de la vie d'un dessinateur*' [169/148]. In that respect, this boy with his clogs, cap and hand-me-down clothes with large patches at the knees was a very welcome model, which may have been why Vincent wrote an unusually neat form of his signature at lower right.

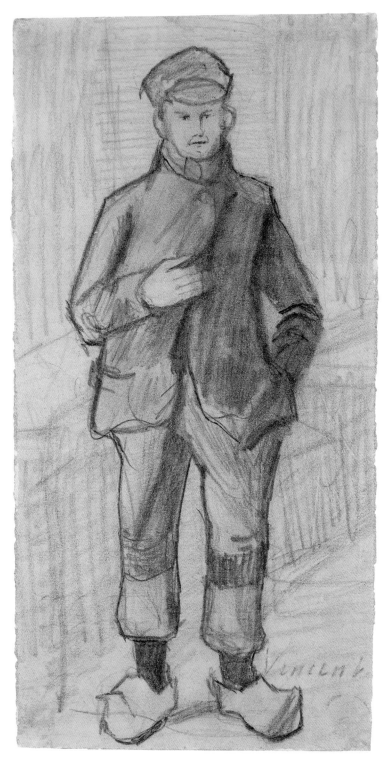

17 Boy with a cap and clogs

18 Portrait of Vincent van Gogh, the artist's grandfather

July 1881

Pencil, brush in brown ink and opaque white watercolour, brown wash, on wove paper
34.5 × 26.1 cm
Unsigned

Inv. d 1040 V/1994
F 876 JH 14

Provenance
1881-86 A.C. van Gogh-Carbentus, Nuenen-Breda; 1886-1902 Schrauwen, Breda; 1902 J.C. Couvreur, Breda; 1902-03 W. van Bakel and C. Mouwen, Breda; 1903-44 H. Tutein Nolthenius, Delft, through the Oldenzeel gallery, Rotterdam; 1947 (possibly) Mettes & Co. gallery, The Hague; 1947-c. 1953 Nieuwenhuizen Segaar gallery, The Hague; c. 1953-86 A.R.W. Nieuwenhuizen Segaar-Aarse, The Hague; 1986-94 J.W. Nieuwenhuizen Segaar, Antwerp; 1994 bought by the Vincent van Gogh Foundation; on permanent loan to the Van Gogh Museum, Amsterdam.

Literature
Bremmer 1904, no. 12, no. 92; De la Faille 1928, vol. 3, pp. 13-14, vol. 4, pl. xiv; Vanbeselaere 1937, pp. 53, 60, 407; De la Faille 1970, p. 327; Chetham 1976, p. 19; Hulsker 1980, pp. 14, 16, no. 14; Den Bosch 1987-88, p. 141, no. 9; De la Faille 1992, vol. 1, pp. 13-14, 225, vol. 2, pl. xiv; Bailey 1994, pp. 44-46; Van Heugten 1994, pp. 12-13.

The man in this profile portrait was traditionally identified as Van Gogh's father, and the drawing was included as such in De la Faille's œuvre catalogue of 1928. It was taken to be one of the copies that Van Gogh made from photographs at Etten in July 1881 in order to practise his drawing.[1] Hulsker did not believe that it was done from a photograph, since profile photographs were uncommon in the 19th century, and considered that Van Gogh had drawn his father's portrait from life.[2]

The earliest mention of the portrait is in 1903, when it was included in a commercial exhibition at the Oldenzeel gallery in Rotterdam. It was no. 85 on the sale list, and had the title *Portrait of Vincent's uncle or father*. There is a copy of that list in the Van Gogh Museum which was annotated by the critic Albert Plasschaert, who added the even vaguer 'family portrait, in profile,' together with a small sketch of the work. Plasschaert used this and other annotations in his exhibition reviews in the journals *De Kroniek* and *Onze Kunst* in November 1903.[3] And it is perfectly true, photographs show that this man with the beaky nose and thin lips has nothing in common with Van Gogh's father. Photographs of various other members of the family have been examined, and there is some likelihood, as Maureen Trappeniers suggested in 1987, that this is the artist's grandfather, who was also called Vincent van Gogh (1789-1874).[4] The features bear a close resemblance to his, as can be seen from a photograph in the Van Gogh Museum in which he is wearing the same skull-cap *(fig. 18a)*.[5] If this identification is correct, the drawing must almost certainly have been made after a profile photograph of the old man, for Van Gogh's grandfather died some years before Vincent began drawing with serious artistic aspirations. Although not common, profile portraits were occasionally made in the 19th century. This sheet is consequently regarded as one of the works done from photographs in July 1881, along with an oval portrait drawing in the Kröller-Müller Museum, which may be of Vincent's sister Willemien.[6]

Van Gogh's grandfather, like his father, was a clergyman, and he served in various places until retiring for health reasons in 1853 (when he had been working for 31 years in Breda). It is not known how he got on with his grandson, but the latter certainly did not regard the old man's letters as particularly pleasant, for when he received one from his father in

18 Portrait of Vincent van Gogh,
the artist's grandfather

EXHIBITIONS
1903 Rotterdam, no. 85; 1913 The
Hague, no. 53; 1941 Delft, no cat-
alogue; 1960 Paris, no. 75b;
1980-81 Stuttgart, unnumbered;
1987-88 Den Bosch, no. 9.

1 See letter 168/147.
2 Hulsker 1980, no. 14 and pp. 14, 16.
3 The annotated list is inv. b 3035
V/1983. It was Marije Vellekoop who
noticed the striking similarities between
the annotations and the reviews.
4 Den Bosch 1987-88, no. 9. Despite
Trappeniers's suggestion, the catalogue
listed the drawing as Portrait of
Theodorus van Gogh, Vincent's father.
When it was acquired by the museum in
1994 I adopted the identification of the
man as Van Gogh's grandfather; see Van
Heugten 1994, pp. 12-13. Jan Hulsker
reacted to this with a letter of 11 July
1994 in which he reaffirmed his stand-
point, although he was coming to believe
that the subject was not Van Gogh's
father but an unknown man. I still con-
sider the identification as Van Gogh's
grandfather to be the most plausible.
5 The Van Gogh Museum also has a
small lithograph with the silhouette of
Van Gogh's grandfather entirely in black.
Although no details can be seen he is
clearly much younger and more robust,
and has that same large, beaky nose.
6 F 849 JH 11.
7 Stokvis 1926, pp. 3-8.
8 In 1904 part of the collection was
again offered for sale at the Frederik
Muller auction rooms in Amsterdam. The
annotated sale catalogue, which is in the
Netherlands Institute for Art History
(RKD) in The Hague, suggests that the
works belonged to Mouwen. However, in
a letter from J.M. Jolles to J. Cohen
Gosschalk of 6 June 1905, it emerges that
Van Bakel was the joint owner, for this
lieutenant received a percentage of the
profits (Van Gogh Museum archives).

1874 that was 'rather cool and disagreeable' [27/20], it reminded him of the tone of his grandfather's missives. However, the fact that he copied his portrait certainly indicates that he had fonder memories as well.

The features are done in pencil only. This was also used for the background hatching, which was then lightly washed with brown (the ink in this drawing may have been darker originally). The light falls onto the man's face from the left, leaving the back of his head in shadow. The background would normally be lighter on the left than the right, but Van Gogh modified this in order to give the head a greater sense of depth. The background was left quite light on the right in order to make the dark passage of the skull-cap and shadowed neck stand out better. On the left the background is a little darker so as to contrast with the face, lending it depth. Van Gogh later used similar devices in the studies of heads he did in The Hague. Down the entire left side there is a strip approximately 0.5 cm wide that was left bare for some reason. The skull-cap and jacket have a brown wash, and the hair and side-whiskers are heightened with white, as are parts of the clothing.

18a Photograph of Vincent's grandfather,
c. 1870. Amsterdam, Van Gogh Museum.

The portrait of Van Gogh's grandfather is one of the works, along with the drawings discussed under catalogue numbers 66-68, that the artist must have left with his mother in Nuenen in 1885. When she moved to Breda a year later, she gave several crates containing Vincent's work (the merits of which she was unable to appreciate) to a carpenter in Breda called Schrauwen. Fifteen years later, probably unaware of the rising value of Van Gogh's œuvre, he sold the drawings and paintings to J.C. Couvreur (1877-1961), a second-hand dealer.[7] He in turn sold them to C. Mouwen and W. van Bakel of Breda,[8] who offered them for sale at the 1903 exhibition in the Oldenzeel gallery mentioned earlier. One of the sheets was this portrait of Van Gogh's grandfather, which was then acquired by the Delft collector Hugo Tutein Nolthenius (1863-1944), who was following H.P. Bremmer's courses in art appreciation at the time, as his parents had done. Encouraged by this Dutch champion of art, Tutein Nolthenius went on to acquire no fewer than five drawings and seven paintings by Van Gogh, including the *Self-portrait* of 1889, which is now in the Whitney Collection.[9] In 1947 this portrait of Van Gogh's grandfather came into the possession of the Hague art dealer G.J. Nieuwenhuizen Segaar and his wife.[10] The Vincent van Gogh Foundation acquired it from their heirs in 1994.

9 Tutein Nolthenius's collection also included F 59 JH 921, F 78 JH 734, F 132 JH 574, F 198 JH 1125, F 262 JH 1102, F 624 JH 1778, F 626 JH 1770, F 846 JH 8, F 852 JH 275, F 1085 (no JH no.) and F 1094 JH 398.

10 In a letter to the museum of 21 March 1994, Jan Nieuwenhuizen Segaar stated that his father bought an unspecified Van Gogh on 25 August 1947 from a gallery called 'Meltes' or 'Metles' on Noordeinde in The Hague, and that it had formerly belonged to Tutein Nolthenius. The actual name of the gallery is Mettes & Co., which was indeed on Noordeinde, but it is not possible to say whether this sheet was the work in question.

19 Man with a sack of wood

Autumn 1881

Black chalk, pencil, on laid paper
61.1 × 41.9 cm
Watermark: ED & Cie [in a cartouche] PL BAS
Unsigned

Inv. d 383 M/1971
F 895 JH 21

Provenance
J. Hageraats gallery, The Hague;
before 1928-56 H.P. Bremmer,
The Hague; 1956-c. 1965 H. Bremmer, Eindhoven-Zeist; 1971 bought
by the Van Gogh Museum with
the aid of the Vincent van Gogh
Foundation and the Vereniging
Rembrandt, London (Sotheby's),
8 July, no. 35; 1971-73 on loan to
the Stedelijk Museum, Amsterdam; 1973 on permanent loan to
the Van Gogh Museum, Amsterdam.

Literature
De la Faille 1928, vol. 3, p. 17,
vol. 4, pl. xvii; Vanbeselaere
1937, pp. 57, 67, 408; De la Faille
1970, p. 331; Jampoller 1971, pp.
13-14; Meijer 1971, pp. 40-41;
Hulsker 1980, pp. 17-18, no. 21;
Amsterdam 1987, p. 387, no.
2.130; De la Faille 1992, vol. 1,
pp. 17, 229, vol. 2, pl. xvii.

Exhibition
1960-61 Eindhoven & Schiedam,
no. 143; 1983-84 Amsterdam, no
catalogue.

This *Man with a sack of wood* is one of the remarkably large figure drawings that Van Gogh made at Etten, some 30 of which have survived. The size was dictated by the exercises he embarked on at the beginning of his career: repeatedly copying the drawing examples in Charles Bargue's *Exercices au fusain*, which were roughly the same size as these sheets. Once accustomed to working on such a large scale he continued doing so. He explained the attractions to Theo in December 1883. 'In general, for my own study, I definitely need the figure with rather large proportions, so that the head, hands and feet do not come out too small, and so that one can draw them firmly. So for my own practice I settled on the size of Bargue's *Exercices au fusain* as a guide, because it is one that can be taken in at a glance without the details becoming too small' [292/250].

The man is shown squarely from the side, a rather drab view that Van Gogh used in around 15 of his model studies from this period. Its major advantage for a novice artist, as Van Gogh was at this time, is that it makes it quite easy to capture a model properly, since there is none of the troublesome foreshortening of limbs and body that arises when drawing a figure diagonally from the front. For this, Van Gogh was prepared to put up with the lack of vitality. The flatness of the figure, a common feature of so many of the Etten drawings, also betrays his inexperience. The stick that the man is gripping with his left hand originally pointed downward far too much, as can be seen in the first effort, which is still clearly visible, but Van Gogh then corrected the angle. Great care was lavished on the details, such as the man's head with the large, hooked nose and the slightly receding chin. Although he bears some resemblance to the Etten *Digger* in the Van Gogh Museum *(cat. 21)*, the man cannot be convincingly identified in any other drawing.

This is an autumnal or winter subject, for the man is carrying a sack of firewood on his back. This kind of wood – branches, twigs and even fir-cones – was both cut and gathered as brushwood. The Brabant name for it was 'geriefhout' (convenience wood), and it was also used for repairing tools. Its main purpose, though, was to keep the stove burning. Large branches were chopped into smaller pieces on a wooden block that stood by the stove. Van Gogh made a drawing of that activity at the same time

19 Man with a sack of wood

1 In letter 36/29 he describes visiting
the exhibition in almost sacral terms.
The relevant drawings shown at the Hôtel
Drouot were nos. 117 and 127. See Murphy
1984, cats. 16 and 57.
2 F 1297v JH 795.

as this sheet *(fig. 19a)*. The cleaver that the man is using in that drawing, called a 'hiep' or a 'sligtmes' in Dutch, is identical to the one seen here. Van Gogh left for The Hague in December 1881, so the drawing can be dated to the autumn of that year.

Van Gogh knew the subject of carrying faggots from the work of Millet, who several times depicted people, mostly women, returning home with large bundles of brushwood on their backs. Van Gogh had seen a couple of those drawings at a large commercial exhibition of Millet's drawings at the Hôtel Drouot in Paris in 1875, when he was working in an art gallery there.[1] It is conceivable that he had them in mind when he took up the subject himself, although this man, who is not exactly bowed down by his burden, has little in common with the drudgery of Millet's bent figures.

Van Gogh used this subject of rural labour as a symbol of winter in a series of paintings of the four seasons, which he made in 1884 *(fig. 19b)*. That was the only time he returned to the motif, apart from a small sketch in a sheet of studies from the Nuenen period.[2]

The drawing is executed in two kinds of black chalk: a deep black variant for the lines and a slightly softer, brownish sort that was used both for lines and for filling in the surfaces. The shadows below the peak of the cap and the index finger of the hand holding the stick are reinforced in pencil.

The Hague art dealer Hageraats, who was already buying and selling Van Goghs at the end of the 19th century, was the first owner of this sheet, although it is not known where or when he acquired it. The next owner, as far as is known, was H.P. Bremmer (1871-1956). After his death in 1956 the drawing passed to his son Henk, who disposed of it around 1965. The Van Gogh Museum bought the *Man with a sack of wood* at auction in 1971.

19ª *Peasant with a cleaver* (F 894
JH 20), 1881. Whereabouts unknown.

20 Donkey and cart

This is one of the few works in Van Gogh's œuvre to focus on an animal. Nevertheless it is known that he had far greater ambitions to depict horses than could be guessed from all his drawings and paintings put together (see *cat. 66*).

Van Gogh decided to study animals early on in his career, as an extension of his desire to depict workers and peasants in their everyday settings.[1] Animals played a vital part in rural life, as Van Gogh well knew, having grown up in the countryside of Brabant. In 1880, while staying in Brussels, he drew up his own, almost academic programme for studying every facet of the human body. That, however, was not enough, as he told Theo: 'I intend to get pictures from the veterinary school of the anatomy of, for instance, a horse, a cow and a sheep, and to draw them the way I did the anatomy of the human body. There are laws of proportion, of light and shadow, of perspective, which one *must know* in order to be able to draw properly; without that knowledge it always remains une lutte stérile [a fruitless struggle], and one never gives birth to anything' [159/138]. Again prompted by his study of human anatomy he asked Theo a little later for 'something on the anatomy of the horse, the sheep and the cow – not from the veterinary point of view but rather in connection with drawing those animals' [163/142]. If anything ever came of these specific wishes, the results have been lost. The first substantial animal in his œuvre is the donkey harnessed to a cart in this sheet from the Etten period.

Van Gogh made rapid progress in his study of people and animals in Etten: 'I count myself very lucky to get models. I am also muddling along with a horse and a donkey' [173/151]. When it was discovered in 1960 it was thought that the *Donkey and cart* was the result of this 'muddling along.'[2] This provided a date that was followed in all subsequent publications, as it is here. However, it is not impossible that the *Donkey and cart* was drawn a bit earlier than that, for in May 1881 Van Gogh wrote that if the weather permitted he made studies out of doors, 'quite large ones, like the few you saw at the time of your visit. [...] I also try to draw the equipment, such as a wagon, plough, harrow, wheelbarrow, etc., etc.' [166/145]. What is particularly striking is how precise Van Gogh was in recording how the donkey was harnessed to the cart, which is of a type known as a high-cart.

OCTOBER 1881

Pencil, charcoal, black chalk, opaque white watercolour, on laid paper
41.5 × 60.1 cm
Watermark: ED & Cie [in a cartouche] PL BAS
No longer signed

Inv. d 382 V/1964
SD 1677 JH 52

PROVENANCE
1890-91 T. van Gogh; 1891-92 J.G. van Gogh-Bonger; 1892-before 1960 W.M.D. van der Linden (from 1898 W.M.D. Spies-van der Linden), bought from the Oldenzeel gallery, Rotterdam; before 1960-63 P. Spies; 1963-64 M. Spies, Eindhoven; 1964 bought by the Vincent van Gogh Foundation; 1964-73 on loan to the Stedelijk Museum, Amsterdam; 1973 on permanent loan to the Van Gogh Museum, Amsterdam.

LITERATURE
Gans 1961, pp. 33-34; De la Faille 1970, pp. 574-75; Hulsker 1980, pp. 22-23, no. 52; Amsterdam 1987, p. 387, no. 2.129; De la Faille 1992, vol. 1, pp. 447-48, vol. 2, pl. CCXLVI.

EXHIBITIONS
1892 Rotterdam, no catalogue; 1966 Paris & Albi, no. 2a; 1967 Lille & Zürich, no. 3; 1967-68 Dallas, Philadelphia, Toledo & Ottawa, no. 3; 1968 Liège, no. 3; 1968-69 London, no. 4; 1971-72 Paris, no. 115; 1975 Malmö, no. 2; 1976 Stockholm, no. 2; 1983-84 Amsterdam, no catalogue.

1 *Horses hitched to carriages, as in Van Gogh's work from Saint-Rémy and Auvers, are therefore disregarded here.*
2 *The 1960 opinion was published in Gans 1961, pp. 33-34.*
3 *F 38 JH 504 and F 39 JH 505.*
4 *The sketch is F 1144 JH 511. Winter was eventually represented in the series by Wood-gatherers in the snow (F 43 JH 516). For the series see Amsterdam 1988-89, no. 18.*
5 *This was pointed out by Marije Vellekoop.*
6 *The other sheet is SD 1674 JH 2.*
7 *Letter of 27 January 1960 from P. Spies to the Expertise Institute in Amsterdam (Van Gogh Museum archives).*
8 *Gans, op. cit. (note 2).*

Whatever his reasons, it seems that Van Gogh managed to combine his need to study both animals and farm equipment in this drawing. The subject of the donkey-cart, or rather horse-drawn cart, recurs in The Hague, but now in an urban setting *(cat. 66, fig. 66a)*. In Nuenen he was to depict a similar subject in two paintings. There, though, the cart is drawn not by a donkey or a horse but by an ox.[3]

The motif never recurred in Van Gogh's œuvre on a large scale. He did use it in Arles as part of the staffage in *The harvest*, which features two horse-drawn carts as well as one without a horse in the very centre of the composition.[4] The purpose of Van Gogh's early efforts was not just to study subjects as independent motifs but to incorporate them in complex compositions of this kind.

The donkey in this Etten variant is peacefully eating, which must have provided Van Gogh with a welcome opportunity to examine the subject. The *Donkey and cart* belongs with the large Etten studies on laid paper measuring some 61 × 47 cm. This sheet is a little smaller because it has been trimmed on all sides. The drawing is largely executed in charcoal reinforced with black chalk. Pencil was used in the hut in the left background, and the whole scene was finally heightened and washed with white. Van Gogh probably took the sheet with him to The Hague and used it in his watercolour of the Enthoven iron-rolling mill *(fig. 20a)*, which has a very similar donkey and cart on the far right.[5]

This drawing only came to light at s fairly late date. It and another sheet were bought from Jo van Gogh-Bonger through the Oldenzeel gallery in Rotterdam by Mrs W.M.D. Spies-van der Linden in 1892.[6] In 1898 the Spies family moved to Transvaal in South Africa. They returned to Holland the following year on the outbreak of the Boer War, and it was during the move that the edges of the sheet were trimmed off, removing the signature, as stated in a letter from P. Spies.[7] The drawing was attributed to Van Gogh in 1960 by the Expertise Institute in Amsterdam and published in 1961, when it was rightly assigned to the Etten period.[8] It was acquired for the collection of the Vincent van Gogh Foundation in 1964.

20ᵃ *Enthoven iron-rolling mill,* The Hague (F 926 JH 166), 1882 (detail). Whereabouts unknown.

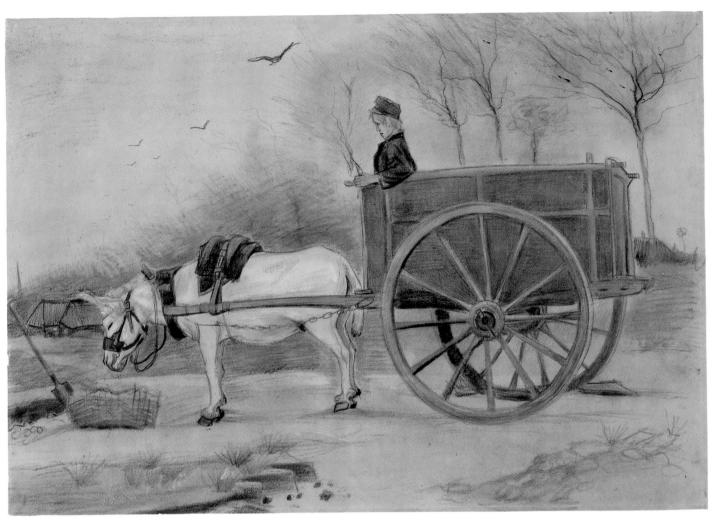

20 Donkey and cart

21 Digger

OCTOBER 1881

Charcoal, black and green chalk,
transparent and opaque water-
colour, on laid paper
62.2 × 46.8 cm
Watermark: ED & Cie [in a car-
touche] PL BAS
Signed at lower left: Vincent

Inv. d 444 V/1962
F 866 JH 54

PROVENANCE
1890-91 T. van Gogh; 1891-1925
J.G. van Gogh-Bonger; 1925-62
V.W. van Gogh; 1962 Vincent
van Gogh Foundation; 1962-73
on loan to the Stedelijk
Museum, Amsterdam; 1973 on
permanent loan to the Van
Gogh Museum, Amsterdam.

LETTER
173/151

LITERATURE
De la Faille 1928, vol. 3, p. 11,
vol. 4, pl. x; Vanbeselaere 1937,
pp. 55, 67, 407; De la Faille
1970, pp. 324-25; Hulsker 1980,
pp. 22-24, no. 54; Amsterdam
1987, pp. 114-15, 387, no. 2.127;
De la Faille 1992, vol. 1, pp. 11,
222, vol. 2, pl. x.

This is one of the five drawings of diggers that Van Gogh made in Etten. It is a motif that recurs dozens of times in his later work, either as the main subject or as a detail.[1] The first time it appears is in the form of two copies after Millet's *Diggers* of 1880-81 *(fig. 21a)*. The Etten sheets are the first independent scenes of this rural activity.

A digger, for Van Gogh, was the absolute embodiment of the harshness of life on the land. The backbreaking work of digging a field was only done by agricultural workers who were unable to afford a plough and a draught animal, and although Van Gogh felt compassion for the wretched life that peasants led, it was precisely this kind of archaic activity that so attracted him. He associated the digger with the words in the Bible: 'In the sweat of thy face shalt thou eat bread' (Genesis 3:19) which, he felt, applied to his own life as well.[2]

This toiling digger was drawn in October 1881, judging by a sketch of the scene that Van Gogh sent his brother that month *(fig. 21b)*. The draughtsmanship owes a great deal to the advice that Van Gogh had received from Anton Mauve (1838-1888) when he paid a brief visit to the artist, who was his cousin by marriage, in The Hague, in the summer of that year (see also *cat. 22*). He had shown Mauve his most recent work, which consisted of pen drawings after Charles Bargue's *Exercices au fusain.*[3] Mauve had said: 'Now you must try it with charcoal and chalk and brush and stump' (198/169), which Van Gogh did on his return to Etten – at first with disappointing results but before long with more success.[4] All those materials were used for this *Digger*: charcoal, black and green chalk, green, blue and brownish-red transparent watercolour, and blue, green and opaque orange-brown watercolour, and in many places Van Gogh indeed stumped the chalk and the charcoal.

The man's face is not sufficiently recognisable for him to be identified with other figures from the Etten œuvre. At most, the profile with the slightly bent nose is vaguely reminiscent of the features of the *Man with a sack of wood (cat. 19)*.

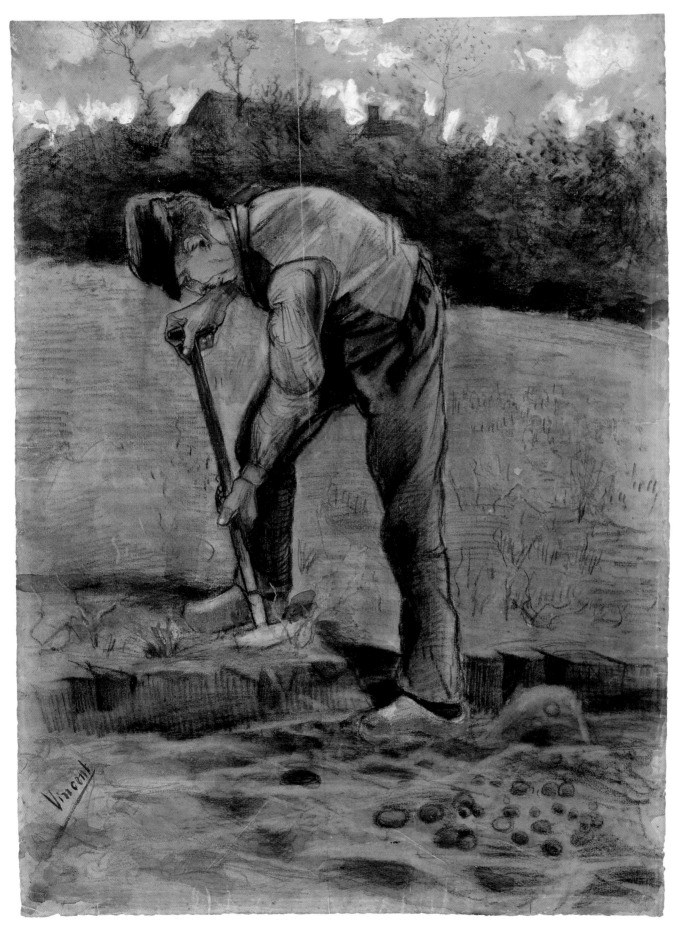

21 Digger

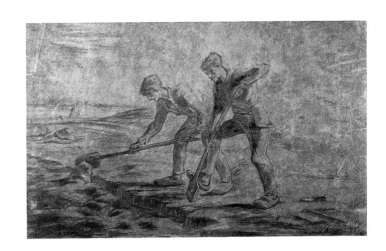

21ᵃ *The diggers (after Millet)* (F 829),
1880-81. Otterlo, Kröller-Müller Museum.

1 *An inventory of the diggers in Van
Gogh's work and an explanation of the
importance of the motif is given by
Tsukasa Kōdera 1990, pp. 67-78, and
Appendix 1, table 3 on p. 136.*
2 *Ibidem. Kōdera goes a step further, say-
ing that Van Gogh wished to express the
difficulties of his own life in works of this
kind, but it is to be doubted whether that
applied to his early Dutch work.*
3 *Van Gogh describes his visit in letter
170/149, where he says that he took his
copies after the Exercices with him. He
raised the subject again in January 1882,
stating that he had shown Mauve pen
drawings [198/169].*
4.*See also letter 172/R 1, in which Van
Gogh reports to Van Rappard on his use
of these drawing materials, which were
new to him.*

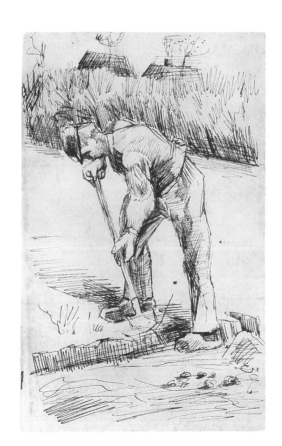

21ᵇ Sketch in a letter to Theo of
c. 12 October 1881 (173/151).
Amsterdam, Van Gogh Museum.

22 Scheveningen woman

In the summer of 1881, while spending a few days in The Hague, Van Gogh
called on the painter Anton Mauve, who was a cousin of his by marriage.
The meeting made a great impression on Van Gogh, and later that year
he asked Mauve if he could come and spend a month or so taking lessons
from him.[1] He arrived towards the end of November and took lodgings
near Uilebomen (now the Zuid-Oost-Buitensingel), where Mauve lived.[2]
He stayed for a little over three weeks, and it is clear from the enthusiastic
reports in his letters that the budding artist found it an extremely instruc-
tive, pleasant and, as far as his artistic ambitions were concerned, encour-
aging apprenticeship.

Mauve gave his pupil every opportunity to try out different techniques.
Van Gogh painted in the daytime and drew with various materials in the
evening.[3] Painting was new to him, and in his drawings he had only occa-
sionally worked with colours, generally combining watercolour or gouache
with other materials that had nothing to do with the preparatory drawing.
Mauve was a talented watercolourist, and for the first time Vincent was
able to explore the possibilities of the medium. Three weeks after his
arrival he reported to Theo on his progress. In addition to five painted
studies he had made 'two watercolours and, of course, a few more rough
sketches' [190/163]. He enclosed the latter so as to give Theo a better idea of
his efforts. They were of two painted still lifes,[4] and three figure studies
(which still exist) of the same model (figs. 22a, 22b). Two of those sheets
are large, measuring approximately 50 × 35 cm, and given their high degree
of finish these must be the two watercolours mentioned in the letter.[5] The
third sheet, the drawing in the Van Gogh Museum discussed here, is very
much smaller and is evidently one of the 'rough sketches' mentioned in
the letter, the signature notwithstanding. The woman is clearly engaged
in some handicraft, but it is not clear precisely what she is doing.

Van Gogh later sent one of the watercolours to a doctor, G.A. Molenaar,
as a token of thanks for treating him for gonorrhea in June and July 1882.[6]
He told Theo that he had picked out his best watercolour, which had the
added cachet that 'Mauve had put in some touches and had come across
several times while I was working on it and called my attention to some
details' [246/214]. It seems from this that Mauve had little or nothing to do

NOVEMBER-DECEMBER 1881

Pencil, transparent watercolour,
on watercolour paper
23.4 × 9.8 cm
Signed at lower left: Vincent

Inv. d 276 V/1962
F 871 JH 85

PROVENANCE
1890-91 T. van Gogh; 1891-1925
J.G. van Gogh-Bonger; 1925-69
V.W. van Gogh; 1962 Vincent van
Gogh Foundation; 1962-69 with
V.W. van Gogh, Laren; 1969-73
on loan to the Stedelijk Museum,
Amsterdam; 1973 on permanent
loan to the Van Gogh Museum,
Amsterdam.

LETTER
190/163

LITERATURE
De la Faille 1928, vol. 3, p. 12,
vol. 4, pl. XIV; Vanbeselaere 1937,
pp. 57, 407; De la Faille 1970,
pp. 326-27; Hulsker 1980, pp. 26,
29, no. 85; Amsterdam 1987,
p. 387, no. 2.131; De la Faille
1992, vol. 1, pp. 12, 223, vol. 2,
pl. XIV.

EXHIBITIONS
1953 Zürich, no. 4; 1975 Malmö,
no. 3; 1976 Stockholm, no. 3.

1 Letter 189/162.
2 Ibidem. The street now called
Uilebomen used to be known as Zuid-
Oost-Binnensingel. See Van der
Mast / Dumas 1990, p. 178, note 7.
3 Letter 190/163.
4 F1 JH 81, in the Van Gogh Museum,
and a now unknown still life with a
sculpture and a piece of canvas or paper.
5 F 896 JH 83 and F 870 JH 84.
6 F 870 JH 84.
7 Cassagne 1875, pp. 128-31, 263-66,
273-75; see the Introduction.

with the other two watercolours. In the sketch, at any rate, there is no compelling evidence of two hands at work.

Van Gogh followed Mauve's example closely and made true watercolours, using transparent watercolour and little or no opaque paint. He was just starting out as an artist and had never done this before, usually mixing gouache and watercolour with other techniques. He did go on to make other drawings with transparent watercolour, but the later ones are usually in gouache, often heavily thinned. It was a technique that he had picked up from Cassagne's *Traité d'aquarelle*, the so-called *aquarelle gouachée*, which was described as being reserved for the very best artists.[7] Although Van Gogh was still far from that, he was delighted with his recent discovery of the technique: 'How marvellous watercolour is for expressing space and airiness, allowing the figure to sit in the atmosphere and life to enter it' [190/163].

22a Sketches in a letter to Theo of
c. 18 December 1881 (190/163).
Amsterdam, Van Gogh Museum.

22b Sketches in a letter to Theo of
c. 18 December 1881 (190/163).
Amsterdam, Van Gogh Museum.

22 Scheveningen woman

23 Old woman with a shawl and a walking-stick

MARCH 1882

Pencil, pen in brown (originally
black) ink, opaque light green
watercolour, on wove paper
57.4 × 32.0 cm
Signed at lower left: Vincent

Inv. d 174 V/1967
F 913 JH 109

LETTERS
207/178, 221/195.

LITERATURE
Van Gogh 1905, no. 4; Steenhoff
1905, p. 5; De la Faille 1928, vol.
3, p. 21, vol. 4, pl. XXI; Vanbese-
laere 1937, pp. 79, 137, 408; Meijer
1968, pp. 217-19; De la Faille 1970,
pp. 338, 341; Op de Coul 1975,
pp. 28-30; Op de Coul 1976, pp. 65-
69; Hulsker 1980, pp. 34-35, 38,
no. 109; Amsterdam 1987, p. 388,
no. 2.132; Van der Mast / Dumas
1990, p. 48; De la Faille 1992,
vol. 1, pp. 21, 233, vol. 2, pl. XXI.

Van Gogh saw this old woman with a shawl over her head shuffling along with a walking-stick on one of his forays into the back streets of The Hague. He had just got to know George Hendrik Breitner (1857-1923), who was four years his junior, and occasionally the two of them went out on drawing expeditions. At the beginning of March 1882 he told Theo that they had been working together the previous day in the Geest, a neighbourhood which Van Gogh often visited to sketch the people there, 'so as to study them afterwards in the studio with a model. In this way I made a drawing of an old woman I saw on the Geest, something like this' [207/178] *(fig. 23a)*. Van Gogh was referring to the sketch in the letter. The sheet in the museum is definitely not the drawing made on the spot but the later model study that Van Gogh spoke of in his letter.

He must have been quite pleased with this figure seen obliquely from the back. He signed it (which is rather unusual for a study of a model without any indication of the setting), and put a pencilled border around it. The importance that Van Gogh attached to this drawing is shown by the fact that he used the woman in two composite drawings *(fig. 23b)*.[1] Like the other figures in those works, she was added to the scene on the basis of the studies that Van Gogh had in stock, which resulted in a crowded and over-contrived composition in the case of figure 23b. It is not clear whether the model for that sheet was the large drawing in the Van Gogh Museum or the location sketch, which is no longer known.

It seems from Van Gogh's drawing of the Pawn Bank *(cat. 24)* that he drew the model in various poses during the session. In the *Pawn Bank* the woman is on the point of passing through the gateway to the bank, but she is reversed left for right compared to this drawing. That version must have been based on another studio study of her in that particular pose. In a letter of May 1882 Van Gogh told Theo of several works that he considered suitable for selling, and they included this drawing.[2]

This drawing was first executed in pencil. Van Gogh then made the dark passage in the skirt more intense with pen and black ink, which has now turned brown. Finally, he gave the figure a background in light green, opaque watercolour, which he deliberately diluted so much that it is semi-transparent. As a result, the pencil lines which he drew in order

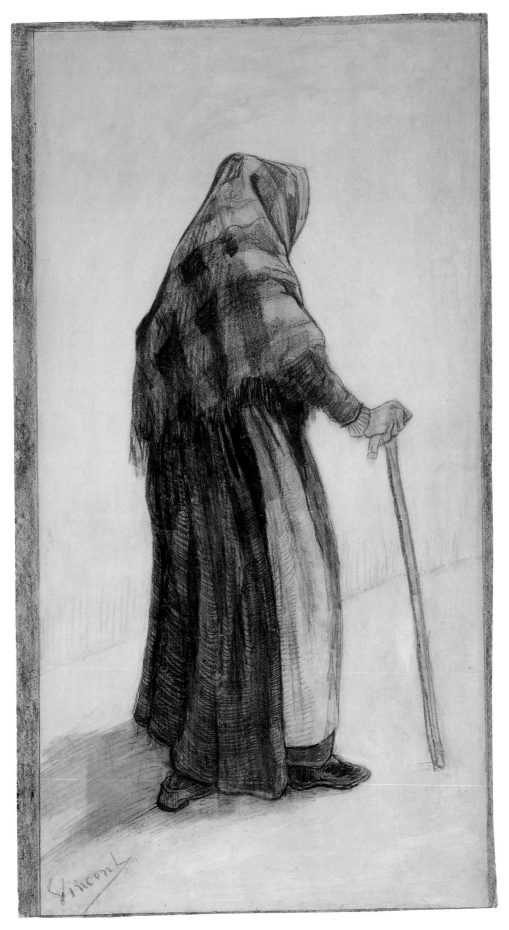

23 Old woman with a shawl and
a walking-stick

EXHIBITIONS
1904 Rotterdam, no. 59; 1914-15
Amsterdam, no. 38?; 1968-69
London, no. 6; 1975 Malmö, no. 4;
1976 Stockholm, no. 4; 1976 Oslo,
no catalogue; 1976-77 Tokyo, Kyoto
& Nagoya, no. 4; 1983-84 Amster-
dam, no catalogue; 1990 Otterlo,
no. 16.

1 *The sheet not illustrated is F 914
JH 112.*

2 *Letter 221/195.*

3 *For Daamen see a memorandum writ-
ten by V.W. van Gogh in December 1967
(Van Gogh Museum archives), and
Commissie voor het verzamelen van
de bouwstoffen voor de geschiedenis
van de boekhandel te 's-Gravenhage
[1967], typescript in the library of the
Hague City Archives.*

to suggest a wall on the left are still visible. There is no watercolour over the woman's shadow. The scene is framed in a pencilled border of varying thickness.

The sheet was bought in 1904 from the Oldenzeel gallery in Rotterdam by D.A. Daamen (1864-1941), the publisher and managing director of the newspaper *Antirevolutionaire Dagblad De Nederlander*.[3] The Vincent van Gogh Foundation bought the drawing from D.K. Daamen-Richardson, the widow of Daamen's son, in 1967.

23a Sketch in a letter to Theo of
3 March 1882 (207/178). Amsterdam,
Van Gogh Museum.

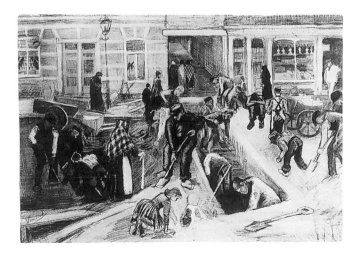

23b *Road works in Noordstraat,
The Hague* (F 930a JH 131), 1882.
Berlin, Nationalgalerie.

24 The entrance to the Pawn Bank, The Hague

This lively little scene is set outside the Pawn Bank in The Hague. The bank had been situated in Westeinde since 1826, but the entrance, shown in this drawing, was at the back in Korte Lombardstraat, where a gateway gave onto a square leading to another gateway, seen here in the background, which was the actual entrance. The bank, where people could borrow money against their personal possessions, was under municipal supervision, and was founded in 1673 in order to prevent private pawnshops (which still existed in Van Gogh's day) making exorbitant profits.[1]

This drawing is one of the three townscapes *(cats. 23-25)* in the museum's collection that come from a series of 12 that Van Gogh made in March 1882 for his uncle Cor, the art dealer Cornelis Marinus van Gogh (1824-1908). Uncle Cor, sometimes referred to as 'C.M.' by Vincent and Theo, had come to visit Van Gogh in his studio. When their conversation was on the point of taking an awkward turn, Van Gogh changed the subject by getting out his portfolio of small sketches and studies and showing it to his uncle. The latter's interest was aroused by a sketch of a small Hague street called Paddemoes, and he placed an order for 12 such townscapes. Vincent told him that the price would be 2$\frac{1}{2}$ guilders for each drawing, 'either in pencil or pen' [210/181]. When asked if that was unreasonable his uncle replied that it was not, adding 'if they turn out well I will ask you to make 12 more of Amsterdam, provided you let me fix the price myself, for that way you will get a little more for them' [210/181]. A fortnight later Van Gogh told his brother that the drawings were finished and had already been sent off, and in his next letter that their uncle had paid him and placed a new order for six more detailed townscapes of The Hague, but this time with views that were more typical of the city.[2] He completed that second batch, of seven not six drawings, by the end of May and sent it off to his uncle.[3] The Van Gogh Museum has none of the drawings from this second series.

It is not really possible to identify the sheets in the first series of 12 from Van Gogh's correspondence, for it contains only the briefest descriptions relating to the commission.[4] In 1969, however, an annotated sale catalogue of 1902 was discovered that listed 11 townscapes by Van Gogh from the collection of C.M. van Gogh, giving the titles, techniques

MARCH 1882

Pencil, pen and brush in brown (originally black) ink, opaque white watercolour, grey wash, on laid paper
Traces of squaring
23.9 × 33.7 cm
Watermark: illegible traces along the top edge
Signed at lower left: Vincent
Annotated on the verso in another hand: Ingang bank van Leening

Inv. d 374 V/1975
F – JH 126

PROVENANCE
1882 C.M. van Gogh, Amsterdam; 1902 The Hague (M. Nijhoff / R.W.P. de Vries), 13-15 May, no. 434 (unsold); after 1902 C. 't Lam; until 1975 A. 't Lam; 1975 C. 't Lam, Rijswijk; 1975 bought by the Vincent van Gogh Foundation; on permanent loan to the Van Gogh Museum, Amsterdam.

LITERATURE
Meijer 1968, p. 219; Op de Coul 1975, pp. 28-30; Hulsker 1976, pp. 18-19; Op de Coul 1976, pp. 65-69; Hulsker 1980, pp. 36-38, no. 126; Amsterdam 1980-81, pp. 39-58, 61, 152, no. 69; Op de Coul 1983, p. 199; Pollock 1983, p. 335; Amsterdam 1987, p. 388, no. 2.134; Dorn 1987, pp. 65-67; Van der Mast / Dumas 1990, pp. 49-51, 53, 170-73; De la Faille 1992, vol. 1, p. 448, no. 1679a, vol. 2, pl. CCXLIV.

EXHIBITIONS
1900-01 Rotterdam, no. 68;
1980-81 Amsterdam, no. 69;
1982 Amsterdam, no catalogue;
1983-84 Amsterdam, no cata-
logue; 1990 Otterlo, no. 22.

1 See Van der Mast / Dumas 1990, p. 53.
Information about the Hague Pawn
Bank has also been taken from the survey
of the bank's archives, no. 405, by J.M.
Coekingh in the Hague City Archives.
2 Letters 212/183 and 213/184. In the lat-
ter Van Gogh mentions the new commis-
sion: 'six special detailed views of the
town.' The word 'special' can hardly be
read as meaning anything but 'typical.'
It is possible that C.M. van Gogh had
been critical of the trivial subjects chosen
for the preceding 12 drawings.
3 Letter 231/R 8.
4 For the two series and the associated
quotations see Van der Mast / Dumas
1990, Appendix 1 on pp. 170-73. See also
the following note.
5 It was the sale held by the R.W.P. de
Vries auction house in the Hague
Kunstkring on 13-15 May 1902, nos. 433-
43. See, respectively, Op de Coul 1969,
Hulsker 1976 and Van der Mast / Dumas
1990, loc. cit. (note 4). It was Op de
Coul who discovered the annotated sale
catalogue containing works from C.M.
van Gogh's collection. Van der
Mast / Dumas combined that data with
references to the works in Van Gogh's let-
ters and with works from C.M. van
Gogh's collection mentioned in the exhib.
cat. Rotterdam 1900-01. They arrived at
the following composition of the first
series: F 914 JH 112, F 917 JH 115, F 918
JH 111, F 919 JH 123, F 920 JH 113, F 921
JH 116, F 922 JH 114, F 922a JH 119,
F 924 JH 118, F 925 JH 117, F SD 1697
JH 121 and JH 126 (no F number).

and dimensions. Using this as a source, a provisional itemisation of the first batch was proposed in 1976. A definitive list was made in 1990 with the aid of additional documentation.[5] Further evidence, if any is needed, is provided by the titles written in a distinctive, bold hand on the backs of at least nine of the sheets. The one discussed here has the words 'Ingang bank van Leening' *(fig. 24a)*. Although the titles are not in the writing of C.M. van Gogh, the works with these annotations (at least one from the series of seven has a similar inscription) have no other common denominator than their presence in his collection.[6] It seems that the titles were translated into French for the 1902 sale, complete with any errors (see *cat. 25*).[7] It is possible that the inscriptions were written by one of C.M. van Gogh's assistants, or were added on the occasion of the auction.

Most of these small townscapes have a pencilled grid, which points to the use of a perspective frame. This ranks them among the earliest of Van Gogh's works to be drawn in this way.[8] He later explained the artistic importance of the drawings in the second series. 'I can only conceive of such drawings as studies in perspective, and I am doing them mainly for practice. Even if he does not take them I shall not regret the trouble they gave me, because I should like to keep them myself and because I practised the elements which so much depends upon: perspective and proportion' [229/200].

There is little reason to think that the 12 earlier studies were anything other than similar technical exercises. A critical look at the perspective of *The entrance to the Pawn Bank, The Hague* makes it abundantly clear that Van Gogh still had quite a lot to learn. The architecture is fairly suc-

24a Verso of cat. 24.

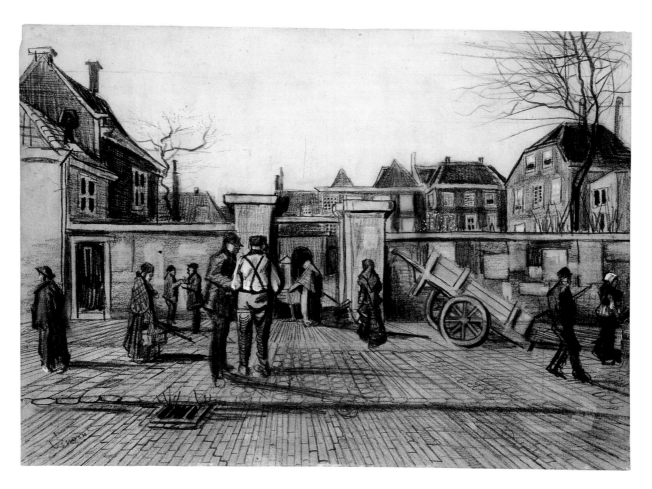

24 The entrance to the Pawn Bank,
The Hague

6 *Apart from the sheet discussed here, there are inscriptions in this hand on the backs of F 914 JH 112, F 917 JH 115, F 919 JH 123, F 920 JH 113, F 921 JH 116, F 924 JH 118, F 925 JH 117 and SD 1697 JH 121. F 918 JH 111 is in a mount, so if there is an inscription it cannot be seen. Oddly enough, an inscription is missing on F 922a JH 119, but there is no other work that matches the description of the scene and technique, no. 442 in the 1902 sale catalogue (see note 5). It is not known whether F 922 JH 114 has a similar annotation. The verso of F 923 JH 125 from the second series has a title in the same hand.*

7 *The Entrance to the Pawn Bank, The Hague is no. 434 in that catalogue, where it is given the French title* Entrée du Mont de piété à La Haye.

8 *See the Introduction. The grid could not be detected for sure in F 918 JH 111, which is too heavily worked with pen and ink, nor could it be found in F 919 JH 123. I do not know whether traces of a grid can be seen in F 922 JH 114 and F 922a JH 119.*

9 *Amsterdam 1980-81, pp. 39-58; the quotation is on p. 50.*

10 *Most of the works do have a staffage of figures, although in F 925 JH 117, F 922a JH 119 and SD 1679 they are of very minor importance. There are none at all in F 917 JH 115, F 921 JH 116 and F 919 JH 123.*

11 *The first letters may be 'ma[r?]'.*

12 *Just before his uncle placed the first order, Van Gogh had sold a drawing to his former employer, H.G. Versteeg, for 10 guilders; see letter 205/176.*

13 *See V.W. van Gogh's memorandum of 19 February 1975 (Van Gogh Museum archives).*

14 *Op de Coul 1975, passim.*

cessful, even if some of the lines are slightly out of true, but the sizes of the figures are completely wrong. The two men in the foreground, for example, reduce all the others to dwarfs. In addition, their shadows should be parallel, not divergent. These mistakes are undoubtedly due to the fact that Van Gogh did not observe and sketch most of the figures on the spot but added them in his studio to the drawing of the street and the houses that he had made earlier, using figure studies he already had in stock. Those models are no longer known, but the woman wearing dark clothing and a shawl to the left of the cart can be seen in an even more complex composition of the same period that is now in Berlin *(fig. 23b)*, where she is standing in front of the shop window on the right. Both figures must have been taken from the same lost drawing. The rear view of the woman with a walking-stick passing under the gateway is known from a very similar but reversed study that Van Gogh used in several works *(cat. 23)*. It seems reasonable to assume that he had more studies of that model, including one in the same pose as in *The entrance to the Pawn Bank, The Hague.*

Griselda Pollock once pointed out that Van Gogh did not select the beautiful old parts of The Hague for his townscapes, but actually preferred subjects that were not very picturesque.[9] In this he was following the example of modern literature rather than any painterly tradition. There is certainly a grain of truth in that observation. People did not go to the Pawn Bank for pleasure but were forced there by poverty. And a subject like *The gasworks (cat. 26)* is unmistakably modern, peculiar and even a little sinister. However, one should treat such interpretations with care. Van Gogh himself did regard the scenes in the residential neighbourhoods where he made his townscapes as picturesque. He never took much interest in the maturer beauty of any town – be it in The Hague, Antwerp, Paris or Arles. If some of his Hague studies look inhospitable, partly because of the absence of human figures, the reason for this lies in their artistic intention, for they were Van Gogh's very first exercises in perspective, which might later be worked up and given a staffage of figures.[10]

The entrance to the Pawn Bank, The Hague was laid down in pencil and then worked up with ink and opaque white watercolour. The ink, applied with both pen and brush, must originally have been black but has now discoloured to brown. In places where it is very thin it has faded away almost entirely. Van Gogh wrote inscriptions on the posters on the wall to the right of the gate, but they are now only barely legible. The left-hand poster, above the cart, says 'AMBACHTSCHOOL' (Trades School); to

the right of it 'VERKOOP HUIS JAN[...]' (sale of the house of Jan[...]); the
next one 'VERKOOP BOERMA' (Boerma sale), and the elongated poster on
the right 'Prospectus EIGEN HAARD geïllustreerd tijdschrift' (Prospectus
of the Eigen Haard illustrated periodical). Above the door on the far left
is an illegible scrap of text in pencil that begins on the righthand door-
frame.[11] About a year later, Van Gogh remarked to Theo that a poster with
the headline 'Prospectus Eigen Haard' ('Eigen Haard' meaning 'hearth
and home') on the Pawn Bank, of all places, where people went to pawn
their personal possessions, was very much a parody [332/275].

Since all these drawn townscapes, which are among the earliest
works that Van Gogh sold, went to his uncle, none passed to the descen-
dants of Theo van Gogh.[12] That gap was filled with the purchase of the
three sheets now in the museum (see also *cats. 25, 26*).

It is not known who owned *The entrance to the Pawn Bank, The Hague*
after C.M. van Gogh, whose business was taken over by his son Vincent
in 1891. It was part of the first batch of drawings that Vincent sent to his
uncle, and remained unknown to the outside world until well into this
century. It certainly spent three generations (precisely how long is not
known) in the collection of the 't Lam family.[13] It was sold to the Vincent
van Gogh Foundation by one of the descendants in 1975, and was pub-
lished that year by Martha op de Coul.[14]

25 Bridge and houses on the corner of Herengracht-Prinsessegracht, The Hague

MARCH 1882

Pencil, pen and brush in brown
(originally black) ink, opaque
white watercolour, brown-grey
wash, on laid paper
Traces of squaring
24.0 × 33.9 cm
Watermark: illegible, cropped
by the bottom edge
Signed at lower left: Vincent
Annotated on the verso in another
hand: Hoek Heerengracht en
Prinsengracht en Boschbrug

Inv. d 372 V/1968
SD 1679 JH 121

PROVENANCE
1882 C.M. van Gogh, Amsterdam;
1902 The Hague (M. Nijhoff /
R.W.P. de Vries), 13-15 May, no. 437
(unsold); after 1902-36 E. du
Quesne van Bruchem-van Gogh,
Dieren-Leiden; 1936-68 R.W. Riem
Vis-Du Quesne van Bruchem,
Amersfoort; 1968 bought by the
Vincent van Gogh Foundation;
1968-73 on loan to the Stedelijk
Museum, Amsterdam; 1973 on
permanent loan to the Van Gogh
Museum, Amsterdam.

LITERATURE
Op de Coul 1969, pp. 42-44;
De la Faille 1970, p. 575; Hulsker
1976, pp. 17-19; Hulsker 1980,
pp. 36-38, no. 121; Amsterdam
1980-81, pp. 39-58, 152, no. 70;
Pollock 1983, pp. 331, 335; Amster-
dam 1987, p. 388, no. 2.133; Dorn
1987, pp. 65-67; Van der Mast /
Dumas 1990, pp. 47, 170-71; De
la Faille 1992, vol. 1, p. 448, vol.
2, pl. CCXLVI.

This drawing of some stately canalside mansions is the only view of the old, patrician part of The Hague in the series of townscapes that Van Gogh made for his Uncle Cor. In the sale catalogue of 1902 (see *cat. 24*) it was given the French title *Coin du Heerengracht et Prinsengracht et vue sur le Boschbrug à la Haye.* That is evidently a translation of the annotation on the verso, which is in the same handwriting as those on the backs of most of the drawings in this series (see *cat. 24*): 'Hoek Heerengracht en Prinsengracht [sic] en Boschbrug'. That is an impossible combination of canals and a bridge in The Hague, as Martha op de Coul pointed out in 1969 when she published this hitherto unknown sheet.[1] The houses on the right are on Prinsessegracht, on the corner of Herengracht. Van Gogh made the drawing from Koningskade. A photograph of 1925-30 was taken from roughly the same spot *(fig. 25a)*, and even today the view has changed very little.

Van Gogh was faced with the task of depicting the bridge on the left in its correct perspective. At first sight he seems to have done so quite successfully, but a photograph of circa 1860 *(fig. 25b)* shows that he was forced to simplify the complicated structure of the bridge (which was replaced in the 1930s). The photograph was taken from the other side of the bridge, looking towards Bezuidenhoutseweg, with the houses drawn by Van Gogh invisible on the left. The structure of the bridge is quite easy to make out. After a straight central section the parapet curves outwards by a support with a lamppost and ends at a broad cornerpiece, where it goes off at right angles in a final, straight stretch. It is not entirely clear from the drawing how Van Gogh intended to simplify this complex struc-ture, but it seems that he omitted the curve, with the result that after the straight stretch the bridge immediately goes off at right angles by the lamppost. In any event, this is the only part of the view that is drawn with straight, sharp lines that are heavily indented in the paper. This per-spectival problem clearly taxed his abilities to the limit, and even beyond.

The drawing was first made in pencil, to which the artist then added some strokes in the water with the pen in black ink (which has now turned brown) and reinforced the dark passages in the windows of the houses with the brush in ink. The treetops were given a brown-grey watercolour

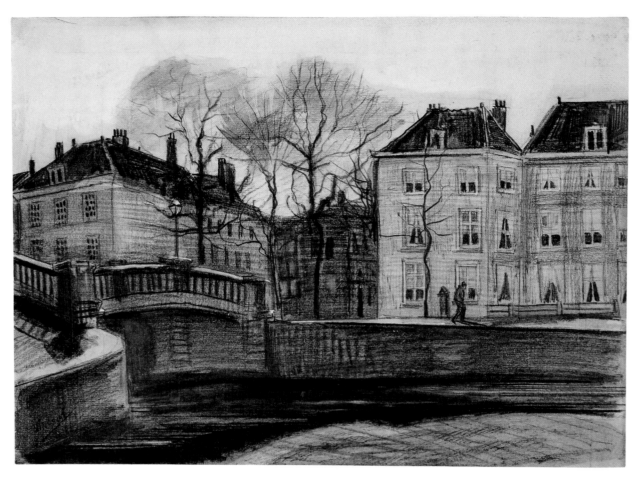

25 Bridge and houses on the corner of
Herengracht-Prinsessegracht, The Hague

EXHIBITIONS
1926 Amsterdam, no. 6; 1969
Humlebaek, no. 5; 1970 The
Hague, no catalogue; 1971-72
Paris, no. 124; 1980-81 Amster-
dam, no. 70; 1983-84 Amster-
dam, no catalogue; 1990 Otterlo,
no. 21.

1. Op de Coul 1969, p. 42.
2. Van Tilborgh / Pabst 1995, pp. 87-101,
esp. p. 88. The donation discussed in that
article also contained two letters from
V.W. van Gogh, Theo's son, to R.W.
Riem Vis-du Quesne van Bruchem deal-
ing with the purchase (15 March and 5
July 1968). They, together with letters
from the archives of the Vincent van
Gogh Foundation, clarified that part of
the provenance.

wash which may have been a deeper shade originally. The parapet, lamp-post and window-frames were accentuated with opaque white water-colour. Van Gogh did the same in the sky to give it a lighter tone, although the contrast with the rest of the drawing is now greater than intended due to the yellowing of the paper.

In 1968 the drawing was still in the possession of Rose Wilhelmine Riem Vis-du Quesne van Bruchem (1897-1972), a daughter of Vincent's sister Lies du Quesne van Bruchem-Van Gogh (1859-1936). The sheet was acquired that year by the Vincent van Gogh Foundation. It was recently concluded from that provenance that it was doubtful whether it belonged to the series of 12 townscapes that Van Gogh made for Cornelis Marinus van Gogh (see *cat. 24*).[2] Those doubts are unfounded. The incorrect description of the location on the back of the sheet is in the same hand found on so many of the works made for 'C.M.', as he was known, and quite definitely ties it to his collection. It is not known how it came into the possession of Lies's daughter.

25ᵃ Photograph of Prinsessegracht,
The Hague, 1925-1930. The Hague
City Archives.

25ᵇ Photograph of Herenbrug and
Bezuidenhoutseweg, The Hague,
c. 1860. The Hague City Archives.

26 Gasworks

The Hague gasworks stood at the corner of Loosduinseweg and the present-day Gaslaan. Van Gogh drew the complex in March 1882, and it was by far the most modern subject in the series of townscapes he made for his Uncle Cor (see *cat. 24*).

The Hague's gas industry had been in private hands since 1820, but the high costs and poor service led the municipality to take it over in 1875, the year in which this gasworks was built.[1] The complex lay on the southwestern edge of the city, and Van Gogh probably came across it while out on a stroll to a more rural area, probably Loosduinen. It presented a good challenge as an exercise in perspective, for it is not easy to depict a row of colossal shapes like these gasometers with the correct foreshortening, nor to capture the subtle curvature of their tops. In order to strengthen the impact of the buildings Van Gogh decided on a high horizon and an empty, sketchy foreground. It is not even possible to say whether the passage on the right, in front of the tree, is a path or a water-filled ditch. The gasworks itself is quite detailed. It is surrounded by a fence in front of which, to the left of centre, is a group of five workmen, two of them with shovels. The houses and windmill on the horizon to the right are also recorded with some precision. The vertical supports around the gasometers were heightened with white to make them stand out against the dark walls of the casings. Comparison with the technical design drawing for one of the gas-holders shows that Van Gogh took great care to depict the structure accurately *(fig. 26a)*.

The windmill in the right background is not, as has been asserted, the 'Prins van Oranje' sawmill, because it would have been hidden by the gasworks from Van Gogh's position. What he could just see, though, was the 'Haas' corn-mill.[2]

Some rather odd shapes in the sky at top right appear at first sight to be birds. Closer examination shows that from the shape of their wings, as well as the pointed ears of the one in the middle, they are probably bats. This would mean that Van Gogh drew the scene at dusk, for bats never come out in daylight.

MARCH 1882

Pencil, brush in brown (originally black) ink, opaque white watercolour, on laid paper
Traces of squaring
23.8 × 33.8 cm
Watermark: illegible, cropped by the bottom edge
Signed at lower left: Vincent
Annotated on the verso: Gasfabriek

Inv. d 776 V/1980
F 924 JH 118

PROVENANCE
1882 C.M. van Gogh, Amsterdam; D. Franken Dzn, Paris / Le Vésinet; C.M. van Gogh, Amsterdam; 1902 The Hague (M. Nijhoff / R.W.P. de Vries), 13-15 May, no. 439 (unsold); before 1926-56 H.P. Bremmer, The Hague; 1956-80 R. Bremmer, The Hague; 1980 bought by the Van Gogh Museum with the aid of the Vereniging Rembrandt through the Monet gallery, Amsterdam.

LITERATURE
De la Faille 1928, vol. 3, p. 24, vol. 4, pl. xxv; Vanbeselaere 1937, pp. 80, 128, 408; De la Faille 1970, p. 345; Visser 1973, pp. 105-06; Hulsker 1976, pp. 16, 19; Hulsker 1980, pp. 36, 38, no. 118; Van der Wolk 1980, pp. 63-64; Amsterdam 1980-81, pp. 39-58, 153, no. 72; Pollock 1983, pp. 335, 339; Amsterdam 1987, p. 389, no. 2.140; Dorn 1987, pp. 65-67; Van der Mast / Dumas 1990, pp. 40-41, 170-71; De la Faille 1992, vol. 1, pp. 24, 236, vol. 2, pl. xxv.

EXHIBITIONS

1913 The Hague, no. 32; 1926 Amsterdam, no. 4; 1960 Paris, no. 80; 1961 Amsterdam, no. 9; 1980-81 Amsterdam, no. 72; 1982 Amsterdam, unnumbered; 1983-84 Amsterdam, unnumbered; 1985-86 Tokyo & Nagoya, no. 37; 1986 Osaka, no. 27; 1988 Rome, no. 57; 1990 Otterlo, no. 23.

1 See Van der Mast / Dumas 1990, pp. 40-41, and Michiel van der Mast (ed.), Den Haag energiek: hoofdstukken uit de geschiedenis van de energievoorziening in Den Haag, The Hague 1981, pp. 176-81.

2 Van der Mast / Dumas 1990, p. 41, identify the mill as the 'Prins van Oranje,' which stood on the junction of present-day Chrispijnstraat and Elandstraat. That is too far to the north-west for it to have been visible to Van Gogh. The 'Haas' mill was on what is now Kleine Veenkade, and was just within Van Gogh's field of view.

3 The three other drawings were F 917 JH 155, F 920 JH 113 and F 923 JH 125. The first two were from Van Gogh's first batch for his uncle, the other from the final batch. On Franken see D. de Hoop Scheffer, 'Het Rijksmuseum en zijn begunstigers,' Bulletin van het Rijksmuseum 6 (1958), pp. 89-91.

4 They are F 914 JH 112, F 917 JH 115, F 919 JH 123, F 920 JH 113, F 921 JH 116, F 922 JH 114, F 925 JH 117, F 941 JH 146 and F 942 JH 147; the last two are from Vincent's second consignment to C.M. van Gogh.

On the back is the annotation 'Gasfabriek' in the same handwriting as that of the inscriptions on the other drawings made for his Uncle Cor (see cats. 24, 25).

This and three of the other townscapes came into the possession of C.M. van Gogh's brother-in-law, Daniël Franken Dzn (1838-1898), an art-lover and retired banker living in Paris.[3] It is unclear whether they were sold or given to him, but they hardly fitted in with the not very progressive nature of Franken's collection.

After Franken's death in 1898 the four sheets probably returned to C.M. van Gogh (or to his son, see *cat. 24*), who sent them for auction in 1902 along with seven other Hague townscapes that had evidently remained unsold. The *Gasworks* then came into the hands of the art educationist H.P. Bremmer (1871-1956), who went on to own nine other sheets from Vincent's series of Hague views.[4] The Van Gogh Museum finally acquired the *Gasworks* in 1980, making it the second example in the collection from the work that sold back in 1882.

26a J.E.M. Kros, Design for a gas-holder, c. 1875. The Hague City Archives.

26 Gasworks

27 Country road

MARCH-APRIL 1882

Pencil, pen and brush in brown
(originally black) ink, opaque
white watercolour, on laid paper
24.6 × 34.4 cm
Signed at lower right: Vincent

Inv. d 428 V/1962
F 1089 JH 124

PROVENANCE
1890-91 T. van Gogh; 1891-1925
J.G. van Gogh-Bonger; 1925-62
V.W. van Gogh; 1931-62 on loan
to the Stedelijk Museum,
Amsterdam; 1962 Vincent van
Gogh Foundation; 1962-73 on
loan to the Stedelijk Museum,
Amsterdam; 1973 on permanent
loan to the Van Gogh Museum,
Amsterdam.

LITERATURE
Van Meurs n.d., p. 19, no. 8;
Lettres 1911, pl. II; Bremmer
1926, no. 11, no. 84; De la Faille
1928, vol. 3, p. 60, vol. 4, pl. LXV;
Vanbeselaere 1937, pp. 85, 148,
410; Cooper 1955, pp. 18-21; De
la Faille 1970, pp. 396-97; Visser
1973, pp. 110-11; Hulsker 1980,
pp. 36-38, no. 124; Amsterdam
1987, p. 389, no. 2.141; Van der
Mast / Dumas 1990, p. 71; De la
Faille 1992, vol. 1, pp. 60, 278,
vol. 2, pl. LXV.

EXHIBITIONS
1905 Amsterdam, no. 261; 1914-
15 Amsterdam, no. 18; 1920 New
York, no. 18; 1926 Amsterdam,
no. 20; 1927-28 Berlin, Vienna &
Hannover, no. 6; 1929 Amster-
dam, no. 12; 1931 Amsterdam,
no. 101; 1937 Paris, no. 59; 1947

The *Country road*, along which a man with a spade is trudging, may not have been one of the 12 Hague townscapes that Van Gogh made for his Uncle Cor (see *cats. 24-26*), but it is certainly closely related to them. It is of a comparable size, drawn with the same materials on laid paper, and it too is an exercise in perspective. There can be little doubt that it dates from the same period, although the margin of error is slightly wider than for those sheets, which can be dated more accurately from Van Gogh's letters.

The road runs as straight as a die towards the distant dunes. On its left are market gardens, in one of which a peasant is crouched over the tender young shoots. Two possible locations have been mooted. Visser believes that this is the Nieuwe Slag in Loosduinen, now called the Groen van Prinsterer-laan. As an alternative, Van der Mast suggests the Laan van Eik en Duinen, referring to a photograph of a very similar scene *(fig. 27a)*.[1] As matters stand at present, neither of these locations can be ruled out or firmly accepted. Both, in any event, indicate that Van Gogh was working near Loosduinen even at this early date, although he does not mention the village in his let-ters until July 1883. After briefly describing to Theo a walk he had taken there, he wrote: 'I do not know if you are familiar with that side [of The Hague]. I myself never went there in former years' [372/307]. This seems to suggest that it was his first visit to Loosduinen, but the words 'former years' (when he wrote this letter Van Gogh had been in The Hague for barely 18 months) are clearly a reference to his earlier stay in the city, when he worked at an art gallery from July 1869 to May 1873.

Both the drawing and the photograph show the distinctive fencing of the gardens on the left with reed mats attached to alders planted for that purpose. They were known as reed-screens or wind-screens,[2] and were erected to shield the crops from the wind and drifting sand. Van Gogh used these long, linear landscape elements to produce this successful exercise in two-point perspective. The road and the reed-screens running parallel to it have a vanishing point on the horizon at the end of the road. The lines of the wind-screens at right angles to them meet at the horizon on the far left. The row of alders presented an additional problem, for not only had they to be made smaller as they neared the horizon, which was a simple matter of two or three construction lines extending from the distance points, but

27 Country road

Groningen, no. 20; 1947 Rotter-
dam, no. 24; 1948-49 The Hague,
no. 176; 1949-50 New York &
Chicago, no. 28; 1951 Lyons,
Grenoble, Arles / St. Rémy, no.
84; 1953 Zürich, no. 20; 1953
The Hague, no. 8; 1953 Otterlo &
Amsterdam, no. 11; 1953-54 Saint
Louis, Philadelphia & Toledo, no.
14; 1954-55 Bern, no. 88; 1955
Antwerp, no. 25; 1955
Amsterdam, no. 5; 1955-56
Liverpool, Manchester &
Newcastle-upon-Tyne, no. 84;
1956 Haarlem, no. 10; 1957
Breda, no. 20; 1957 Marseille,
no. 2; 1957 Stockholm, no. 7;
1958-59 San Francisco, Los
Angeles, Portland & Seattle, no.
96; 1959-60 Utrecht, no. 67;
1960 Enschede, no. 12; 1961
Scarborough, no catalogue; 1961-
62 Baltimore, Cleveland, Buffalo
& Boston, no. 90; 1962-63
Pittsburgh, Detroit & Kansas
City, no. 90; 1963 Sheffield, no.
16; 1963 Amsterdam, no. 94;
1965 Charleroi & Ghent, no. 46;
1966 Paris & Albi, no. 8; 1967
Lille & Zürich, no. 9; 1967-68
Dallas, Philadelphia, Toledo &
Ottawa, no. 10; 1968 Liège, no.
10; 1968-69 London, no. 7; 1969
Humlebaek, no. 4; 1971-72 Paris,
no. 122; 1972 Bordeaux, no. 43;
1972-73 Strasbourg & Bern, no.
50; 1977 Paris, unnumbered;
1980-81 Amsterdam, no. 55;
1988 Rome, no. 56; 1990
Otterlo, no. 69.

1 Visser 1973, pp. 110-11; Van der Mast /
Dumas 1990, pp. 71-72 (without photo-
graph) and note 47.
2 There is a more detailed description of
these screens in Visser 1973, p. 110.
3 Cassagne 1879, pp. 62-63, section 81:
'Allée d'arbres en perspective.'

there was also the difficulty of establishing the distances between them. This was more of a challenge, but Van Gogh had found solutions to stumbling-blocks of this kind in his textbooks and probably applied them here, although there are no visible traces of them on the sheet (fig. 27b). As that drawing shows, parallel diagonals can be constructed to fix the correct position of the next tree in the row.[3]

Van Gogh first drew the scene in pencil and then worked it up with black ink, which has now turned brown. He used iron-gall ink, which has that property in addition to causing damage to the paper due to its acid-ity, as can be seen in this sheet. He probably intended to depict dusk falling, and did so very effectively by using opaque white watercolour in the sky to suggest the last rays of dying sunlight being reflected off the clouds. He also used the white to give the branches at bottom left small buds, as harbingers of spring.

27a Photograph of Laan van Eik en
Duinen, The Hague, c. 1915. The
Hague City Archives.

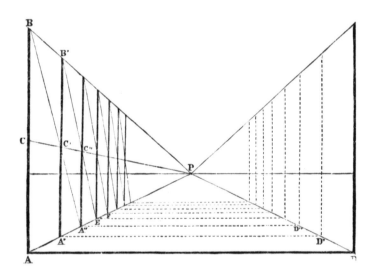

27b *Allée d'arbres en perspective*, in:
Armand Cassagne, *Traité pratique de
perspective*, Paris 1879, p. 62.

28 Head of a woman

SPRING-SUMMER 1882

Pencil on laid paper
29.1 × 22.5 cm
Watermark: ED & Cie [in cartouche]
Unsigned

Inv. d 777 V/1980
F – JH –

PROVENANCE
Until 1942 L.J. Falkenburg, The
Hague; 1942-80 J.W. Falkenburg,
Delft; 1980 bought by the Vincent
van Gogh Foundation; on permanent loan to the Van Gogh
Museum, Amsterdam.

LITERATURE
Amsterdam 1987, p. 388, no. 2.137.

EXHIBITION
1983-84 Amsterdam, no catalogue; 1990 The Hague, unnumbered.

1 See letters 234/201 and 247/215.
2 Van Gogh's lithographs of November
1882 show that one should be cautious in
associating a particular kind of paper with
a specific period in his œuvre, for he used
several types at the same time. In general
he had the lithographs printed on cheap,
machine-made paper, but there are also
impressions on watercolour sheets (see Van
Heugten/Pabst 1995, imps. 3.1 and 4.2).
Others are printed on laid paper with the
same watermark as this drawing: 'ED &
Cie' (ibidem, imps. 5.6 and 5.7).

This is probably a portrait of Sien Hoornik. Although the resemblance to other drawings of her does leave some room for doubt, the profile view with the distinctive, slightly indented nose provides sufficient grounds for the identification. Van Gogh found his companion's profile beautiful, even noble, and regularly did justice to it in drawings for which she posed.[1]

There are various technical clues which make it possible to date the sheet roughly. Only pencil was used, as it was in so many drawings of 1882, and the support is laid paper, which was largely supplanted by watercolour paper by the end of the summer of that year. This suggests that the drawing was made in the spring or summer of 1882, although a slightly later date cannot be entirely ruled out.[2]

The initial drawing is quite subtle, and the way in which the face is modelled with shadows in stumped pencil is almost delicate by Van Gogh's standards. He then decided to accentuate the woman's clothing, and it was this that led to a prominent feature of the drawing – the vertical lines in the dress, which is the pattern left by the grain of the piece of wood that Van Gogh used as his drawing-board. Once recognised for what it is, it can be detected in several other drawings from the Hague period, particularly those on thin paper.[3] The question is: how deliberate was it? It generally appears to be unintentional, for he simply needed a piece of wood to rest his paper on. This thin sheet of laid paper inevitably took up the pattern of the wood grain when the artist put extra pressure on his pencil. Nevertheless, the effect seems to have been exploited here, possibly in order to imitate the fairly coarse texture of the clothing.

The existence of this sheet was unknown until well into the present century. It was acquired by the Vincent van Gogh Foundation from the descendants of the architect L.J. Falkenburg (1872-1942), whose clients had included Mr and Mrs Kröller-Müller.[4]

28 Head of a woman

3 For the pattern of the wood grain see ibi-
dem, cat. 3, on Van Gogh's Digger litho-
graph. In that catalogue I stated that this
is the only print with that effect and that it
can be assumed it was unintentional. In
fact, the grain can also be seen in the
impressions of the Old man drinking
coffee and the Workman's meal-break
(ibidem, cats. 4 and 6). Isolated parts of
the grain were transferred to many of Van
Gogh's drawings. In virtually every case,
though, this does not appear to be deliber-
ate, if only because it is difficult to think of
a reason for their presence.
4 See Van der Wolk 1992, pp. 13-14, 40.
Falkenburg was not a born collector, which
is why P.H. Hefting suggested (in a letter
to J.W. Falkenburg of 20 May 1980, copy
in the Van Gogh Museum archives) that
the architect had been given it from Mrs
Kröller-Müller. Since the latter was not
known for her generosity, this theory is to
be doubted.

29 View of Scheveningen

SUMMER-AUTUMN 1882

Pencil, transparent and opaque
watercolour, on watercolour paper
Squaring lines clearly visible
43.1 × 59.7 cm
Unsigned

Inv. d 182 V/1962
F 1041 JH 167

PROVENANCE
1890-91 T. van Gogh; 1891-1925
J.G. van Gogh-Bonger; 1925-62
V.W. van Gogh; 1931-62 on loan
to the Stedelijk Museum, Amster-
dam; 1962 Vincent van Gogh
Foundation; 1962-73 on loan to
the Stedelijk Museum, Amster-
dam; 1973 on permanent loan to
the Van Gogh Museum, Amster-
dam.

LITERATURE
Bremmer 1926, no. 11, no. 82;
De la Faille 1928, vol. 3, p. 50,
vol. 4, pl. LIV; Vanbeselaere 1937,
pp. 78, 410; De la Faille 1970,
pp. 384-85; Visser 1973, pp. 95-
97; Hulsker 1974, pp. 31-32;
Hulsker 1980, p. 45, no. 167;
Amsterdam 1987, p. 389, no.
2.142; Van der Mast/Dumas
1990, pp. 65-67; De la Faille
1992, vol. 1, pp. 50, 268, vol. 2,
pl. LIV.

EXHIBITIONS
1905 Amsterdam, no. 260; 1914-
15 Amsterdam, no. 19; 1923 Utrecht
& Rotterdam, no. 11; 1926 Amster-
dam, no. 21; 1927-28 Berlin,
Vienna & Hannover, no. 5; 1928
Paris, no. 5?; 1929 Amsterdam,
no. 10; 1931 Amsterdam, no. 99;
1947 Groningen, no. 18; 1947

In the summer and autumn of 1882 Van Gogh was enthusiastically work-
ing in and around Scheveningen, and that is probably when he made this
view of the picturesque fishing village.

He knew Scheveningen well from the many times he had visited it
when he was working in the Goupil gallery in The Hague from 1869 to
1873. When he left Brussels in April 1881 the village was high on his list
of picturesque places where, as a young artist, he wanted to live. For the
time being it was Etten, but when he moved from there to The Hague he
hoped that he could work in Scheveningen again. Much to his
disappointment, rooms there were 'terribly expensive' [194/166]. Prices had
been driven up not only because Scheveningen was popular with other
artists, but even more so by the fact that it had become an increasingly
fashionable seaside resort. In order to find subjects there Van Gogh was
forced to travel from his house on Schenkweg – on foot or by tram.
Another solution was to camp in the dunes, as he and Sien did for a few
days in May 1882. In July of the following year, when he had taken up
painting and found the trip even more laborious due to the extra baggage,
Théophile de Bock (1851-1904), who lived in Scheveningen, allowed him
to store his equipment there.

Van Gogh worked in the fishing village on many occasions, some-
times alone and sometimes with the artist friends De Bock or Herman
van der Weele (1852-1930). It is not known on which of those trips this
drawing was made. In 1973 Visser identified the location as Vuurbaak-
straat, but in 1990 Van der Mast made out a plausible case for a spot
near Duinstraat, close to the fish-drying barns that Van Gogh drew in
May-July 1882.[1] It is fair to assume that this drawing was made then or
a little later. Van der Mast, however, points out that this sheet, with its
broad style and lack of detail, is closer to Van Gogh's view of a carpen-
ter's yard of March 1883,[2] than it is to the more highly finished village
views of a year earlier. In itself that is a perfectly accurate observation,
but the 'style' of this drawing is probably due to the fact that it is
unfinished. The main indications of this are the indeterminate brush-
strokes to the right of the couple on the far left, the highly schematic
head of the man on the left, and the odd skein of brushstrokes on the

29 View of Scheveningen

Rotterdam, no. 21; 1948-49
The Hague, no. 174; 1949-50
New York & Chicago, no. 27; 1953
Zürich, no. 18; 1953 The Hague,
no. 4; 1953 Otterlo & Amsterdam,
no. 7; 1953-54 Saint Louis,
Philadelphia & Toledo, no. 13; 1954-
55 Bern, no. 86; 1955 Antwerp,
no. 23; 1955 Amsterdam, no. 3;
1957 Nijmegen, no. 13; 1957
Stockholm, no. 6; 1958-59 San
Francisco, Los Angeles, Portland
& Seattle, no. 95; 1960 Enschede,
no. 11; 1963 Humlebaek, no. 67;
1964 Washington & New York,
no. 67; 1965-66 Stockholm &
Gothenburg, no. 65; 1967 Wolfs-
burg, no. 86; 1967-68 Dallas,
Philadelphia, Toledo & Ottawa,
no. 9; 1968 Liège, no. 9; 1968-69
London, no. 9; 1971-72 Paris,
no. 121; 1975 Malmö, no. 6; 1976
Stockholm, no. 6; 1976-77 Tokyo,
Kyoto & Nagoya, no. 11; 1980-81
Amsterdam, no. 53; 1982 Amster-
dam, no catalogue; 1990 Otterlo,
no. 32.

1 *Visser 1973, pp. 95-97; Van der
Mast / Dumas 1990, pp. 65-67 and
p. 177. The fish-drying barns are
F 938 JH 152, F 940 JH 154 and
F 945 JH 160.*
2 *F 1022 JH 344.*
3 *See the Introduction.*

right. Moreover, Van Gogh made no attempt to erase the lines of the grid associated with the use of a perspective frame. If a drawing satisfied him he generally tried to remove those lines or conceal them by drawing over them. One possible reason for his not completing this drawing is the very large expanse of sand dune, which takes up almost half the composition. The early date of summer-autumn 1882 therefore still seems reasonable.

The perspective frame was a valuable aid in drawing the fairly complex groups of houses that Van Gogh could see from his vantage-point on the edge of the dunes. He drew the scene in pencil and then added colour with opaque watercolour, which is highly thinned here and there. He had learned this technique of *aquarelle gouachée* from Cassagne's watercolour manual.[3] He gave the foreground a very light pink hue with a wash.

30 Four people on a bench

This small drawing is one of two watercolours that Van Gogh enclosed with a letter in September 1882 in the hope that his brother would consider them worth selling.[1] It is clear from the reactions in Van Gogh's letters that both Theo and Vincent's former employer at the Hague art gallery, H.G. Tersteeg, had often tried to convince him that his drawings were not yet very attractive to a wide public. Earlier that year Theo had impressed on him that watercolours were far more popular than the black-and-white drawings Vincent had been sending him. Although Van Gogh made watercolour drawings with some regularity, he did not want to concentrate on the medium too much. Quite apart from the expense of working in watercolour, he did not fancy tackling the problem of colour at that time, or the technical difficulties presented by watercolour. For the time being he had to concentrate on the correct depiction of anatomy, proportions and perspective, but felt that he would be able to send his brother commercially attractive watercolours by around Christmas 1882.[2]

However, the need to sell something was irresistible, and Van Gogh wanted to get a better idea of what his brother, who had raised the subject again during a recent visit, considered commercially interesting. 'As you know, when you were here you spoke about me someday doing my best to send you a little drawing of the kind known as "salable." You must excuse me, though, for not knowing exactly when a drawing is of that nature and when it is not. I believe that I used to know, but now I see daily that I am mistaken. Well I hope this little bench, though perhaps not yet salable, will show you that I am not averse to choosing subjects occasionally that have something pleasant or attractive about them and, as such, will find buyers sooner than things of a gloomier nature' [263/230].[3] As a pendant to this watercolour he also enclosed 'a bit of a wood' *(fig. 30a)*.[4]

Van Gogh had made the watercolour of the people on the bench after a larger one he was currently working on *(fig. 30b)*. There are various differences between the two. The large work has a woman and child on the left and a man on the right. The latter is missing in the smaller sheet, and the woman and child have been replaced by a couple out for a stroll.

SEPTEMBER 1882

Transparent and opaque watercolour, pen in brown ink, on watercolour paper
9.4 × 11.8 cm
Signed at lower left: Vincent

Inv. d 321 V/1972
F – JH 195

PROVENANCE
1882-91 T. van Gogh; 1891-1925 J.G. van Gogh-Bonger; 1925-62 V.W. van Gogh; 1962 Vincent van Gogh Foundation; 1962-72 with V.W. van Gogh, Laren; 1972-73 on loan to the Stedelijk Museum, Amsterdam; 1973 on permanent loan to the Van Gogh Museum, Amsterdam.

LETTERS
263/230, 273/238.

LITERATURE
Hulsker 1980, pp. 52-53, 58, no. 195; Amsterdam 1987, p. 390, no. 2.145; De la Faille 1992, vol. 1, p. 469, no. 1768, vol. 2, pl. CCLXVII.

EXHIBITION
1975 Amsterdam, no. 116.

1 *Letter 263/230.*

2 *See letter 249/217. For further references to the subject see letters 204/175, 206/177, 209/180, 235/205, 247/215, 251/219, 252/220 and 253/221.*

3 *The remark 'I believe that I used to know' is a reference to the time when Van Gogh was working in the art trade (July 1869-March 1876).*

4 *For some unknown reason only this pendant is reproduced in the 1990 edition of the letters, not the sketch discussed here. The roles were reversed in the 1953 edition, when only the Van Gogh Museum's watercolour was illustrated.*

It is quite clear from Van Gogh's words that the museum's watercolour was more than a sketch enclosed with a letter in order to give Theo an idea of his recent work. This is supported by the signature, which is evidence that this was a finished work intended for sale, and by the care that Van Gogh took over it. We do not know precisely what Theo thought of it, but he did tell his brother that it was done in an old-fashioned way, by which he meant that it was rather traditional [273/238].

This congenial scene was executed in watercolour and opaque watercolour, with parts of the figures worked up with the pen in brown ink. As with so many of the artist's watercolours, this mixed-media technique is not watercolour in the strictest sense of the word.

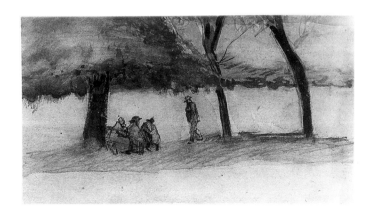

30ª Sketch in a letter to Theo of 11 September 1882 (263/230). Private collection.

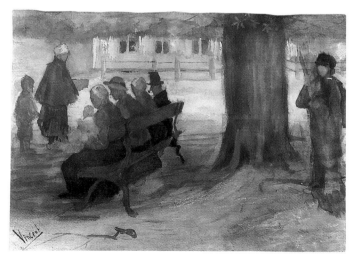

30ᵇ *Four people sitting on a bench* (F 951 JH 197), 1882. Whereabouts unknown.

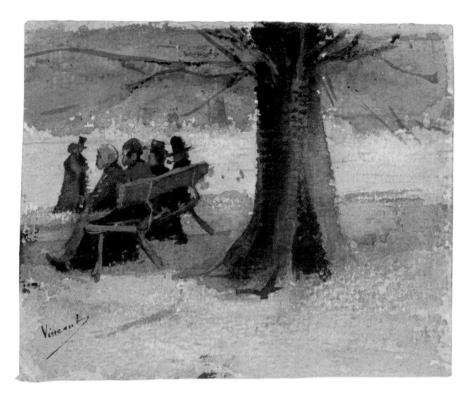

30 Four people on a bench

31 Old man with a stick

SEPTEMBER-NOVEMBER 1882

Pencil on watercolour paper
Traces of squaring, fixative dis-
colouration around the figure
50.4 × 30.2 cm
Watermark: DAMBRICOURT FRERES
Unsigned

Inv. d 437 V/1962
F 962 JH 212

PROVENANCE
1890-91 T. van Gogh; 1891-1925
J.G. van Gogh-Bonger; 1925-62
V.W. van Gogh; 1931-62 on loan
to the Stedelijk Museum,
Amsterdam; 1962 Vincent van
Gogh Foundation; 1962-73 on
loan to the Stedelijk Museum,
Amsterdam; 1973 on permanent
loan to the Van Gogh Museum,
Amsterdam.

LITERATURE
De la Faille 1928, vol. 3, p. 33,
vol. 4, pl. xxxv; Vanbeselaere
1937, pp. 88-89, 170, 173, 192,
409; De la Faille 1970, p. 360;
Visser 1973, pp. 62-65; Chetham
1976, p. 29; Hulsker 1980, pp. 56,
60, no. 212; Amsterdam 1987, p.
391, no. 2.150; Van der Mast/
Dumas 1990, pp. 128, 130; De la
Faille 1992, vol. 1, pp. 33, 248,
vol. 2, pl. xxxv; Van Heugten/
Pabst 1995, p. 34.

EXHIBITIONS
1905 Amsterdam, no. 249; 1914-
15 Amsterdam, no. 22; 1923
Utrecht & Rotterdam, no. 76;
1931 Amsterdam, no. 109; 1947
Groningen, no. 6; 1947
Rotterdam, no. 9; 1947-48
London, Birmingham & Glasgow,

As we know from the letters, Van Gogh made a large number of figure
studies in the months September-December 1882, and those letters
make it possible to identify a solid core group. Other sheets can be
attached to that group on the basis of stylistic features and similarities
in the use of materials. The majority were drawn on heavy watercolour
paper, almost exclusively in pencil, and were only very occasionally
worked up with some other material.

The Van Gogh Museum has 12 such works (cats. 31-38, 42-45). Most
of them cannot be dated any more precisely than September-December
1882 (cats. 33-38), but the letters allow some to be dated more closely
(cats. 42-45). Two others must have been drawn before November, for in
that month Van Gogh used those studies, or a variant (see cat. 32), as a
model for lithographs. Those two are this sheet of an old man striking a
dignified pose and the following catalogue number.

The man in this drawing is exceptional in that he was the model
Van Gogh used most often, not just in works from the Hague period but
in the entire œuvre. In September 1881 he told his brother that he
would be getting a 'man from the almshouse' to pose for him that week
[268/233], and a few days later he informed Van Rappard (1858-1892): 'I am
very busy working on drawings of a weesman ["orphan man"], as these
almsmen are called here. Don't you think the expressions weesman and
weesvrouw ["orphan woman"] superb? It is not easy to do those charac-
ters one is always meeting in the streets' [269/R 14]. He enclosed a sketch
of the man with the annotation 'Nº 199' (fig. 31a), and it was that num-
ber that led to the identification of the man as Adrianus Jacobus
Zuyderland (1810-1897), a resident since 1876 of the Dutch Reformed
Old People's Home in Om en Bij in The Hague.[1] The drawing on which
this sketch is based shows Zuyderland's distinctive muttonchop
whiskers. There is also a profile study in which he is wearing the num-
ber 199 on his sleeve.

Visser noted in his article on Van Gogh's Hague period that the
male residents of the old people's home were known locally as 'alms-
men.' They wore long black overcoats and top hats, as can be seen in a
whole series of studies of Zuyderland and other elderly models, and did

indeed display a number on their clothing. The term *weesman* was in fact reserved for the men who passed their declining years in the Roman Catholic Orphanage and Old People's Home in Warmoezierstraat (who wore neither numbers nor a black top hat). The above extract from the letter to Van Rappard shows that Van Gogh paid little heed to the distinction between the two terms, assuming he was even aware of it, for he was not a native of The Hague. In any event, all his models came from the Dutch Reformed Old People's Home with its distinctive uniform, which is also seen in a contemporary photograph *(fig. 31b)*.

Van Gogh paid the men 'a few quarters for an afternoon or morning' [273/238]. This relatively anonymous source of income would have been very welcome to these particular models, for financially (and in other respects) they were kept on a tight rein in the home.[2] Van Gogh was not always able to get hold of them, for they were only allowed out from 9.30 to 5.30 on Sundays, Wednesdays and Christian feast days, with the men having an extra day out on Fridays.[3]

There is no model in Van Gogh's œuvre who is depicted in so many ways as Zuyderland. He can be recognised in drawings of a single figure, groups and in studies of heads. He appears in different outfits and poses and with various attributes. In this study of September or November 1882 he is wearing the formal overcoat with the two rows of buttons that was probably part of the official uniform (see *fig. 31b*).[4] Instead of a top hat he is wearing a cap, as he is in several other drawings. It is difficult to say whether it is always the same one, and whether it was his own or came from Van Gogh's stock of attributes. His eyes, oddly, are closed. The reason for this is unclear but it was probably unintentional. Other studies show that Zuyderland had rather small, heavily lidded eyes, and the simple explanation may be that Van Gogh was unable to depict them properly on this occasion.

Van Gogh must nevertheless have been pleased with this study, for in early November he selected it from the portfolios of his own work for the first of six experiments with lithography. The drawing bears traces of the squaring that was associated with viewing a subject through a perspective frame, and Van Gogh used that grid again for copying the drawing onto the transfer paper, which was then impressed on the lithographic stone. The print differs from the drawing only in minor details *(fig. 31c)*, but some of them are quite important in that they indicate what Van Gogh felt was lacking in the original drawing. Zuyderland's eyes are now open, his stick is shorter and rests on the ground, as can be seen from the shadow. On his lapel is a medal, the 'metal cross' awarded to

no. 107; 1948 Bergen & Oslo, no. 69; 1948-49 The Hague, no. 177; 1953 Zürich, no. 8; 1953 The Hague, no. 10; 1953 Otterlo & Amsterdam, no. 13; 1953-54 Saint Louis, Philadelphia & Toledo, no. 21; 1954-55 Bern, no. 80; 1955 Antwerp, no. 28; 1955 Amsterdam, no. 7; 1957 Nijmegen, no. 8; 1957 Stockholm, no. 10; 1958-59 San Francisco, Los Angeles, Portland & Seattle, no. 91; 1960 Enschede, no. 7; 1961-62 Baltimore, Cleveland, Buffalo & Boston, no. 86; 1962-63 Pittsburgh, Detroit & Kansas City, no. 86; 1963 Sheffield, no. 15; 1964 Zundert, no. 3; 1965-66 Stockholm & Gothenburg, no. 63; 1967 Wolfsburg, no. 84; 1967-68 Dallas, Philadelphia, Toledo & Ottawa, no. 5; 1968 Liège, no. 5; 1968-69 London, no. 11; 1974 Florence, no. 10; 1975 Malmö, no. 8; 1976 Stockholm, no. 8; 1976 Oslo, no catalogue; 1976-77 Tokyo, Kyoto & Nagoya, no. 7; 1977 Paris, unnumbered; 1980-81 Amsterdam, no. 62; 1990 Otterlo, no. 47; 1995 Amsterdam, ex catalogue.

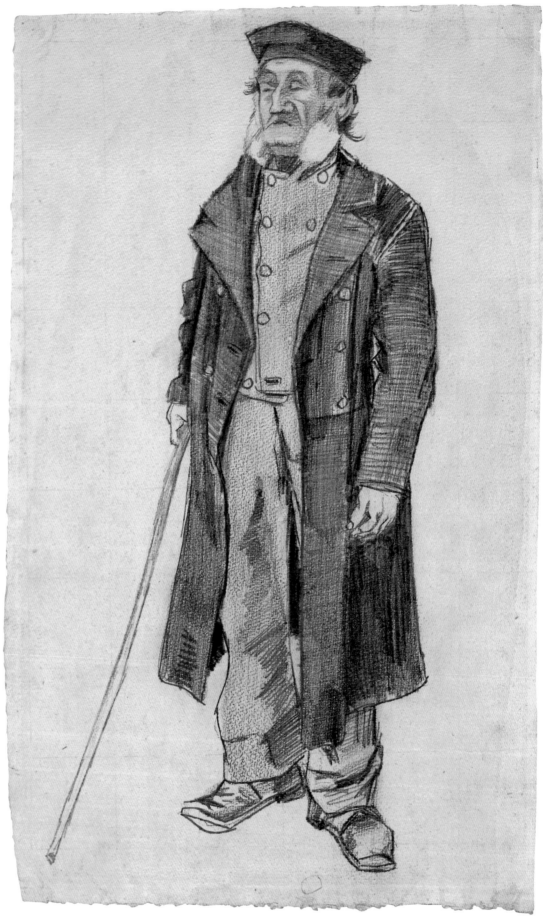

31 Old man with a stick

veterans of the war that led to Belgian independence in 1830-31.[5] The dress is a little more detailed. The waistcoat and coat are slightly different, and whereas the drawing only shows a patch by the ankle of the right leg, the lithograph also has one by the knee.

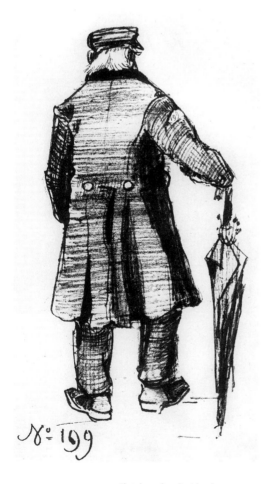

31a Sketch enclosed with a letter to Anthon van Rappard of c. 22 September 1882 (269/R 14). Whereabouts unknown.

1 *F 954 JH 287. It was from this drawing that the man was identified in Visser 1973, pp. 62-65. All the residents of the old people's home had a number which they were required to wear so that it was visible at all times.*

2 *These elderly people had to observe strict rules and were answerable in almost every respect to 'the Father and the Mother,' as the supervisors were cosily described in the regulations. Article 14 stipulated that paid work could only be undertaken with the approval of the Father or Mother, and if it was done outside the home the permission of the board of governors was also required. Any payment had to be handed over to the Father of the home, and 'provided the governors agree, part of it can be paid out to the resident,'* Reglement van orde en tucht voor de verpleegden in het Diakonie Oude Mannen- en Vrouwenhuis te 's-Gravenhage, *preserved in the archives of the Diaconie der Nederlands Hervormde Gemeente 's-Gravenhage, archive no. 133, no. 1646 in the Hague City Archives.*

3 *Ibidem, Article 7.*

4 *Ibidem, Article 10, decreed that 'Residents may not wear any outer clothing outside the home other than that supplied by the governors.' For Van Gogh's collection of attributes see the Introduction.*

5 *Visser 1973, pp. 63-64.*

31b Photograph of elderly residents of
the Dutch Reformed Old People's
Home in The Hague. The Hague City
Archives.

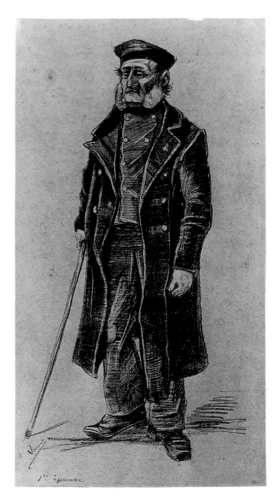

31c *Old man with a stick* (F 1658 JH 256),
1885. Amsterdam, Van Gogh Museum.

32 Old man drinking coffee

Like the preceding sheet, this *Old man drinking coffee* dates from September-November 1882. It once again shows Adrianus Zuyderland, who posed for Van Gogh from September that year. Around 20 November the artist used this drawing as the basis for his fourth lithograph, so it must have been made before then. Actually, it is not absolutely certain that the print was based on this particular version, for there is another, more finished variant. The latter was more probably the model, for the handle of the cup is visible in both, whereas here it is hidden by the man's hand.[1] However, it has to be said that this drawing could only be examined from a rather poor reproduction, so no definitive decision can be reached.

The missing handle is the only significant difference between the sheet in the Van Gogh Museum and the print. The drawing still has faint traces of the grid associated with the use of a perspective frame but given the uncertainty over which sheet was the model for the lithograph it is not clear at the moment whether it was also used to copy the drawing onto the transfer paper.

Van Gogh also drew Zuyderland from various angles for this subject of a coffee-drinker, but it is not known how often. In addition to the sheet in the Van Gogh Museum and its variant, there is a drawing in Otterlo in which the man is in a different pose and is sitting astride his chair *(fig. 32a)*.

The drawing was restored at some stage, although when and by whom is not known. Up until then, like most of the pencil studies from this period, the figure was probably surrounded by a large stain – the result of Van Gogh fixing the image with milk and giving it a matt appearance. It seems that the restorer used quite a lot of liquid. The sheet was fairly well preserved at the places where it had been fixed, but the fixative discolouration was removed. Where there was no fixative the paper became smudged and grubby as a result of this treatment, which also all but removed the annotation 'del' (delineavit: drew this), which is rare in Van Gogh's work.

At the end of 1963 this *Old man drinking coffee* was offered to V.W. van Gogh by A. Sarkissian of Paris, whereupon it was acquired for the Vincent

SEPTEMBER-NOVEMBER 1882

Pencil, scratched, on watercolour paper
Traces of squaring
49.4 × 28.6 cm
Watermark: DAMBRICOURT FRERES
Signed at lower left: Vincent del [the last word has disappeared almost entirely]

Inv. d 77 V/1964
SD 1682 JH 263

PROVENANCE
Sarkissian; until 1964
A. Sarkissian, Paris; 1964 bought by the Theo van Gogh Foundation; 1964 Vincent van Gogh Foundation; 1964-73 on loan to the Stedelijk Museum, Amsterdam; 1973 on permanent loan to the Van Gogh Museum, Amsterdam.

LETTERS
287/246, 289/R18.

LITERATURE
Museumjournaal 1968, pp. 42-45; De la Faille 1970, p. 576; Visser 1973, pp. 62-65; Hulsker 1980, pp. 64-65, no. 263; Amsterdam 1987, p. 393, no. 2.159; De la Faille 1992, vol. 1, p. 449, vol. 2, pl. CCXLVII; Van Heugten / Pabst 1995, p. 50.

EXHIBITIONS
1968-69 London, no. 16; 1969
Humlebaek, no. 6; 1969-70 Los
Angeles, Saint Louis, Philadelphia
& Columbus, no. 4; 1970-71
Baltimore, San Francisco & New
York, no. 72; 1974-75
Nottingham, Newcastle-upon-
Tyne, London, Leigh, Sheffield,
Bradford, Brighton & Reading,
no. 102; 1975 Amsterdam, no.
102; 1976-77 Tokyo, Kyoto &
Nagoya, no. 6; 1983-84
Amsterdam, no catalogue; 1995
Amsterdam, ex catalogue.

*1 The drawing is F 996a JH 264. I failed
to spot this detail in Van Heugten / Pabst
1995, cat. 4, and consequently was firm in
identifying the sheet in the Van Gogh
Museum as the model for the print.*
*2 See the letter from A. Sarkissian to
V.W. van Gogh of 12 December 1963
(Van Gogh Museum archives). His name
is incorrectly spelt 'Sirkissian' in the
provenance given in De la Faille 1970.
The funds of the Theo van Gogh
Foundation were also used for the pur-
chase, as they were on several occasions
when a work had to be acquired quickly.*
*3 Letter from Knud W. Jensen to V.W. van
Gogh of 18 March 1964 (Van Gogh
Museum archives). The exhibition was
1963 Humlebaek.*

van Gogh Foundation.[2] It had been in the Sarkissian family from the beginning of the century, and had never appeared in an exhibition or at auction. The purchase was made possible by a financial donation from the Louisiana Museum in Humlebaek (Denmark), where the Vincent van Gogh Foundation had exhibited several works from its collection in 1963.[3]

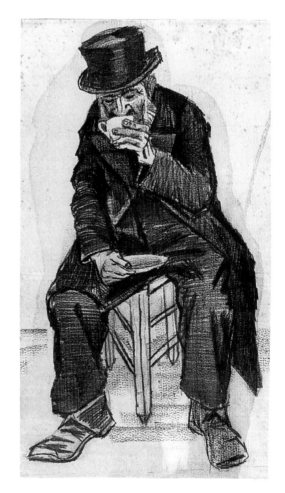

32ª *Old man drinking coffee* (F 976
JH 265), 1882. Otterlo, Kröller-Müller
Museum.

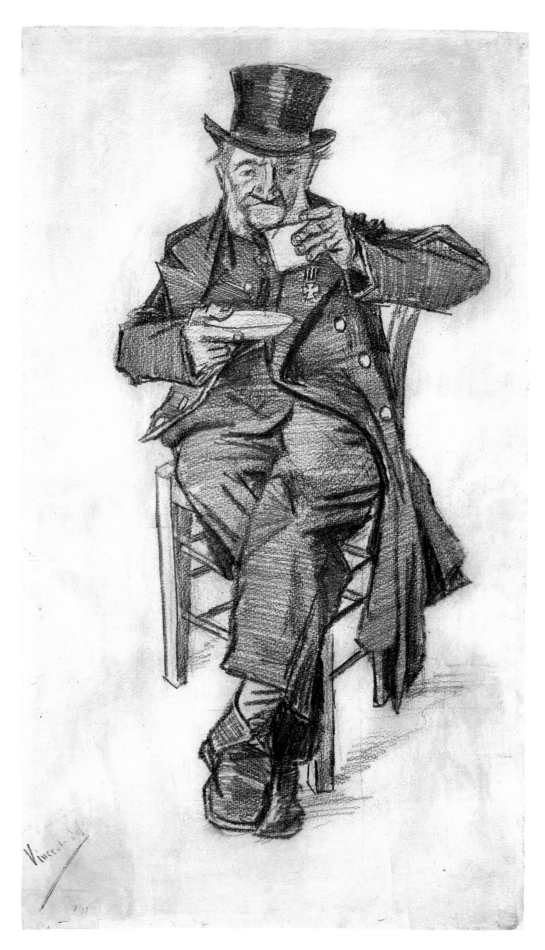

32 Old man drinking coffee

33 Old man in a tail-coat

SEPTEMBER-DECEMBER 1882

Pencil, scratched, on wove paper
Traces of squaring, fixative dis-
colouration around the figure
47.4 × 26.0 cm
Embossed stamp: CANSON &
MONTGOLFIER VIDALON-LES-
ANNONAY
Unsigned

Inv. d 380 V/1962
F 960 JH 241

PROVENANCE
1890-91 T. van Gogh; 1891-1925
J.G. van Gogh-Bonger; 1925-62
V.W. van Gogh; 1931-62 on loan
to the Stedelijk Museum,
Amsterdam; 1962 Vincent van
Gogh Foundation; 1962-73 on
loan to the Stedelijk Museum,
Amsterdam; 1973 on permanent
loan to the Van Gogh Museum,
Amsterdam.

LITERATURE
De la Faille 1928, vol. 3, p. 32,
vol. 4, pl. XXXIV; Vanbeselaere
1937, pp. 88-89, 170, 408; Wadley
1969, p. 27; De la Faille 1970,
p. 359; Visser 1973, pp. 62-65;
Chetham 1976, p. 29; Hulsker
1980, p. 61, no. 241; Amsterdam
1987, p. 391, no. 2.151; Van der
Mast / Dumas 1990, pp. 128, 130;
De la Faille 1992, vol. 1, pp. 32,
247-48, vol. 2, pl. XXXIV.

EXHIBITIONS
1905 Amsterdam, no. 457; 1914-15
Amsterdam, no. 35; 1931 Amster-
dam, no. 113; 1947 Groningen, no.
5; 1947 Rotterdam, no. 8; 1949-50
New York & Chicago, no. 23; 1953
Zürich, no. 7; 1954-55 Bern,

This is one of seven studies showing Adrianus Zuyderland obliquely or squarely from the back.[1] He now has a top hat and a walking-stick, as he has in several other drawings, and is wearing a tail-coat. To our eyes, the latter, which he wears only in this and the next study, gives him a slightly more elegant air in combination with the top hat than he has in most of the other figure studies. This effect is heightened by the walking-stick. That, though, is a distorted view. Today we associate a top hat and a tail-coat (or the black formal topcoat that the residents of the old people's home had to wear) with stylishness and wealth. In this case, though, that would be an incorrect interpretation, for Van Gogh's contemporaries would have been in no doubt at all that the smartly turned-out old men like the one in a photograph from the period (*fig. 32b*) were poor people dependent on charity.

33ª *Beach scene* (F 982 JH 247), 1882.
Private collection.

This sheet belongs to the large group of pencil drawings, most of them matted with milk, that Van Gogh made of this model in September-December 1882. He scratched away the graphite slightly at lower right in the coat and rubbed it in the trousers and shoes. There is some opaque white watercolour on the latter, but it serves no purpose and is unintentional. Van Gogh probably used this or a comparable but lost study in the foreground of a watercolour of the beach at Scheveningen, where there is a very similar figure seen from the back, but without a stick and with a woman on his arm *(fig. 33a)*.

For the dating see catalogue number 31.

no. 79; 1955 Antwerp, no. 30; 1957 Nijmegen, no. 7; 1957 Stockholm, no. 9; 1958-59 San Francisco, Los Angeles, Portland & Seattle, no. 90; 1960 Enschede, no. 6; 1961-62 Baltimore, Cleveland, Buffalo & Boston, no. 85; 1962-63 Pittsburgh, Detroit & Kansas City, no. 85; 1966 Paris & Albi, no. 4; 1967 Lille & Zürich, no. 5; 1971-72 Paris, no. 117; 1975 Malmö, no. 7; 1976 Stockholm, no. 7; 1990 The Hague, unnumbered.

1 *In addition to this sheet they are F 968 JH 213, F 953 JH 234, F 972a JH 239, F 974 JH 246, F 965 JH 298 and F 979 JH 314. F 978a JH 240, which was included in the 1970 edition of De la Faille, also shows him from the back, but there are doubts about the existence of that drawing. It could be a smaller variant of F 972a JH 239, but comparison of illustrations of the two works reveals such a close correspondence, right down to the tiniest details, that F 978a must be a photographic reproduction of F 972a.*

33 Old man in a tail-coat

34 Old man in a tail-coat

34 Old man in a tail-coat

SEPTEMBER-DECEMBER 1882

Pencil on wove paper
Traces of squaring, fixative dis-
colouration around the figure
47.2 × 23.5 cm
Unsigned

Inv. d 65 V/1962
F 977 JH 243

PROVENANCE
1890-91 T. van Gogh; 1891-1925
J.G. van Gogh-Bonger; 1925-62
V.W. van Gogh; 1931-62 on loan
to the Stedelijk Museum, Amster-
dam; 1962 Vincent van Gogh
Foundation; 1962-73 on loan to
the Stedelijk Museum, Amsterdam;
1973 on permanent loan to the
Van Gogh Museum, Amsterdam.

LITERATURE
Lettres 1911, pl. XXI; De la Faille
1928, vol. 3, p. 36, vol. 4, pl. XXXVII;
Vanbeselaere 1937, pp. 88, 90,
170, 192, 409; De la Faille 1970,
p. 363; Visser 1973, pp. 62-65;
Hulsker 1980, p. 61, no. 243;
Amsterdam 1987, p. 391, no.
2.152; De la Faille 1992, vol. 1,
pp. 36, 252, vol. 2, pl. XXXVII.

EXHIBITIONS
1905 Amsterdam, no. 250; 1914-15
Amsterdam, no. 24; 1923 Utrecht
& Rotterdam, no. 85; 1924 Basel,
no. 80; 1924 Zürich, no. 80; 1924
Stuttgart, no. 5; 1925 The Hague,
no. 57; 1928 Paris, no. 15; 1929
Amsterdam, no. 6; 1931 Amster-
dam, no. 110; 1932 Manchester,
no. 54; 1947 Groningen, no. 9;
1947 Rotterdam, no. 12; 1955
Antwerp, no. 27; 1957 Nijmegen,
no. 10; 1965-66 Stockholm &
Gothenburg, no. 64; 1967
Wolfsburg, no. 85; 1990
The Hague, unnumbered.

This study may have been drawn during the same session as the preced-
ing sheet, for Zuyderland once again has a top hat and a walking-stick
and is wearing the same coat (the tails can be glimpsed beside and
between his legs). The paper is very similar, although in this case it has
turned browner.[1] In catalogue number 31 Zuyderland's eyes appear com-
pletely closed, and here they are only slightly opened. The vagueness of
the left eye is due to the milk that Van Gogh spread lavishly over the
drawing, white traces of which can be seen throughout the figure. As in
the lithograph after catalogue number 31, the old man is wearing a medal
on his lapel (fig. 31c).

For the dating see catalogue number 31.

1 The embossed stamp is missing, but the
sheets are almost the same size and are
both 0.22 mm thick.

35 Old man reading

This is one of three drawings of men reading from Van Gogh's Hague period. He first depicted this age-old subject in October 1881 at Etten in a scene of a peasant reading a book by his hearth *(fig. 14a)*.[1] In December 1882 he wrote to Theo about another version of the subject: 'I have two new drawings now, one of a man reading the Bible, the other of a man saying grace before his midday meal, which is on the table. Both are certainly done with what you may call an old-fashioned sentiment – they are figures like the little old man with his head in his hands. The "Bénédicité" [Grace] is, I think, the best, but they complement each other. In one there is a view of the snowy, ploughed fields through the window' [295/253]. The companion to the 'Bénédicité' was undoubtedly the drawing of Adrianus Zuyderland standing with an open book in his hands *(fig. 35a)*. Both sheets are large and very detailed, both technically and in their composition. One problem, though, is that neither has a 'view of the snowy, ploughed fields through the window.' Its absence can be explained by the very peculiar, deep black passage at top left in the drawing of Zuyderland. It looks as if Van Gogh wanted to eliminate part of the composition which he later considered unsuccessful.[2]

The other Hague scenes of men reading are not so ambitious. The sheet in the Van Gogh Museum shows Adrianus Zuyderland wearing a cap and waistcoat and facing right as he reads a book that is resting on his knee. In the other drawing, now in the museum at Otterlo *(fig. 35b)*, he is again wearing a waistcoat but is bareheaded, facing left, and is resting his arms on his thighs as he reads. Both works are about the same size and are in pencil on similar paper. The one in the Van Gogh Museum also has a transparent watercolour wash in the trousers and waistcoat. It is now almost colourless but has a very light pink sheen. The perspective of the chair is decidedly odd. One would expect the side rungs to be parallel, but in fact they almost meet on the left, suggesting that the chair was considerably wider at the front than the back, which was a common type in the Netherlands. The same applies to the chair in the Otterlo sheet, although there the effect is less obvious. Something similar is seen in another drawing in the same collection.[3]

SEPTEMBER-DECEMBER 1882

Pencil, pale pink wash, on water-colour paper
Traces of squaring
48.0 × 28.9 cm
Unsigned

Inv. d 379 V/1962
F 966 JH 280

LITERATURE
De la Faille 1928, vol. 3, pp. 33-34, vol. 4, pl. XXXVI; Vanbeselaere 1937, pp. 88, 90, 409; De la Faille 1970, p. 361; Visser 1973, pp. 62-65; Hulsker 1980, pp. 69-71, no. 280; Amsterdam 1987, p. 395, no. 2.167; De la Faille 1992, vol. 1, pp. 33-34, 249, vol. 2, pl. XXXVI.

1 *It seems to me that this man is identical to the peasant, Schuitemaker, who posed for* Worn out; *see catalogue number 42.*

2 *I have not examined the* Prayer before the midday meal, F 1002 JH 281, *whose present whereabouts are unknown. It was sold at Christie's in New York on 12 May 1992. According to De la Faille it is in pencil and black chalk with white heightening, and measures 60 × 50 cm. The chalk (the auction catalogue says that it is charcoal but that is very unlikely, since Van Gogh rarely used it) is probably lithographic crayon, and judging from a large transparency the support is watercolour paper. The standing man reading a book is in a private collection and was examined in 1994. It is in pencil and lithographic crayon, with pen and brush in black ink and opaque white watercolour on watercolour paper, and measures 65.0 × 45.5 cm. There is no watermark. It had already been noted in De la Faille 1970 that the window may have been brushed over with dark wash. This deep black passage completely hides whatever may have been there originally.*

3 *F 1058 JH 348.*

4 *The* Woman reading a novel *is F 497 JH 1632. Scenes in which people have books as attributes but are not reading them have been omitted from this discussion.*

Van Gogh only once returned to the subject of a person reading, and that was in his *Woman reading a novel* from the Arles period. That, though, is a poetic scene, and is in a totally different category to the working-class folk from The Hague.[4]

For the dating see catalogue number 31.

35a *Old man reading* (F 1683 JH 279), 1882. Private collection.

35b *Old man reading* (F 1001 JH 278), 1882. Otterlo, Kröller-Müller Museum.

35 Old man reading

36 Man and woman seen from the back

SEPTEMBER-DECEMBER 1882

Pencil on watercolour paper
Traces of squaring, fixative dis-
colouration around the figures
49.8 × 31.0 cm
Watermark: DAMBRICOURT FRERES
Unsigned

Inv. d 435 V/1962
F 991 JH 233

PROVENANCE
1890-91 T. van Gogh; 1891-1925
J.G. van Gogh-Bonger; 1925-62
V.W. van Gogh; 1931-62 on loan to
the Stedelijk Museum, Amsterdam;
1962 Vincent van Gogh Foundation;
1962-73 on loan to the Stedelijk
Museum, Amsterdam; 1973 on
permanent loan to the Van Gogh
Museum, Amsterdam.

LITERATURE
Lettres 1911, pl. XXXVI; De la Faille
1928, vol. 3, p. 39, vol. 4, pl. XLII;
Vanbeselaere 1937, pp. 91, 190-91,
409; De la Faille 1970, p. 367; Am-
sterdam 1987, p. 392, no. 2.156;
Hulsker 1989, p. 59, no. 233; Van
der Mast / Dumas 1990, p. 128; De
la Faille 1992, vol. 1, pp. 39, 255-
56, vol. 2, pl. XLII.

Exhibitions
1905 Amsterdam, no. 242; 1914-15
Amsterdam, no. 23; 1923 Utrecht
& Rotterdam, no. 77; 1929 Amster-
dam, no. 8; 1930 Laren, no. 5; 1931
Amsterdam, no. III; 1932
Manchester, no. 50; 1947 Gronin-
gen, no. II; 1947 Rotterdam, no.
14; 1948-49 The Hague, no. 180;
1953 Zürich, no. II; 1953 Zundert,
no. 38; 1953 Hoensbroek, no. 74;
1953 Assen, no. 32; 1953-54 Bergen
op Zoom, no. 13; 1954-55 Bern,
no. 82; 1955 Antwerp, no. 38;
1955 Amsterdam, no. II; 1955-56
Liverpool, Manchester & Newcastle-
upon-Tyne, no. 86; 1958-59 San
Francisco, Los Angeles, Portland
& Seattle, no. 93; 1960 Enschede,
no. 9; 1961-62 Baltimore,
Cleveland, Buffalo & Boston,
no. 88; 1962-63 Pittsburgh, Detroit
& Kansas City, no. 88; 1965
Charleroi & Ghent, no. 45; 1966
Paris & Albi, no. 7; 1967 Lille &
Zürich, no. 8; 1967-68 Dallas,
Philadelphia, Toledo & Ottawa,
no. 8; 1968 Liège, no. 8; 1968-69
London, no. 13; 1971-72 Paris, no.
120; 1972 Bordeaux, no. 42; 1977
Paris, unnumbered; 1980-81
Amsterdam, no. 63; 1990 Otterlo,
no. 51.

The man in this drawing is undoubtedly Adrianus Zuyderland, who is instantly recognisable, here and elsewhere, from his large ears and mut-tonchop whiskers. He is wearing the cap in which he often posed. The woman, whose cap, coat and shawl suggest that the couple are out for a stroll, is unrecognisable. She is certainly not Zuyderland's wife, for he was a widower when he was admitted to the old people's home in 1876.[1] Scenes like this, which appear to be taken directly from life but were in fact composed in the studio, were intended for use in later compositions. In a letter of October 1882 Van Gogh wrote that he had made a drawing of 'a man and a woman arm-in-arm' [273/238], but that description is too cursory for it to be taken as referring to this sheet. A wide margin has therefore been chosen for the dating (see *cat. 31*).

Above the man's left shoulder are some pencilled lines where Van Gogh first started sketching the figure before restarting a few centimetres lower down.

1 *Visser 1973, p. 63.*

36 Man and woman seen from the back

37 Woman with a broom

SEPTEMBER-DECEMBER 1882

Pencil, grey wash, on watercolour
paper
Traces of squaring
49.1 × 27.6 cm
WATERMARK: HALLINES 1877
Unsigned

Inv. d 75 V/1962
F 1074 JH 249

PROVENANCE
1890-91 T. van Gogh; 1891-1925
J.G. van Gogh-Bonger; 1925-62
V.W. van Gogh; 1962 Vincent van
Gogh Foundation; 1962-73 on
loan to the Stedelijk Museum,
Amsterdam; 1973 on permanent
loan to the Van Gogh Museum,
Amsterdam.

LITERATURE
De la Faille 1928, vol. 3, p. 57,
vol. 4, pl. LXI; Vanbeselaere 1937,
pp. 90, 176, 410; De la Faille
1970, pp. 392-93; Hulsker 1980,
p. 63, no. 249; Amsterdam 1987,
p. 392, no. 2.158; De la Faille 1992,
vol. 1, pp. 57, 275, vol. 2, pl. LXI.

EXHIBITIONS
1905 Amsterdam, no. 244; 1914-
15 Amsterdam, no. 36; 1927-28
Berlin, Vienna & Hannover, no.
8; 1928 Paris, no. 8? (possibly
cat. 38); 1968-69 London, no. 8.

This and the following drawing of a woman sweeping are among the studies of men and women that Van Gogh drew in September-December 1882, usually with pencil on watercolour paper. He had already experimented with the subject back in Etten, for he wrote telling Theo that the various figure studies he had made there included two of a girl with a broom.[1] Although those drawings are lost, two that have survived from that period show a man with a broom, one as a figure on his own, the other sweeping in a country lane.[2]

The anonymous woman who posed for this sheet cannot be firmly identified in other drawings. She has dressed for her work by putting on a long apron to keep the dust off her clothes and a simple cap to protect her hair.

For the dating see catalogue number 31.

1 *Letter 171/150.*
2 *F 890 JH 45 and F 1678 JH 46 respec-*
tively. The figures are almost identical,
although the man in the lane is much
smaller. The larger figure study probably
served to furnish the landscape with a figure.

38 Woman with a broom

The fact that this woman is bending towards the viewer makes it difficult to identify her. As far as can be made out she is not the same as the one in the previous sheet. Her clothing is certainly different, for her counterpart has a striped jacket and a cap, while the woman in this sheet appears to have a plain jacket and a scarf to protect her hair from the dust. The long aprons the women are wearing to protect their skirts, though, are identical. There is also a small difference between the brooms. The bundle of twigs in the previous drawing is held together by three separate lengths of twine wrapped several times around the bundle, with a fourth piece at the bottom to prevent the ends of the twigs from spreading out too much. That last length of twine is missing in this broom, which is sketched with less finish. Here Van Gogh concentrated on capturing the woman's pose, which is a more difficult one than the side view of the other woman. He had to find a way of handling the awkward perspective of someone bending forwards slightly, towards the viewer, with the left arm severely foreshortened.

This time far more attention is paid to the shadowed effect. Van Gogh gave the woman's dress and the left background a green wash. For the dating see catalogue number 31.

SEPTEMBER-DECEMBER 1882

Pencil, green wash, on watercolour paper
Traces of squaring
45.5 × 23.3 cm
Watermark: HALLINES
Unsigned

Inv. d 76 V/1962
F 1075 JH 224

PROVENANCE
1890-91 T. van Gogh; 1891-1925 J.G. van Gogh-Bonger; 1925-62 V.W. van Gogh; 1962 Vincent van Gogh Foundation; 1962-73 on loan to the Stedelijk Museum, Amsterdam; 1973 on permanent loan to the Van Gogh Museum, Amsterdam.

LITERATURE
De la Faille 1928, vol. 3, p. 57, vol. 4, pl. LXI; Vanbeselaere 1937, pp. 90, 176, 410; De la Faille 1970, pp. 392-93; Hulsker 1980, p. 58, no. 224; Amsterdam 1987, p. 390, no. 2.147; De la Faille 1992, vol. 1, pp. 57, 275, vol. 2, pl. LXI.

EXHIBITIONS
1905 Amsterdam, no. 235; 1914-15 Amsterdam, no. 6; 1928 Paris, no. 8? (possibly cat. 37); 1947 Rotterdam, no. 23; 1948-49 The Hague, no. 179; 1953 Zürich, no. 19; 1953-54 Bergen op Zoom, no. 21; 1990 The Hague, unnumbered.

37 Woman with a broom

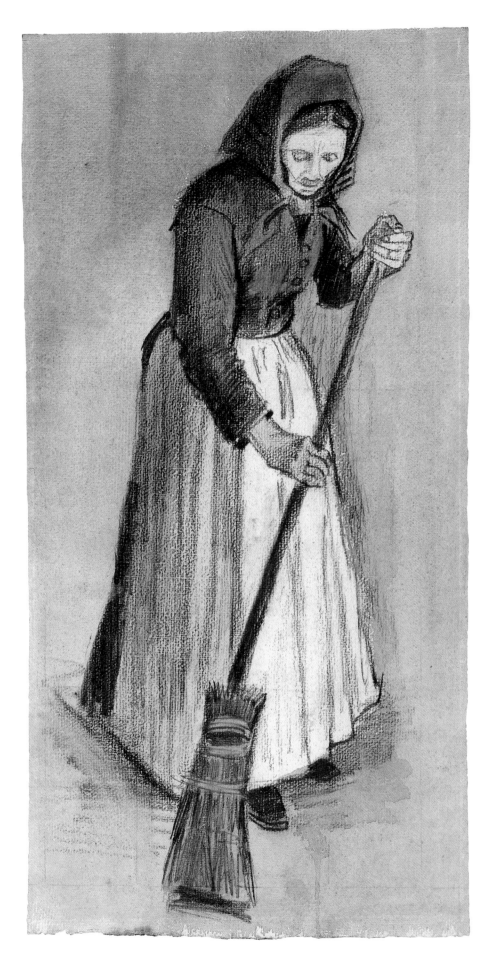

38 Woman with a broom

39 The poor and money

SEPTEMBER-OCTOBER 1882

Black chalk and opaque water-
colour, pen in black ink, on
wove paper
37.9 × 56.6 cm
Unsigned

Inv. d 376 V/1962
F 970 JH 222

PROVENANCE
1890-91 T. van Gogh; 1891-1925
J.G. van Gogh-Bonger; 1925-62
V.W. van Gogh; 1931-62 on loan
to the Stedelijk Museum,
Amsterdam; 1962 Vincent van
Gogh Foundation; 1962-73 on
loan to the Stedelijk Museum,
Amsterdam; 1973 on permanent
loan to the Van Gogh Museum,
Amsterdam.

LETTERS
271/235, 274/237.

LITERATURE
Van den Eerenbeemt 1924,
pp. 274, 281; De la Faille 1928,
vol. 3, p. 34, vol. 4, pl. XXXVI;
Vanbeselaere 1937, pp. 86, 164,
409; Cooper 1955, pp. 24-26;
Jaffé 1968, pp. 383-87; Wadley
1969, p. 28; De la Faille 1970,
p. 362; Visser 1973, p. 81;
Chetham 1976, p. 28; Hulsker
1980, pp. 58, 60, 62, 67, no.
222; Pollock 1983, p. 349;
Amsterdam 1987, pp. 116-17,
390, no. 2.149; Van der
Mast / Dumas 1990, pp. 125,
127; De la Faille 1992, vol. 1,
pp. 34, 250, vol. 2, pl. XXXVI.

Around 1 October 1882 Van Gogh wrote to his brother telling him that
he was hard at work on some watercolours, one of which was this sheet,
the museum's only large watercolour from Van Gogh's Hague period.
It shows a number of people who have gathered outside an office of
the State Lottery to check the winning numbers in the latest draw, as
announced by the poster on the left: 'HEDEN TREKKING STAATSLOTERIJ'
(State Lottery draw today). Van Gogh is vague in his description of the
scene about what is actually going on. He was working on the drawing
at the time, and he speaks of both 'Heden trekking' – the announcement
of the winning numbers – and the sale of 'lottery tickets' [271/235]. Nothing
can be seen of the latter in the drawing, so we can assume that the people
have indeed flocked to the office to find out whether their number has
come up.

The lottery, which is run by the Dutch state, was the only one per-
mitted in the Netherlands since the 18th century. Because the tickets
were quite expensive, fractions of a ticket were also sold (as they are in
the Dutch State Lottery even today). Thus a winning number may only
have been worth that same fraction of the prize, but this did enable
poorer people to try their luck, as can be seen in Van Gogh's drawing.[1]

Vincent not only enclosed a sketch of the scene in his letter to Theo
(fig. 39a), but also gave a detailed account of the event itself. One rainy
morning he had seen a crowd of people flocking together outside the lot-
tery office run by the Mooijman brothers (whom he incorrectly calls
Mooiman) in Spuistraat – at No. 17, as Visser later discovered.[2] He had
been struck by the poverty of most of the people there, which gave the
scene a deeper meaning. 'For it becomes more meaningful, I think, if
one looks on it as *the poor and money*. So it is, indeed, with almost all
groups of figures: you really have to think before you realise what you are
actually seeing. The curiosity and illusion about the lottery seem rather
childish to us, but it becomes serious when one considers the contrasting
element of misery and this sort of forlorn effort by poor wretches who
imagine that salvation lies in going short of food for the sake of a lottery
ticket' [271/235]. Laden with these associations, this was precisely the kind
of contemporary, social-realist subject that Van Gogh was looking for.

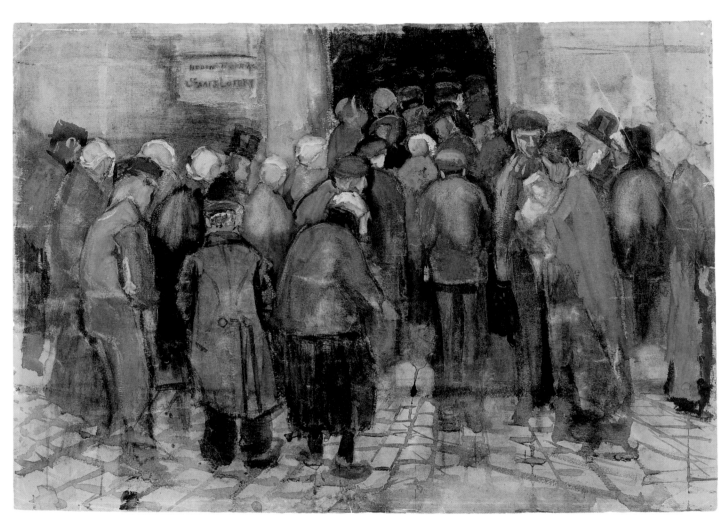

39 The poor and money

The highly literary title, *The poor and money*, is also comparable to the eloquent, anecdotal titles used by artists whom Van Gogh admired, among them Luke Fildes (1844-1927), Hubert Herkomer (1849-1914) and, in Holland, Jozef Israëls (1824-1911).

Several authors have remarked on both the similarities and differences between this drawing and George Breitner's *Soup kitchen* watercolour of the same year *(fig. 39b)*.[3] The two artists had met in The Hague and sometimes went out together in search of suitable subjects. They also knew each other's work. Both scenes had been discovered out on the streets, as it were, and both deal with a crowd of poor people. It is impossible to say whether Breitner (1857-1923) had a direct influence on Van Gogh's choice of subject and composition. The wood engravings by English illustrators that Van Gogh had in his collection would certainly have provided him with ample material for such a scene, both for the subject and the composition. One very similar work, for instance, is *A queue in Paris (fig. 39c)* by William Small (1843-1929), and another is Luke Fildes's *Houseless and hungry*. Van Gogh had learned from experience how difficult it was to make such a large number of figures in different poses look natural. He had recently been concentrating on depictions of 'people in groups': 'But how difficult it is to give them life and movement, and to put the figures in their places yet to separate them from each other. It is that great problem, to *moutonner* groups of figures of which, although they form a whole, the heads or shoulders of one rise

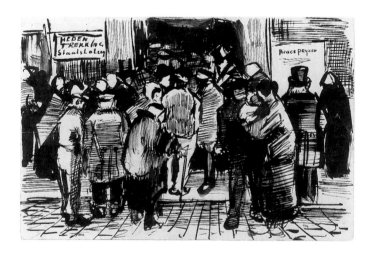

39ª Sketch in a letter to Theo of
c. 1 October 1882 (271/235).
Amsterdam, Van Gogh Museum.

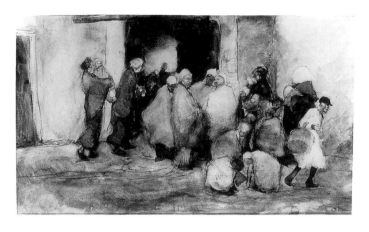

39ᵇ George Hendrik Breitner, *Soup kitchen*, 1882. Amsterdam, Stedelijk Museum.

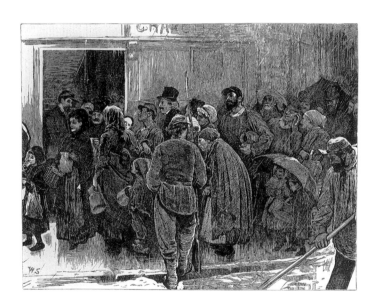

39ᶜ William Small, *A queue in Paris*, from: *The Graphic*, 11 March 1871, p. 271. Amsterdam, Van Gogh Museum.

1 For more information on the State Lottery in the 19th century see H. Houtman-De Smedt, 'Noordwest-Europa in de ban van het loterij- en lot-tospel tijdens de 18e en de 19e eeuw,' in Loterijen in Europa: vijf eeuwen geschiedenis, Ghent 1994, pp. 137-85.
2 Visser 1973, p. 81. Visser also spells the name wrong, Mooyman instead of Mooijman, and states merely that 'C.J.M. Mooyman' lived at that address. It was in fact a business run by the brothers Cornelis Josephus Machiel Mooijman and Jacobus Wilhelmus Mooijman. That is how they are recorded in the 1879-82 gazetteer of The Hague, as I.M. uit de Bos-van der Naaten told Jan Hulsker in a letter of 3 May 1990. Mr Hulsker was so kind as to give the Van Gogh Museum a copy of that letter.
3 See Jaffé 1968 and Amsterdam 1987, no. 11 on pp. 116-17.
4 It is not known where Van Gogh found the word 'moutonner' used in this sense. In everyday French it is applied to things tightly packed together, like the curls of a sheep's fleece, but not to a flock of sheep.
5 Cassagne 1875, pp. 128-31, 263-66, 273-75.

above those of another, while in the foreground the legs of the first figures stand out strongly, and a little higher up the skirts and trouser-legs form a kind of confusion in which the lines are still quite visible. Then, to the right and left, depending on the vantage-point, the greater extension or shortening of the sides. As to the composition, all possible scenes with figures [...] are based on that same principle of the flock of sheep (from which the word *moutonner* is probably derived), and it all depends on the same problems of light and brown and perspective' [265/231].[4]

Van Gogh probably made sketches of the group of people he saw at the lottery office. The composition, though, was not conceived on the spot but was put together in the studio using his stock of studies for the figures. It is true that there is no convincing model for any of them, although the rear view of the man on the left wearing a tail-coat and cap and with hair extending down his neck does look like Adrianus Zuyderland (see *cat. 33*). He is probably based on a sheet that is now lost. Interestingly, the sketch in the letter does not correspond all that closely to the water-colour. The arrangement of the group is a little different, but what is more surprising is that on the far right in the sketch, by a poster with the words 'HOOGE PRIJZEN' (Big prizes), there is another man who resembles the figure of Zuyderland in catalogue number 33, although the walking-stick is missing. Van Gogh must have decided while doing the sketch that this passage was too distracting, for there is no trace of it in the finished sheet.

Van Gogh closed his letter to Theo with a description of the colours he had seen in the group of figures outside the lottery office. In his view, only paint or watercolour could do justice to them. This sheet is not a pure watercolour composed of transparent passages but is done with opaque watercolour which is sometimes very highly thinned. This makes it an *aquarelle gouachée*, which Van Gogh had read about in Cassagne's watercolour manual (see also *cat. 22*).[5] Visible at various places are thin lines of black chalk with which Van Gogh sketched the initial design of the scene. The text on the board beside the door is written with pen and black ink.

40 Miners in the snow: winter

In October 1882 Van Gogh sent his brother a series of four small water-colours illustrating the traditional theme of the four seasons. The subject of only one of them, this small sheet of miners in a snow-covered land-scape (representing *Winter)*, is mentioned in the accompanying letter. Van Gogh added: 'To complete the seasons, I am sending you a small rough sketch of the spring and another of the fall; they came into my mind while I was making the first one' [272/236]. It can be concluded from this that he sent Theo the complete set. *Summer* was a 'rapid sketch of a large watercolour,' as he said in the opening line of the letter. As far as can be made out from the letter this was the only one of the four that was based on a larger work. It is not known what it looked like for the sketch has disappeared, nor is there a large watercolour that can be firmly identified as the model. The 'sketch' of *Autumn* is also lost. *Spring*, like *Winter*, has survived, and is discussed in the next entry.

Van Gogh illustrated winter with a scene of miners in the snow – at first sight not a very likely subject, given that there were no mines any-where near The Hague. There were two reasons for the choice: Van Gogh's collection of magazine illustrations, and his memories of the time he had spent as an evangelist in the Borinage mining region of Belgium from 1878 to 1880. It is impossible to say whether the magazine illustra-tions reminded him of the Borinage or whether his memories led him to collect prints of miners.[1] Whatever the answer, in September 1882 he wrote to Anthon van Rappard (and a little later to Theo, in letter 273/238) telling him how much he admired a print after Alfred Roll, *Striking min-ers*, of circa 1881. He continued: 'I have gone to a lot of trouble to get things about miners. This and an English one of an accident are the most beautiful – but for the rest these subjects are rare – I wish I myself could make studies of them eventually. Do let me know, Rappard, but in all seriousness, whether, if I went away, for instance to the mining district of the Borinage for two months, you would like to come with me. It is rather a difficult stretch of country – such a journey is not a pleasure trip – but it is one of those things I should undertake with enormous plea-sure as soon as I feel I have gained more dexterity in drawing people in action with lightning speed – for I know that there are so many beautiful

OCTOBER 1882

Transparent and opaque water-colour, pen in brown ink, on wove paper
7.2 × 10.9 cm
Signed at lower left: Vincent
Verso: pencilled scribbles and numerals

Inv. d 278 V/1971
F 1202 JH 229

PROVENANCE
1882-91 T. van Gogh; 1891-1925 J.G. van Gogh-Bonger; 1925-62 V.W. van Gogh; 1962 Vincent van Gogh Foundation; 1962-71 with V.W. van Gogh, Laren; 1971-73 on loan to the Stedelijk Museum, Amsterdam; 1973 on permanent loan to the Van Gogh Museum, Amsterdam.

LETTER
272/236.

LITERATURE
De la Faille 1928, vol. 3, p. 84, vol. 4, pl. xcv; Vanbeselaere 1937, pp. 265, 353, 412; De la Faille 1970, p. 434; Hulsker 1980, p. 59, no. 229; Amster-dam 1987, p. 392, no. 2.154; De la Faille 1992, vol. 1, pp. 84, 306, vol. 2, pl. xcv.

EXHIBITION
1953 Zürich, no. 36.

1 *His collection of prints from magazines, which is now in the Van Gogh Museum, contains 15 featuring miners or conditions in salt or coal mines.*
2 *One important motif in that work is the distinctive way the women of the Borinage carried sacks of coal. The two corners at the bottom of the sack were tied together and looped over the forehead like a monk's cowl. Van Gogh described this practice in letter 278/R 16, complete with a small sketch.*
3 *F 986 JH 231, a boy seated on a barrel with a spade and a sack on his head, and F 987 JH 303, showing Adrianus Zuyderland with a pickaxe and a similar sack on his head. Both works are dated to October 1882 in De la Faille, which Hulsker follows for the first sheet but abandons for the second, shifting it to January 1883 but without giving an explanation. He was probably influenced by the materials used, for the latter is believed to be in black chalk (I have not been able to inspect it myself). If it is lithographic crayon that would indeed argue for a slightly later dating, since Van Gogh only started using that medium in December 1882. Ordinary chalk, though, would certainly not preclude a date around November of that year, and as far as the subject matter goes that would also be the more likely.*

things to be done there which have hardly, if ever, been painted by others' [264/R 12]. He never did return to the Borinage, but scenes of miners now made their appearance in his œuvre. *Miners in the snow: winter* was the first of them, and in November he incorporated a memory of the Borinage in a new winter scene *(fig. 40a)*.[2] Two associated figure studies must date from the same period,[3] but Van Gogh then dropped the subject.

It would not be easy to guess the occupation of the three men in the left foreground of *Miners in the snow: winter*, for the pickaxes two of them are carrying could be used for all kinds of work. In the background are some elongated, vertical shapes which are probably chimneys or the pit-head gear over the lift shafts, but they are too vague to be identified for certain. On the right is a fenced garden with two figures.

Although this is a remarkably small drawing, Van Gogh probably thought that it would appeal to a wide public, just like catalogue number 30. In any event, it is not just a rough sketch, whatever he said. It is carefully executed in watercolour and gouache, with the outlines in pen and ink, and moreover it was signed at lower left.

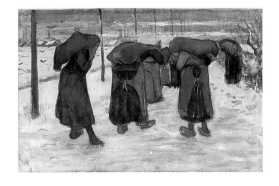

40a *Miners' wives* (F 994 JH 253), 1882. Otterlo, Kröller-Müller Museum.

41 Orchard in blossom with two figures: spring

This springtime scene comes from the same series of the four seasons as the previous work, *Miners in the snow: winter*. The motif of trees in blossom symbolising spring has a rich tradition, and Van Gogh's idea of including a young couple ties in neatly with the idea of new life awakening.

This drawing is almost the same size as the preceding one and is technically identical in its use of the rather non-purist mixed media technique of watercolour and gouache finished with pen and ink.

OCTOBER 1882

Transparent and opaque water-colour, pen in brown ink, on wove paper
5.8 × 10.6 cm
Signed at lower left: Vincent
Verso: pencilled scribbles

Inv. d 277 V/1971
F 1245 JH 230

PROVENANCE
1882-91 T. van Gogh; 1891-1925 J.G. van Gogh-Bonger; 1925-62 V.W. van Gogh; 1962 Vincent van Gogh Foundation; 1962-71 with V.W. van Gogh, Laren; 1971-73 on loan to the Stedelijk Museum, Amsterdam; 1973 on permanent loan to the Van Gogh Museum, Amsterdam.

LETTER
272/236.

LITERATURE
De la Faille 1928, vol. 3, p. 94, vol. 4, pl. cv; Vanbeselaere 1937, pp. 107, 412; De la Faille 1970, p. 443; Hulsker 1980, p. 59, no. 230; Amsterdam 1987, p. 392, no. 2.155; De la Faille 1992, vol. 1, pp. 94, 319, vol. 2, pl. cv.

EXHIBITION
1953 Zürich, no. 46.

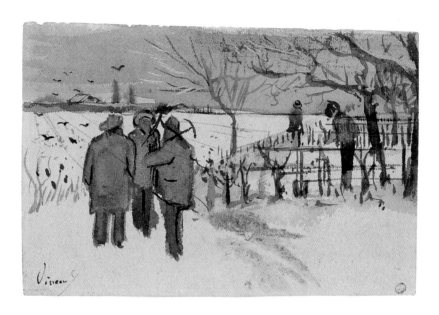

40 Miners in the snow: winter

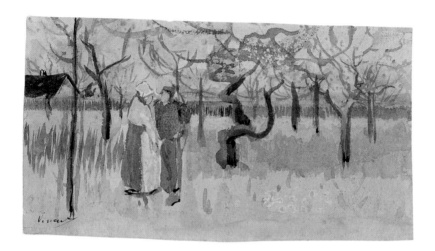

41 Orchard in blossom with two
figures: spring

42 Worn out

NOVEMBER 1882

Pencil on watercolour paper
Traces of squaring, fixative dis-
colouration around the figure
50.4 × 31.6 cm
Signed at lower left in black
chalk: Vincent

Inv. d 378 V/1962
F 997 JH 267

PROVENANCE
1890-91 T. van Gogh; 1891-1925
J.G. van Gogh-Bonger; 1925-62
V.W. van Gogh; 1931-62 on loan
to the Stedelijk Museum,
Amsterdam; 1962 Vincent van
Gogh Foundation; 1962-73 on
loan to the Stedelijk Museum,
Amsterdam; 1973 on permanent
loan to the Van Gogh Museum,
Amsterdam.

LETTERS
288/247, 289/R18, 290/248,
292/250, 293/251, 295/253.

LITERATURE
Bremmer 1904, no. 6, cover;
De la Faille 1928, vol. 3, p. 41,
vol. 4, pl. XLIII; Vanbeselaere
1937, pp. 94, 96, 185, 192, 409;
De Gruyter 1961, p. 96, fig. 14;
Wadley 1969, p. 28; De la Faille
1970, pp. 368-69; Chetham
1976, p. 26; Hulsker 1980,
pp. 66, 69, 444, no. 267;
Amsterdam 1987, p. 393,
no. 2.160; Feilchenfeldt 1988,
p. 127; De la Faille 1992, vol. 1,
pp. 41, 257, vol. 2, pl. XLIII;
Van Heugten / Pabst 1995,
pp. 23, 52.

When he drew this weary old man in November 1882 Van Gogh was returning to a subject that he had already explored in Etten. 'Today and yesterday I drew two figures of an old man sitting with his elbows on his knees and his head in his hands. I originally made it of Schuitemaker, and I kept the drawing because I wanted to make a better one some day. I might even make a lithograph of it. How beautiful an old workman like that is, with his patched bombazine clothes and bald head' [288/247].

Here Van Gogh is referring to a drawing called *Worn out* that he had made at Etten in September 1881. He took the title from a wood engraving of 1868 by Thomas Faed that he knew, and probably owned, and which he wrote about [282/242]. An agricultural worker, the Schuitemaker mentioned in the letter, posed for the Etten drawing of 'an old, sick peasant sitting on a chair near the hearth, his head in his hands and his elbows on his knees,' as he wrote in 1881 [171/150]. A colour sketch in the same letter gave Theo an even better idea of the subject *(fig. 42a)*. There is also a second, identical sketch, which was probably sent to Anthon van Rappard (1858-1892).[1] Neither of those sketches are of the Etten version of *Worn out (fig. 42b)*. There are two striking differences between the small sheets and the actual drawing. In the sketches the kettle stands amongst the wood of the fire with its spout to the left, and there is a spade leaning against the wall behind the man. In the drawing, the kettle hangs over the fire, its spout to the right, and there is no spade. Given the amount of detail, the letter sketches were quite definitely made after a second Etten version of the subject. Moreover, Van Gogh spoke of a 'large [drawing] of "Worn out"' to Van Rappard [175/R 2]. Since he often worked at that time on sheets of paper measuring some 60 by 40 centimetres (see *cats. 19-21*), such a description simply does not fit a sheet of a mere 23.5 by 31 cm. The lost version, with the addition of the spade, was more anecdotal than the one that has survived, for it suggests that the man is worn out by his hard toil. The version without the spade is not so much a snapshot from daily life, but has the rather more abstract connotation of a man worn down by his harsh and troubled life.

In The Hague, Van Gogh began experimenting with the subject again. He mentioned two studies to Theo, and a few days later he told

Van Rappard that he now had three, of two different models, and that he was planning to work on the subject further.[2] It is not known how many figure studies he eventually produced, but the only surviving sheet is the one in the Van Gogh Museum, for which Adrianus Zuyderland posed. Like the Etten variant, it is a generalised scene. The man beside the extinguished hearth lowers his weary head, but there is nothing in the scene to explain why he is so dispirited. Van Gogh used this sheet as the model for the lithograph he made a few days later. The grid he drew so that he could work with a perspective frame also served for copying the scene onto the transfer paper.[3] The lithograph differs little from the drawing; only the wood in the hearth is more detailed.

EXHIBITIONS

1905 Amsterdam, no. 246; 1910 Cologne & Frankfurt, no catalogue; 1914-15 Amsterdam, no. 29; 1923 Utrecht & Rotterdam, no. 78; 1927-28 Berlin, Vienna & Hannover, no. 14; 1930 Laren, no. 3; 1931 Amsterdam, no. 115; 1932 Manchester, no. 57; 1946 Stockholm, Gothenburg & Malmö, no. 4; 1946 Copenhagen, no. 4; 1947 Groningen, no. 12; 1947 Rotterdam, no. 15; 1947-48 London, Birmingham & Glasgow, no. 109; 1948 Bergen & Oslo, no. 71; 1948-49 The Hague, no. 181; 1949-50 New York & Chicago, no. 24; 1953 Zürich, no. 12; 1953 Zundert, no. 39; 1953 Hoensbroek, no. 75; 1953-54 Saint Louis, Philadelphia & Toledo, no. 23; 1955 Antwerp, no. 26; 1955 Amsterdam, no. 6; 1955-56 Liverpool, Manchester & Newcastle-upon-Tyne, no. 85; 1956 Haarlem, no. 5; 1957 Breda, no. 21; 1957 Marseille, no. 3; 1957 Stockholm, no. 11; 1958-59 San Francisco, Los Angeles, Portland & Seattle, no. 94; 1959-60 Utrecht, no. 68; 1960 Enschede, no. 10; 1963 Humlebaek, no. 65; 1964 Washington & New York, no. 65; 1968-69 London, no. 14; 1971-72 Paris, ex catalogue; 1975 Recklinghausen, no. 80; 1975 Amsterdam, no. 119; 1990 Otterlo, no. 41; 1995 Amsterdam, ex catalogue.

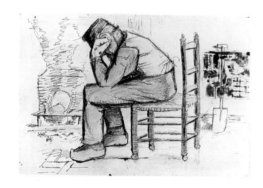

42ª Sketch in a letter to Theo of
c. September 1881 (171/150).
Amsterdam, Van Gogh Museum.

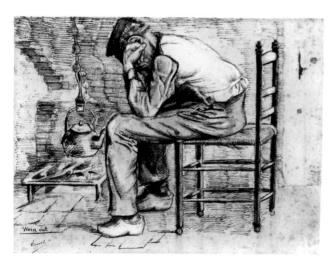

42ᵇ *Worn out* (F 863 JH 34), 1881. Amsterdam, P. and N. de Boer Foundation.

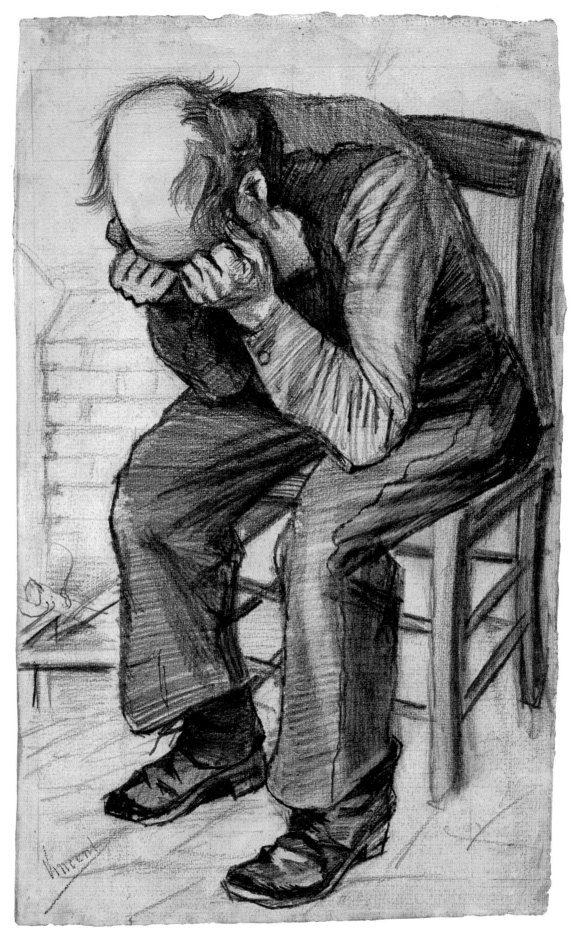

42 Worn out

It is known from the letter to Van Rappard that Van Gogh also gave this version the title borrowed from Faed: 'You may remember the drawing "Worn out"; I did it all over again the other day' [289/R 18].⁴ He eventually gave the lithograph a different title, *At eternity's gate*, which was probably inspired by his reading of John Bunyan's *The pilgrim's progress*, which contains numerous references to the 'gate' that pilgrims find at the end of their path through life, beyond which lies the 'celestial city' of the hereafter.⁵ Despite the difference in titles, the meaning of both drawing and print is the same, and their subject sets them within a respectable 19th-century tradition of scenes of humble folk sorely tried by life. One such work known to Van Gogh was Jozef Israëls's *Old friends* of 1882 (now in the Philadelphia Museum of Art), in which an old man and his dog are seated by the hearth. Although Van Gogh's treatment of the theme looks bleaker, he was trying to express a sense of something loftier, something that transcends the daily grind, identical to the sentiment he felt in the Israëls. He tried to explain this to Theo when he sent him the lithograph, citing both *Old friends* and Harriet Beecher-Stowe's *Uncle Tom's cabin*. He also referred to Alfred Sensier's biography of Jean-François Millet, which he had read in March 1882.⁶ It was a book that supplied him with many saws about the difficulties of everyday life. 'It seems to me that it is a painter's duty to try and put an idea into his work. In this print I have tried to express (although I cannot put it as beautifully or as strikingly as it is in reality, of which this is just a weak reflection in a dark mirror), what I believe to be one of the strongest proofs of the existence of "quelque chose là-haut" that Millet believed in, that is to say the existence of a God and an eternity, certainly in the inexpressibly moving quality that there can be in the expression of a little old man like this, perhaps without him even being aware of it, when he sits so quietly in the corner by his hearth. Also something grand, something noble, that cannot be intended for the worms. Israëls has done it so very beautifully.

'Perhaps the most splendid passage in *Uncle Tom's cabin* is the one where the poor slave, knowing that he must die, sits by his fire for the last time and recalls the words: Let cares like a wild deluge come, And storms of sorrow fall, May I but safely reach my home, My God, my heaven, my all.

'This is far removed from all theology – simply the fact that the poorest little woodcutter, peasant on the heath or miner can have moments of emotion and a state of mind which give him a feeling of an eternal home which he is nearing' [290/248].⁷ In a slightly later letter

1 F 864 JH 51. Hulsker 1973, p. 18, places the sketch with letter R 2 (now 175/R 2). In that letter Van Gogh writes about drawings that he wanted to show his friend, including 'the large [one] of "Worn out",' but says nothing about enclosing a sketch. That may have been why the editors of the 1990 edition of the correspondence did not reproduce this drawing. All the same, it is perfectly possible that Van Gogh gave Van Rappard an idea of what he had done without saying anything about it in the letter. In any event, the small work does have the character of the fairly faithful letter sketches known from this period, and this is borne out by the dimensions of 13 × 21 cm.
2 Letter 289/R 18.
3 For the lithograph see Van Heugten / Pabst 1995, cat. 5.
4 The sheet is generally given descriptive titles like Old man with his head in his hands (see F 997 JH 267, and Amsterdam 1987, no. 2.160). It is sometimes wrongly called At eternity's gate (Otterlo 1990, no. 41), and has also been published with interpretative titles: Vieillard pleurant (De la Faille 1928), or New Year's Eve (Amsterdam 1905, no. 246). The latter was derived from the letter in which Van Gogh explained that in this and other works he had wanted to express the kind of mood one feels at 'Christmas and New Year's Eve' [295/253]. See below in this entry.
5 Van Heugten / Pabst 1995, cat. 5, p. 54.
6 Sensier 1881.

7 Van Gogh quoted from a French edition of Beecher Stowe's book, according to Lauren Soth La case de l'oncle Tom ou vie des nègres en Amérique, Paris 1853, published by Hachette; see Soth 1994, pp. 156-62. There were at least four other French translations of this popular novel in circulation at the time.

8 F 998 JH 269. For the use of lithograph chalk see the Introduction.

9 F 1060 JH 326 and F 1069 JH 325.

10 See letter 594/473.

11 F 702 JH 1967. On this copy after his own work see Homburg 1994, pp. 118-20.

he likened the feeling he was trying to convey to 'the odd mood [...] of Christmas and New Year's Eve' [295/253].

Van Gogh made three more drawings in The Hague in which a seated figure is slumped, head in hands. One of them is very similar to the sheet discussed here. It, too, is of Zuyderland, who is now turned to the right and is shown from the waist up. Since lithographic crayon was used in that drawing it must be of a later date, probably December 1882-January 1883.[8] That also applies to the two other comparable scenes for which Sien Hoornik posed.[9]

Van Gogh never made any more variants of the subject, but it retained its appeal for him. It seems that he planned to have the lithograph framed in Paris, where he lived from March 1886 to February 1888, for he left it for some time with a frame-maker called Boyer.[10] In 1890 he made a painting after the lithograph when he was in the asylum at Saint-Rémy.[11]

43 Digger

Van Gogh made a close study of his model for the *Digger*, as he
reported to his friend Van Rappard (1858-1892): 'I have drawn the
digger in 12 different poses and am still looking for better ones. He is
a marvelously fine model, a true veteran digger' [289/R 18]. It is impossi-
ble to say whether Van Gogh made more than 12 figure studies of the
man, but only three are known today. There were two posing sessions,
for in this drawing and catalogue number 45 the man is wearing clogs
and a patched pair of trousers with straight legs, but in the third draw-
ing he has shoes and trousers turned up at the ankle. Van Gogh had a
wardrobe of costumes and attributes for dressing up his models, but
since this particular man was a digger in real life it can be assumed
that he posed in his own working clothes and that he brought his own
spade.

All three surviving studies are in the Van Gogh Museum. In
this drawing he is seen from the front, in the other two from the back
(cats. 44, 45). The challenge in all three studies must have been to cap-
ture the man's bent, foreshortened pose convincingly. In a lithograph
that Van Gogh made after one of the lost sheets the man is seen from
the side, and is again wearing clogs and trousers without turn-ups
(fig. 43a). As a result of his ventures into graphic art in the last two
months of 1882, Van Gogh was thinking of becoming a professional
illustrator. His lithograph of the *Digger* gave him the idea that the sub-
ject might well be suitable for *De Zwaluw*, a popular illustrated maga-
zine which, in fact, he did not rate very highly.[1]

Van Gogh reinforced this pencil drawing with the brush in black
ink at various points. The other two studies were not worked up, which
suggests that, in addition to the lost variant he used for the lithograph,
Van Gogh considered this frontal view the most successful of the trio
and went over it a second time. He evidently approved of this and
the following drawing, for he used both of them in various composite
works.[2] The last of the three drawings of the digger was never reused,
and is indeed a rather clumsy work. The frontal digger reappears on
his own in a couple of works, including, surprisingly, a view of Paris
made several years later.[3] In the two versions of the *Churchyard in the*

NOVEMBER 1882

Pencil, brush in black ink, on
watercolour paper
Traces of squaring, fixative dis-
colouration around the figure
48.7 × 29.7 cm
Watermark: DAMBRICOURT FRERES
Unsigned

Inv. d 64 V/1962
F 908 JH 258

PROVENANCE
1890-91 T. van Gogh; 1891-1925
J.G. van Gogh-Bonger; 1925-62
V.W. van Gogh; 1962 Vincent van
Gogh Foundation; 1962-73 on
loan to the Stedelijk Museum,
Amsterdam; 1973 on permanent
loan to the Van Gogh Museum,
Amsterdam.

LETTERS
283/243, 286/245, 287/246,
289/R18, 332/275, 348/R36.

LITERATURE
De la Faille 1928, vol. 3, p. 20,
vol. 4, pl. XXI; Vanbeselaere 1937,
pp. 78, 95-96, 185, 408; Wadley
1969, p. 25; De la Faille 1970, p.
337; Hulsker 1980, p. 64, no. 258;
Amsterdam 1987, p. 394, no.
2.163; De la Faille 1992, vol. 1,
pp. 20, 232, vol. 2, pl. XXI; Van
Heugten / Pabst 1995, pp. 43, 45.

EXHIBITIONS
1905 Amsterdam, no. 238; 1911
Amsterdam, no. 60? (possibly cat.
21 of 44); 1914-15 Amsterdam, no.
5; 1953 Zürich, no. 6; 1957
Nijmegen, no. 5; 1957 Stockholm,
no. 14; 1958-59 San Francisco,
Los Angeles, Portland & Seattle,
no. 89; 1960 Enschede, no. 5;

rain, which probably dates from Van Gogh's Hague period, he is accompanied by the digger seen from the back in the following catalogue number *(fig. 43b)*.[4]

1 *Letter 287/246. For the lithograph see Van Heugten / Pabst 1995, cat. 3, and for Van Gogh's opinion of* De Zwaluw, *ibidem, pp. 12-14.*

2 *This was pointed out in Osaka 1986, nos. 12, 13.*

3 *He is found in the letter sketches F 1028 JH 367 and F 1029 JH 366 of the lost Hague sheet of* Digging sand in Dekkersduin, *and in the view of* Montmartre, *F 349 JH 1184.*

4 *F 1399 JH 1031 and F 1399a JH 1032. Both drawings used to be wrongly assigned to the Paris period, but Jan Hulsker now argues that they were made in The Hague; see Jan Hulsker, 'Van Goghs raadselachtige* Kerkhof bij regen,' *in: Hulsker 1993, pp. 187-96.*

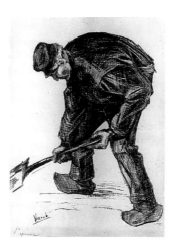

43ª *Digger* (F 1656 JH 262), 1882.
Amsterdam, Van Gogh Museum.

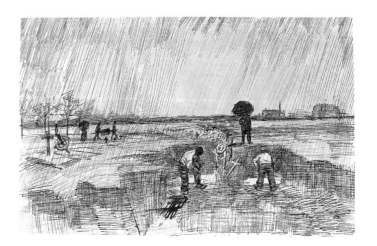

43ᵇ *Churchyard in the rain* (F 1399
JH 1031), 1882-83. Vienna, Graphische
Sammlung Albertina.

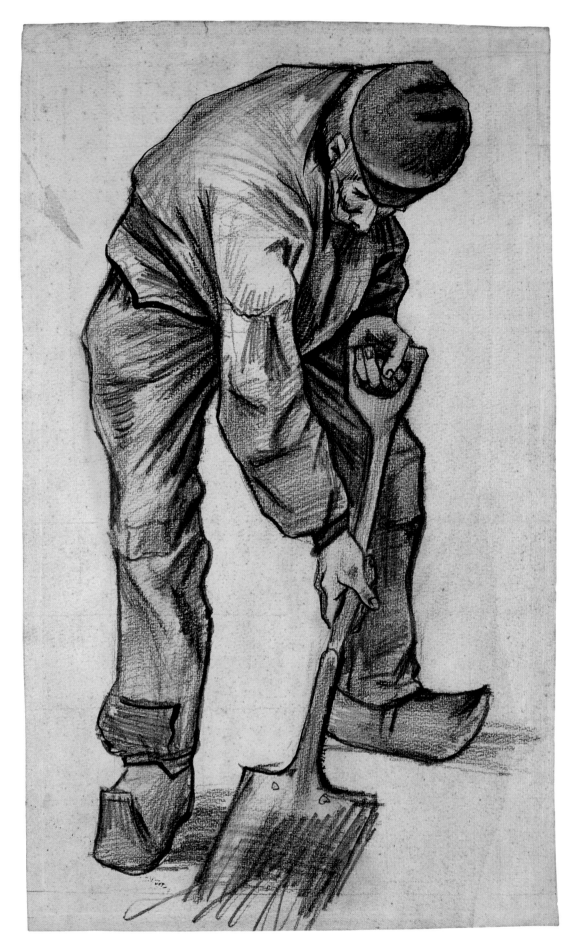

43 Digger

44 Digger

NOVEMBER 1882

Pencil (a few lines in black
chalk) on watercolour paper
Traces of squaring, fixative dis-
colouration around the figure
50.6 × 31.6 cm
Watermark: DAMBRICOURT
FRERES
Unsigned

Inv. d 63 V/1962
F 906 JH 260

PROVENANCE
1890-91 T. van Gogh; 1891-1925
J.G. van Gogh-Bonger; 1925-62
V.W. van Gogh; 1931-62 on loan
to the Stedelijk Museum,
Amsterdam; 1962 Vincent van
Gogh Foundation; 1962-73 on
loan to the Stedelijk Museum,
Amsterdam; 1973 on permanent
loan to the Van Gogh Museum,
Amsterdam.

LETTERS
283/243, 286/245, 287/246,
289/R18, 332/275, 348/R36.

LITERATURE
De la Faille 1928, vol. 3, p. 20,
vol. 4, pl. XXI; Vanbeselaere
1937, pp. 78, 96, 185, 408; De la
Faille 1970, p. 336; Hulsker
1980, pp. 64-65, no. 260;
Amsterdam 1987, p. 394, no.
2.161; Van der Mast / Dumas
1990, pp. 128-29; De la Faille
1992, vol. 1, pp. 20, 231, vol. 2,
pl. XXI.

This is the more successful of the two versions of the digger seen from
the back. One can immediately visualise how he is holding his spade,
and his pose convincingly conveys the effort he is putting into his work.
Van Gogh used this figure in several composite works, in one case com-
bining him with the digger seen from the front (see *cat. 43*). In the *Peat
cutters in the dunes* he paired him with the digger from the lithograph
(*fig. 44a*).[1]

The man's clothing differs from that in the lithograph and the two
other studies, where he is wearing clogs and trousers with straight legs.
Here the bottoms have been turned back, and he has stout workman's
shoes.

Van Gogh added some horizontal lines in black chalk on either side
of the man's chest: two on the left and one on the right. They appear to
be horizon lines inserted at two different heights with the aim of gauging
the effect of a figure standing out against a horizon.

1. *The latter also features in a drawing
(F 1023 JH 343), where he is on his own.*

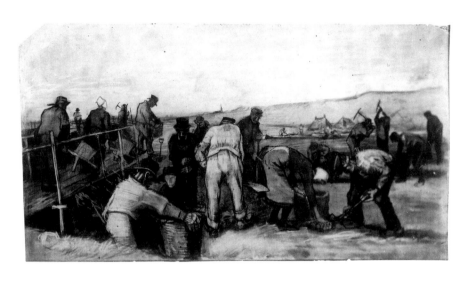

44ª *Peat diggers in the dunes* (F 1031
JH 363), 1883. Whereabouts unknown.

EXHIBITIONS
1905 Amsterdam, no. 255; 1911
Amsterdam, no. 60? (possibly
cat. 21 of 43); 1947 Groningen,
no. 3; 1947 Rotterdam, no. 5;
1954-55 Bern, no. 77; 1955
Antwerp, no. 31; 1957 Nijmegen,
no. 4; 1957 Stockholm, no. 13;
1958-59 San Francisco, Los
Angeles, Portland & Seattle, no.
88; 1960 Enschede, no. 4; 1961-
62 Baltimore, Cleveland, Buffalo
& Boston, no. 84; 1962-63
Pittsburgh, Detroit & Kansas
City, no. 84; 1965-66 Stockholm
& Gothenburg, no. 62; 1967
Wolfsburg, no. 83; 1974-75
Nottingham, Newcastle-upon-
Tyne, London, Leigh, Sheffield,
Bradford, Brighton & Reading,
no. 103; 1975 Amsterdam, no.
103; 1979 Tokyo, Sapporro,
Hiroshima & Nagoya, no. 56;
1982 Holland, no. 6; 1990
Otterlo, no. 48; 1995
Amsterdam, ex catalogue.

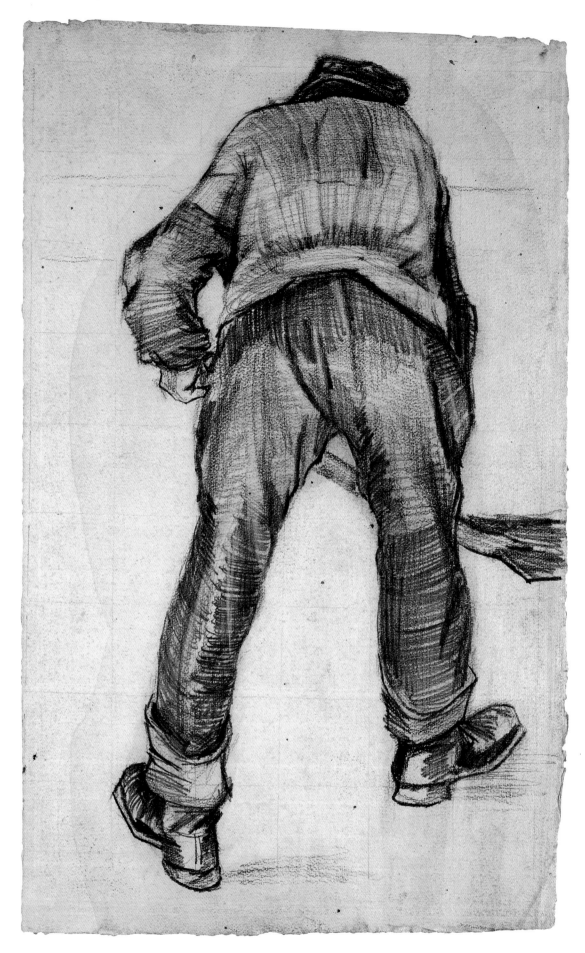

44 Digger

45 Digger

45 Digger

NOVEMBER 1882

Pencil on watercolour paper
Traces of squaring, fixative stain
around the figure
50.4 × 28.4 cm
Watermark: HALLINES 1877
Unsigned

Inv. d 381 V/1962
F 907 JH 261

PROVENANCE
1890-91 T. van Gogh; 1891-1925
J.G. van Gogh-Bonger; 1925-62
V.W. van Gogh; 1931-62 on loan
to the Stedelijk Museum,
Amsterdam; 1962 Vincent van
Gogh Foundation; 1962-73 on
loan to the Stedelijk Museum,
Amsterdam; 1973 on permanent
loan to the Van Gogh Museum,
Amsterdam.

LETTERS
283/243, 286/245, 287/246,
289/R18, 332/275, 348/R36.

LITERATURE
De la Faille 1928, vol. 3, p. 20,
vol. 4, pl. XXI; Vanbeselaere 1937,
pp. 78, 96, 185, 208, 408; De la
Faille 1970, pp. 336-37; Hulsker
1980, pp. 64-65, no. 261;
Amsterdam 1987, p. 394, no.
2.162; De la Faille 1992, vol. 1,
pp. 20, 231-32, vol. 2, pl. XXI; Van
Heugten / Pabst 1995, pp. 43-44.

EXHIBITIONS
1947 Groningen, no. 4; 1947
Rotterdam, no. 6; 1953 Zürich,
no. 5; 1985-86 Tokyo & Nagoya,
no. 2; 1986 Osaka, no. 12; 1990
Otterlo, no. 49; 1995 Amsterdam,
ex catalogue.

The subtle foreshortening makes it difficult to capture a bending figure seen from the back, and this version of a digger is not entirely successful. Part of the right hand can be seen grasping the spade, but it is almost impossible to envisage exactly how the man is holding it. In addition, his posture does not convey the effect of heavy work, and the right leg is joined to the hip at an implausible angle. A possible indication that Van Gogh, too, was not very happy with the result is that, unlike the previous studies, he did not incorporate this figure in any of his composite works from the Hague period (see *cat. 43*).

The reverse of the sheet gives a good idea of the force Van Gogh used when drawing with his carpenter's pencil, for a large part of the digger's outlines stands out in relief.

46 Two sowers

This drawing of two sowers belongs to a group of four such studies that Van Gogh made in December 1882.[1] It was the first time since leaving Etten that he had returned to the subject, which was to become one of the main leitmotifs of his œuvre. Living in a city, Van Gogh had little reason to depict rural subjects, but these studies were part of a larger plan to make a series of inexpensive prints, a 'series of, for instance, 30 sheets of working types – a sower, a digger, a woodcutter, a ploughman, a washer-woman, then also a child's cradle or a man from the almshouse' [291/249]. As he explained to Theo in the letter, Van Gogh mainly wanted to show people at work in his planned series of prints. Their significance was similar to that of *Worn out (cat. 42)*, but the feeling expressed there by a figure in repose, namely 'that there is more drudgery than rest in life,' was now to be captured by figures in action, which Van Gogh regarded as a more difficult challenge.

While busily experimenting with lithography he was also making drawings to serve as the basic material for that series (which never actually came to fruition).[2] In a slightly later letter he told Theo that he had made four drawings for it, two of a sower, one of a mower and the fourth of an old man in a top hat carrying a basket of peat. He described the sowers at length. The first one was 'a big old fellow, a tall dark silhouette against a dark ground. Far away in the distance a little cottage with a moss-covered roof and a bit of sky with a lark. The man is a sort of rooster type, a clean-shaven face, quite a sharp nose and chin, small eyes and sunken mouth. Long legs with boots' [293/251]. Some of those elements can be seen in the foreground of this drawing, which is why it has always been associated with that passage.[3] However, Van Gogh says that the man was wearing boots, and he was so explicit that they would undoubtedly have been visible to the viewer. It is also strange that he makes no mention of the second sower in the right background, nor does the foreground figure resemble a 'tall dark silhouette.' This is clearly not the sheet described in the letter, which must be considered lost.

The man's sunken cheeks and sharp features nevertheless do match Van Gogh's description of a 'rooster type,' so this is probably a variant of the drawing mentioned in the letter. Van Gogh occasionally used this

DECEMBER 1882

Pencil on watercolour paper
Fixative discolouration
31.7 × 21.2 cm
Watermark: HALLINES 1877
Signed at lower left: Vincent

Inv. d 202 V/1962
F 853 JH 274

PROVENANCE
1890-91 T. van Gogh; 1891-1925 J.G. van Gogh-Bonger; 1925-62 V.W. van Gogh; 1962 Vincent van Gogh Foundation; 1962-73 on loan to the Stedelijk Museum, Amsterdam; 1973 on permanent loan to the Van Gogh Museum, Amsterdam.

LITERATURE
Lettres 1911, pl. xxxv; De la Faille 1928, vol. 3, p. 8, vol. 4, pl. viii; Vanbeselaere 1937, pp. 58, 66, 98, 186-87; De la Faille 1970, p. 398; Hulsker 1980, pp. 69-70, no. 274; Amsterdam 1987, p. 395, no. 2.169; Amsterdam 1988-89, pp. 172-73, no. 70; Van der Mast / Dumas 1990, p. 132; De la Faille 1992, vol. 1, pp. 8, 218-19, vol. 2, pl. viii.

EXHIBITIONS
1905 Amsterdam, no. 450; 1914-15 Amsterdam, no. 1; 1958 Etten-Leur, no catalogue; 1975 Malmö, no. 9; 1976 Stockholm, no. 9; 1976 Oslo, no catalogue; 1976-77 Tokyo, Kyoto & Nagoya, no. 3; 1990 The Hague, unnumbered.

1 The other drawings are F 852 JH 275, F 999 JH 277 and F 1000 JH 276.

2 For Van Gogh's experiments with printmaking in December 1882 and associated projects see Van Heugten / Pabst 1995, pp. 14-25 and cats. 1-6.

3 The drawing is linked to this quotation in the œuvre catalogues of De la Faille and Hulsker, and some years ago I too did not doubt for a second the relevance of the description when I discussed it in Amsterdam 1988-89, no. 70.

4 Van Heugten / Pabst, op. cit. (note 2), loc. cit. The book is A. Ysabeau, Lavater et Gall. Physiognomonie et phrénologie rendues intelligibles pour tout le monde, Paris n.d. Van Gogh first mentions it (without giving the author's name) in letter 159/138 of November 1888 from Brussels. Chapter 7, pp. 108-18, deals with the physiognomy of animals. Incidentally, in letter 293/251 Van Gogh likened another sower from this period to an ox, F 852 JH 275.

kind of simile for faces, which reflected his belief in the 19th-century theory of physiognomy. He had learned it from a book summarising the physiognomic theories of Johann Caspar Lavater (1741-1801). It contained a chapter on the 'Analogie des figures humaines avec divers animaux' (Correspondences between the human face and various animals), which provided the basis for Van Gogh's similes.[4] He felt that this would-be 'science,' which was very popular in the 19th century, was an essential part of his training as an artist, and to some extent it was an extension of his study of anatomy.

Neither of these two sowers is found in Van Gogh's other figure drawings. There is no drawn grid from which it could be deduced that he used his perspective frame, so it is tempting to speculate that he saw these sowers at work and made a quick sketch of them which he worked up in the studio. In truth, though, this is probably a staged scene, for sowing is done in early autumn and Van Gogh could not have seen sowers at work in December.

Comparison with the sowers that Van Gogh made in Etten shows how much progress he had made in the interim. The clumsy Etten figures, who give not the slightest suggestion of being in action, have made way for these men convincingly scattering seed over the land and portraying the exhausting nature of their toil, which is precisely the effect that Van Gogh was after.

46 Two sowers

47 Old man with a top hat

December 1882-January 1883

Pencil, black lithographic crayon, pen and brush in brown (originally black) ink, scratched, on watercolour paper
Traces of squaring
60.0 × 36.0 cm
Watermark: HALLINES [cut in half lengthwise by the right edge]
Signed at lower left (incised): Vincent

Inv. d 183 V/1962
F 985 JH 286

PROVENANCE
1890-91 T. van Gogh; 1891-1925 J.G. van Gogh-Bonger; 1925-62 V.W. van Gogh; 1931-62 on loan to the Stedelijk Museum, Amsterdam; 1962 Vincent van Gogh Foundation; 1962-73 on loan to the Stedelijk Museum, Amsterdam; 1973 on permanent loan to the Van Gogh Museum, Amsterdam.

LITERATURE
De la Faille 1928, vol. 3, p. 38, vol. 4, pl. XL; Vanbeselaere 1937, pp. 91, 99, 189, 409; De la Faille 1970, p. 366; Hulsker 1980, pp. 69, 72, no. 286; Pollock 1983, p. 352; Amsterdam 1987, p. 395, no. 2.168; De la Faille 1992, vol. 1, pp. 38, 254, vol. 2, pl. XL.

EXHIBITIONS
1905 Amsterdam, no. 258; 1914-15 Amsterdam, no. 25; 1927-28 Berlin, Vienna & Hannover, no. 9a; 1929 Amsterdam, no. 7; 1931 Amsterdam, no. 105; 1947 Groningen, no. 10; 1947 Rotterdam, no. 13; 1948-49

In December 1882-January 1883, Van Gogh began a series of studies of the heads of working-class people. His source of inspiration was a series of wood engravings entitled *Heads of the people*, which was published in *The Graphic*, an English periodical. The studies from those two months are very similar in technique, for the artist worked largely with pencil and lithographic crayon on watercolour paper. Only one sheet *(cat. 53)* can be dated more precisely within that period.

This study of a greybeard in a top hat, who was undoubtedly recruited from a local old people's home, cannot be dated exactly. The man appears to be the same person who posed in the same headgear in a sheet that is now in the collection of the Hannema-De Stuers Fundatie, although there the nose looks a little narrower and the hair is flatter to the sides of the head *(fig. 47a)*. Both studies give a good idea of Van Gogh's efforts to master the 'structure of the skull and the arrangement of a physiognomy' [297/255].

47a *Old man in a top hat* (F 961 JH 284), 1882. Heino, Hannema-De Stuers Fundatie.

47 Old man with a top hat

The Hague, no. 183; 1953
Zürich, no. 10; 1953 Zundert,
no. 37; 1953 Hoensbroek, no. 73;
1953 Assen, no. 31; 1953-54
Bergen op Zoom, no. 12; 1954-
55 Willemstad, no. 33; 1955
Palm Beach, Miami & New
Orleans, no. 33; 1955 Antwerp,
no. 29; 1955 Amsterdam, no. 8;
1955-56 Liverpool, Manchester &
Newcastle-upon-Tyne, no. 87;
1956 Haarlem, no. 4; 1957
Breda, no. 22; 1957 Marseille,
no. 4; 1957 Stockholm, no. 16;
1958-59 San Francisco, Los
Angeles, Portland & Seattle, no.
92; 1959-60 Utrecht, no. 69;
1960 Enschede, no. 8; 1961-62
Baltimore, Cleveland, Buffalo &
Boston, no. 87; 1962-63
Pittsburgh, Detroit & Kansas
City, no. 87; 1963 Humlebaek,
no. 68; 1964 Washington &
New York, no. 68; 1965
Charleroi & Ghent, no. 44;
1966 Paris & Albi, no. 6; 1967
Lille & Zürich, no. 7; 1967-68
Dallas, Philadelphia, Toledo &
Ottawa, no. 7; 1968 Liège, no. 7;
1968-69 London, no. 12; 1969
Humlebaek, no. 3; 1969-70 Los
Angeles, Saint Louis,
Philadelphia & Columbus, no. 3;
1970-71 Baltimore, San
Francisco & New York, no. 71;
1971-72 Paris, no. 119; 1972-73
Strasbourg & Bern, no. 49;
1980-81 Amsterdam, no. 60;
1990 Otterlo, no. 45.

1 *The exhibitions of their work held from 1872 in the Dudley Gallery in London were accordingly dubbed 'Black-and-White Exhibitions.' Van Gogh undoubtedly read reviews of them in* The Graphic. *See also Nottingham 1974-75, p. 44.*

The effect of shadow on the drawn, sunken face is very convincing. Some details, such as the hair, are reinforced with pen and ink. The latter is now brown, but since Van Gogh tried to structure these drawings with the boldest greys and blacks (even using deep black lithographic crayon rather than the usual materials for ordinary drawings) it must have been black originally. This study accordingly belongs to a group of drawings and lithographs in which ink that has faded to brown is found in combination with a material that remained black. It is mainly on the evidence of this group that it can be said that the ink which is now brown in many of Van Gogh's drawings was often considerably darker, if not black. The precise tone and shade, though, can no longer be reconstructed.

The black passages of the hat and coat are the result of Van Gogh's efforts to 'paint with black,' as he called it [298/256], or 'Black & White' – a term that English illustrators applied to their wood engravings, which were printed in black on white.[1] Vincent explained to Theo that 'one must be able to go from the highest light to the deepest shadow, and this with only a few simple ingredients.' Those ingredients consisted in this case mainly of pencil with lithographic crayon on top that was then wetted and worked with the brush. In this way Van Gogh produced a wide range of tones which he reinforced in the coat with the brush in ink, and by scratching off the lithographic crayon in areas like the sheen on the top hat.

48 Head of a woman

Using the effect of light and shade was one way in which Van Gogh could capture the physiognomy of a head. The series of studies of the heads of women and fishermen in the Van Gogh Museum, which he drew in December 1882 and January 1883, show just how much use he made of this device. The five drawings of women's heads, in particular, reveal how he studied a face under different kinds of lighting: fairly evenly lit against a dark background in the drawing discussed below, shaded in catalogue number 49, diagonally backlit in number 53, again quite uniformly lit in number 51, but now with a white background, and full face with the light coming from the viewer's left, so that one half of the face is darker than the other *(cat. 52)*.

The woman is usually identified as Sien Hoornik, whom Van Gogh lived with in The Hague. There is certainly a close resemblance to known portraits of her *(fig. 48a)*, although here the face is a little fuller and the chin more pronounced than they are in other sheets for which she posed. She can be recognised in two of the studies made during these two months – this and the following sheet. A study dating from spring-summer 1882 may also be a portrait of her *(cat. 28)*.

Sien's head, with the eye-catching white cap, stands out against a very dark background. The features are modelled with soft shadows. Although the cap is the brightest feature, heavy shadowing tones it down so that it does not contrast too much with the face. Van Gogh also lightened two areas on the woman's breast, probably with an eraser, for the paper is abraded here.

Like so many of Van Gogh's drawings from this period, the surface is severely blistered in places due to Van Gogh's practice of reworking the lithographic crayon with water. The tops of some of the blisters are worn.

For the dating see catalogue number 47.

DECEMBER 1882-JANUARY 1883

Pencil, black lithographic crayon, grey wash, scratched, on water-colour paper
47.6 × 26.3 cm
Watermark: DAMBRICOURT FRERES
Signed at lower left: Vincent

Inv. d 203 V/1962
F 931 JH 291

PROVENANCE
1890-91 T. van Gogh; 1891-1925 J.G. van Gogh-Bonger; 1925-62 V.W. van Gogh; 1931-62 on loan to the Stedelijk Museum, Amsterdam; 1962 Vincent van Gogh Foundation; 1962-73 on loan to the Stedelijk Museum, Amsterdam; 1973 on permanent loan to the Van Gogh Museum, Amsterdam.

LITERATURE
Lettres 1911, pl. XXXVII; De la Faille 1928, vol. 3, p. 25, vol. 4, pl. XLI; Vanbeselaere 1937, pp. 49, 99, 408; De la Faille 1970, p. 348; Hulsker 1980, p. 73, no. 291; Amsterdam 1987, p. 395, no. 2.170; Zemel 1987, p. 360; Feilchenfeldt 1988, p. 127; De la Faille 1992, vol. 1, pp. 25, 238-39, vol. 2, pl. XLI.

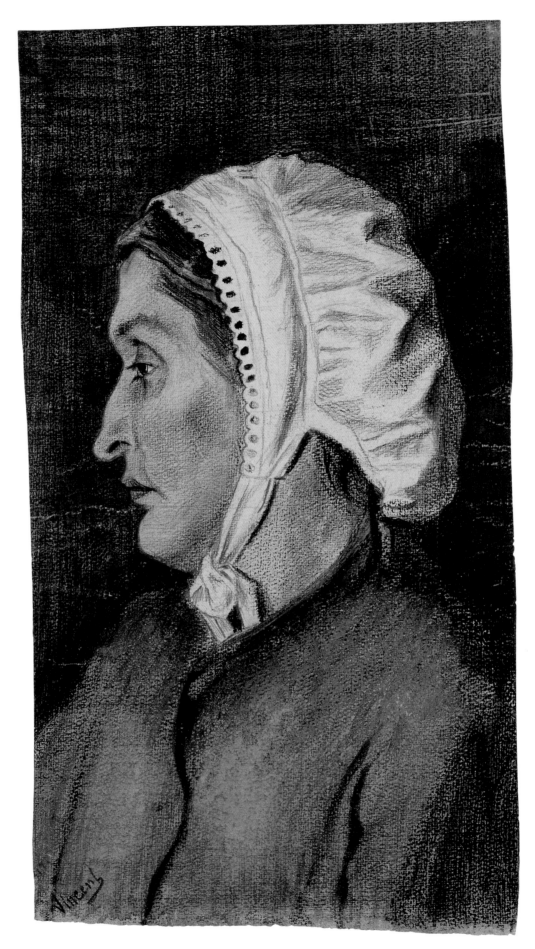

48 Head of a woman

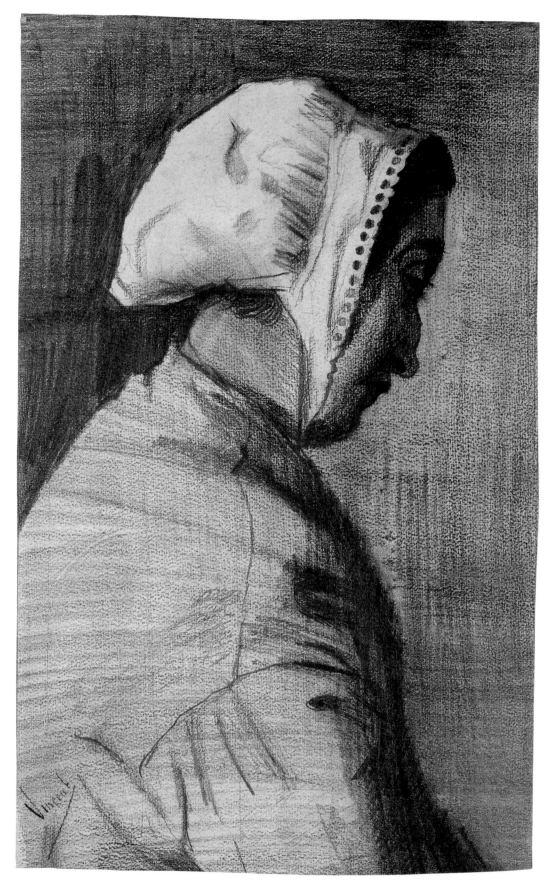

49 Head of a woman

EXHIBITIONS

1905 Amsterdam, no. 245; 1910
Cologne & Frankfurt, no cata-
logue; 1914-15 Amsterdam,
no. 10; 1923 Utrecht & Rotter-
dam, no. 64; 1931 Amsterdam,
no. 103; 1945 Amsterdam,
unnumbered; 1947 Rotterdam,
no. 7; 1954-55 Bern, no. 78; 1955
Antwerp, no. 32; 1955 Amster-
dam, no. 9; 1957 Nijmegen,
no. 6; 1957 Stockholm, no. 15;
1975 Malmö, no. 10; 1976
Stockholm, no. 10; 1976-77
Tokyo, Kyoto & Nagoya, no. 5.

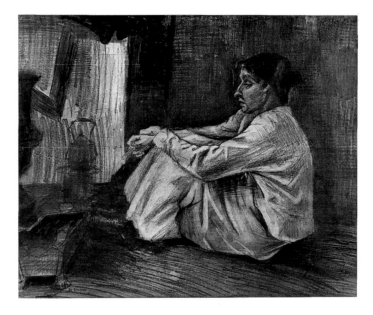

48a *Woman seated by the stove* (F 898
JH 141), 1882. Otterlo, Kröller-Müller
Museum.

49 Head of a woman

This woman is the same as the one in the preceding sheet, and is thus very probably Sien Hoornik wearing the same cap. Both portraits may have been drawn in a single session, with Van Gogh trying out two different lighting effects. On this occasion the woman has turned her head rather sharply to the right, away from the light source that illuminated her evenly in the first study, with the result that her face is in shadow. The background is lighter than in the preceding sheet, while the face, only the cheek of which catches a little light, and the front of the body are largely in shadow, contrasting with the highlighted cap, neck and back. Van Gogh adroitly used the background to enhance this effect, making it darker to the left of the cap and the woman's back and keeping it light around the profile.

For the dating see catalogue number 47.

DECEMBER 1882-JANUARY 1883

Pencil, pen and brush in black
ink, scratched, on watercolour
paper
Traces of squaring
43.3 × 27.1 cm
Watermark: HALLINES
Signed at lower left: Vincent

Inv. d 73 V/1962
F 1055 JH 290

PROVENANCE
1890-91 T. van Gogh; 1891-1925
J.G. van Gogh-Bonger; 1925-62
V.W. van Gogh; 1962 Vincent van
Gogh Foundation; 1962-73 on loan
to the Stedelijk Museum,
Amsterdam; 1973 on permanent
loan to the Van Gogh Museum,
Amsterdam.

LITERATURE
De la Faille 1928, vol. 3, p. 53,
vol. 4, pl. LVII; Vanbeselaere 1937,
pp. 101, 199, 410; De la Faille
1970, p. 388; Hulsker 1980, p. 73,
no. 290; Amsterdam 1987, p. 396,
no. 2.171; De la Faille 1992, vol. 1,
pp. 53, 271, vol. 2, pl. LVII.

EXHIBITIONS
1905 Amsterdam, no. 463; 1914-15
Amsterdam, no. 40; 1923 Utrecht
& Rotterdam, no. 84; 1953-54
Bergen op Zoom, no. 19.

50 Girl with a shawl

DECEMBER 1882-JANUARY 1883

Pencil, black lithographic crayon,
scratched, on watercolour paper
Traces of squaring, fixative dis-
colouration around the figure
51.0 × 31.3 cm
Watermark: HALLINES
Signed at lower left (incised): Vincent

Inv. d 375 V/1962
F 1008 JH 301

LITERATURE
Lettres 1911, pl. XXII; De la Faille
1928, vol. 3, p. 43, vol. 4, pl. XLVI;
Vanbeselaere 1937, pp. 100, 409;
De la Faille 1970, p. 372; Hulsker
1980, pp. 74-75, no. 301; Amsterdam
1987, p. 397, no. 2.182; Feilchenfeldt
1988, p. 127; De la Faille 1992, vol.
1, pp. 43, 260, vol. 2, pl. XLVI.

The model for the *Girl with a shawl* and two other studies is identified in De la Faille's œuvre catalogue as Sien's daughter *(figs. 50a, 50b)*. Hulsker agrees that the girl facing right is the same as the one in this Amsterdam drawing, but feels that the girl with the shawl in Otterlo is older. He cautiously suggests that she might be Sien's youngest sister, Maria Wilhelmina Hoornik, who was born on 2 July 1872 and would thus have been ten years old when she sat to the artist. He adds, though, that going by what Van Gogh said in one of his letters she is also the girl seen from the back in the *Public soup kitchen*. There she has her hair in a braid, which cannot be seen here (see *cat. 60*).[1]

Other people from Van Gogh's immediate circle could also have posed for him. Sien's daughter, who was born on 7 May 1877 and was also called Maria Wilhelmina, was five at this time.[2] Not only does the girl in the Otterlo sheet look older, but in my opinion the Amsterdam drawing, too, is of a girl who must be at least ten years old. The child who posed for the third study looks considerably younger. She clearly has chubby cheeks, whereas the girls in the other studies do not. Admittedly, those two do differ a little, but that is probably due to the angles of view: directly from the side in the Amsterdam sheet and a little from above in the Otterlo variant. The hairstyles are very similar, the shawls identical, and the left ears remarkably large. The timid, hesitant gazes turned in the artist's direction are also comparable. It seems very possible that both are indeed Sien's youngest sister. Against this, the girl in the *Soup kitchen* has a braid, but perhaps that identification is incorrect, for Van Gogh merely said that she *would* be coming to pose for him, not that she actually did so. It is not inconceivable that her place was taken by another child, one with a braid.

The portrait of the girl, whoever she may be, is done with great vigour. Van Gogh scored the paper with his pencil so heavily that the lines stand out on the back of the sheet. He then went over the pencil sketch with lithographic crayon before moistening the paper and working on it further. This left blisters in the clothing and hair. The stain around the figure was caused by the fixative, probably milk.

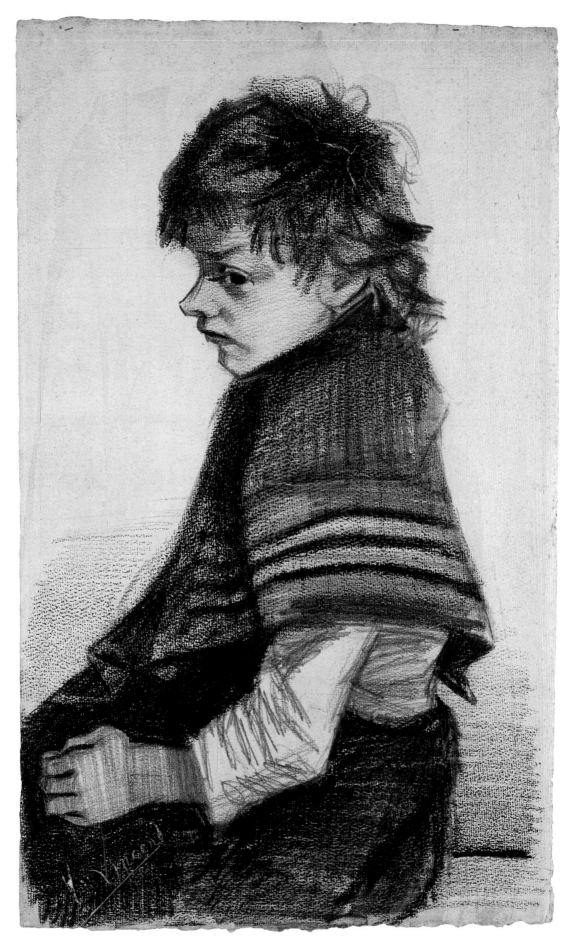

50 Girl with a shawl

no. 14; 1947-48 London, Birmingham
& Glasgow, no. 111; 1948 Bergen &
Oslo, no. 72; 1948-49 The Hague,
no. 186; 1953-54 Bergen op Zoom,
no. 15; 1955 Antwerp, no. 35; 1956
Haarlem, no. 7; 1957 Leiden &
Schiedam, no. 52; 1958 Bergen, no.
53; 1961-62 Baltimore, Cleveland,
Buffalo & Boston, no. 89; 1962-63
Pittsburgh, Detroit & Kansas City,
no. 89; 1964 Zundert, no. 4; 1975
Malmö, no. 11; 1976 Stockholm, no.
11; 1976-77 Tokyo, Kyoto & Nagoya,
no. 8; 1990 Otterlo, no. 53.

1 *For the biographical information on Sien*
and her children see Jan Hulsker, 'Van
Goghs dramatische jaren in Den Haag
(december 1881-september 1883),' in:
Hulsker 1993, pp. 50-53.
2 *Ibidem.*

Finally, Van Gogh scratched in his signature at lower left. He botched
the 'V' at the first attempt and had to start again a little to the right.
For the dating see catalogue number 47.

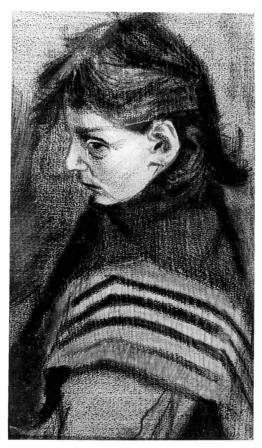

50a *Girl with a shawl* (F 1007 JH 299),
winter 1882-83. Otterlo, Kröller-Müller
Museum.

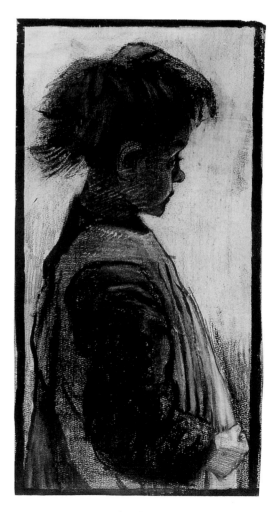

50b *Girl in an apron* (F 1685 JH 300),
winter 1882. Boston, Museum of Fine
Arts.

51 Head of a woman

Van Gogh started by placing this unknown woman, who is quite uniformly lit, against a dark background, but the effect was evidently not to his liking, for he then painted over the background with opaque white watercolour. The black still shows through, producing a delicate grey shade. He was evidently so pleased with the result that he felt it worth adding his signature. Although the woman bears some resemblance to the model in the previous catalogue number and is wearing a similar cap, she has a less pronounced chin and a rounder nose. She does, however, appear to be the woman known from two full-face portraits *(fig. 51a).*[1] Hulsker suggests that all these studies, and the preceding catalogue entry, may be of Sien Hoornik's mother, but there is no way of verifying this.

For the dating see catalogue number 47.

DECEMBER 1882-JANUARY 1883

Pencil, black lithographic crayon, opaque white and pink watercolour, grey wash, scratched, on watercolour paper. Possible traces of squaring at lower left
50.1 x 28.0 cm
Watermark: HALLINES 1877
Signed at lower left: Vincent

Inv. d 373 V/1962
F 1006 JH 295

PROVENANCE
1890-91 T. van Gogh; 1891-1925 J.G. van Gogh-Bonger; 1925-62 V.W. van Gogh; 1931-62 on loan to the Stedelijk Museum, Amsterdam; 1962 Vincent van Gogh Foundation; 1962-73 on loan to the Stedelijk Museum, Amsterdam; 1973 on permanent loan to the Van Gogh Museum, Amsterdam.

LITERATURE
Lettres 1911, pl. XXIII; Havelaar 1915, fig. 2; De la Faille 1928, vol. 3, p. 43, vol. 4, pl. XLV; Vanbeselaere 1937, pp. 99, 189, 409; De la Faille 1970, p. 371; Hulsker 1980, p. 74, no. 295; Amsterdam 1987, p. 396, no. 2.173; De la Faille 1992, vol. 1, pp. 43, 258, vol. 2, pl. XLV.

EXHIBITIONS
1905 Amsterdam, no. 464; 1914-15 Amsterdam, no. 39; 1927-28 Berlin, Vienna & Hannover, no. 7; 1929 Amsterdam, no. 9; 1931 Amsterdam, no. 102; 1947 Rotterdam, no. 17; 1948-49 The Hague, no. 184; 1956 Haarlem, no. 6; 1974-75 Nottingham, Newcastle-upon-Tyne, London, Leigh, Sheffield, Bradford, Brighton & Reading, no. 111; 1975 Amsterdam, no. 111.

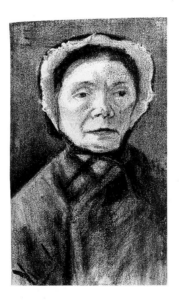

Head of a woman (F 1057 JH 294), winter 1882-83. Groningen, Groninger Museum.

1 *The work not illustrated here is F 1057a JH 296.*

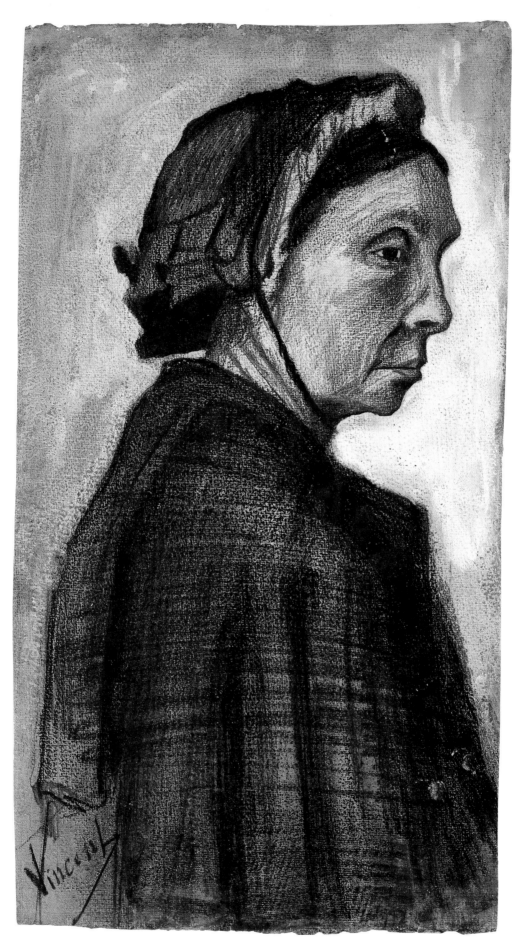

51 Head of a woman

52 Head of a woman

52 Head of a woman

DECEMBER 1882-JANUARY 1883

Pencil, black lithographic crayon,
on watercolour paper
39.5 × 24.7 cm
Signed at lower left in black chalk,
reinforced with pencil: Vincent

Inv. d 67 V/1962
F 1009 JH 335

PROVENANCE
1890-91 T. van Gogh; 1891-1925
J.G. van Gogh-Bonger; 1925-62
V.W. van Gogh; 1931-62 on loan to
the Stedelijk Museum,
Amsterdam; 1962 Vincent van
Gogh Foundation; 1962-73 on loan
to the Stedelijk Museum,
Amsterdam; 1973 on permanent
loan to the Van Gogh Museum,
Amsterdam.

LITERATURE
De la Faille 1928, vol. 3, p. 43,
vol. 4, pl. XLVI; Vanbeselaere 1937,
pp. 100, 409; De la Faille 1970,
p. 372; Hulsker 1980, pp. 80-81,
no. 335; Amsterdam 1987, p. 398,
no. 2.183; De la Faille 1992, vol. 1,
pp. 43, 260, vol. 2, pl. XLVI.

EXHIBITIONS
1905 Amsterdam, no. 236; 1914-15
Amsterdam, no. 9; 1927-28 Berlin,
Vienna & Hannover, no. 11; 1931
Amsterdam, no. 112; 1947
Groningen, no. 15; 1947
Rotterdam, no. 18; 1975 Malmö,
no. 13; 1976 Stockholm, no. 13;
1976-77 Tokyo, Kyoto & Nagoya,
no. 9.

This haggard and careworn, middle-aged woman features in another study in the Gemeentemuseum in The Hague, where she looks a little less downcast *(fig. 52a)*.[1] Once again, identification is a difficult and often highly personal matter. Jan Hulsker is certain that the woman in the Hague sheet is Sien Hoornik's mother, but is doubtful about the identity of the sitter in the Amsterdam drawing. The woman in the Amsterdam study is not named in De la Faille 1970, and she remains anonymous to this day. There is little difference between the Hague and Amsterdam drawings in the use of materials. The latter is entirely in black, but the Hague study also has some red chalk and is heightened with white here and there.[2]

52a *Head of a woman* (F 1009a JH 106),
winter 1882-83. The Hague, Haags
Gemeentemuseum, on loan from the
heirs of Paul Citroen.

Like the previous five catalogue numbers, this woman's head was undoubtedly done in December 1882 or January 1883. Hulsker sets it apart from the other studies by assigning it to March 1883, but does not say why. It is also segregated from the others in the 1987 catalogue of the museum's collection, although both January and March 1883 are given as the possible dates. In view of the paper and the materials used, and in the absence of any sound reasons for a later dating, everything favours the inclusion of this sheet in the series. Equally, the drawing in the Haags Gemeentemuseum, which Hulsker identifies as Sien's mother and dates to March 1882, must have originated in those same winter months.[3]

The woman appears to be wearing a cloak or a large shawl. The light source, which is outside the picture on the left, shrouds the left half of the woman's face and body in shadow. Here, too, Van Gogh darkened the left background in order to heighten the chiaroscuro effect. He also made skilful use of the relief in the watercolour paper. In the right background, which is also quite dark, he left the lower parts paler, but in the left background he reworked up the lithographic crayon with brush and water so that it flowed into the 'valleys' in the relief.[4] The sidelighting brings out the crease to the left of the woman's mouth, shadows the right eye and picks out the wrinkles in the forehead. These details, together with the model's expression, help to create the mournful look.

1 De la Faille, too, felt that both heads are of the same woman.
2 Traces of squaring can be seen in the woman's face and cap. A study of a woman's head in the Groninger Museum, F 1057 JH 294, is executed in almost identical materials, although the red in the clothing looks more like thinned gouache.
3 The same applies to F 1057 JH 294 in Groningen.
4 See the Introduction.

53 Head of a woman

JANUARY 1883

Pencil, black lithographic crayon,
opaque white (greyed) water-
colour, on watercolour paper
Traces of squaring
45.4 × 26.3 cm
Unsigned

Inv. d 66 V/1962
F 1005 JH 292

PROVENANCE
1890-91 T. van Gogh; 1891-1925
J.G. van Gogh-Bonger; 1925-62
V.W. van Gogh; 1931-62 on loan to
the Stedelijk Museum, Amsterdam;
1962 Vincent van Gogh Foundation;
1962-73 on loan to the Stedelijk
Museum, Amsterdam; 1973 on
permanent loan to the Van Gogh
Museum, Amsterdam.

LETTER
301/259

LITERATURE
De la Faille 1928, vol. 3, p. 42,
vol. 4, pl. XLV; Vanbeselaere 1937,
pp. 100, 198-99, 409; De la Faille
1970, p. 371; Hulsker 1980, p. 73,
no. 292; Amsterdam 1987, p. 396,
no. 2.172; De la Faille 1992, vol. 1,
pp. 42, 258, vol. 2, pl. XLV.

EXHIBITIONS
1905 Amsterdam, no. 241; 1914-15
Amsterdam, no. 33; 1931 Amster-
dam, no. 104; 1947 Groningen,
no. 13; 1947 Rotterdam, no. 16;
1948-49 The Hague, no. 185; 1953
Zürich, no. 14; 1953 The Hague,
no. 11; 1953 Otterlo & Amsterdam,
no. 14; 1953-54 Bergen op Zoom,
no. 14; 1957 Stockholm, no. 17;
1990 The Hague, unnumbered.

This study of the head of an unknown woman who appears nowhere else in Van Gogh's œuvre ties in with a description in a letter to Theo of around 11 January 1883: 'I did a woman's head this way, also standing out against the light, so the whole is toned, with glancing lights on the profile' [301/259]. This drawing is not necessarily the one referred to, but it is certainly the result of a similar experiment. The 'glancing lights' are the bands along the woman's profile where Van Gogh left the paper blank or even heightened it with white, in the forehead for instance. Apart from that, the face is shaded a fairly even grey – 'toned,' in Van Gogh's words. Judging by the shadows in the face and the fall of light on the breast, the light source is obliquely to the right of the model. The white trim of her cap still stands out, despite the fact that the white watercolour has turned grey. Another device that Van Gogh used to heighten the effect of the spotlit profile was to make the left half of the background very dark while leaving the right half light, where it contrasts with the shadowed back and cap.

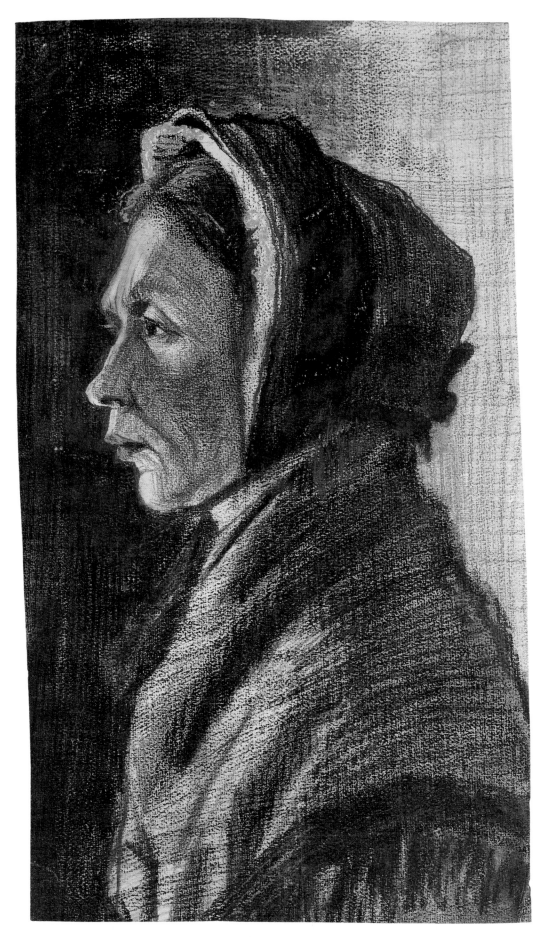

53 Head of a woman

54 Baby

WINTER 1882-1883

Charcoal (possibly oiled), red
and brown oil paint, opaque
white watercolour, on water-
colour paper
33.8 × 25.7 cm
Unsigned

Inv. d 778 M/1981
F 912 JH 318

PROVENANCE
1918 C. Henny, The Hague;
until 1981 A. Cohen Tervaert-
Henny, Zeist; 1981 donated to
the Van Gogh Museum,
Amsterdam.

LITERATURE
Van Gogh 1905, no. 1; Pfister
1922, p. 45; De la Faille 1928,
vol. 3, p. 21, vol. 4, pl. XXII;
Vanbeselaere 1937, pp. 78, 103,
408; De la Faille 1970, p. 338;
Hulsker 1980, pp. 78-79,
no. 318; Amsterdam 1987,
p. 396, no. 2.174; De la Faille
1992, vol. 1, pp. 21, 233, vol. 2,
pl. XXII.

EXHIBITIONS
1964 Zeist, no. 24; 1970
Frankfurt, no. 20; 1983-84
Amsterdam, no catalogue; 1990
Otterlo, no. 55.

This baby seen from the side is undoubtedly Sien's son, Willem Hoornik,
who was born on 2 July 1882. Van Gogh was very fond of this 'little man,'
as he affectionately called him [371/306, 391/326], and a few months later drew
the child lying in its cradle *(cat. 62)*.[1]

This particular drawing cannot be dated very precisely. There is a letter
sketch of it *(fig. 54a)* that is reproduced with letter 300/258 of early January
1883 in the 1953 edition of Van Gogh's correspondence. The only reason
for doing so on the internal evidence of the letter is Van Gogh's statement
that he was sending his brother 'some studies,' adding in a postscript: 'The
drawings I want to send you are like the figures in the lithographs, all kinds
of types – men, women, children.' This is a very shaky basis for identifying
or dating any sheet, but there is little more to go on. The paper is of no help,
since Van Gogh used watercolour paper a great deal from the late summer
of 1882, and anyway it is the obvious choice when using paint. Nor do the
drawing materials give any clue as to the date, because technically this is a
most unusual sheet. At first sight it appears that the artist made the draw-
ing with lithographic crayon and then worked it up with brown watercolour
or ink, parts of which overlie the crayon. The brown material has pene-
trated right through the watercolour paper, despite the fact that the latter is
quite thick. Every brushstroke can be seen on the back, which makes it
abundantly clear that Van Gogh worked with oil paint. The oil has probably
turned rather brown with age, for the tint is in striking contrast with the
unpainted parts of the paper. Under the microscope, apart from the browned
oil, it could be seen that there is a thin, almost transparent amber shade
which is probably closer to the original colour of these passages. Van Gogh
also added touches of red vermilion here and there, one being in the child's
mouth.[2] As an experiment, this sheet is related to the drawings in 'black
and white' (see *cat. 47)* that Van Gogh was to make in April 1883 [337/R 33]. In
those works he laid down the initial composition in pencil or charcoal and
then worked it up with printing ink thinned with turpentine and a little oil
paint. There, however, the emphasis was on the effect of the deep black of
the printing ink. As far as is known, none of those trials has survived.

The microscopic examination revealed another surprise. To the naked
eye the black drawing material, which is overpainted in many places,

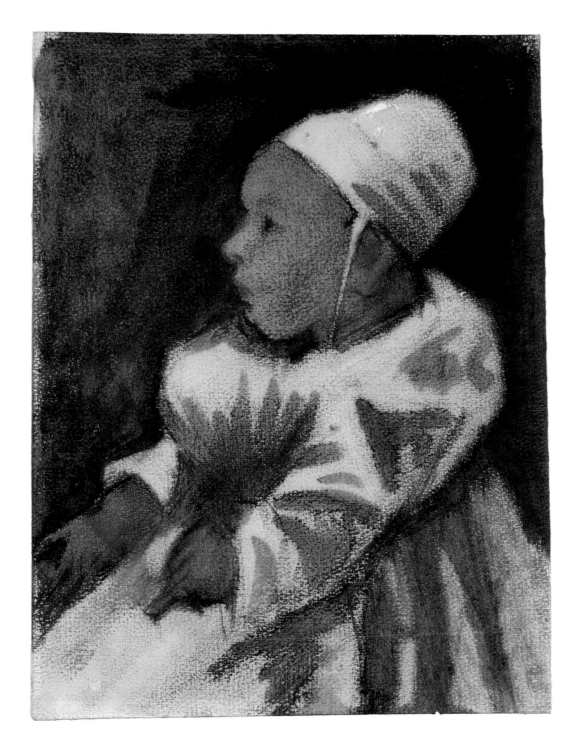

54 Baby

looked like lithographic crayon. However, that theory was demolished when the drawing was examined under high magnification and compared with other works in which Van Gogh used that crayon. The black, in fact, closely resembles charcoal, particularly charcoal that has been soaked in linseed oil.[3] Van Gogh wrote about that material in letters of April and May 1882.[4] He had seen J.H. Weissenbruch (1824-1903) using the technique, but felt that he himself was still too inexperienced and would only be able to take it up in a year's time. It seems that this drawing of the baby was an initial experiment with oiled charcoal, which has so far not been identified in any of Van Gogh's other works. One odd feature is the heavy, almost treacly passage to the right of the child's cap, which is probably a fairly thick layer of charcoal overpainted with oils.

In 1918 the drawing came into the possession of Carel Henny (b. 1871), whose taste as a collector had been influenced by H.P. Bremmer (1871-1956).[5] Henny received the work as a farewell gift on his resignation as managing director of the insurance company *De Nederlanden van 1845*.[6] His daughter, Mrs A. Cohen Tervaert-Henny, donated it to the Van Gogh Museum in 1981, with Bremmer's son Floris acting as the intermediary.[7]

1 For biographical information on Sien and her children see Jan Hulsker, 'Van Goghs dramatische jaren in Den Haag (december 1881-september 1883),' in: Hulsker 1993, pp. 50-53.

2 This amber-coloured layer has not been analysed, since it is far too thin to take samples. No grains of pigment could be detected in it, which, given its colour, could mean that it is asphalt. I am grateful to Cornelia Peres for her assistance in examining this sheet. F 1061 JH 220 in the Kröller-Müller Museum, a scene of Sien with her baby, is also largely executed in oil paint that penetrated through to the back of the watercolour paper. There, too, the oil has faded badly, as can be seen in the brown heads and hands. That sheet must date from the same period as the drawing discussed here.

3 Since no drawings have been found in which Van Gogh quite definitely used oiled charcoal, we ourselves carried out trials with it on different types of paper for the purposes of comparison.

4 Letters 216/187 and 221/195.

5 Balk 1993, p. 19.

6 Letter from A. Cohen Tervaert-Henny to J. van der Wolk of 14 February 1981 (Van Gogh Museum archives).

7 Letter from J. van der Wolk to F. Bremmer of 7 April 1981 (Van Gogh Museum archives).

54a Sketch probably enclosed with a
letter to Theo, winter 1882-83.
Amsterdam, Van Gogh Museum.

55 Fisherman with sou'wester, pipe and coal-pan

Among the series of heads along the lines of illustrations published in *The Graphic* under the title: *Heads of the people* (see *cat. 47)* is a group of six fishermen. The Van Gogh Museum has four of them – the sheet illustrated here and the following three works. All six are roughly the same size, and the models are wearing the same type of sou'wester. Van Gogh also made a fine, full-length figure study of a fisherman which is now in Otterlo, where the man is also wearing the sou'wester. There are two other, standing fishermen, but they have different headgear.[1]

Van Gogh mentions these fishermen's heads several times in his letters, and a close reading of his remarks makes it clear that the numbering of those letters has to be revised. In one to Anthon van Rappard (1858-1892), which is usually dated 15 January 1883, Van Gogh writes: 'What I have been slaving away at especially of late is heads – Heads of the people [written in English] – including fishermen's heads with sou'westers' [303/R 22]. In a letter to Theo which up until now has been dated later, he told his brother: 'Tomorrow I will be getting a sou'wester for the heads. Heads of fishermen, old and young, that's what I have been thinking of for a long time, and I have made one already, but then I couldn't get hold of a sou'wester any more. Now I shall have one of my own, an old one over which many storms and seas have passed' [305/261]. The beginning and end of this 'letter,' which was previously thought to have been written around 21 January 1883, were believed to have been lost.

The statements in these two passages throw considerable doubt on the accepted sequence. By 15 January Van Gogh had been 'slaving away' at several fishermen's heads with sou'westers, but then, a week later, he had apparently only done one, and had only vague plans for making more once he had got hold of a sou'wester. The order of these letters has clearly been reversed; 305/261 must have been written before 303/R 22, and is probably not a separate letter at all, for it can easily be read as a postscript to letter 302/260 of around 13 January. This would also explain the absence of an opening greeting and a closing signature. Both, too, are on identical paper with similar folds. This reordering also suggests that there was a slightly longer interval between the letters to Theo and

JANUARY 1883

Pencil, black lithographic crayon, opaque white, grey and pink watercolour, on watercolour paper
44.5 × 28.4 cm
Unsigned
Verso: a grid

Inv. d 69 V/1962
F 1016 JH 304

PROVENANCE
1890-91 T. van Gogh; 1891-1925 J.G. van Gogh-Bonger; 1925-62 V.W. van Gogh; 1962 Vincent van Gogh Foundation; 1962-73 on loan to the Stedelijk Museum, Amsterdam; 1973 on permanent loan to the Van Gogh Museum, Amsterdam.

LITERATURE
De la Faille 1928, vol. 3, p. 46, vol. 4, pl. XLVIII; Vanbeselaere 1937, pp. 101, 199-200, 409; De la Faille 1970, p. 374; Hulsker 1980, p. 76, no. 304; Amsterdam 1987, p. 397, no. 2.180; De la Faille 1992, vol. 1, pp. 46, 262, vol. 2, pl. XLVIII; Van Heugten / Pabst 1995, p. 12.

EXHIBITIONS
1905 Amsterdam, no. 240; 1914-15 Amsterdam, no. 21; 1990 The Hague, unnumbered; 1995 Amsterdam, ex catalogue.

Van Rappard. Vincent (who got his sou'wester around 14 January) told the latter that he had been working on fishermen's heads 'of late' – in other words for several days, at least.

This demonstrates that the series of fishermen's heads originated around mid-January and was preceded by a single study of the same subject. The only one of the known fishermen's heads that it could be (some of Van Gogh's studies have doubtless not survived) is a sheet that was once in the Norton Simon Foundation, which is of a man around 30 (fig. 55a).[2] That study, in other words, could date from the last weeks of December 1882 or the first half of January 1883. It can be assumed that the four studies in the Van Gogh Museum were made in the second half of January, shortly after Van Gogh got hold of a sou'wester. One head of a fisherman with a fringe of beard (cat. 58) can be dated to the end of the month thanks to a probable reference to it in one of the letters.

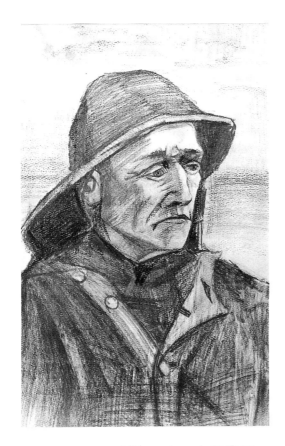

55a *Fisherman in a sou'wester* (F 1012 JH 308), 1883. Whereabouts unknown.

55b Johannes Walter after Petrus van de Velde, *Piet van de Visscher*, from: *De Zwaluw: volksblad met platen* 1 (1882), p. 1. Amsterdam, Van Gogh Museum.

55 Fisherman with sou'wester, pipe
and coal-pan

1 The drawing in Otterlo is F 1010
JH 306. The two fishermen with a
different kind of headgear are F 1049
JH 312 and F 1083 JH 313.
2 That drawing was sold at Sotheby's,
New York, on 2-4 May 1973, no.30.
The present owner is unknown.
3 F 1011 JH 309.
4 Van Heugten / Pabst 1995, p. 14.

For the head in the present drawing, Adrianus Zuyderland, the pensioner who was also the model for the seated fisherman in Otterlo, was fitted out with the sou'wester. For three of the other sheets, catalogue numbers 56 and 57, and the study of a head in Otterlo,[3] Van Gogh also seems to have enlisted his models from the old people's home. All three are probably of the same elderly man with sunken cheeks and fierce-looking mouth turned down sharply at the corners. It can be assumed that these sheets of posed pensioners belong to the series executed after around 14 January.

Here Zuyderland is lighting his meerschaum pipe from a glowing piece of coal from a coal-pan. Van Gogh got his idea for this from a wood engraving after Peter van de Velde that he came across in the illustrated magazine *De Zwaluw*, which he had savaged the month before in a letter to Theo *(fig. 55b)*.[4] It, too, shows a fisherman lighting his pipe from a coal-pan – an earthenware box holding glowing coals that was also used in stoves. Van Gogh's version concentrates exclusively on this action. The light comes from the right, illuminating the hand holding the pipe. In the coal-pan, prominent in the foreground, the area by the bowl of the pipe has been left light in order to suggest the flaring glow of the coal. This drawing is quite exceptional among the studies and male and female heads of the period, for nowhere else does Van Gogh allow his models to perform an action. In order to accommodate this the man is shown almost half-length, unlike the pure studies of heads.

The back of the sheet is squared with a grid. Van Gogh evidently drew it when preparing for the drawing but then seems to have forgotten that he had done so and used the other side of the paper instead.

56 Head of a fisherman with a sou'wester

Van Gogh was understandably enthusiastic when he added a sou'wester to his collection of attributes (see *cat. 55*), because that distinctive and easily recognisable headgear was almost all he needed to transform his models into fishermen. The various parts of the sou'wester, such as the extended brim at the back for keeping the neck dry and the two ear-flaps which could be fastened with a cord passing under the chin, are illustrated in a 19th-century posed photograph in the series *Costumes des Pays-Bas (fig. 56a)*.

Van Gogh also tried to show those parts of the hat in this sheet. The elderly man is probably also wearing a fisherman's jacket. He looks

JANUARY 1883

Pencil, black lithographic crayon, white chalk, brush in black ink, watercolour, grey washed, scratched, on watercolour paper
50.5 × 31.6 cm
Unsigned

Inv. d 377 V/1962
F 1014 JH 310

PROVENANCE
1890-91 T. van Gogh; 1891-1925 J.G. van Gogh-Bonger; 1925-62 V.W. van Gogh; 1962 Vincent van Gogh Foundation; 1962-73 on loan to the Stedelijk Museum, Amsterdam; 1973 on permanent loan to the Van Gogh Museum, Amsterdam.

LITERATURE
De la Faille 1928, vol. 3, p. 44, vol. 4, pl. XLVI; Vanbeselaere 1937, pp. 101, 199-200, 409; De la Faille 1970, p. 374; Hulsker 1980, pp. 77, 84, no. 310; Amsterdam 1987, p. 397, no. 2.178; De la Faille 1992, vol. 1, pp. 44, 261-62, vol. 2, pl. XLVI.

56ª *Traditional Scheveningen costume*, from the series: *Costumes des Pays-Bas*. Not dated. The Hague City Archives.

EXHIBITIONS
1905 Amsterdam, no. 458; 1914-
15 Amsterdam, no. 28; 1947 Gro-
ningen, no. 16; 1947 Rotterdam,
no. 19; 1954-55 Bern, no. 83;
1955 Antwerp, no. 37; 1968-69
London, no. 17; 1974-75
Nottingham, Newcastle-upon-
Tyne, London, Leigh, Sheffield,
Bradford, Brighton & Reading,
no. 112; 1975 Amsterdam,
no. 112; 1990 Otterlo, no. 52;
1992 London, no. 19.

a little like Adrianus Zuyderland, but since he does not have the latter's distinctive side-whiskers this must be another of the residents of the old people's home.

Van Gogh devoted considerable attention to the details in this sheet. The eyes are accentuated with a little pink watercolour. One feature that it shares with many other drawings is that Van Gogh retouched the lithographic crayon and pencil with brush and water. Here he used that technique chiefly to intensify the dark passages to the left of the face and in the uppermost part of the clothing on the right. The face, which is lit from the left and cleverly modelled with light and shade, gains added plasticity from that contrast, as do the folds heightened with white in the left of the jacket. The surface of the areas treated with water has scattered blisters, the tops of which are often a little worn, making them shinier than the artist intended.

For the dating see catalogue number 55.

57 Head of a fisherman with a sou'wester

The elderly man in this drawing is the same as the one in the previous sheet. This time he is seen obliquely from above – an odd angle that Van Gogh never repeated to such an extreme – and clenched between his lips is the meerschaum pipe so beloved of fishermen of the day. The sketchy clothing is not easily classified.

Van Gogh highlighted the face by accentuating the areas around it – the shoulders, neck and the brim of the hat – with lithographic crayon.

In most of these studies virtually the whole surface of the sheet is filled, leaving little or no bare paper. Here, though, the background has been left open, revealing that Van Gogh used his perspective frame even for studies of this kind. The lines of the grid he ruled on the paper are still faintly visible, as are the shiny streaks left when he rubbed them out. Around the head there is a stain caused by the milk (or some other fixative) used to treat the image.

For the dating see catalogue number 55.

JANUARY 1883

Pencil, black lithographic crayon, grey wash, on watercolour paper Traces of squaring, fixative discolouration around the head
41.7 × 26.5 cm
Watermark: HALLINES (cut in half lengthwise by the lower edge)
Unsigned

Inv. d 68 V/1962
F 1015 JH 307

PROVENANCE
1890-91 T. van Gogh; 1891-1925 J.G. van Gogh-Bonger; 1925-62 V.W. van Gogh; 1931-62 on loan to the Stedelijk Museum, Amsterdam; 1962 Vincent van Gogh Foundation; 1962-73 on loan to the Stedelijk Museum, Amsterdam; 1973 on permanent loan to the Van Gogh Museum, Amsterdam.

LITERATURE
De la Faille 1928, vol. 3, p. 46, vol. 4, pl. XLVIII; Vanbeselaere 1937, pp. 101, 199, 409; De la Faille 1970, p. 374; Hulsker 1980, pp. 76-77, no. 307; Amsterdam 1987, p. 397, no. 2.179; De la Faille 1992, vol. 1, pp. 46, 262, vol. 2, pl. XLVIII.

EXHIBITIONS
1900-01 Rotterdam, no. 73? (possibly F 1010); 1905 Amsterdam, no. 256; 1908 Amsterdam, no. 109? (possibly F 1010); 1914-15 Amsterdam, no. 20; 1931 Amsterdam, no. 114; 1953-54 Bergen op Zoom, no. 17; 1956 Haarlem, no. 8.

56 Head of a fisherman with a sou'wester

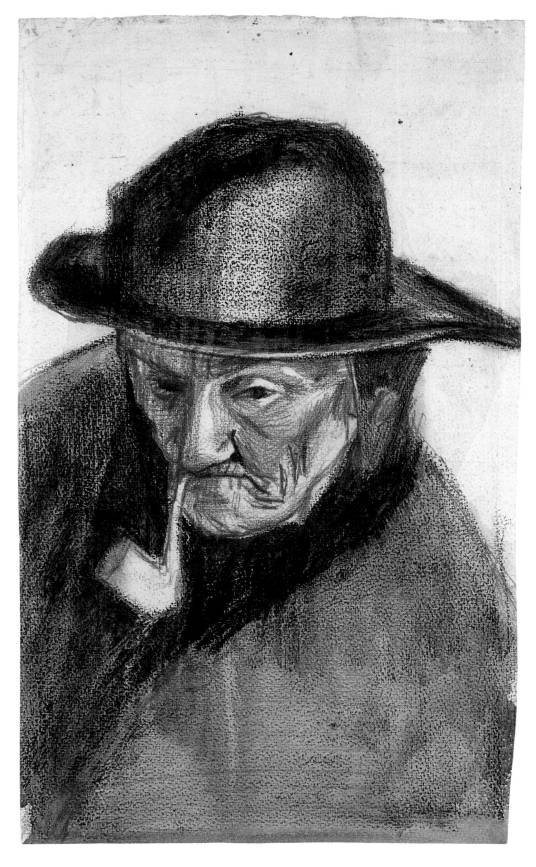

57 Head of a fisherman with a sou'wester

58 Head of a fisherman with a fringe of beard and a sou'wester

DECEMBER 1882-JANUARY 1883

Pencil, black lithographic crayon,
brush and pen in black ink,
opaque white, pink and reddish
brown watercolour, grey wash,
scratched, on watercolour paper
47.2 × 29.4 cm
Unsigned

Inv. d 70 V/1962
F 1017 JH 302

PROVENANCE
1890-91 T. van Gogh; 1891-1925
J.G. van Gogh-Bonger; 1925-62
V.W. van Gogh; 1962 Vincent van
Gogh Foundation; 1962-73 on loan
to the Stedelijk Museum, Amster-
dam; 1973 on permanent loan to the
Van Gogh Museum, Amsterdam.

LETTER
307/262

LITERATURE
De la Faille 1928, vol. 3, p. 46,
vol. 4, pl. XLVIII; Vanbeselaere
1937, pp. 101, 199-200, 409; De la
Faille 1970, pp. 374, 376; Visser
1973, p. 103; Hulsker 1980, p. 75,
no. 302; Amsterdam 1987, p. 397,
no. 2.181; De la Faille 1992, vol. 1,
pp. 46, 262, vol. 2, pl. XLVIII.

EXHIBITIONS
1905 Amsterdam, no. 253; 1914-15
Amsterdam, no. 37; 1975
Amsterdam, no. 121; 1990 The
Hague, unnumbered.

1 Letter 307/262.

Only one of the fishermen's heads can be specifically associated with a passage in a letter by Van Gogh. At the end of January 1883 he again told how happy he was with his sou'wester, adding that the latest head of a fisherman for which he had used it was of a man with his beard in a fringe.[1] There can be little doubt that he was referring to this study.

With his bearded, heavily lined face, the man looks like an archetypal Dutch fisherman. He is dressed for rough weather in a fisherman's jacket fastened high around the neck, and with the ear-flaps of his sou'wester tied. Technically, it is a highly finished sheet. Like most of the head studies from this period it was first set down in pencil and then reworked with black lithographic crayon, in which scratches were made. This sheet, though, was worked up further with thin, white watercolour, accents in pink and some reddish-brown opaque watercolour, black ink with the brush and pen, and was then given a grey wash.

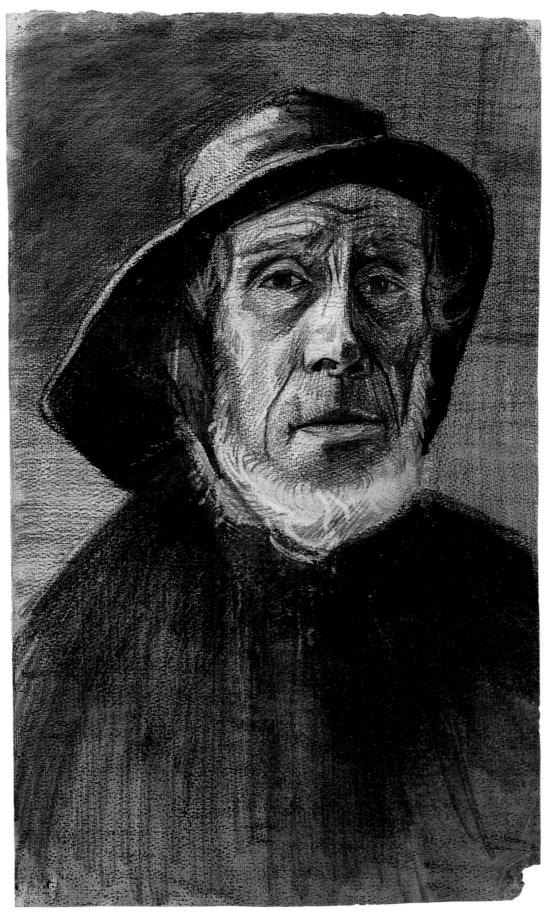

58 Head of a fisherman with a fringe
of beard and a sou'wester

59 Five men and a child in the snow

MARCH 1883

Natural black chalk, transparent
grey and brown watercolour,
opaque black watercolour, on part
of an envelope
13.8 × 10.5 cm
Unsigned
Recto: postmark
Annotation on the verso: Het zijn
zeer groote / stukken bergkrijt /
die gij medebragt verl. / jaar – *die*
zijn het die / ik bedoel. Juist door /
dat zij grooter zijn / hoeft men
geen / teekenpen te gebruiken
[They are very big pieces of natural
chalk that you brought me last
year, and *they* are the type I mean.
Because they are bigger one does
not have to use a drawing pen]

Inv. d 318 V/1970
F – JH 323

PROVENANCE
1883-91 T. van Gogh; 1891-1925
J.G. van Gogh-Bonger; 1925-62
V.W. van Gogh; 1962 Vincent van
Gogh Foundation; 1962-70 with
V.W. van Gogh, Laren; 1970-73 on
loan to the Stedelijk Museum,
Amsterdam; 1973 on permanent
loan to the Van Gogh Museum,
Amsterdam.

LETTER
324/270

LITERATURE
Hulsker 1980, pp. 78-79, no. 323;
Amsterdam 1987, p. 398, no. 2.185;
De la Faille 1992, vol. 1, p. 471,
no. 1780, vol. 2, pl. CCLXIX.

EXHIBITIONS
None.

Van Gogh sent his brother this small drawing to demonstrate the fine, graphic effect of natural chalk, a material whose merits he had recently discovered.[1] Theo had brought him the chalk in the summer of 1882, but Van Gogh found that he was unable to use it properly. He tried again in March 1883, and this time he was delighted with the result: 'Enclosed is a scratch done with it; you see it is a peculiar, warm black. I would be greatly obliged if you would bring me some more this summer. It has one great advantage – the big pieces are much easier to handle while sketching than a thin stick of conté, which is hard to hold and breaks all the time. So it is delightful for sketching outdoors' [324/270]. On the back of the sketch he again explained precisely what he wanted, adding that the advantage of the chalk was that, because the pieces were big, he did not need a 'drawing pen.' The latter was itself a slip of the pen; what he undoubtedly meant was the holder into which sticks of chalk were inserted to make them more manageable.

Although Van Gogh described it as a 'scratch,' and drew it on the back of an envelope, this sketch has been done with considerable care. Nothing in the letter indicates that it is a reproduction of a larger sheet. It is a finished drawing in its own right with no fewer than six figures, for which Van Gogh used studies of models that he had in stock. The man seen from the back on the far left is known from a large pencil drawing of Adrianus Zuyderland *(fig. 59a; see also cat. 33)*. The companion with whom he seems to be conversing is taken from the study of Zuyderland with a cap and a walking-stick *(cat. 31)*, judging by the position of the feet and the left arm, or from the lithograph made after it. The other four figures may have been based on now unknown models that Van Gogh had in his portfolios of sketches. The covered heads and thick overcoats of the six figures, who appear to be standing in snow, show that this is a winter scene.

Technically this sheet has been worked up quite highly. The main medium is natural chalk, but Van Gogh reinforced it here and there with opaque black watercolour and finished the drawing with grey and brown washes.

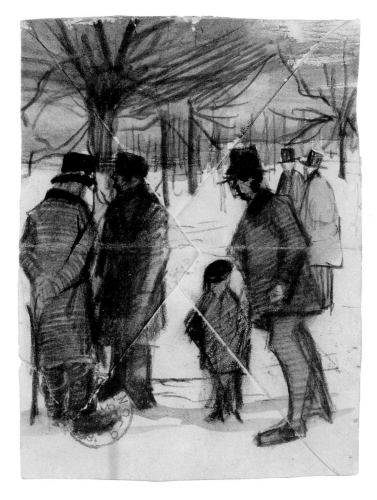

59 Five men and a child in the snow

1 See the Introduction.

2 The drawing covers more than half the postmark, which is anyway difficult to read because part of it was stamped over the flap, with the result that a section is missing due to the difference in levels. All the same, it can be partly deciphered. It consists of two concentric circles within which part of the word ''SGRAVENHAGE' (The Hague) can be made out at the top. At the bottom is '5-6 N', standing for 5 to 6 pm, the time the letter was postmarked. In the middle of the stamp was the date, but only the '3' of the year '83' is now visible. I am grateful to Mr R. Lagerwey of the Dutch Postal and Telecommunications Museum in The Hague for his assistance here.

The paper he used forms a rather shabby contrast with the care lavished on the composition and drawing technique. It is the back of an envelope. The front, with the address, was cut off (so the text now on the back was written on what was originally the inside of the envelope). At lower left on the drawing is a postmark. It is not the type used nowadays, but the mark that was stamped on letters in the 19th century in the post office at the town of receipt. Post went out several times a day – there were usually four deliveries or more – and was postmarked on the back of the envelope shortly before being given to the postman.[2]

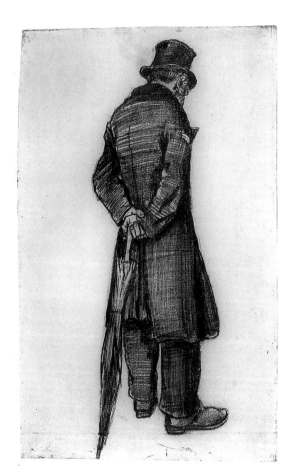

59a *Old man with an umbrella, seen from the back* (F 972a JH 239), 1882. Bern, Kunstmuseum.

60 Soup distribution in a public soup kitchen

Van Gogh began using public soup kitchens in January 1881, during the first few weeks of his stay in The Hague. The city ran two such facilities where the poor could eat cheaply: the ''s-Gravenhaagse Volksgaarkeukens' in Torenstraat and Stationstraat. There were also several kitchens operated by charities that were known as 'soepkeukens' or 'spijskokerijen.' It is not clear from Van Gogh's letters which of them he visited, but since he usually speaks of 'volksgaarkeuken' they were probably the municipal kitchens [199/170].[1] He did so, needless to say, for financial reasons, but there were also artistic considerations involved. He could make rapid sketches of the customers, who were by definition the working-class types he sought as models.

It was at that time that he met the slightly younger artist George Hendrik Breitner (1857-1923), who was also living in The Hague. They went out on drawing expeditions together, and often made sketches 'in the soup kitchen or in the waiting room etc.' [203/174]. Breitner made a watercolour of a *Soup kitchen* around this time that is now in the Stedelijk Museum in Amsterdam. Nothing is known of Van Gogh's early efforts in this vein, although a letter to Van Rappard (1858-1892) shows that the subject was still occupying him some months later.[2]

It resurfaces in another letter to Van Rappard of October 1882. They had got to know each other in Brussels in 1880, and Van Gogh now reminded his friend of the city's 'établissements de bouillon.' 'One of Roger's was opened that winter near the Hôtel de Ville, and I saw the opening, when soup was being given away free to poor people early in the morning. I suddenly recalled it the other day, and this is the drawing I am working on at present' [275/R 28]. That sheet, for which residents of the Geest district of The Hague had posed, is also lost. The first surviving versions of the subject were made in March 1883: a drawing in chalk and watercolour in a private collection *(fig. 60a)*, and this large chalk drawing in the Van Gogh Museum.

Settings like soup kitchens and third-class waiting rooms were part of a 'realistic' tradition that had been flourishing for several decades, chiefly abroad, which highlighted the often appalling conditions under which the working classes lived and laboured. Van Gogh knew many of

MARCH 1883

Natural black chalk, brush in black paint, opaque white watercolour, scratched, on watercolour paper. A strip of canvas along the top
Traces of squaring
56.5 × 44.4 cm
Signed at lower left: Vincent

Inv. d 783 V/1982
F 1020a JH 330

PROVENANCE
1883-91 T. van Gogh; 1891-1912 J.G. van Gogh-Bonger; 1912 Artz en De Bois gallery, The Hague, for Dfl. 1,200; 1918 J.H. de Bois gallery, Haarlem; d'Audretsch gallery, The Hague; Unger en Van Mens gallery, Rotterdam; 1953-72 A. Stoll, Arlesheim-Corseaux; 1972 bought by the Theo van Gogh Foundation, Bern (Kornfeld und Klipstein), 18 November, no. 81; 1972-73 on loan to the Stedelijk Museum, Amsterdam; 1973 on permanent loan to the Van Gogh Museum, Amsterdam; 1982 Vincent van Gogh Foundation.

LETTERS
325/271, 326/272, 327/R30.

LITERATURE
Bremmer 1934, no. 1, no. 5; Stoll
1961, p. 18, no. 75; Tralbaut 1969,
p. 96; De la Faille 1970, p. 378;
Hulsker 1973, pp. 12-15; Visser
1973, pp. 73-76; Hulsker 1980,
pp. 74, 78, 80-81, no. 330; Amster-
dam 1987, p. 398, no. 2.187; Zemel
1987, pp. 353, 356; Van der Mast /
Dumas 1990, pp. 134-35; De la
Faille 1992, vol. 1, p. 263, vol. 2,
pl. CCXIX; Heijbroek / Wouthuysen
1993, p. 201.

EXHIBITIONS
1912 The Hague, no. 16; 1954
Geneva, no. 235; 1970 Frankfurt,
no. 25; 1980-81 Amsterdam,
no. 66; 1983-84 Amsterdam,
no catalogue; 1987-88 Manchester,
Amsterdam & New Haven,
no. 101; 1990 Otterlo, no. 58;
1992 London, no. 21.

those works of art, and had become familiar with this particular subject from his own collection of prints and magazine illustrations. That collection, which is now in the Van Gogh Museum, includes a wood engraving and a few other prints by Auguste Lançon (1836-1887) which Van Gogh bought in September 1882. He was so fascinated by them that he 'got up during the night to look at them again' [264/R 12]. The wood engraving is inscribed 'Distribution de soupe' in Van Gogh's handwriting *(fig. 60b)*.[3]

It was with scenes like this in the back of his mind that he embarked on his own versions in March 1883. As before, he probably made several sketches on the spot. One of them, 'a rough sketch that I made of soup being sold in the soup kitchen' [325/271], he enclosed in a letter to Theo in

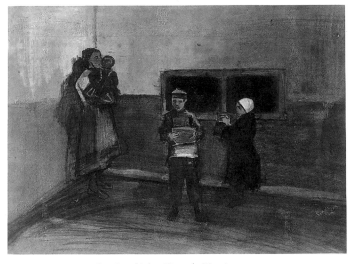

60a *Soup kitchen* (F 1020b JH 331),
1883. Private collection.

60b F. Moller after Auguste Lançon,
Distribution de soupe. Amsterdam, Van
Gogh Museum.

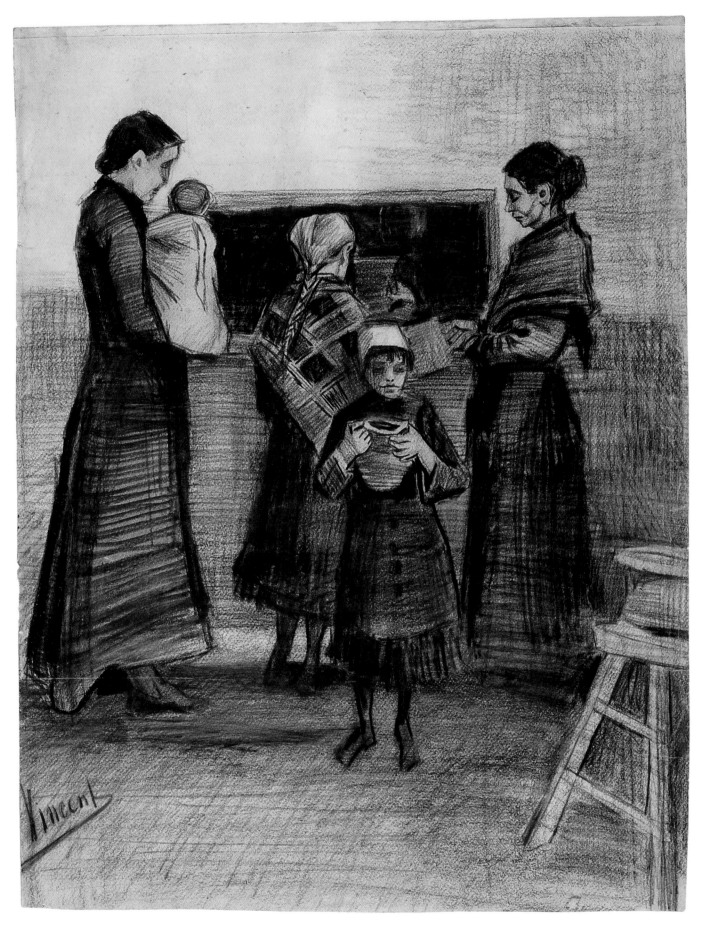

60 Soup distribution in a public
soup kitchen

1 This information is taken from Visser 1973, pp. 73-76. Visser comes to the conclusion that when Van Gogh was living with Sien Hoornik he must have used the Catholic charity kitchen of St Vincent de Paul, for the Hoorniks were Catholics and lived in the parish where that kitchen was situated. It also had an oblong serving hatch like the one in the drawings. However, the appearance of the other soup kitchens is not known, so it remains unclear from which kitchen or kitchens Van Gogh collected his cheap meals.
2 See letter 231/R 28.
3 In Van Gogh's collection of magazine illustrations housed in the Van Gogh Museum there is a wood engraving of the subject by William Jenkins, The distress in Paris: giving soup to the poor at the charity kitchen, which he took from The Illustrated London News 64 (28 March 1874). A closely related work is Edwin Buckman's People waiting for ration tickets in Paris from: The Graphic 2 (19 November 1870). In the letter to Van Rappard cited above, 275/R 28, Van Gogh compares the soup kitchens 'in Brussels or London or The Hague' to another of E. Buckman's prints, Vor dem Asylhause, which is not known to me.
4 The slightly later letter is 328/273, in which Van Gogh merely speaks of an 'enclosed sketch [which] is very unfinished,' but does not specify the subject. The preceding passage is devoted mainly to the landscape he had seen while out on a walk that morning, and it is possible that the now unknown sketch was intended to give his brother an impression of it.

which he outlined his plans for the subject *(fig. 60c)*. Since the publication of the 1953 edition of the letters, that small study has been regarded as a sketch that Van Gogh sent with a slightly later letter, but since he says nothing there about the subject there is every reason to believe that this is the 'rough sketch' mentioned in the letter quoted above.[4]

After closely studying the procedure of soup distribution he decided to make a reconstruction in his studio, which had recently undergone several improvements, above all in the lighting. In his letter he illustrated his plans with a sketch *(fig. 60d)*, and told his brother about the setting he had reconstructed. The soup was doled out in 'a large hall where the light falls from above through a door on the right. Now I tried to get that same effect in the studio. I placed a white screen in the background, on which I drew the window [hatch] with its real proportions and measurements. I closed over the rear window [in the studio] entirely, and the middle window at the bottom, so that the light enters at P [written in the window in the sketch], exactly as it does in the place itself. You will understand that when the models are posing there I will have them just as they are in the real soup kitchen. The sketch above shows the grouping in the studio. I have framed the part I intend to draw. Of course I can now experiment with the poses of the figures as long and as much and as precisely as I like, yet generally remaining true to what I have seen. I should like to try this again in watercolour, for instance, and work hard on it to develop it more. It seems to me that there is more opportunity for figure painting in the studio now' [325/271].

In order to stage the scene in his studio he would be getting three models the next day, in addition to Sien and her children. They were Sien's mother and youngest sister, and a local boy. As already pointed out *(cat. 50)*, this was merely a plan, not a description of something that had already taken place, so one has to be cautious about identifying the figures, particularly since it is not even certain that this is the drawing that Van Gogh made that following day. He undoubtedly made several studies of the location that he had created in his studio at some expense and trouble, possibly using different actors. However valuable Van Gogh's letters may be in documenting his life, they do not tell us everything about his phenomenal output.

A boy is only seen in the other surviving version of the *Soup kitchen (fig. 60b)*, a fairly sketchy work with faces that have barely any individualised features. This leaves us guessing at the identity of the other models. The woman on the left is probably Sien (or her mother) with the baby on her arm, and the little girl with the white cap is probably Sien's five-

year-old daughter. The chalk drawing in the Van Gogh Museum is far more detailed but no less problematic. Sien is easily recognisable on the far right, but the woman with the baby on the left has turned her head so far away that nothing can be said about her features or about any resemblance to other studies of women in Van Gogh's œuvre. We can only assume that she is Sien's mother. The little girl in the middle, again wearing a white cap, is almost certainly Sien's daughter, Maria Wilhelmina. The bigger girl with the braid, by the serving hatch, could be Sien's youngest sister, but that seems unlikely (see *cat. 50*).

This sheet is one of a group of drawings in natural chalk that Van Gogh made at this time (see also *cats. 59, 61, 63*).[5] Theo had sent his brother the chalk in the summer of 1882, but Vincent was disappointed by the studies he made with it. Now, though, he had discovered its potential,

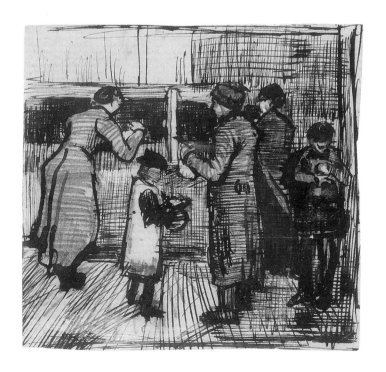

60c Sketch enclosed with a letter to
Theo of c. 3 March 1883 (325/271).
Amsterdam, Van Gogh Museum.

60d Sketch in letter to Theo of
c. 3 March 1883 (325/271). Amsterdam,
Van Gogh Museum.

5 For a more detailed discussion see the
Introduction.
6 Heijbroek / Wouthuysen 1993, p. 201.
7 The other three works were F 487
JH 1651, F 886 JH 69, and the lithograph
F 1662 JH 268; for the latter see Van
Heugten / Pabst 1995, p. 93, imp. 5.6.

and wanted Theo to send him some more, saying that it had 'the soul of a gypsy' [326/272]. In this drawing the distinctive black, slightly brownish tint of the chalk has been reinforced here and there with the brush in black paint. Van Gogh added a few accents in opaque white watercolour, which he also used to create the impression of steam rising from the pot of soup in the hatch. In many places the chalk looks almost transparent. One possible explanation for this effect is that he used bread-crumbs. It is known from one of the letters that by rolling the crumbs over the chalk he was able to remove much of it and obtain 'half-tones' [328/273]. Van Gogh worked on watercolour paper with quite a fine grain. Along the top edge is a strip of canvas that was already there when the drawing was made. Its original purpose is unclear. Van Gogh finally signed the sheet boldly at bottom left and sent it to his brother [326/272].

In 1912, Johanna van Gogh-Bonger sold *Soup distribution in a public soup kitchen* for Dfl. 1,200 to the Artz and De Bois gallery in The Hague.[6] It proved difficult to sell, and passed through the hands of at least three other dealers before entering the collection of Arthur Stoll (1887-1971) in Zürich in 1953, who owned four works by Van Gogh.[7] His collection was auctioned in 1972, when V.W. van Gogh acquired this drawing for the Theo van Gogh Foundation. It was transferred to the Vincent van Gogh Foundation ten years later.

61 Woman sewing, with a girl

There is a description of this drawing of Sien and her daughter in a letter to Theo, together with an account of the artistic problems Van Gogh had encountered. 'As to what you write about the sketch of those two figures, one above the other, it is mostly an effect of perspective – and also of the great difference in size between the little child and the woman on the basket. What I personally dislike more than that line of the composition is something which, in fact, you have also remarked upon – that the force of the two figures is too similar. That is partly because one lacks some tones with the natural chalk and would like to strengthen it, with lithographic crayon for instance. But I think that the main reason is that I do not always have enough time to work as thoroughly as I should wish. If one returns to a drawing time and again it is possible to seek the different tones more fully. But usually I have to work quite quickly' [329/274].[1]

The precise nature of Theo's criticism is not known, but it may have had something to do with the very compact nature of the scene. There is hardly any suggestion of space between the woman and the child. As Van Gogh himself indicated, that could have been remedied by using a wider range of greys, which would have separated the figures a little more, but that was impossible with natural chalk. He tried to correct the problem, not very successfully, by reinforcing the black with ink and adding lighter greys with opaque watercolour. Finally, he gave the drawing a watercolour wash – probably of a grey shade, but the discolouration of the paper makes it impossible to say for certain.

As an exercise in perspective, though, it was very satisfactory. The slightly downward-looking view of the seated woman shows that Van Gogh was standing when he drew her, which would not have presented any great difficulties with the perspective. The girl, though, was another matter, for she was foreshortened. The challenge was to combine these two views convincingly. Van Gogh also seems to have made things more difficult for himself by not using a perspective frame, for there is not a trace of a drawn grid.

Here Sien is busy with her work as a seamstress, seated on a basket which features in other several drawings.[2] It is known that Van Gogh had an old fish-basket which he took with him on drawing expeditions to

MARCH 1883

Natural black chalk, pen and brush in brown-black ink (possibly black originally), black watercolour, opaque grey watercolour, grey (?) wash, scratched, on wove paper
55.6 × 29.9 cm
Signed at lower left: Vincent

Inv. d 74 V/1962
F 1072 JH 341

PROVENANCE
1890-91 T. van Gogh; 1891-1925 J.G. van Gogh-Bonger; 1925-62 V.W. van Gogh; 1962 Vincent van Gogh Foundation; 1962-73 on loan to the Stedelijk Museum, Amsterdam; 1973 on permanent loan to the Van Gogh Museum, Amsterdam.

LETTERS
329/274, 334/276.

LITERATURE
De la Faille 1928, vol. 3, p. 56, vol. 4, pl. LXI; Meier-Graefe 1928, pl. 4; Vanbeselaere 1937, pp. 103-04, 190, 410; De la Faille 1970, pp. 392-93; Hulsker 1980, pp. 80, 82-83, no. 341; Amsterdam 1987, p. 399, no. 2.191; Zemel 1987, p. 361; Feilchenfeldt 1988, p. 127; De la Faille 1992, vol. 1, pp. 56, 275, vol. 2, pl. LXI; Soth 1994, pp. 105-10.

EXHIBITIONS
1909-10 Berlin, ex catalogue;
1914-15 Amsterdam, no. 7; 1927-
28 Berlin, Vienna & Hannover,
no. 12; 1928 Paris, no. 4?; 1948-
49 The Hague, no. 187; 1953-54
Bergen op Zoom, no. 20; 1955
Antwerp, no. 33; 1956 Haarlem,
no. 9; 1957 Nijmegen, no. 15;
1957 Stockholm, no. 18; 1990
Otterlo, no. 43.

1 Although it is also quite clear from this quotation that the drawing was made with natural chalk, the material was strangely enough described as charcoal in Amsterdam 1987, no. 2.189, and in Otterlo 1990, no. 43.

2 There are three other studies of a woman seated on a basket: F 1083 JH 313, F 1069 JH 325 and F 1070 JH 326. In the lithograph, A workman's meal-break, F 1663 JH 272, the man sits on it as he slices his bread. There is also a fisherman with a basket on his back, F 1083 JH 313.

3 As suggested in Van Heugten / Pabst 1995, cat. 6.

4 Borders are also frequently found around Van Gogh's paintings; see Van Tilborgh 1995, pp. 165-68.

serve as a seat, and probably for carrying his drawing implements as well.[3] The seated girl with the neatly combed hair and hands clasped over her knees is very likely Sien's five-year-old daughter, but once again that identification is a little problematical. Her face is quite similar to that of the girl sitting on Sien's lap in catalogue number 63, but it cannot be denied that that girl looks a bit older and sturdier.

One interesting point is that Van Gogh drew a border around the scene with chalk and black paint. He regularly did this with his later drawings, above all in Nuenen, but it is most unusual in the Hague period.[4] The paper is slightly damaged below the girl's left hand, but that was done by the artist himself. In order to suggest that the fingers of her right hand are peeping out from below her left hand he scraped away not only the drawing material but some of the paper as well.

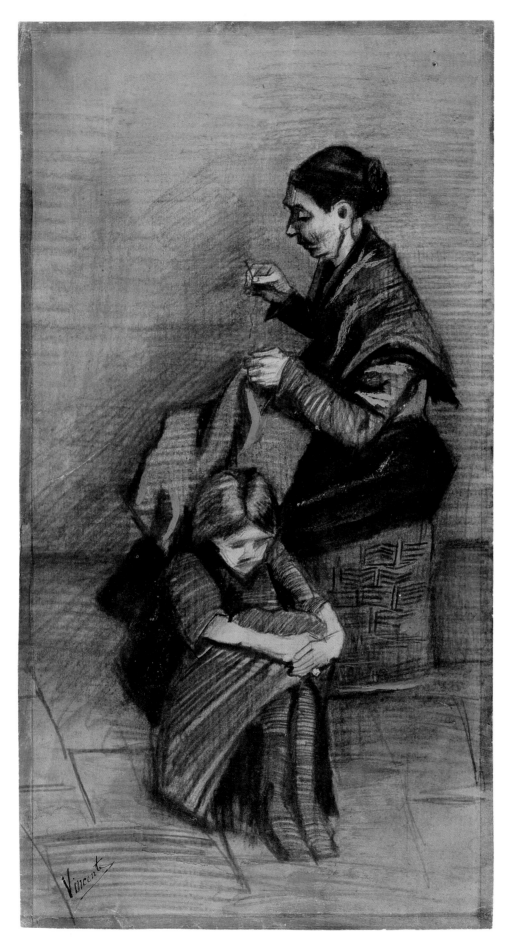

61 Woman sewing, with a girl

62 Girl kneeling by a cradle

MARCH 1883

Pencil, natural black chalk,
opaque white watercolour,
grey (?) wash, on wove paper
Traces of squaring
48.0 × 32.3 cm
Signed at lower left: Vincent

Inv. d 72 V/1962
F 1024 JH 336

PROVENANCE
1890-91 T. van Gogh; 1891-1925
J.G. van Gogh-Bonger; 1925-62
V.W. van Gogh; 1931-62 on loan
to the Stedelijk Museum,
Amsterdam; 1962 Vincent van
Gogh Foundation; 1962-73 on
loan to the Stedelijk Museum,
Amsterdam; 1973 on permanent
loan to the Van Gogh Museum,
Amsterdam.

LETTERS
329/274, 334/276.

LITERATURE
De la Faille 1928, vol. 3, p. 47,
vol. 4, pl. I; Vanbeselaere 1937,
pp. 104, 204, 409; De la Faille
1970, p. 380; Van Crimpen 1975,
p. 17; Hulsker 1980, pp. 80-82,
no. 336; Amsterdam 1987, p. 399,
no. 2.189; Van der Mast / Dumas
1990, p. 20; Zemel 1987, p. 362;
De la Faille 1992, vol. 1, pp. 47,
264, vol. 2, pl. L.

EXHIBITIONS
1905 Amsterdam, no. 239; 1914-
15 Amsterdam, no. 8; 1931 Am-
sterdam, no. 107; 1947 Gronin-
gen, no. 17; 1947 Rotterdam,
no. 20; 1948-49 The Hague,
no. 188; 1954-55 Bern, no. 84;
1955 Antwerp, no. 36; 1955

Van Gogh drew this domestic scene of Sien's children in March 1883, at around the same time as the preceding drawing. Sien's daughter, Maria Wilhelmina, who was born in 1877, is kneeling at the foot of the cradle containing her eight-month-old brother Willem. Van Gogh mentions the sheet briefly in two letters, once describing it merely as a sketch of 'a cradle' [329/274], and a little later enclosing a sketch *(fig. 62a)* of 'the little girl by the cradle' [334/276]. He had made a drawing of the newborn baby in its cradle in July the previous year. That scene is known only from a sketch sent with one of the letters: 'a study [...] with a few touches of colour in it' [250/218].

The brief mentions of these works in the letters do not reflect the significance of the subject for Van Gogh. To him, the child in its cradle embodied not only the sense of family security that he had with Sien and her children, but it also gave him a comforting, quasi-religious feeling of an eternity that he once described as a 'rayon d'en haut' [282/242], a ray of light from on high that rose way above man's daily drudgery. The emotional charge of the theme was thus related to what he experienced in the story of the Nativity. He knew pictures of the infant Christ in the crib, as well as everyday scenes of babies in their cradles, from the work of the great masters of the Dutch seventeenth century and contemporary realist painters like Millet. For years he had had a print of a similar subject after Rembrandt in his collection of graphic art, the *Holy family at night*.[1] In 1876, when he was working in a Paris art gallery, it had been one of the 25 prints with which he decorated his room in Montmartre, and it was the only one in the list he gave that he commented on: 'A large old-Dutch room (evening, a candle on the table), where a young mother is sitting reading the Bible beside her baby's cradle. An old woman sits listening. It is a thing that reminds you of: "Again, I say unto you, where two or three are gathered together in my name, there am I in the midst of them"' [37/30]. In the years that followed, Van Gogh's religious fervour assumed breathtaking proportions before being transformed into a world view with a very human face and a certain pantheistic slant. His original feelings for the subject remained undiminished, though, and were aroused particularly strongly by the sight of Sien's child in the cradle.

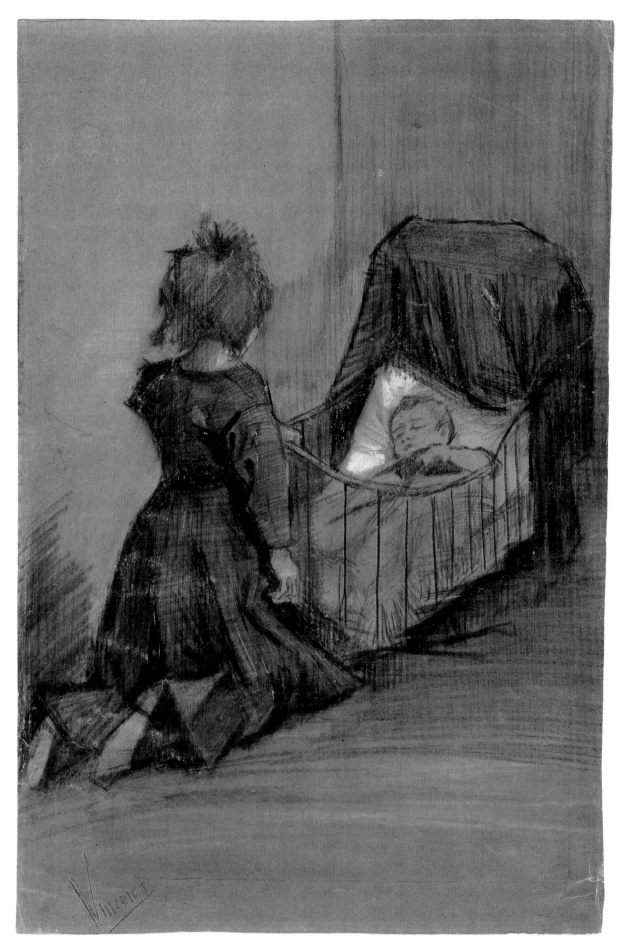

62 Girl kneeling by a cradle

1 For this see Van Lindert / Van Uitert 1990, pp. 56-58, as well as for the subject of a woman beside a cradle in Van Gogh's œuvre. The painting after which the engraving was made is now in the Rijksmuseum in Amsterdam, and shows the Virgin reading a book while her mother Anne is rocking the Christ Child to sleep in a cradle. Doubt has been cast on the correctness of the attribution to Rembrandt, but it has certainly been ascribed to him since time immemorial. On this point see Peter Hecht, 'Een topstuk in de hoek gezet,' Kunstschrift no. 98, 38 (1994), pp. 2-3.

2 See letter 291/249.

3 The Portrait van Léonie Rose Davy-Charbuy, F369 JH1206, is vaguely related, but is mainly a portrait of the young mother with the cradle as a secondary detail in the background and no child visible. A sketchbook from the Auvers period contains a drawing of a baby in a pram.

4 Similar sentiments are found in letters 397/332, 400/335 and 404/339, all of which were written in Drenthe.

5 This idea is mentioned in letter 671/ W 6. The baby, Marcelle Roulin, was depicted twice with its mother, Augustine Roulin (F490 JH1637 and F491 JH1638), and three times on its own (F440 JH1639, F441 JH1641 and F441a JH1640). In Arles Van Gogh again expressed the feeling aroused by the subject: 'A child in the cradle, if you watch it at leisure, has the infinite in its eyes' [660/518].

He still had the print after Rembrandt, and he now surrounded the baby's sleeping area with this and other appropriate scenes. He said that he could not look at the cradle 'without emotion, for it is a strong and powerful emotion that grips a man when he has sat beside the woman he loves with a baby in the cradle near her. [...] It is always that eternal poetry of Christmas night with the baby in the stable – as the old Dutch painters saw it, and Millet and Breton – that light in the darkness, a brilliance in the middle of the dark night. I accordingly hung the large etching after Rembrandt over it, the two women by the cradle, one of whom is reading from the Bible by the light of a candle, while great shadows cast a deep chiaroscuro all over the room. [...] And just listen, between ourselves, without being preachy, it may be true that there is no God here, but there must be one not far off, and at such a moment one feels His presence. Which is to say, and I readily give this sincere profession of faith: I believe in a God, and believe that it is His will that man does not live alone, but with a wife and a child, if everything is to be normal' [245/213]. In his preceding letter he had used more down-to-earth words to express his joy over 'a new studio, a young home in full swing. No mystical or mysterious studio but one that is rooted in real life – *a studio with a cradle and a baby's commode*' [244/212].

He also felt that the subject of a cradle would be suitable for a series of inexpensive prints that he hoped to make.² However, there are no other known variants, notwithstanding Van Gogh's assertion in July 1882 that he wanted to depict the subject 'a hundred times more' [250/218].³ The only full treatment in his entire œuvre is this sheet with the child kneeling by the cradle.

However, the subject never lost its grip on Van Gogh. In Drenthe, to which he retreated, deeply depressed, from The Hague, he found peace of spirit 'by a peasant's peat fire with a cradle beside it' [398/333].⁴ Five years later, when he got to know the Roulin family with their newborn child in Arles in the south of France, he again thought of painting a baby in its cradle. He did immortalise that child in five paintings, but not one of them includes a cradle.⁵ A little later he decided to paint his bedroom, with a nude woman or a child in its cradle, but that plan, too, came to nothing.⁶ The only work that can really be seen as an extension of the motif is Van Gogh's large copy after Millet's *Evening: La veillée (fig. 62b)*, but that is an interpretation of another artist's work, and as such had a different significance from the Hague sheet.

Like the preceding three drawings *(cats. 59-61)*, this sheet is executed mainly in natural chalk. Van Gogh may have rubbed the chalk with bread-

crumbs here and there in order to get more delicate gradations (see *cat. 61*). There is quite a lot of pencil in the girl's dress, the purpose of which was to widen the range of tones. He focused even greater attention on the baby by heightening the pillow with white, which he also used to make corrections around the girl's head. The fairly cheap, woody paper has browned badly, giving the whites a greater contrast than was at first intended. The drawing is finished with a wash which was probably grey originally, although the discolouration of the paper makes it difficult to say for certain.

6 Letter 680/534: '[...] mon lit à moi je vais le peindre, il y aura 3 sujets. Peut-être une femme nue, je ne suis pas fixé, peut-être un berceau avec un enfant, je ne sais, mais je prendrai mon temps' ('I am going to paint my own bed; there will be three subjects in it. Perhaps a nude woman, I haven't yet decided, or perhaps a child in a cradle. I don't know, but I shall take my time over it'). In both the 1990 Dutch edition of Van Gogh's letters and the English edition of 1958 this passage is interpreted as though the artist was planning to decorate his bed with these motifs. Although that is perfectly feasible as a translation, it seems very unlikely that that is what Van Gogh actually intended. It is simply his first announcement of the painted subject of The bedroom.

62a Sketch in a letter to Theo of c. 21-28 March 1883 (334/276). Amsterdam, Van Gogh Museum.

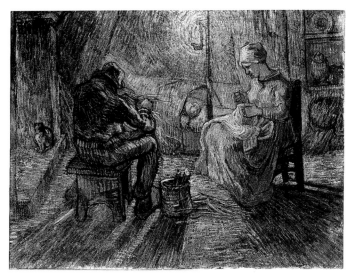

62b *Evening (after Millet)* (F 647 JH 1834), 1889. Amsterdam, Van Gogh Museum.

63 Woman with a child on her lap

MARCH-APRIL 1883

Natural black chalk, opaque white watercolour, brown (?) wash, scraped, on wove paper
Traces of squaring
53.8 × 35.5 cm
Signed at lower left: Vincent

Inv. d 71 V/1962
F 1067 JH 356

PROVENANCE
1890-91 T. van Gogh; 1891-1925 J.G. van Gogh-Bonger; 1925-62 V.W. van Gogh; 1931-62 on loan to the Stedelijk Museum, Amsterdam; 1962 Vincent van Gogh Foundation; 1962-73 on loan to the Stedelijk Museum, Amsterdam; 1973 on permanent loan to the Van Gogh Museum, Amsterdam.

LITERATURE
De la Faille 1928, vol. 3, p. 55, vol. 4, pl. LX; Vanbeselaere 1937, pp. 106, 207, 410; De la Faille 1970, p. 391; Hulsker 1980, p. 86, no. 356; Amsterdam 1987, p. 399, no. 2.192; Zemel 1987, p. 362; Van Lindert / Van Uitert 1990, pp. 12-13; De la Faille 1992, vol. 1, pp. 55, 274, vol. 2, pl. LX.

EXHIBITIONS
1914-15 Amsterdam, no. 11; 1923 Utrecht & Rotterdam, no. 2; 1927-28 Berlin, Vienna & Hannover, no. 4; 1929 Amsterdam, no. 11; 1931 Amsterdam, no. 108; 1947 Groningen, no. 19; 1947 Rotterdam, no. 22; 1948-49 The Hague, no. 189; 1954-55 Bern, no. 87; 1955 Antwerp, no. 34; 1957 Nijmegen, no. 14; 1961 Scarborough, no catalogue; 1975 Malmö, no. 12; 1976 Stockholm, no. 12; 1976 Oslo, no catalogue; 1990 Otterlo, no. 42.

This drawing occupies a special position within a group of nine scenes of a mother, usually Sien, with a child on her lap.[1] It is the only one in which the child is not a baby but a young girl. It can be assumed that all those works illustrate motherhood. This was one of the themes in which Van Gogh set out to express the role he believed women should play in modern society. His ideas on the subject were formed primarily by *La femme* by Jules Michelet, whom he greatly admired. Michelet's view was that a woman's real purpose in life was to be a wife and mother, and that only total dedication to those tasks gave her existence true value.[2]

However well-intentioned Van Gogh's ideas, the drawing has a rather oppressive air. Sien has turned her head towards the child – her eyes hooded, her face expressionless. The girl has a distant, rather timid look. One would have expected the role of the girl to have been played by Sien's five-year-old daughter, but this is quite a big child and looks a little older, so she might be Sien's younger sister (see *cat. 53*).

This sheet has always been regarded as a charcoal drawing, but comparison with works that are known beyond doubt to have been done in natural chalk *(cats. 59, 62)* shows that this was the main material used here.[3] Van Gogh gave the scene a watercolour wash which may have had a brown shade, but since the paper – a sheet of cheap, woody wove – has browned badly that cannot be established conclusively. The suggestion of light reflected off the hair and accentuating parts of the figure's dress, such as the folds in Sien's left sleeve, was achieved by scraping away the drawing material.

1 The other drawings are F1061 JH220, F1062 JH216, F1063 JH218, F1064 JH221, F1065 JH217, F1066 JH322 (in which the woman does not look like Sien), F1068 JH219 and F1071 JH104.
2 Jules Michelet, La femme, Paris 1860. Zemel 1987 provides a detailed survey of the theme of motherhood in Van Gogh's work and its association with Michelet's book. See also Van Lindert / Van Uitert 1990, pp. 56-58. Van Gogh did not return to the motif of a woman and child until 1888, in Arles.
3 The comparisons were made using a magnifying glass and a stereomicroscope.

63 Woman with a child on her lap

64 Man in a village inn

MARCH 1883

Pencil, pen and brush in brown
ink (possibly black originally),
opaque white watercolour, on
wove paper
11.7 × 7.5 cm
Unsigned
Verso: pencilled scribbles

Inv. d 317 V/1970
F – JH 339

PROVENANCE
1883-91 T. van Gogh; 1891-1925
J.G. van Gogh-Bonger; 1925-62
V.W. van Gogh; 1962 Vincent
van Gogh Foundation; 1962-70
with V.W. van Gogh, Laren;
1970-73 on loan to the Stedelijk
Museum, Amsterdam; 1973 on
permanent loan to the Van
Gogh Museum, Amsterdam.

LETTER
334/276.

LITERATURE
Hulsker 1980, pp. 82-83,
no. 339; Amsterdam 1987, p. 398,
no. 2.188; De la Faille 1992,
vol. 1, p. 471, no. 1786, vol. 2,
pl. CCLXX.

EXHIBITION
1962 London, no. 10.

1 Letter 334/276.
2 F – JH 342.
3 See the Introduction.

Van Gogh drew a sketch in a letter of late March 1883, and added two
loose sheets of 'scratches.'[1] The drawing in the letter itself is a view of a
snow-covered yard,[2] and one of the two enclosed sketches reproduces the
drawing of Sien's daughter kneeling in front of her baby brother's cradle
(fig. 62a). The other sheet is the one shown here.

Unlike the other sketches sent with the letter, this is not a copy of a
larger drawing. It is an autonomous work, and is unusually anecdotal for
Van Gogh. That, and the considerable care bestowed on it, is why it has
been included in this catalogue, despite the fact that it is a sketch sent
with a letter. When Van Gogh made it he had a story, or in his own words
a 'figment of the imagination,' complete with an evocation of the mood.
'It shows a gentleman who has been obliged to spend the night at a vil-
lage inn because the coach was delayed, or some such reason. Now he has
got up early in the morning, and while ordering a glass of brandy against
the cold pays the landlady (a woman in a peasant's cap). It is still very
early in the morning, "la piquette du jour" [the crack of dawn], he must
catch the mail coach; the moon is still shining, and through the inn's par-
lour window one sees the snow glittering, and every object casts a pecu-
liar, outlandish shadow. This little story is of no importance whatsoever,
nor is the little sketch, but the one as well as the other will perhaps make
you understand what I mean, which is that everything lately has had a
certain air of je ne sais quoi that made one long to dash it off on paper'
[334/276]. Although Van Gogh does not say so, it is more than likely that he
was considering small scenes of this type as subjects for illustrations that
he hoped to sell to magazines.[3]

The initial drawing is in pencil, and the blacks were then reinforced
with the pen and brush in ink which has since turned brown. The cap of
the woman behind the counter is heightened with white.

64 Man in a village inn

65 Man breaking up the soil

APRIL-MAY 1883

Pencil, black chalk, brush in
black, opaque grey and white
watercolour, grey wash, on pale,
pinkish brown laid paper
43.7 × 30.1 cm
Watermark: JV
Unsigned

Inv. d 119 V/1962
F 1307 JH 853

PROVENANCE
1890-91 T. van Gogh; 1891-1925
J.G. van Gogh-Bonger; 1925-62
V.W. van Gogh; 1931-62 on loan
to the Stedelijk Museum, Amster-
dam; 1962 Vincent van Gogh
Foundation; 1962-73 on loan to
the Stedelijk Museum, Amster-
dam; 1973 on permanent loan to
the Van Gogh Museum, Amster-
dam.

LITERATURE
De la Faille 1928, vol. 3, p. 107,
vol. 4, pl. cxx; Vanbeselaere 1937,
pp. 278, 413; De la Faille 1970,
p. 457; Hulsker 1980, p. 192,
no. 853; Amsterdam 1987, p. 423,
no. 2.335; Kôdera 1990, p. 136,
note 254; Otterlo 1990, pp. 121,
123, no. 71; De la Faille 1992,
vol. 1, pp. 107, 335, vol. 2, pl. cxx.

EXHIBITIONS
1905 Amsterdam, no. 296;
1914-15 Amsterdam, no. 92;
1926 Munich, no. 2106; 1927-
28 Berlin, Vienna & Hannover,
no. 37; 1955 Antwerp, no. 85;
1975 Malmö, no. 39; 1976
Stockholm, no. 39; 1976 Oslo,
no catalogue; 1976-77 Tokyo,
Kyoto & Nagoya, no. 31; 1990
Otterlo, no. 71.

In the œuvre catalogues of De la Faille and Hulsker, and in the catalogue of the collection of the Van Gogh Museum, this drawing was grouped with several others that Van Gogh made of agricultural workers in the summer of 1885, when he was living at Nuenen, in Brabant. In 1990, though, Van der Wolk relocated it to the Drenthe period on the basis of two pieces of evidence. In letter 389/324, which was written in Drenthe in September 1883, Van Gogh wrote that the men there wore short trousers, and the man in this drawing is indeed wearing shorts, although they could perhaps be better described as half-length trousers. Moreover, the 'JV' watermark is not found in paper used at Nuenen, but it does occur in the sheet *Potato field in the dunes*,[1] which was made in The Hague, and also in a drawing that Van der Wolk discovered in 1990, which he identified as a landscape in Drenthe.[2] He accordingly suggested that Van Gogh had taken some sheets of this paper from The Hague to Drenthe. However, what was overlooked, or at least not mentioned, was that Tsukasa Kôdera had already pointed out in 1987 that this drawing did not belong in the Nuenen period but was made in The Hague, before May 1883.[3] The reason for this is that the same man is found in the right background of a large drawing, *Peat-cutters in the dunes (fig. 65a)*, which Van Gogh executed in May 1883, incorporating in it various studies that he had made earlier (see also *cats. 43, 44*). The whereabouts of that large, composite work are unknown, and the surviving photograph is of rather mediocre quality. However, the identification does appear convincing.

The man is traditionally described as a digger, but closer study of the two sheets shows this to be incorrect. In the large composition he is in the company of two figures with pickaxes raised above their heads, and it seems that he has just wielded the same implement to break up the soil. The study with the single figure clearly shows that he is holding the handle by the very end, so he cannot be digging, for he would be unable to exert much force if he was holding a spade that way. It is also striking that the handle widens out towards the head, which is not the case with a spade, and appears to be very short, for the broad end is almost touching the ground. A pickaxe does indeed have a shorter

65 Man breaking up the soil

1 F 1037 JH 390.

2 See Otterlo 1990, p. 121 and no. 71. The newly discovered landscape is no. 72, Landscape in Drenthe, from a private collection. According to the catalogue it is in black chalk, ink and watercolour, and measures 27.5 × 42.0 cm.

3 Kōdera 1987, p. 62, note 11. Also included in Kōdera 1990, p. 136, note 254.

4 De la Faille 1930, no. 161.

5 The landscape with the woman and child measures 29.3 × 43.8 cm and was executed in pencil, pen and brush in brown-black ink, opaque white paint, light brown wash, on pale, pinkish brown laid paper with the watermark 'JV'.

handle than a spade, and often widens out considerably in order to absorb the shock from the heavy blows delivered with it.

There is another drawing *(fig. 65b)* that can now be added to the small group of works on paper with the 'JV' watermark. De la Faille had rejected its attribution to Van Gogh and listed it in his *Les faux Van Gogh*.[4] That opinion must now be revised. The drawing, which is in a private collection, was brought to the Van Gogh Museum at the end of 1995 for authentication. It shows a landscape typical of the provinces of North or South Holland, not Drenthe, with a farmhouse and a windmill, and a woman and a child walking down a country lane. It is very close in style to the *Potato field in the dunes*, and is executed in similar media to that sheet and this drawing of the man breaking up the soil. All three are brush drawings in black or brown-black and white, and as such form a distinct group within Van Gogh's Hague work.[5] The landscape would also have been drawn in April-May 1883, when Van Gogh acquired a batch of tinted, laid paper with the watermark 'JV'. The drawing discovered in 1990 offers few clues for identifying the location, and could have been made in either Drenthe or The Hague.

65a Detail of fig. 44a.

65b *Landscape with a woman and child,* 1883. Private collection.

66 Old nag

Although Van Gogh had decided early on in his career to draw animals, this scene of a pitiful horse is the only known sheet in which he recorded such a motif as an independent work, without any detail and on a large scale. He had studied animals in Etten (see *cat. 20)*, and continued doing so in The Hague by sketching horses and donkeys in the streets.[1] Those efforts resulted in two street scenes of September 1882 *(fig. 66a).*[2] Two months later he discovered a worn-out horse that he wanted to use as a model, but its owner demanded three guilders a morning if he had to bring the animal to Van Gogh and at least half that if the artist came to him. Van Gogh never paid the people who posed for him more than 50 cents for a morning or an afternoon, and balked at the prices of $1^1/_2$ or two guilders a day charged by more experienced models.[3] The fee for the animal was more than he could afford, especially because he wanted to do 'about 30 large studies' [281/241]. Since 'a study that is of any use' easily took half an hour to make, he would have to hire the horse for several mornings.

It was not until June 1883 that another opportunity arose, when Van Gogh had the idea of depicting the subject of the Hague rubbish dump

66a *Sheet of studies of a horse and cart and a donkey-cart* (F 952v JH 193), 1882. Otterlo, Kröller-Müller Museum.

JUNE 1883

Pencil, brush in transparent and opaque black watercolour, on watercolour paper
51.0 × 63.5 cm
Unsigned

Inv. d 808 V/1986
F 1032 JH 368

PROVENANCE
1881-86 A.C. van Gogh-Carbentus, Nuenen-Breda; 1886-1902 Schrauwen, Breda; 1902 J.C. Couvreur, Breda; 1902 W. van Bakel and C. Mouwen, Breda; 1911-40 S.R. Steinmetz, Amsterdam; 1940 R.T. Steinmetz, Ellecom; 1963-70 on loan to the Haags Gemeentemuseum, The Hague; Steinmetz's heirs; 1985 London (Sotheby's), 27 March, no. 303 (unsold); 1986 bought by the Vincent van Gogh Foundation through the Monet gallery, Amsterdam; on permanent loan to the Van Gogh Museum, Amsterdam.

LITERATURE
Van Gogh 1905, no. 14; Steenhoff 1905, p. 5; De la Faille 1928, vol. 3, p. 48, vol. 4, pl. XII; Vanbeselaere 1937, pp. 108, 214, 409; De la Faille 1970, p. 382; Visser 1973, pp. 84-86; Hulsker 1980, p. 88, no. 368; Amsterdam 1987, p. 496, no. 2.787; Van Crimpen 1987 1, no p. no.; Kunstbeeld 1987, p. 7; Amsterdam 1991, pp. 36-37; De la Faille 1992, vol. 1, pp. 48, 266, vol. 2, pl. XII.

EXHIBITIONS
1903 Rotterdam, no. 77; 1910-11
Rotterdam, no. 24; 1961
Amsterdam, no. 26; 1990
The Hague, unnumbered.

1 See letter 263/230.

2 The other sheet is F 1079 JH 192.

3 For these prices see letters 207/178, 273/238 and 336/278; and for the higher prices letters 190/163 (Scheveningen models) and 202/173 (the model used by David Artz, a Hague painter).

4 For some information on the Hague Sanitation Department and rubbish dump see Schmal 1995, p. 116.

5 See letter 352/289.

6 I am grateful to Prof. H.J. Breukink of the Department of Veterinary Medicine at Utrecht University for the information on the characteristics of these horses.

7 See also Louis van Tilborgh in his discussion of the Old nag in Amsterdam 1991, pp. 36-37. Van Gogh made a variant of the subject of a boat being dragged up onto a beach in a lost painting of September 1882, the composition of which is known from a sketch in letter 265/231. Boats had to be hauled out of the sea at Scheveningen because the village had no harbour.

8 On Steinmetz see Balk 1993, p. 5.

9 In addition to this Old nag they were F 131 JH 685, F 132 JH 574, and F 951 JH 197.

with rag-pickers. Horses were part of the theme, for they pulled the carts in which refuse was brought to the dump.[4] Van Gogh felt that he needed to make preparatory studies of them, and the stables at Rijnspoor Station, not far from his house, provided him with a way of doing so. He made two drawings there, and also hoped to study one of the rubbish dump horses.[5] It is not known whether he ever did, so it can be cautiously assumed that this old nag was one of the animals from the Rijnspoor stable.[6] The large drawing of the rubbish dump that Van Gogh made a little later has been lost, but the composition is known from a sketch in a letter (fig. 66b). There, in the shadowy background, is a horse in the same pose as this *Old nag*, but reversed right for left.

Although this sheet is a study, Van Gogh's choice of a quadruped worn down by its daily work meshes seamlessly with his conviction that life may be laborious and filled with 'more drudgery than rest' [293/251], but that the only solution was to 'savoir souffrir sans se plaindre' (know how to suffer without complaining) [210/181]. He used that French quotation when describing his feelings about the broken-down horses in Anton Mauve's Salon painting of 1881, which are straining to drag a fishing boat up onto the beach at Scheveningen (fig. 66c).[7] He had had a similar feeling in Brussels some years before, in the autumn of 1878, when he saw the miserable horses of the city's street-sweepers. He compared them to one in a print in the series *La vie d'un cheval* which stands awaiting its end 'patiently and meekly yet bravely and seemingly unflinchingly' [147/126]. The *Old nag* expresses a similar sentiment. The animal has just finished work, for although it has been freed from the traces it still has its blinkers on, and is eating with forelegs buckling from weariness and ears drooping. There can be no great expectations for its remaining life, but Van Gogh's message is that it accepts its wretched existence with resignation.

The initial drawing is in pencil, and Van Gogh made two light strokes with an eraser in the horse's mane. The animal is placed against a dark background. Transparent paint was used in the lower parts of the composition, opaque paint higher up. Both are now largely dark grey to black, but around the edges there are much browner strips where the paper was once covered by a mount. The watercolour was therefore probably a dark sepia colour originally. In addition to providing a powerful contrast to the white horse, Van Gogh had another reason for this dark background, for he had already used the sheet for another sketch of a horse, some lines of which must still have been visible. One can just be seen even now, at lower centre. Van Gogh must have drawn it with considerable force, for it is visible on the back of the sheet, along with other lines. The paper was evidently

66 Old nag

resting on another study and picked up dark material at the points where Van Gogh sketched. It can vaguely be seen that the first horse extended over the width of the paper, with the present righthand edge at the bottom. The animal's head was on the right (part of it, with a nostril, was transferred to the verso), and the pencil line that is still visible on the front belonged to the hind legs on the left.

Like catalogue numbers 18, 67 and 68, this drawing featured in the 1903 exhibition in the Oldenzeel gallery in Rotterdam, where it was given the title *Horse*. It can be deduced from its presence in this exhibition that it belonged to the works that Van Gogh left behind with his mother when he left Nuenen at the end of 1885 (see *cat. 18*). Around 1911 it was in the collection of Rudolf Steinmetz (1862-1940), a professor of sociology in Amsterdam and the brother-in-law of the art educationist H.P. Bremmer (1871-1956). Interestingly, it was this academic who had encouraged Bremmer to start giving drawing lessons and hold his associated courses in aesthetics.[8] Steinmetz eventually acquired a total of two paintings and two drawings by Van Gogh, all from the artist's Dutch period, and it is possible that his brother-in-law served as his adviser and intermediary.[9] In 1986 the Vincent van Gogh Foundation bought the work from an art dealer acting for the widow of Steinmetz's son.

66b Sketch in a letter to Theo of c. 10 June 1883 (354/292). Amsterdam, Van Gogh Museum.

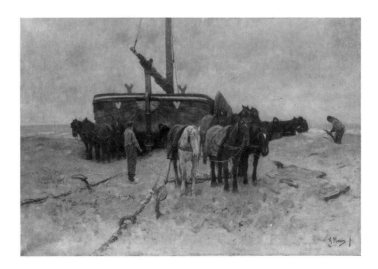

66c Anton Mauve, *Fishing boat on the beach*, 1882. The Hague, Haags Gemeentemuseum.

67 Landscape in Drenthe

The museum has two of the 16 or 17 known drawings that resulted from Van Gogh's stay in Drenthe,¹ including this subtle rendering of dusk falling.

In October 1881, when Van Gogh was still living at Etten, he had made a vague promise to visit Anton Mauve (1838-1888) in Drenthe, where the latter regularly worked. He never did so, however, and until September 1883 only knew of the picturesque features of this eastern province from the accounts of his colleagues Mauve, Frans ter Meulen (1843-1927) and Anthon van Rappard (1858-1892). The latter was so enthusiastic that Van Gogh felt that he really would have to go and see Drenthe for himself, and when he broke up with Sien he decided to move there for a while. There was also a financial attraction, for it was a great deal cheaper to live in the country.² In the event, Van Gogh spent barely three months there, from 11 September to 5 December 1883.

Van Rappard's descriptions of the moors had reawakened Van Gogh's memories of the heaths of Brabant that he had known in his youth but which had now largely disappeared as a result of agricultural development. It had possessed a sort of 'stern poetry' for him [257/R 11], and he thought that he would find something similar in Drenthe. He discovered, though, that the moors were far more extensive, and that at certain times of the day they looked almost desolate, 'as aggravating, monotonous and wearying as the desert' [390/325], which he nevertheless wanted to capture if he could. What attracted him more, though, was the dusk. 'In the evening, when a poor little figure moves through the twilight – when that vast, sun-scorched crust of the earth stands out darkly against the delicate lilac hues of the evening sky and the dark blue, very last thin line on the horizon separates earth from sky – that same aggravating, monotonous spot can be as sublime as a J. Dupré' [390/325]. That beautiful evocation of nature is recorded in this drawing. The sun has set, and its dying rays hang just above the horizon, as it were. Van Gogh achieved this effect with pencil hatchings which become heavier towards the sides of the sheet, and by heightening the central section with thin, opaque white watercolour. The small figures of a man on a horse and a woman stand out against the half-light, but in the right half the backlit effect is pro-

SECOND HALF OF SEPTEMBER-EARLY OCTOBER 1883

Pencil, pen and brush in brown ink, opaque white watercolour, on laid paper
31.4 × 42.1 cm
Watermark: VdL; a coat of arms with a lion with a sword bordered by the inscription PRO PATRIA EENDRAGT MAAKT MAGT
Unsigned

Inv. d 810 M/1986
F 1104 JH 424

PROVENANCE
1881-86 A.C. van Gogh-Carbentus, Nuenen-Breda; 1886-1902 Schrauwen, Breda; 1902 J.C. Couvreur, Breda; 1902-04 W. van Bakel and C. Mouwen, Breda; 1904 Buffa gallery, Amsterdam, at Amsterdam (Frederik Muller), 3 May, no. 34, for Dfl. 62; H. Gorter, Bussum; before 1928 d'Audretsch gallery, The Hague; G.H.E. van Suchtelen, The Hague; A.L.J. Einthoven-van Suchtelen, The Hague; 1953 Huinck and Scherjon gallery, Amsterdam; until 1956 W. Weinberg, New York; 1957-86 P.J. Goldberg, London, at London (Sotheby's), 10 July, no. 54; 1986 bought by the Van Gogh Museum, Amsterdam, at London (Christie's), 2 December, no. 127.

LITERATURE
De la Faille 1928, vol. 3, p. 63, vol. 4, pl. LXIX; Vanbeselaere 1937, pp. 237, 410; Tralbaut 1959, pp. 215, 224, no. 22; Tralbaut 1969, p. 122; De la Faille 1970, p. 404; Hulsker 1980, p. 100,

no. 424; Amsterdam 1980-81,
p. 71; Van Crimpen 1986, p. 70;
Amsterdam 1987, p. 496,
no. 2.789; Van Crimpen 1987
II, no p. no.; Amsterdam 1991,
pp. 40-41; De la Faille 1992,
vol. 1, pp. 63, 282, vol. 2, pl. LXIX.

EXHIBITIONS
1900-01 Rotterdam, no. 52?
(possibly cat. 68); 1903
Rotterdam, no. 78; 1953 Amster-
dam, no. 9; 1955 New York,
no. 92; 1988 Rome, no. 64;
1990 Otterlo, no. 74.

*1 Another sheet from the collection, cat.
65, was recently dated to that period, but
in this catalogue it is regarded as a work
from The Hague, as explained in that
entry.*
2 See letter 381/316.
*3 I am grateful to Kees Posthuma for
this technical information.*
*4 See the annotated copy of the sale cat-
alogue in the Netherlands Institute for
Art History (rkd) in The Hague.*
5 Ibidem; the painting is F 20 JH 417.

vided by the masts and rigging of two ships, a few trees and the large farmhouse. The ships are probably moored in a waterway behind the farmhouse that runs parallel to the horizon, judging by their angle. The one on the right has lowered its sails and raised its bowsprit, which is still just visible above the horizon. The other ship seems to have brailed up its sails to dry them, for the area of canvas is too small for a ship under way.[3]

Van Gogh's letters are of no help in dating this pen drawing, but from the appearance of the trees, which are still in full leaf, it seems likely that it was made quite early on in Van Gogh's Drenthe period – in the second half of September or early October.

The sheet must have been one of the works that Van Gogh left with his mother in Nuenen in 1885. They then disappeared for a long time (see *cat. 18*), only resurfacing in 1903, when they were exhibited at the Oldenzeel gallery in Rotterdam. This sheet was offered for sale there, along with numbers 18, 66 and 68 in the present catalogue. *Landscape in Drenthe* remained unsold, and a year later it appeared with 40 other works in an auction held by Frederik Muller in Amsterdam.[4] It was bought for Dfl. 62 by the Amsterdam Buffa gallery, which probably sold it to the poet Herman Gorter (1864-1927) shortly afterwards, together with a painting, *Peasant burning weeds*, which had been bought at the same auction.[5]

The sheet was quite badly damaged when it was with one of its owners. It was torn along its full height on the left, and even after restoration and mounting the tear is still visible.

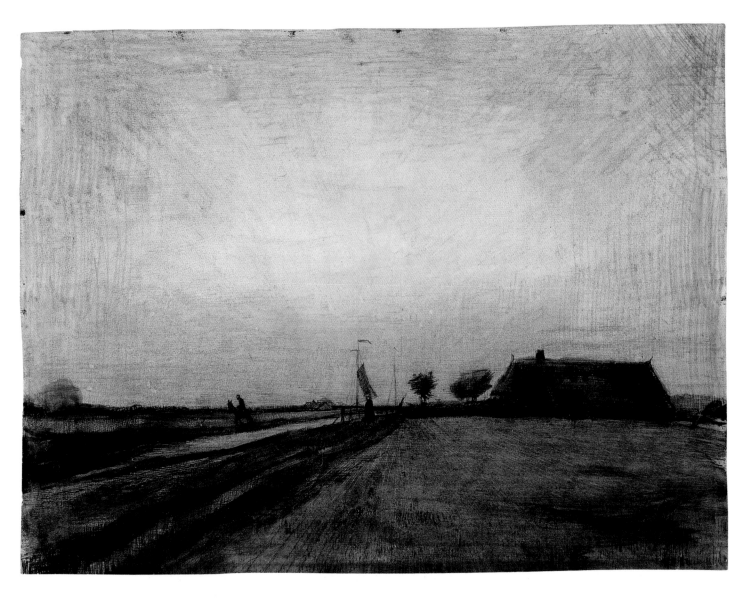

67 Landscape in Drenthe

68 Landscape with a stack of peat and farmhouses

SEPTEMBER-DECEMBER 1883

Opaque watercolour on wove paper
41.7 × 54.1 cm
Unsigned

Inv. d 386 M/1977
F 1099 JH 399

PROVENANCE
1881-86 A.C. van Gogh-Carbentus,
Nuenen-Breda; 1886-1902 Schrau-
wen, Breda; 1902 J.C. Couvreur,
Breda; 1902 W. van Bakel and
C. Mouwen, Breda; until 1925
M. Gieseler, Rotterdam-The Hague;
1925-48 W. van Beuningen, Utrecht,
at Amsterdam (Mak van Waay),
27 October, no. 28, for Dfl. 1,000;
1948-76 C.E. van Beuningen-
Fentener van Vlissingen, Wassenaar;
1976-77 W. van Beuningen, Zutphen;
1977 bought by the Van Gogh
Museum, Amsterdam.

LITERATURE
De la Faille 1928, vol. 3, p. 62,
vol. 4, pl. LXVIII; Vanbeselaere
1937, pp. 236, 410; Tralbaut 1959,
pp. 214, no. 15, p. 223; De la Faille
1970, p. 402; Hulsker 1980, pp. 94-
95, no. 399; Amsterdam 1987, pp.
120-21, 400, no. 2.197; De la Faille
1992, vol. 1, pp. 62, 280-81, vol. 2,
pl. LXVIII.

EXHIBITIONS
1900-01 Rotterdam, no. 52?
(possibly cat. 67); 1903 Rotterdam,
no. 88; 1932 Amsterdam, no. 9;
1980-81 Amsterdam, no. 105; 1982
Amsterdam, no catalogue; 1983-84
Amsterdam, no catalogue; 1990
Otterlo, no. 73.

This watercolour dates from Van Gogh's three-month stay in Drenthe. It is not known precisely when it was made, for there is no mention of it in his letters and there are no internal clues in the scene itself. Like the previous sheet, this a landscape at dusk, the time of day when Van Gogh considered the countryside of Drenthe to be at its most beautiful (see *cat. 67*).

The dark structure in the middle is not an unlit hut, as once stated,[1] but probably a stack of peat. Several works by the artist show that in Drenthe such stacks were often built up in the form of a house with sloping roofs. In a letter sketch from that period, for instance, there is the same sort of hut-shaped stack of peat with some workers beside it.

68a Sketch in a letter to Theo of
c. 22 October 1883 (399/335).
Amsterdam, Van Gogh Museum.

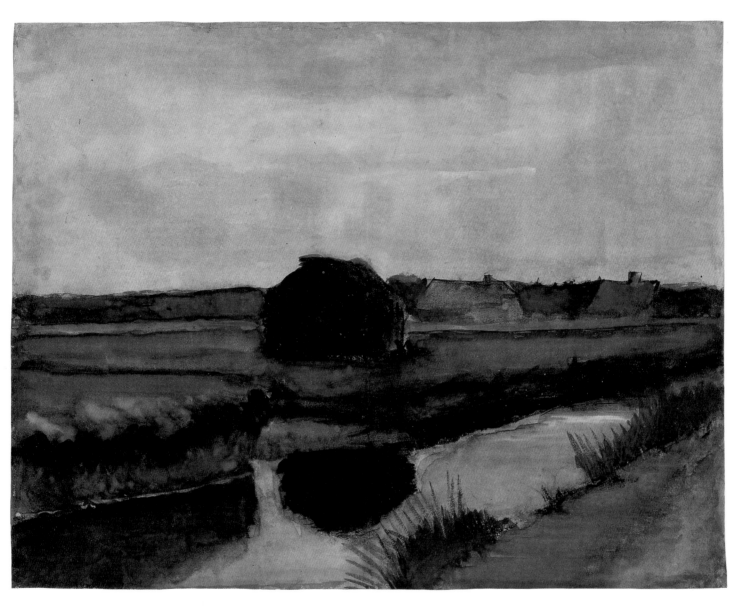

68 Landscape with a stack of peat and
farmhouses

1 Amsterdam 1987, no. 13 on p. 120.

2 Similar stacks feature in F 22 JH 421.
There they are more rounded, but the
sketch of that painting in letter 404/339
shows that the peat stacks behind and to
the right of the farmhouse have a similar
structure to the one in this watercolour.

3 There is a similar fold in F 1094 JH 398,
a watercolour of peat-beds in Drenthe.
The paper is identical to that of the draw-
ing discussed here (and also lacks a
watermark), and the scene is drawn with
comparable materials. It measures
42.5 × 55.2 cm. The paper of cat. 39 is
also the same as that of these sheets:
wove paper with a fine grain.

4 The sheet must have been one of the
works that Van Gogh left behind in his
mother's keeping when he left Nuenen in
1885; see further cat. 18.

5 F 468 JH 1578. The other works were
from Van Gogh's Dutch period: F 24
JH 500, F 110 JH 941, F 177 JH 543,
F 190 JH 492, F 943 JH 156, F 995
JH 56, and F 1099 JH 399. All except
F 995 were auctioned after Gieseler's
death by Mak van Waay in Amsterdam.

6 For this information see the annotated
copy of the sale catalogue in the
Netherlands Institute for Art History
(RKD) in The Hague.

Van Gogh explained that 'these were people I saw at the peat cuttings, who were sitting eating their lunch behind a stack of peat, with a fire in the foreground' [399/335] (*fig. 68a*).[2] The dark stack in the watercolour domi-nates the composition, the more so in that it is reflected in the watercourse that takes up much of the foreground. Two farmhouses can be seen in the distance.

The drawing was done with opaque watercolour, sometimes highly thinned in order to achieve the effect of a true watercolour (see *cat. 39*). The sheet was folded over (before it was painted), which left a vertical crease in the centre.[3]

This is probably the drawing that was exhibited as no. 88, *Evening landscape*, at the Oldenzeel gallery in Rotterdam in November 1903.[4] It came into the possession of the Rotterdam merchant M. Gieseler (1859-1925), who built up quite a large collection of works by Van Gogh: three drawings and five paintings, including the superb *View of a garden* from Arles, which is now in the Art Institute of Chicago.[5] When Gieseler's collection was auctioned in 1925, this Drenthe sheet was bought for Dfl. 1,000 by Willem van Beuningen (1873-1948), a brother of the shipping magnate D.G. van Beuningen (1877-1955).[6] The Van Gogh Museum acquired it from one of his heirs in 1977.

Appendices

Appendix 1

Works not included in the catalogue

1 *See the Introduction, p. 32.*

2 *Thomas Moore,* Who is the maid? St. Jerome's love, *which Van Gogh copied from Harriet Beecher Stowe,* We and our neighbours, London *1875, pp. 108-09. See Pabst 1988, p. 95. The drawing is on the right half of the sheet, with the poem parallel to it but upside down. The paper was originally blank below the drawing, but V.W. van Gogh later used it to make a few notes. The sketch is reproduced in the 1958 edition of the letters in vol. 1, p. 294.*

3 *See also Van der Wolk 1986, p. 16, fig. 19.*

4 *Ibidem, loc. cit., fig. 18.*

5 *Two other mounts for magazine illustrations, t 79 V/1962 and t 821 V/1962, were used for jottings which are so insignificant that they have not been reproduced here.*

6 *Van der Wolk 1986, p. 16, figs. 16-17.*

This appendix briefly examines seven sketches in the Van Gogh Museum's collection that are not included in the catalogue proper. They are unpretentious works from the periphery of Van Gogh's œuvre, and are reproduced here mainly for the sake of completeness, although one or two of them do give some insight into Van Gogh's way of working. They have survived more or less by chance. Five, for example, were used by Van Gogh as mounts for prints in his collection of magazine illustrations (nos. 1.1, 1.3-1.6).

The smudged scene of a sower (no. 1.1) is probably a composition sketch in which the artist studied the subject and marked off the part of the composition that he wanted to keep so as to use it in a larger sheet. It was probably drawn in Etten in September 1881.[1] A small scene of a landscape with fields and houses (no. 1.2) also looks as if was intended to establish the composition for a larger work. Van Gogh later copied out a poem by Thomas Moore on the same piece of paper.[2] The sketch was published in the 1958 edition of Van Gogh's correspondence preceding the letters from the Hague period, although there is no indication that it ever accompanied a letter. It may have been made in The Hague, but there is little internal evidence that would help date it.

The landscape with a puzzling, apparently wooden structure (possibly a lift bridge) was probably made while Van Gogh was out walking near Etten or The Hague (no. 1.3). He presumably intended to work on the subject later, but never seems to have done so.[3]

The subjects of three other sketches are difficult if not impossible to identify, and nor are they easy to date. A study of what appears to be a woman with a shawl viewed from the side, whose outstretched left hand can be seen at the bottom (no. 1.4), was drawn with a white material, possibly chalk. Van Gogh evidently considered it too poor to be worth keeping, and unsuccessfully tried to erase it.

A sheet of the cheap, machine-made paper which Van Gogh used as mounts for many of his magazine illustrations has a drawing of a totally unrecognisable construction (no. 1.5). Another rapid sketch on similar paper is possibly of a woman (no. 1.6).[4] The curved lines are in fact more reminiscent of Van Gogh's late work, for his early style is rather angular, but the drawing is far too sketchy for anything definite to be said about it.[5]

Finally, the margin of a book cover with the title *Les victimes du devoir* has two tiny landscapes with willows (no. 1.7).[6]

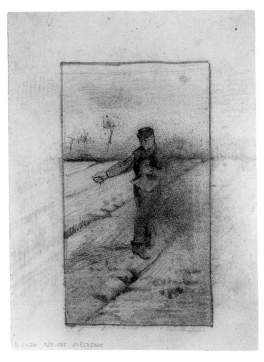

1.2 *Fields and houses.*
Possibly The Hague 1882-83.
Pencil on wove paper. Paper size:
20.6 × 26.8 cm, bordered area:
5.0 × 9.2 cm.
Inv. b 1455 V/ 1962; F – JH –

1.1 *Sower.*
Etten, September 1881.
Pencil on wove paper. Paper size:
29.8 × 22.5 cm, bordered area: 23.5 ×
13.5 cm.
Verso: magazine illustration after George
Henry Boughton, with the inscription
'Pricilla. Dessin de G.-H. Boughton,
d'après son tableau (cent-onzième
Exposition de la Royal Academy)'.
Unknown periodical.
Inv. d 302 V/1962; F – JH 44

1.3 *Landscape with a lift bridge (?).*
Etten or The Hague 1881-83.
Brownish black chalk on laid paper,
40.0 × 31.1 cm.
Watermark: MICHALLET.
Verso: magazine illustration by
William Jenkin, *The distress in Paris:
giving soup to the poor at the charity
kitchen*, from: *The Illustrated London
News* 64 (1873).
Inv. t 204 V/1962; F – JH –

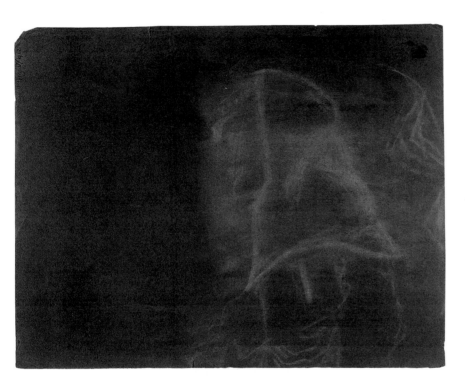

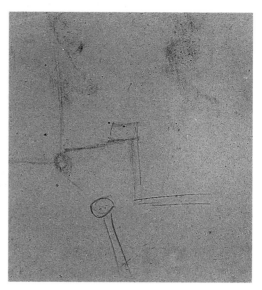

1.4 *Side view of a woman with a shawl.*
Etten or The Hague 1881-83.
White chalk (?), largely erased or
rubbed off, on grey wove paper,
39.9 × 30.9 cm.
Verso: magazine illustration, *Cottage
life in Warwickshire, baking day*, from:
The Illustrated London News 60 (1872).
Inv. t 419 V/ 1962; F – JH –

1.5 *Construction sketch.*
Possibly The Hague 1882-83.
Charcoal on coarse, brown laid paper,
29.7 × 26.2 cm.
Verso: magazine illustration by
Bealmarch, *The English Sunday as it is.*
Unknown periodical.
Inv. t 532 V/1962; F – JH –

1.6 *Female figure (?)*.
Undatable.
Black chalk on coarse, brown laid
paper, 30.7 × 41.6 cm.
Verso: magazine illustration, *St.
Andrew's day, banquet of the Scottish
Corporation at St. James's Hall*, from:
The Graphic 6 (1872).
Inv. t 576 V/ 1962; F – JH –

1.7 *Two sketches of landscapes with
willows*.
Undatable.
Charcoal on wove paper (book cover).
Upper sketch: 5.0 × 5.8 cm, lower
sketch: 4.8 × 5.8 cm.
Drawn in the righthand margin of the
cover of Luc-Olivier Merson's *Les vic-
times du devoir*, n.p., n.d.
Inv. t 1344 V/ 1962; F – JH –

Appendix 2

Rejected works

1 See Jo van Gogh-Bonger's introduction to the letters, p. 4 in the 1990 edition. See also Du Quesne-Van Gogh 1913. p. 7.
2 Van Gelder 1955, pp. 23-28. His article was included virtually unaltered in the 1957 catalogue of Van Gogh's works in the Kröller-Müller Museum. The edition that has been used here is Otterlo 1959, pp. xiii-xxi. In the 1953 edition of the letters, Juv. IX and X are reproduced in vol. 4, pp. 328-29.
3 I only know Juv. XII, a view of a barn and a farmhouse, from reproductions. De la Faille states that it is annotated '8 Februari 1864 Vincent' on the back in the handwriting of Van Gogh's father. February 8 was his birthday, so the drawing was taken as being a present from his son. The style of drawing is far more awkward than that of Juv. I-XI, and partly in the light of the annotation it seems likely that this sheet is indeed by Van Gogh. However, since I have been unable to study it at first hand it has been left out of this discussion.

JUVENILIA

When, in 1880, Van Gogh decided to follow his brother's advice and become an artist it was not because he had some latent, virtuoso talent for drawing that merely had to be fanned gently into life. That is abundantly clear from the drawings he made between roughly 1872 and 1879 *(cats. 1-12)*. Nor could any members of the family recall that he had shown any artistic precocity.[1] Van Gogh's mother could draw quite well, and would certainly have noticed if her son had displayed any ability.

In the 1940s and 1950s a number of youthful works that Van Gogh had supposedly made between the ages of eight and ten suddenly materialised out of nowhere. They appeared to give evidence of an unsuspected, early gift for drawing. There were seven sheets in all, two of which, Juv. IX and X *(figs. 1-2)*, are in the Van Gogh Museum.

The art historian Jan G. van Gelder of Utrecht played a key role in the discovery of these reputedly youthful Van Goghs, and first wrote about a number of them in *De Tafelronde* in 1955. Juv. IX and X had already been published by V.W. van Gogh in the 1953 edition of Van Gogh's letters.[2] These finds led to the introduction of a new category in the 1970 revised edition of De la Faille's 1928 œuvre catalogue: the so-called 'Juvenilia,' the introduction to which was written by Van Gelder. It was not only the genuinely youthful drawings that were gathered together under this heading, but also much later sheets and three sketchbooks that Van Gogh had used before settling on a career as an artist. They probably originated between 1872-73 and 1879 (see *cats. 1-4)*, in other words when Van Gogh was aged between 19 and 26. Eleven of those drawings are in the Van Gogh Museum *(cats. 1-11)*, as are the three sketchbooks. Van Gelder looked on the juvenilia as a whole as evidence that Van Gogh had started out on the road to becoming a draughtsman in 1862 or even earlier, and that all he really did in the Borinage was pick up the threads again.

That is a debatable point of view, for even if the youthful drawings are authentic it is doubtful whether they should be added as a sort of prelude to the œuvre that an adult artist made years later with totally different intentions. But even if one is prepared to be more lenient, only the bulk of Van Gogh's *later* juvenilia can convincingly be counted as part of his œuvre (see the relevant catalogue entries). The authenticity of only one of the works in that category in the Van Gogh Museum is called into question here *(fig. 7)*.

That being said, the attribution of most of the *earliest* works in De la Faille, Juv. I-XII, is highly suspect.[3] They include the sheets published by Van Gelder in 1955. These 'child's drawings' were apparently made between January 1862 and February 1864, going by the

246

dates on most of them. This places them in the period when Van Gogh was aged eight to ten. In addition to the two sheets already mentioned *(figs. 1-2)*, the Van Gogh Museum has three more of these drawings, Juv. I, IV and VII *(figs. 3-5)*. There is also a sixth work that is not in De la Faille but which should certainly be added to the group because of its inscription: '1862 V.W. van Gogh 8 maart' *(fig. 6)*.

These, the earliest works to be attributed to Van Gogh, form a very mixed bag indeed. Doubts about their authenticity were already being voiced in 1957 by Marc Edo Tralbaut, a Belgian expert on Van Gogh.[4] Ten years later, Anna Szymańska roundly dismissed the attributions in her study of Van Gogh's earliest drawings.[5] In 1990, Van Gelder's view was hesitantly endorsed by Frank Kools in his book on Van Gogh's youth in Zundert, although he did not accept that these drawings should be seen as the curtain-raiser to Van Gogh's career as a draughtsman.[6]

One important reason why they were included in the 1970 edition of De la Faille must have been their provenance. If the oral tradition is to be trusted, the drawings of the thistle and the colourful bouquet of flowers can be traced back to three of Van Gogh's aunts, his father's sisters Antje, Doortje and Mietje.[7] They gave religious instruction to children in Helvoirt, and rewarded the industrious ones with pictures, which apparently included drawings by their nephew. One of those pupils, Mrs J. van Erkelens, acquired three sheets in this way, Juv. IX, X and XI, which she gave to a friend in Helvoirt, Mrs Rijnders-Coolen, and it was while they were in her possession that they came to notice in the 1950s.

Juv. IX and X were acquired by V.W. van Gogh for the Vincent van Gogh Foundation in 1966. Because works of this kind had long been unrepresented in the collection he had already bought Juv. I, IV and VII from H. Kokkeel in Utrecht the year before. Kokkeel had received them in lieu of payment from a Mr Cloos of Amsterdam, who in his turn had got them from the Aalbersberg family, one of whose relatives had worked for the Van Goghs. The sixth sheet in the Van Gogh Museum, which is not in De la Faille but is boldly inscribed '1862 V.W. van Gogh 8 maart', appeared completely out of the blue. An accountants' report shows that it was very probably donated to the museum in 1967, but it is not known by whom.[8]

If the provenance of this last drawing is unclear, that of the other five strikes one as being tortuous, to put it mildly, for they had to undergo many twists and turns before they could be brought to a safe haven comfortably close to Van Gogh. Other works attributed to the embryonic artist also have the worrying habit of emerging almost from nowhere. None of the juvenilia in the Kröller-Müller Museum were known prior to their publication by Van Gelder. Two of them, Juv. III and VIII, belonged to A. Declemy in The Hague in 1953, and the other two, Juv. II and VI, were donated to the museum by Van Gelder himself. That is the sum total of their provenance.

It is not only the provenances that are unconvincing. There is little in the sheets in the Van Gogh Museum to inspire confidence in their authenticity. Technically they are

4 *Tralbaut 1957, p. 20.*

5 *Szymańska 1968, pp. 6-7.*

6 *Kools 1990, pp. 105-16.*

7 *Johanna Wilhelmina ('Antje') van Gogh (1812-1883), Dorothea Maria ('Doortje') van Gogh (1815-1882) and Maria Johanna ('Mietje') van Gogh (1831-1911).*

8 *The source is a report of 1972 on the additions to the collection of the Vincent van Gogh Foundation that was drawn up by the Nederlandse Accountants Maatschappij. Listed under the year 1967 is the donation of an otherwise unspecified youthful drawing by Vincent van Gogh. There is no other sheet, however, that could match this entry.*

far too good to be the work of a child. It makes little difference that they are all probably copies after prints, as Van Gelder rightly states, for one can recognise a child's hand even in a copy. Here the lines and hatchings are clearly the work of quite a practised artist. If the young Vincent had been capable of producing drawings like this, someone in the family would certainly have remembered.

The signatures merely reinforce the doubts. Juv. I, IV and VII, all of which came from Kokkeel, have inscriptions in a child's hand. However, there are such glaring differences in the formation of the different letters that they do not appear to have been written by one person. Perhaps, though, because it was a child, one should not attach too much importance to this. The two drawings that were so generously given away in the religious instruction class were signed by two different adults, one of whom had sloping handwriting, the other more upright. The latter signed with 'V van Gogh jr [junior] ft [fecit: made this]'. The qualifying 'junior,' which is normally used for a son with the same forename as his father, is utterly superfluous. Van Gogh's father was called Theodorus. It is true that *his* father was called Vincent, but jr. and sr. were never used to distinguish between grandfather and grandson.

The sixth sheet in the museum also has an inscription in adult script, but it is in a different, third hand. Taking all these contradictions, obscurities and implausibilities together, there is every reason to reject the attribution of these six works to Van Gogh out of hand. They have therefore not been included in this catalogue.

OTHER OMITTED WORKS

Two studies after examples in Charles Bargue's *Exercices au fusain* have been left out because they were not made in the Borinage or Brussels, as stated in the 1987 catalogue of the museum's collection, but in Auvers-sur-Oise in 1890. They will be discussed in the final volume of the catalogue of the drawings.[9]

The present author doubts the authenticity of a sheet that is included in De la Faille 1970 under the later juvenilia as number XXIV *(fig. 7)*. It was not in the 1928 edition of that œuvre catalogue. In 1953, V.W. van Gogh reproduced it alongside a letter that Van Gogh wrote from Isleworth, England, in July 1876, although the contents of that letter had no particular connection with it [83/70]. In an exhibition in 1962 the drawing was then exhibited as *Houses at Isleworth*,[10] and it retained that title as Juv. XXIV. It is amazing that it did so, for the editors of De la Faille 1970 did not associate it with Isleworth at all but with a passage in the same letter in which Van Gogh tells his brother about the magnificent gardens and avenues at Hampton Court. The drawing was also published as *Houses at Isleworth* in the 1987 catalogue of the Van Gogh Museum's collection.

No one would ever have taken this drawing to be a youthful work by Van Gogh if it had been in any collection but that of the Van Gogh family. It has none of the features of the other early drawings (see *cats. 1-12*). It is executed in pencil alone, whereas Van Gogh generally combined pencil with a fine pen for outlines and details. Even more important,

9 One of them, F 1609, is also assigned to that period in De la Faille. Jan Hulsker only published the verso, a scene of a horse and carriage (JH 2089). The other sheet after Bargue, inv. d 62 V/1962, is not in either of those œuvre catalogues.

10 London 1962, no. VI.

2.1 *Thistle.*
Black chalk on wove paper,
18.5 × 14.5 cm.
Signed at lower right: V W van Gogh
6 October 1863.
Verso: start of a drawing in blue chalk
(a bouquet of flowers?).
Inv. d 750 V/1966; Juv. IX JH –

2.2 *Bouquet of flowers.*
Pen and brush in transparent water-
colour on wove paper, 15.9 × 13.9 cm.
Signed at lower right: V van Gogh jʳ fᵗ.
Inv. d 751 V/1966; Juv. X JH –

2.3 *Studies of animal and human heads.*
Black chalk on laid paper, 22.1 × 17.5 cm
Watermark: DE ERVEN D.B [...] (cropped
at the bottom and on the right)
Signed in pencil at lower right:
V W van Gogh 3 Januarij 1862
Inv. d 404 V/1972; Juv. I JH –

2.4 *Sawmill.*
Black chalk on laid paper,
14.2 × 19.0 cm.
Signed in pencil at lower right:
V.W. v. Gogh 2 October 1862.
Inv. d 305 V/1972; Juv. IV JH –

though, is the style of drawing. The entire scene is built up, in a controlled and skilful way, with passages in numerous shades of grey applied with the tip or side of a blunt pencil, and it was probably stumped as well, here and there. The only true lines are in a few of the branches, but they are not at all reminiscent of the tangle of spindly branches found in most of Van Gogh's early drawings of trees (see *cats. 1-4, 7)*. The way in which the foliage is drawn, with small, irregular patches of grey and slightly heavier strokes to indicate individual leaves, has nothing at all in common with Van Gogh's drawing style from any period whatever. The sheet may have been a present to Theo or Vincent van Gogh from an artist who remains anonymous.

A sheet with studies of hands and a woman with a bundle of faggots on her back, which was first published in De la Faille 1970 as number 1689 in the 'Supplementary drawings,' has also been omitted here *(fig. 8)*. It had already been rejected both by Hulsker and in the catalogue of the museum's collection. The editors of De la Faille even went so far as to place this remarkably clumsy sheet in Van Gogh's Nuenen period. They believed that the small woman with the bundle of faggots (which can barely be recognised as such) was associated with the scene of *Winter* from a series of the four seasons that Van Gogh made at Nuenen in 1884 for a goldsmith, Antoon Hermans – a canvas in which figures can be seen carrying faggots in the snow.[11] The hands supposedly date from a little later, and belong to a group of similar studies that the artist sketched in the early months of 1885. This sheet, though, has nothing of the sureness of touch that Van Gogh had already mastered by this stage in his career. If it is to be attributed to him at all, it is as one of his first sketches from the Borinage or Brussels, and should consequently be dated 1879-80. However, it looks too clumsy even for that very early period, and is anyway less assured than Van Gogh's work from the 1870s *(cats. 1-12)*. It is unlikely that this, of all works, gives us an idea of Van Gogh's first steps towards becoming an artist, and it has been decided not to give it the benefit of the doubt.

11 F 43 JH 516.

2.5 *House and barn.*
Black chalk on laid paper,
22.3 × 14.5 cm.
Watermark ED [...] (and a lion?;
cropped at top right).
Signed in pencil at lower right:
V.W. van Gogh 25 January 1863.
Inv. d 304 V/1972; Juv. VII JH –

2.6 *Barn.*
Pencil and transparent watercolour
on laid paper, 19.7 × 25.0 cm.
Signed at lower right: 1862
V.W. van Gogh 8 Maart.
Inv. d 406 V/1969; F – JH –

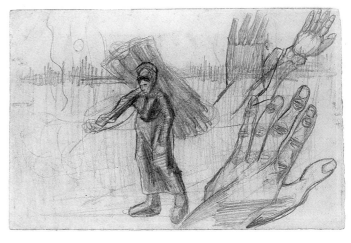

2.7 *Houses.*
Pencil on wove paper, 14.3 × 14.7 cm.
Unsigned.
Inv. d 306 V/1970; Juv. XXIV JH –

2.8 *Woman with a bundle of faggots and
studies of hands.*
Pencil on watercolour paper, 22.4 × 35.7 cm.
Unsigned.
Verso: rectangle in pencil, with traces of
glue.
Inv. d 55 V/1962; F 1689 JH –

Exhibitions

1892 ROTTERDAM Kunstzalen
Oldenzeel, October-November
Vincent van Gogh

1897 GRONINGEN Groningsch
Museum, March-April
[Title unknown]

1900-01 ROTTERDAM Rotter-
damsche Kunstkring, 23 Decem-
ber-10 February
*Tentoonstelling van teekeningen van
Vincent van Gogh*

1903 ROTTERDAM Kunstzalen
Oldenzeel, November
Vincent van Gogh

1904 ROTTERDAM Kunstzalen
Oldenzeel, 10 November-15
December
Vincent van Gogh

1905 AMSTERDAM Stedelijk
Museum, 15 July-1 September
Tentoonstelling Vincent van Gogh

1906 MIDDELBURG Vereeniging
'Voor de Kunst', 25 March-1 April
*Tentoonstelling van werken van
Vincent van Gogh (verzameling
mevr. Cohen Gosschalk)*
ROTTERDAM Kunstzalen
Oldenzeel, 26 January-28 February
Tentoonstelling Vincent van Gogh

1907 BERLIN Ausstellungshaus
am Kurfürstendamm, December
*Vierzehnte Ausstellung der Berliner
Secession, Zeichnende Künste*

1908 AMSTERDAM Kunstzalen
C.M. van Gogh, 3-24 September
Vincent van Gogh tentoonstelling
DRESDEN Emil Richter, April-May
Vincent van Gogh / Paul Cézanne
FRANKFURT Kunstverein, 14-28 June
V. van Gogh Ausstellung

MUNICH Moderne
Kunsthandlung, April
Vincent van Gogh

1909-10 BERLIN Ausstellungshaus
am Kurfürstendamm,
27 November-9 January
*19. Ausstellung der Berliner
Secession, Zeichnende Künste*

1910 COLOGNE Kunstverein,
January; FRANKFURT, Moderne
Kunsthandlung Marie Held,
February
[Title unknown]

1910-11 ROTTERDAM Kunsthandel
A.M. Reckers, 17 December-
15 January
Het dier in de beeldende kunst

1911 AMSTERDAM Larensche
Kunsthandel, June
*Tentoonstelling van schilderijen,
aquarellen en teekeningen van
Vincent van Gogh*

1912 THE HAGUE Modelhuis,
July-August
*Tentoonstelling van teekeningen
door Vincent van Gogh*

1913 THE HAGUE Gebouw Lange
Voorhout 1, July-1 September
Werken van Vincent van Gogh

1914-15 AMSTERDAM Stedelijk
Museum, 22 December-12 January
*Teekeningen door Vincent van
Gogh uit de verzameling van
mevrouw J. van Gogh-Bonger en
den heer V.W. van Gogh*

1920 NEW YORK Montross
Gallery, 23 October-closing date
unknown
Vincent van Gogh exhibition

1923 UTRECHT Vereeniging
'Voor de Kunst', 28 January-
25 February; ROTTERDAM
Rotterdamsche Kunstkring,
15 March-2 April
*Vincent van Gogh. Teekeningen-
collectie van Mevr. J. van Gogh-
Bonger*

1924 AMSTERDAM Gebouw voor
Beeldende Kunst, March-April
Vincent van Gogh tentoonstelling
BASEL Kunsthalle, 27 March-
21 April
Vincent van Gogh
STUTTGART Württembergischer
Kunstverein, October-November
*Ausstellung Vincent van Gogh.
1853-1890*
ZÜRICH Kunsthaus, 3 July-
10 August
Vincent van Gogh

1925 THE HAGUE Pulchri Studio,
March-April
Vincent van Gogh

1926 AMSTERDAM Stedelijk
Museum, 15 May-15 June
*Vincent van Gogh tentoonstelling
ter gelegenheid van het interna-
tionale jeugdfeest der S.J.I.*
LONDON The Leicester Galleries,
November-December
Vincent van Gogh exhibition
MUNICH Glaspalast, 1 June-
early October
I. Allgemeine Kunst-Ausstellung

1927-28 BERLIN Otto Wacker,
6 December-1 February; VIENNA
Neue Galerie, February-March;
HANNOVER Kestner Gesellschaft,
3-25 April
*Vincent van Gogh. Erste grosse
Ausstellung seiner Zeichnungen
und Aquarelle*

1928 PARIS Galerie Dru,
23 June-12 July
*Aquarelles, dessins et pastels de
Van Gogh (1853-1890)*

1929 AMSTERDAM Stedelijk
Museum, 19 October-17 November
*Teekeningen en aquarellen door
Vincent van Gogh*

1930 LAREN Openbare Leeszaal,
4-30 September
Teekeningen van Vincent van Gogh

1931 AMSTERDAM Stedelijk
Museum, 7 February-7 March
*Vincent van Gogh. Werken uit de
verzameling van Ir. V.W. van Gogh,
in bruikleen afgestaan aan de
Gemeente Amsterdam*

1932 AMSTERDAM Kunsthandel
Huinck & Scherjon, 14 May-18 June
*Schilderijen door Vincent van Gogh,
J.B. Jongkind, Floris Verster*
MANCHESTER Manchester City
Art Gallery, 13 October-
27 November
*Vincent van Gogh. Loan collection
of paintings & drawings*

1937 OSLO Kunstnernes Hus,
3-24 December
*Vincent van Gogh. Malerier,
tegninger, akvareller*
PARIS Les Nouveaux Musées,
June-October
La vie et l'oeuvre de Van Gogh

1938 COPENHAGEN
Charlottenborg, January
*Vincent van Gogh. Malerier, teg-
ninger, akvareller*

1941 DELFT Museum Paul Tétar
van Elven, April-7 May
*Kunstverzameling H. Tutein
Nolthenius*

1945 AMSTERDAM Stedelijk
Museum, 14 September-1 December
*Vincent van Gogh. Een documentaire
tentoonstelling*

1946 COPENHAGEN
Charlottenborg, 22 June-14 July
Vincent van Gogh
MAASTRICHT Bonnefanten,
13-27 January; HEERLEN
Raadhuis, 8-24 February
Vincent van Gogh
STOCKHOLM Nationalmuseum,
8 March-28 April; GOTHENBURG
Göteborgs Konstmuseum,
3-26 May; MALMÖ Malmö Museum,
29 May-16 June
*Vincent van Gogh. Utställning
anordnad till förmån för svenska
hollandshjälpen*

1947 GRONINGEN Kunstlievend
Genootschap Pictura, 25 May-
15 June
*Tentoonstelling van tekeningen en
aquarellen van Vincent van Gogh
uit de collectie van Ir. V.W. van
Gogh*
ROTTERDAM Museum Boymans,
July-August
*Vincent van Gogh. Tekeningen uit de
verzameling van Ir. V.W. van Gogh*

1947-48 LONDON The Tate
Gallery, 10 December-14 January;
BIRMINGHAM City Art Gallery,
24 January-14 February; GLASGOW
City Art Gallery, 21 February-
14 March
Vincent van Gogh 1853-1890

1948 BERGEN Kunstforening,
23 March-18 April; OSLO
Kunstnernes Hus, 24 April-15 May
Vincent van Gogh

1948-49 THE HAGUE Gemeente-
museum, 12 October-10 January
*Vincent van Gogh. Collectie
Ir. V.W. van Gogh*

1949-50 NEW YORK
The Metropolitan Museum of Art,
21 October-15 January; CHICAGO
The Art Institute of Chicago,

2 February-16 April
*Vincent van Gogh paintings and
drawings. A special loan exhibition*

1951 LYON Musée de Lyon,
5 February-27 March; GRENOBLE
Musée de Grenoble, 30 March-
2 May; ARLES Musée Réattu /
ST. RÉMY Hotel de Sade, 5-27 May
Vincent van Gogh en Provence

1953 AMSTERDAM Kunsthandel
Huinck & Scherjon, June-July
*Tentoonstelling van schilderijen,
aquarellen, tekeningen en beeld-
houwwerken uit de verzameling van
kunsthandel H & S*
ASSEN Provinciehuis,
6-29 November
Vincent van Gogh in Assen
THE HAGUE Gemeentemuseum,
30 March-17 May
Vincent van Gogh
HOENSBROEK Kasteel
Hoensbroek, 23 May-27 July
Vincent van Gogh
OTTERLO Kröller-Müller Museum,
24 May-19 July; AMSTERDAM
Stedelijk Museum, 23 July-
20 September
Eeuwfeest Vincent van Gogh
ZÜRICH Kunsthaus Zürich,
24 January-1 March
*Van Gogh. Zeichnungen und
Aquarelle aus der Vincent van
Gogh-Stiftung im Stedelijk Museum
Amsterdam*
ZUNDERT Parochiehuis, 30 March-
20 April
Vincent van Gogh in Zundert

1953-54 BERGEN OP ZOOM
Stadhuis, 23 December-10 January
Vincent van Gogh
SAINT LOUIS City Art Museum
of Saint Louis, 17 October-13
December; PHILADELPHIA
Philadelphia Museum of Art,
2 January-28 February; TOLEDO
The Toledo Museum of Art, 7
March-30 April
Vincent van Gogh. 1853-1890

1954 GENEVA Musée Rath,
26 June-3 October
Trésors des collections romandes

1954-55 BERN Kunstmuseum
Bern, 27 November-30 January
Vincent van Gogh
WILLEMSTAD Curaçaosch
Museum, 19 December-15 January
Vincent van Gogh

1955 AMSTERDAM Stedelijk
Museum, June-September
Vincent van Gogh
ANTWERP Feestzaal, 7 May-
19 June
Vincent van Gogh
NEW YORK Wildenstein & Co,
24 March-30 April
Vincent van Gogh loan exhibition
PALM BEACH Society of the Four
Arts, 21 January-13 February;
MIAMI Lowe Gallery of the Uni-
versity of Miami, 24 February-
20 March; NEW ORLEANS Isaac
Delgado Museum, 27 March-
20 April
Vincent van Gogh 1853-1890

1955-56 LIVERPOOL The Walker
Art Gallery, 29 October-10
December; MANCHESTER
Manchester City Art Gallery,
17 December-4 February;
NEWCASTLE-UPON-TYNE Laing
Art Gallery, 11 February-
24 March
*Vincent van Gogh. Paintings &
drawings, mainly from the collec-
tion of Ir. V.W. van Gogh*

1956 HAARLEM Vishal, 21 July-
27 August
Vincent van Gogh

1957 BREDA De Beyerd,
2-24 February
Vincent van Gogh
MARSEILLES Musée Cantini,
12 March-28 April
Vincent van Gogh
NIJMEGEN Waag, 13 March-
15 April
*Tekeningen en aquarellen van
Vincent van Gogh*

STOCKHOLM Nationalmuseum,
5 October-22 November
*Vincent van Gogh. Akvareller,
teckningar, oljestudier, brev*

1957-58 LEIDEN Stedelijk
Museum De Lakenhal,
9 November-16 December;
SCHIEDAM Stedelijk Museum,
21 December-27 January
Vincent van Gogh

1958 BERGEN (Belgium)
Museum voor Schone Kunsten,
22 March-5 May
*Vincent van Gogh (1853-1890).
Son art et ses amis*
ETTEN-LEUR De Nobelaer,
15 November-14 December
*Facetten van Etten of van Van Gogh
tot Zadkine, wie was Van Gogh?*

1958-59 SAN FRANCISCO
The M.H. de Young Memorial
Museum, 6 October-30 November;
LOS ANGELES Los Angeles
County Museum, 10 December-
18 January; PORTLAND The Portland
Art Museum, 28 January-1 March;
SEATTLE Seattle Art Museum,
7 March-19 April
*Vincent van Gogh. Paintings and
drawings*

1959-60 UTRECHT Centraal
Museum, 18 December-1 February
*Vincent van Gogh schilderijen en
tekeningen, verzameling Ir. V.W.
van Gogh*

1960 ENSCHEDE Rijksmuseum
Twente, 6 February-20 March
Vincent van Gogh. Tekeningen
PARIS Musée Jacquemart-André,
February-May
Vincent van Gogh 1853-1890

1960-61 EINDHOVEN Stedelijk
Van Abbe Museum, 5 November-
13 December; SCHIEDAM Stedelijk
Museum, 17 December-30 January
*Eindhoven verzamelt, van Jongkind
tot Jorn*
MONTREAL The Montreal
Museum of Fine Arts, 6 October-

OTTAWA The National Gallery of Canada, 17 november-18 december; WINNIPEG The Winnipeg Art Gallery, 29 december-31 januari; TORONTO The Art Gallery of Toronto, 10 februari-12 maart
Vincent van Gogh. Paintings-drawings. Tableaux-dessins

1961 AMSTERDAM Kunsthandel E.J. van Wisselingh, 19 april-18 mei
Vincent van Gogh. Aquarelles & dessins de l'époque 1881-1885 provenant de collections particulières néerlandaises
SCARBOROUGH Scarborough Art Gallery, 12-17 juni
Dutch Graphic Art

1961-62 BALTIMORE The Baltimore Museum of Art, 18 oktober-26 november; CLEVELAND The Cleveland Museum of Art, 5 december-14 januari; BUFFALO Albright Art Gallery, 30 januari-11 maart; BOSTON Museum of Fine Arts, 22 maart-29 april
Vincent van Gogh. Paintings, watercolors and drawings
LUIK Museum voor Schone Kunsten, 24 november-8 januari; BREDA De Beyerd, 26 januari-4 maart
Aquarelles et gouaches hollandaises de 1850 à nos jours / Nederlandse aquarellen en gouaches van 1850 tot heden

1962 LONDEN Marlborough Fine Art Limited, mei-juni
Van Gogh's life in his drawings. Van Gogh's relationship with Signac

1962-63 PITTSBURGH Carnegie Institute, 18 oktober-4 november; DETROIT Detroit Institute of Arts, 11 december-29 januari; KANSAS CITY William Rockhill Nelson Gallery of Art / Mary Atkins Museum of Fine Arts, 7 februari-26 maart
Vincent van Gogh. Paintings, watercolors and drawings

1963 AMSTERDAM Stedelijk Museum, 6 juli-29 september
150 jaar Nederlandse Kunst. Schilderijen, beelden, tekeningen, grafiek 1813-1963
HUMLEBAEK Louisiana, 24 oktober-8 december
Vincent van Gogh. Malerier og tegninger
SHEFFIELD Graves Art Gallery, 20 april-12 mei
An exhibition of the works of Vincent van Gogh. Paintings and drawings lent by Mr. V.W. van Gogh through the Stedelijk Museum, Amsterdam

1964 WASHINGTON The Washington Gallery of Modern Art, 2 februari-19 maart; NEW YORK The Solomon R. Guggenheim Museum, 2 april-28 juni
Vincent van Gogh. Paintings, watercolors and drawings
ZEIST Het Slot Zeist, 15 mei-21 juni
Kunstbezit uit Zeist en omgeving
ZUNDERT Parochiehuis, 28 mei-8 juni
Tentoonstelling van tekeningen van Vincent van Gogh

1965 CHARLEROI Palais des Beaux-Arts, 9 januari-9 februari; GENT Museum voor Schone Kunsten, 19 februari-21 maart
Vincent van Gogh. Schilderijen, aquarellen, tekeningen

1965-66 STOCKHOLM Moderna Museet, 22 oktober-19 december; GÖTEBORG Göteborgs Konstmuseum, 30 december-20 februari
Vincent van Gogh. Målningar, akvareller, teckningar

1966 PARIJS Institut Néerlandais, 28 januari-20 maart; ALBI Musée Toulouse Lautrec, 27 mei-31 augustus
Vincent van Gogh. Dessinateur

1967 LILLE Palais des Beaux Arts, 14 januari-13 maart; ZÜRICH Kunsthaus, 5 april-4 juni

Vincent van Gogh. Dessins, aquarelles
WOLFSBURG Stadthalle, 18 februari-2 april
Vincent van Gogh. Gemälde, Aquarelle, Zeichnungen

1967-68 DALLAS Dallas Museum of Fine Arts, 6 oktober-4 november; PHILADELPHIA Philadelphia Museum of Art, 17 november-31 december; TOLEDO The Toledo Museum of Art, 20 januari-3 maart; OTTAWA The National Gallery of Canada, 14 maart-15 april
Vincent van Gogh. Drawings, watercolors

1968 LUIK Museum voor Schone Kunsten, 3-30 september
Vincent van Gogh. Dessins, aquarelles

1968-69 LONDEN Hayward Gallery, 23 oktober-12 januari
Vincent van Gogh. Paintings and drawings of the Vincent van Gogh Foundation Amsterdam

1969 HUMLEBAEK Louisiana, 25 januari-16 maart
Vincent van Gogh. Tegninger og akvareller

1969-70 LOS ANGELES The Los Angeles County Museum, 14 oktober-1 december; SAINT LOUIS City Art Museum of Saint Louis, 20 december-1 februari; PHILADELPHIA Philadelphia Museum of Art, 28 februari-5 april; COLUMBUS The Columbus Gallery of Fine Arts, 5 maart-5 april
Vincent van Gogh. Paintings and drawings

1970 DEN HAAG Haags Gemeentemuseum, 6 maart-10 mei
Schilders rond de Herengracht
FRANKFURT Frankfurter Kunstverein, 30 april-21 juni
Vincent van Gogh. Zeichnungen und Aquarelle

1970-71 BALTIMORE The Baltimore Museum of Art, 11 oktober-

29 november; SAN FRANCISCO The M.H. de Young Memorial Museum, 11 december-31 januari; NEW YORK The Brooklyn Museum, 14 februari-4 april
Vincent van Gogh. Paintings and drawings

1971-72 PARIJS Orangerie des Tuileries, 21 december-10 april
Vincent van Gogh. Collection du Musée National Vincent van Gogh à Amsterdam

1972 BORDEAUX Musée des Beaux Arts, 21 april-20 juni
Vincent van Gogh. Collection du Musée National Vincent van Gogh à Amsterdam

1972-73 STRAATSBURG Musée d'Art Moderne, 22 oktober-15 januari; BERN Kunstmuseum Bern, 25 januari-1 april
Vincent van Gogh. Collection du Musée National Vincent van Gogh à Amsterdam

1974 FLORENCE Palazzo Strozzi, 11 mei-30 juni
Quarta biennale internazionale della grafica d'arte. La grafica dal realismo al simbolismo

1974-75 NOTTINGHAM University Art Gallery, 5-30 november; NEWCASTLE-UPON-TYNE Laing Art Gallery, 7 december-12 januari; LONDEN Victoria and Albert Museum, 30 januari-23 februari; LEIGH Turnpike Gallery, 1-22 maart; SHEFFIELD Graves Art Gallery, 29 maart-20 april; BRADFORD Cartwright Hall, 26 april-18 mei; BRIGHTON Gardner Centre Gallery, 24 mei-14 juni; READING Museum and Art Gallery, 21 juni-12 juli
English influences on Vincent van Gogh

1975 AMSTERDAM Van Gogh Museum, 24 september-31 december
De verzameling Engelse prenten van Vincent van Gogh

MALMÖ Malmö Konsthall, 6 June-
10 August
*Vincent van Gogh. 100 teckningar
och akvareller. 100 drawings and
water colours*
RECKLINGHAUSEN Städtische
Kunsthalle, 22 May-10 July
*Der Einzelne und die Masse.
Kunstwerke des 19. und
20. Jahrhunderts*

1976 OSLO Munch Museet,
5 April-15 June
*Vincent van Gogh. 100 tegninger
og akvareller*
STOCKHOLM Galleriet,
Kulturhuset, 10 February-28 March
Vincent van Gogh

1976-77 TOKYO The National
Museum of Western Art,
30 October-19 December; KYOTO
The National Museum of Modern
Art, 6 January-20 February;
NAGOYA The Aichi Prefectural
Art Gallery, 24 February-
14 March
Vincent van Gogh exhibition

1977 PARIS Grand Palais,
4 November-3 December
Vincent van Gogh

1979 TOKYO Odakyu Grand
Gallery, 27 April-16 May; SAPPORO
Hokkaido Museum of Modern
Art, 20 May-10 June; HIROSHIMA
The Hiroshima Prefectural
Museum, 15 June-1 July; NAGOYA
Aichi Prefectural Art Gallery,
12-30 September
*Dutch painting from the century
of Van Gogh*

1980-81 AMSTERDAM Van Gogh
Museum, 13 December-22 March
*Vincent van Gogh in zijn Hollandse
jaren. Kijk op stad en land door Van
Gogh en zijn tijdgenoten 1870-1890*
STUTTGART Württembergischer
Kunstverein, 23 November-
18 January
*Van Gogh bis Cobra. Holländische
Malerei 1880-1950*

1982 AMSTERDAM Van Gogh
Museum, 5 July-28 November
*Een nieuwe keuze uit de collectie
tekeningen en prenten*
HOLLAND Hope College, De Pree
Art Center & Gallery, 2 October-
13 November
Dutch art & modern life. 1882-1982

1983 PARIS Grand Palais,
15 January-28 March; LONDON
Royal Academy of Arts, 16 April-
10 July; THE HAGUE Haags
Gemeentemuseum, 5 August-
31 October
*The Hague School. Dutch masters
of the 19th century*

1983-84 AMSTERDAM Van Gogh
Museum, 20 December-February
*Presentatie aanwinsten
Rijksmuseum Vincent van Gogh*

1985-86 TOKYO The National
Museum of Western Art,
12 October-8 December; NAGOYA
Nagoya City Museum,
21 December-2 February
Vincent van Gogh exhibition

1986 OSAKA The National
Museum of Art, 21 February-
31 March
*Vincent van Gogh from Dutch col-
lections. Religion, humanity, nature*

1987-88 DEN BOSCH Noord-
brabants Museum, 2 November-
10 January
*Van Gogh in Brabant. Schilderijen
en tekeningen uit Etten en Nuenen*
MANCHESTER Manchester City
Art Gallery, 14 November-10
January; AMSTERDAM Van Gogh
Museum, 24 January-13 March;
NEW HAVEN Yale Centre for
British Art, 6 April-29 May
*Hard Times. Social realism in
Victorian art*

1988 ROME Galleria Nazionale
d'Arte Moderna, 28 January-4 April
Vincent van Gogh

1988-89 AMSTERDAM Van Gogh
Museum, 9 December-
26 February
Van Gogh & Millet

1990 THE HAGUE Haags
Historisch Museum, 8 September-
18 November
Van Gogh en Den Haag
OTTERLO Kröller-Müller Museum,
30 March-29 July
Vincent van Gogh. Tekeningen

1992 LONDON Barbican Art
Gallery, 27 February-4 May
*Van Gogh in England. Portrait of
the artist as a young man*

1995 AMSTERDAM Van Gogh
Museum, 19 May-27 August
*Vincent van Gogh. Het grafische
werk*

Literature

AMSTERDAM 1980-81 Griselda Pollock, exhib. cat. *Vincent van Gogh in zijn Hollandse jaren. Kijk op stad en land door Van Gogh en zijn tijdgenoten 1870-1890*, Amsterdam (Van Gogh Museum) 1980-81

AMSTERDAM 1987 Evert van Uitert and Michael Hoyle (eds.), cat. *The Rijksmuseum Vincent van Gogh*, Amsterdam 1987

AMSTERDAM 1988-89 Louis van Tilborgh et al., exhib. cat. *Van Gogh & Millet*, Amsterdam (Van Gogh Museum) 1988-89

AMSTERDAM 1991 Cat. *Van Gogh Museum: aanwinsten / acquisitions 1986-1991*, Amsterdam & Zwolle 1991

BAILEY 1994 Martin Bailey, 'Theo van Gogh identified. Lucien Pissarro's drawing of Vincent and his brother', *Apollo* 138 (1994), no. 388, pp. 44-46

BALK 1993 Hildelies Balk, 'De freule, de professor, de koopman en zijn vrouw. Het publiek van H.P. Bremmer', *Jong Holland* 9 (1993), no. 2, pp. 4-24, with appendix

Charles Bargue, *Cours de dessin*, Paris 1868-1870

Charles Bargue, *Exercices au fusain pour préparer à l'étude de l'académie d'après nature*, Paris 1871

DE BODT 1995 Saskia de Bodt, *Halverwege Parijs. Willem Roelofs en de Nederlandse schilderskolonie in Brussel 1840-1890*, Ghent 1995

BREMMER 1904 H.P. Bremmer, *Moderne Kunstwerken* 2 (1904), inst. 12, no. 92

BREMMER 1926 H.P. Bremmer, *Beeldende Kunst* 13 (1926), inst. 11, pp. 82-83, no. 82, pp. 84-85, no. 84

BREMMER 1934 H.P. Bremmer, *Beeldende Kunst* 21 (1934) inst. 1, no. 5

Jaap W. Brouwer et al., *Anthon van Rappard. Companion & correspondent of Vincent van Gogh: his life & all his works*, Amsterdam & Maarssen 1974

Armand Cassagne, *Le dessin pour tous*, Paris 1868

CASSAGNE 1873 Armand Cassagne, *Guide pratique pour les différents genres de dessin*, Paris 1873

CASSAGNE 1875 Armand Cassagne, *Traité d'aquarelle*, Paris 1875

CASSAGNE 1879 Armand Cassagne, *Traité pratique de perspective: appliquée au dessin artistique et industriel*, Paris 1879

CASSAGNE 1880 Armand Cassagne, *Guide de l'alphabet du dessin ou l'art d'apprendre et d'enseigner les principes rationnels du dessin d'après nature*, Paris 1880

Armand Cassagne, *Éléments de perspective*, Paris 1881

CHETHAM 1976 Charles Chetham, *The role of Vincent van Gogh's copies in the development of his art*, New York & London 1976

The complete letters of Vincent van Gogh, 4 vols., Greenwich (Conn.) 1958

COOPER 1955 Douglas Cooper, *Drawings and watercolours by Vincent van Gogh*, New York & Basel 1955

VAN CRIMPEN 1975 Han van Crimpen, 'Drawings by Vincent not included in de la Faille (2)', *Vincent. Bulletin of the Rijksmuseum Vincent van Gogh* 4 (1975), no. 1, pp. 14-17

VAN CRIMPEN 1986 Han van Crimpen, 'Landschap in Drente, met kanaal en zeilboot, Vincent van Gogh, 1853-1890', *Vereniging Rembrandt. Jaarverslag 1986*, pp. 70-71

VAN CRIMPEN 1987 I Han van Crimpen, 'Aankoop', *Van Gogh Bulletin* 2 (1987), no. 1, unpag.

VAN CRIMPEN 1987 II Han van Crimpen, 'New acquisition', *Van Gogh Bulletin* 2 (1987), no. 2, unpag.

Han van Crimpen and Monique Berends-Albert (eds.), *De brieven van Vincent van Gogh*, 4 vols., The Hague 1990

DEN BOSCH 1987-88 Evert van Uitert (ed.), exhib. cat. *Van Gogh in Brabant. Paintings and drawings from Etten and Nuenen*, Den Bosch (Noordbrabants Museum) 1987-88

Cat. *A detailed catalogue of the paintings and drawings by Vincent van Gogh in the collection of the Kröller-Müller National Museum*, Otterlo 1980

DORN 1987 Roland Dorn, 'Als Zeichner unter Malern: Vincent van Gogh in Den Haag, 1881-1883', in: John Sillevis et al. (eds.), exhib. cat. *Die Haager Schule: Meisterwerke der holländische Malerei des 19. Jahrhunderts aus Haags Gemeentemuseum*, Mannheim (Kunsthalle Mannheim) 1987, pp. 58-80

VAN DEN EERENBEEMT 1924 [Herman van den Eerenbeemt], 'Vincent van Gogh', *Opgang* 4 (1924), no. 162, pp. 265, 268-82

DE LA FAILLE 1928 J.-B. de la Faille, *L'oeuvre de Vincent van Gogh: catalogue raisonné*, 4 vols., Paris & Brussels 1928

DE LA FAILLE 1930 J.-B. de la Faille, *Les faux Van Gogh*, Paris & Brussels 1930

DE LA FAILLE 1970 J.-B. de la Faille, *The works of Vincent van Gogh. His paintings and drawings*, Amsterdam 1970

DE LA FAILLE 1992 J.-B. de la Faille, *Vincent van Gogh. The complete works on paper: catalogue raisonné*, 2 vols., San Francisco 1992

FEILCHENFELDT 1988 Walter Feilchenfeldt, *Vincent van Gogh & Paul Cassirer, Berlin. The reception of Van Gogh in Germany from 1901 to 1914*, Zwolle 1988

GANS 1961 L. Gans, 'Twee onbekende tekeningen uit Van Gogh's Hollandse periode', *Museumjournaal* 7 (1961), no. 2, pp. 33-34

VAN GELDER 1955 J.G. van Gelder, 'Vincent's begin', *De Tafelronde* 2 (1955), no. 8-9. pp. 23-28

VAN GELDER 1959 J.G. van Gelder, 'The beginnings of Vincent's art', in: *A detailed catalogue with full documentation of 272 works by Vincent van Gogh belonging to the collection of the state museum Kröller-Müller*, Otterlo 1959, pp. XV-XXI

VAN GOGH 1905 *Vincent van Gogh. 40 photocollographies d'après ses tableaux et dessins*, Amsterdam [1905]

Vincent van Gogh. Brieven aan zijn broeder, uitgegeven en toegelicht door zijn schoonzuster J. van Gogh-Bonger, 3 dln., Amsterdam 1914

DE GRUYTER 1961 W. Jos de Gruyter, *Tekeningen van Vincent van Gogh*, [Amsterdam 1961]

HAVELAAR 1915 Just Havelaar, *Vincent van Gogh*, Amsterdam [1915]

HEENK 1994 Liesbeth Heenk, 'Revealing Van Gogh. An examination of his papers', *The paper conservator* 18 (1994), pp. 30-39

Liesbeth Heenk, 'Van Gogh's drawings. A closer look', *Apollo* 140 (1994), nr. 393, pp. 37-42

VAN HEUGTEN 1994 Sjraar van Heugten, 'Vincent van Gogh. Portret van Vincent van Gogh, grootvader van de kunstenaar, Etten, juli 1881', *Van Gogh bulletin* 9 (1994), nr. 1, pp. 12-13

VAN HEUGTEN / PABST 1995 Sjraar van Heugten en Fieke Pabst, *The graphic work of Vincent van Gogh*, Zwolle 1995

HEIJBROEK / WOUTHUYSEN 1993 J.F. Heijbroek en E.L. Wouthuysen, *Kunst, kennis en commercie. De kunsthandel J.H. de Bois (1878-1946)*, Amsterdam & Antwerpen 1993

HOMBURG 1994 Cornelia Homburg, *The copy turns original. Vincent van Gogh and a new approach to traditional art practice*, (ongepubliceerde diss.) Amsterdam 1994

HULSHOFF / VAN HEUGTEN 1994 Claas Hulshoff & Sjraar van Heugten, 'Restauratie van een bosgezicht van Vincent van Gogh', *Van Gogh bulletin* 9 (1994), nr. 1, pp. 8-10

Jan Hulsker, *Van Gogh door Van Gogh. De brieven als commentaar op zijn werk*, Amsterdam 1973

HULSKER 1973 Jan Hulsker, 'Van Gogh's family and the public soup kitchen. A new acquisition', *Vincent. Bulletin of the Rijksmuseum Vincent van Gogh* 2 (1973), nr. 2, pp. 12-15

HULSKER 1974 Jan Hulsker, 'A new extensive study of Van Gogh's stay in The Hague', *Vincent. Bulletin of the Rijksmuseum Vincent van Gogh* 3 (1974), nr. 2, pp. 29-32

HULSKER 1976 Jan Hulsker, 'Van Gogh's first and only commission as an artist', *Vincent. Bulletin of the Rijksmuseum Vincent van Gogh* 4 (1976), nr. 4, pp. 5-19

HULSKER 1985 Jan Hulsker, *Lotgenoten. Het leven van Vincent en Theo van Gogh*, Weesp 1985

HULSKER 1989 Jan Hulsker, *Van Gogh en zijn weg. Het complete werk*, Amsterdam 1989

HULSKER 1993 Jan Hulsker, *Van Gogh in close-up*, Amsterdam 1993

Jan Hulsker, *Vincent van Gogh. A guide to his work and letters*, Zwolle 1993

JAFFÉ 1968 H.L.C. Jaffé, 'Vincent van Gogh en G. Breitner een parallel?', in: *Miscellanea Joseph Duverger I*, Gent 1968, pp. 383-87

JAMPOLLER 1971 Lili Jampoller, 'Gardner with pruning knife', *Vincent. Bulletin of the Rijksmuseum Vincent van Gogh* 1 (1971), nr. 3, pp. 13-14

KÔDERA 1987 Tsukasa Kôdera, '"In het zweet uws aanschijns". Spitters in Van Gogh's œuvre', in: Evert van Uitert (ed.), tent. cat. *Van Gogh in Brabant. Schilderijen en tekeningen uit Etten en Nuenen*, Den Bosch (Noordbrabants Museum) 1987, pp. 59-71

KÔDERA 1990 Tsukasa Kôdera, *Vincent van Gogh. Christianity versus nature*, Amsterdam & Philadelphia 1990

KOOLS 1990 Frank Kools, *Als een boer van Zundert. Vincent van Gogh en zijn geboorteplaats*, Zutphen 1990

KOSCHATZKY 1977 Walter Koschatzky, *Die Kunst der Zeichnung. Technik, Geschichte, Meisterwerke*, Stuttgart 1977

KUNSTBEELD 1987 'Van Gogh en het grote formaat', *Kunstbeeld* 11 (1987), nr. 6, p. 7

LETTRES 1911 *Lettres de Vincent van Gogh à Emile Bernard*, Paris 1911

VAN LINDERT / VAN UITERT 1990 Juleke van Lindert en Evert van Uitert, *Een eigentijdse expressie. Vincent van Gogh en zijn portretten*, Amsterdam 1990

LUTJEHARMS 1978 W. Lutjeharms, *De Vlaamse opleidingsschool van Nicolaas de Jonge en zijn opvolgers (1875-1926)*, Brussel 1978

John Marshall, *Anatomy for artists*, London 1883

VAN DER MAST / DUMAS 1990 Michiel van der Mast en Charles Dumas (eds.), *Van Gogh en Den Haag*, Zwolle 1990

MEDER 1922 Joseph Meder, *Die Handzeichnung. Ihre Technik und Entwicklung*, Wien 1922

MEIER-GRAEFE 1928 J. Meier-Graefe, *Vincent van Gogh der Zeichner*, Berlin 1928

VAN MEURS z.j. *Isographieën systeem W. van Meurs. Volledige geïllustreerde catalogus*, Amsterdam z.j.

MEIJER 1968 E.R. Meijer, 'Van Gogh publikaties (4). Rijksmuseum Vincent van Gogh: een nieuwe aanwinst en een nieuwe publikatie', *Museumjournaal* 13 (1968), nr. 4, pp. 216-19

MEIJER 1971 E.R. Meijer, 'Tuinman met kapmes', *Vereniging Rembrandt. Verslag over 1971*, pp. 40-41

MURPHY 1984 Alexandra R. Murphy, *Jean-François Millet*, Boston 1984

MUSEUMJOURNAAL 1968 'Van Gogh publikaties (1)', *Museumjournaal* 13 (1968), nr. 1, pp. 42-45

NOTTINGHAM 1974-75 Ronald Pickvance, tent. cat. *English influences on Vincent van Gogh*, Nottingham (University Art Gallery) etc. 1974-75

OP DE COUL 1969 Martha Op de Coul, 'Van Gogh publikaties (7). Een onbekend Haags stadsgezicht van Vincent van Gogh', *Museumjournaal* 14 (1969), nr. 1, pp. 42-44

OP DE COUL 1975 Martha Op de Coul, 'The entrance to the "Bank van Leening" (Pawnshop)', *Vincent. Bulletin of the Rijksmuseum Vincent van Gogh* 4 (1975), nr. 2, pp. 28-30

OP DE COUL 1976 Martha Op de Coul, 'De toegang tot de

OP DE COUL 1976 Martha Op de Coul, 'De toegang tot de "Bank van Leening" in Den Haag, getekend door Vincent van Gogh', *Oud Holland* 90 (1976), no. 1, pp. 65-68

OP DE COUL 1983 Martha Op de Coul, 'Een mannenfiguur, in 1882 door Vincent van Gogh getekend', *Oud Holland* 97 (1983), no. 3, pp. 196-200

OSAKA 1986 Exhib. cat. *Vincent van Gogh from Dutch collections. Religion, humanity, nature*, Osaka (The National Museum of Art) 1986

OTTERLO 1990 Johannes van der Wolk et al., exhib. cat. *Vincent van Gogh. Drawings*, Otterlo (Kröller-Müller Museum) 1990

PABST 1988 Fieke Pabst, *Vincent van Gogh's poetry albums*, Zwolle 1988

PEY 1990 E.B.F. Pey, 'Chalk the colour of ploughed-up land on a summer evening', in: exhib. cat. *Vincent van Gogh. Drawings*, Otterlo (Kröller-Müller Museum) 1990, pp. 28-40

PFISTER 1922 Kurt Pfister, *Van Gogh*, Potsdam 1922

Griselda F.S. Pollock, *Vincent van Gogh and Dutch art. A study of the development of Van Gogh's notion of modern art*, (unpublished dissertation) London 1980

POLLOCK 1983 Griselda Pollock, 'Stark encounters. Modern life and urban work in Van Gogh's drawings of The Hague 1881-3', *Art History* 6 (1983), no. 3, pp. 330-58

Griselda Pollock, 'Van Gogh and the poor slaves. Images of rural labour as modern art', *Art History* 11 (1988), no. 3, pp. 406-32

DU QUESNE-VAN GOGH 1913 E.H. du Quesne-van Gogh, *Personal recollections of Vincent van Gogh*, Boston & New York 1913

DU QUESNE-VAN GOGH 1923 E.H. du Quesne-van Gogh, *Vincent van Gogh. Herinneringen aan haar broeder*, Baarn 1923

Karl Robert, *Le fusain sans maître. Traité pratique et complet sur l'étude du paysage au fusain*, Paris 1928

SCHMAL 1995 Henk Schmal, *Den Haag of 's-Gravenhage? De 19de-eeuwse gordel, een zone gemodelleerd door zand en veen*, Utrecht 1995

SENSIER 1881 Alfred Sensier, *La vie et l'oeuvre de J.-F. Millet*, Paris 1881

SOTH 1994 Lauren Soth, 'Van Gogh's images of women sewing', *Zeitschrift für Kunstgeschichte* 57 (1994), no. 1, pp. 105-10

STEENHOFF 1905 W. Steenhoff, 'Vincent van Gogh', *De Amsterdammer* (15 January 1905), p. 5

STOKVIS 1926 Benno J. Stokvis, *Nasporingen omtrent Vincent van Gogh in Brabant*, Amsterdam 1926

STOLL 1961 *Sammlung Arthur Stoll. Skulpturen und Gemälde des 19. und 20. Jahrhunderts*, Zürich & Stuttgart 1961

SZYMAŃSKA 1968 Anna Szymańska, *Unbekannte Jugendzeichnungen Vincent van Goghs und das Schaffen des Künstlers in den Jahren 1870-1880*, Berlin 1968

VAN TILBORGH 1995 Louis van Tilborgh, 'Framing Van Gogh: 1880-1990', in: exhib. cat. *In perfect harmony: picture + frame 1850-1920*, Amsterdam (Van Gogh Museum) etc. 1995, pp. 163-80

VAN TILBORGH / PABST 1995 Louis van Tilborgh and Fieke Pabst, 'Notes on a donation. The poetry album for Elisabeth Huberta van Gogh', in: *The Van Gogh Museum journal 1995*, Amsterdam 1995

TRALBAUT 1957 Marc Edo Tralbaut, *Van Gogh. Début & évolution*, Amsterdam 1957

TRALBAUT 1959 Marc Edo Tralbaut, *Vincent van Gogh in Drenthe*, Assen 1959

TRALBAUT 1969 Marc Edo Tralbaut, *Van Gogh, le mal aimé*, Lausanne 1969

VAN UITERT 1983 Evert van Uitert, *Vincent van Gogh in creative competition. Four essays from Simiolus*, [Utrecht] 1983

VANBESELAERE 1937 Walther Vanbeselaere, *De Hollandsche periode (1880-1885) in het werk van Vincent van Gogh*, Amsterdam [1937]

VERKADE-BRUINING 1974 A. Verkade-Bruining, 'Vincent's plans to become a clergyman', *Vincent. Bulletin of the Rijksmuseum Vincent van Gogh* 3 (1974), no. 4, pp. 14-23

VERKADE-BRUINING 1975 A. Verkade-Bruining, 'Vincent's plans to become a clergyman (2)', *Vincent. Bulletin of the Rijksmuseum Vincent van Gogh* 4 (1975), no. 1, pp. 9-13

VISSER 1973 W.J.A. Visser, 'Vincent van Gogh en 's-Gravenhage', *Geschiedkundige Vereniging Die Haghe. Jaarboek 1973*, pp. 1-125

WADLEY 1969 Nicholas Wadley, *The drawings of Van Gogh*, London [etc.] 1969

WERNESS 1972 Hope Benedict Werness, *Essays on Van Gogh's symbolism*, (unpublished dissertation) [Santa Barbara] 1972

VAN DER WOLK 1980 J. van der Wolk, 'Gashouders te Den Haag, 1882, Vincent van Gogh, 1853-1890', *Vereniging Rembrandt. Verslag over 1980*, pp. 63-64

VAN DER WOLK 1987 Johannes van der Wolk, *The seven sketchbooks of Vincent van Gogh. A facsimile edition*, New York 1987

VAN DER WOLK 1992 Johannes van der Wolk, *De Kröllers en hun architecten: H.E.L.J. Kröller-Müller, A.G. Kröller, L.J. Falkenburg, P. Behrens, L. Mies van der Rohe, H.P. Berlage, A.J. Kropholler, H. van de Velde*, Otterlo 1992

WYLIE 1970 Anne Stiles Wylie, 'An investigation of the vocabulary of line in Vincent van Gogh's expression of space', *Oud Holland* 85 (1970), no. 4, pp. 210-35

WYLIE 1974 Anne Stiles Wylie, 'Coping with a dizzying world', *Vincent. Bulletin of the Rijksmuseum Vincent van Gogh* 3 (1974), no. 1, pp. 8-18

A. Ysabeau, *Lavater et Gall. Physiognomonie et phrénologie rendues intelligibles pour tout le monde*, Paris n.d.

ZEMEL 1987 Carol Zemel, 'Sorrowing women, rescuing men. Van Gogh's images of women and family', *Art History* 10 (1987), no. 3, pp. 351-68

Index

Colophon

EDITORS
Louis van Tilborgh
Marije Vellekoop

DOCUMENTATION
Monique Hageman
Fieke Pabst
Marije Vellekoop

TRANSLATOR AND ENGLISH EDITOR
Michael Hoyle

DESIGN
Cees de Jong
Corine Teuben
V+K Design, Bussum

LAY-OUT
Cees de Jong
Corine Teuben
José K. Vermeulen
V+K Design, Bussum

PRINTED BY
bv Kunstdrukkerij Mercurius, Wormerveer

PHOTO CREDITS
All the photographs have been provided by the museums or the owners of the works. The photographs of the drawings in the Van Gogh Museum were taken by Thijs Quispel.

FRONT COVER
Detail of cat. 27, *Country road*, 1882.